HENRY'S ATTIC

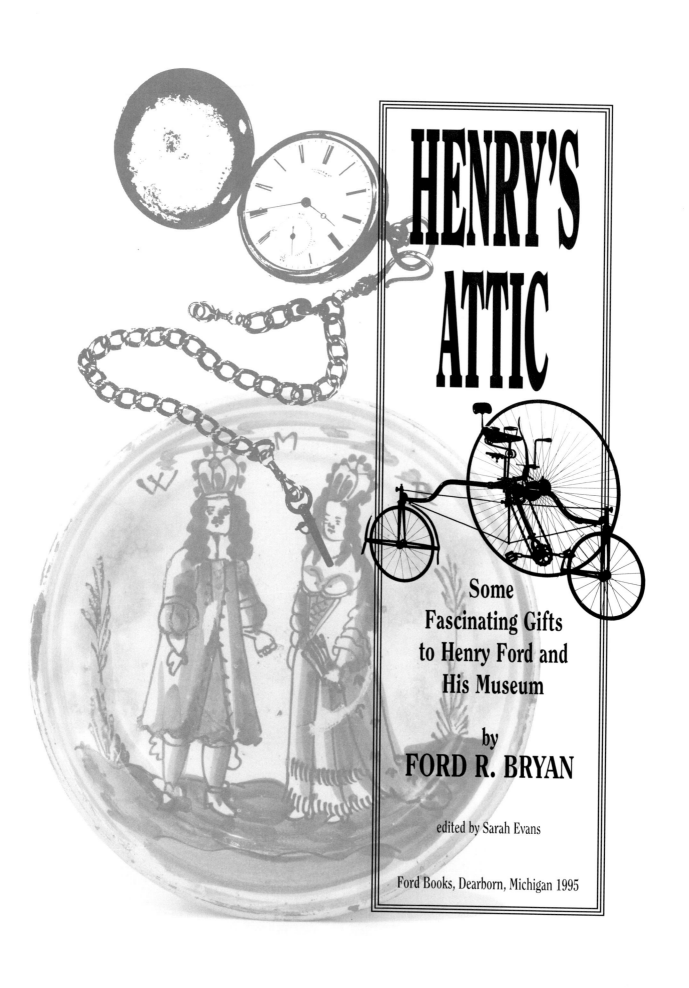

HENRY'S ATTIC

Some
Fascinating Gifts
to Henry Ford and
His Museum

by
FORD R. BRYAN

edited by Sarah Evans

Ford Books, Dearborn, Michigan 1995

95 96 97 98 99 5 4 3 2 1

Library of Congress Cataloging-in-Publication Data

Bryan, Ford R. (Ford Richardson).

 Henry's Attic: some fascinating gifts to Henry Ford and his museum / Ford R. Bryan ; edited by Sarah Evans.

 p. cm.

Includes index.

ISBN 0-8143-2641-2 (cloth : alk. paper)
ISBN 0-8143-2642-0 (paper : alk. paper)

 1. Henry Ford Museum and Greenfield Village. 2. Ford, Henry, 1863-1947—Museums—Michigan— Dearborn. 3. Americana—Private collections— Michigan—Dearborn. 4. Inventions—Private collec- tions—Michigan—Dearborn. 5. Technology—United States—History. I. Evans, Sarah. II. Title.

E161.B79 1995
607'.34'77433—dc20 95-40243
 CIP

Book design by Mary Primeau

Cover photos courtesy of Henry Ford Museum & Greenfield Village and Ford R. Bryan.

This book is dedicated to my
grandfather, Charles W. Richardson,
who did his best to teach American history to
Henry Ford at age fifteen in the
sixth grade at the
Scotch Settlement School
during the school year 1878–1879.

CONTENTS

PREFACE

When Henry and Clara Ford's home was cleaned out after Clara's death in 1950, it appeared that the couple had discarded few, if any, of the items they had accumulated since their marriage in 1888. The fifty-six rooms of Fair Lane, as the Fords called their residence, were fairly bulging with personal belongings and memorabilia. Storage rooms were crammed so full that a team of researchers, exploring the mansion on the off-chance that it might contain some of Henry Ford's papers, could only open the doors and gawk. A bowling alley was completely filled with rolled carpets; another room, with candelabra; another, with old drapes. Before they were finished, the researchers had turned a large indoor swimming pool into a two-story document file that contained seemingly every piece of paper that had ever passed through the Fords' hands. Dating from the 1890s and early 1900s were a myriad of rent receipts, grocery bills, letters, little Edsel's Christmas notes to Santa—even ticket stubs and a newspaper boy's receipt for forty-five cents. Among the Fords' welter of three-dimensional memorabilia were such curiosities as a denture that had once adorned the mouth of Thomas Edison, a small cigar that the Queen Mother of Siam had lit for Clara and from which Clara had taken three puffs, and a cardboard box containing, among other mysterious things, an opium pipe and five marijuana cigarettes.

An innate tendency to collect and save may in part explain the Fords' accumulation of goods at Fair Lane, but the "pack-rat" theory is hardly sufficient to account for another part of "Henry's attic": the Henry Ford Museum and Greenfield Village, which Ford established in his hometown of Dearborn, Michigan, in the late 1920s. The 240-acre village, now a collection of about one hundred historic structures that came to Dearborn from all over the nation and from as far away as the Cotswolds in England, is intended to re-create the slow-paced, rural character of America before the advent of the automobile. The adjacent Henry Ford Museum, patterned after Independence Hall in Philadelphia and spreading over 12 acres, houses an enormous number of machines, tools, and other artifacts, most dating from the days when America was almost completely rural.

Visitors to the site might well ask why Henry Ford, the man who probably did more than any other individual to foster America's transition from a rural and agrarian nation to an urban and industrial one—and who prospered mightily in the process—would want to enshrine and glorify the past in this way. One possible answer to this question is that Henry came to abhor the kind of world his motor cars had helped create. To him, the modern metropolis was a "pestiferous growth" where people led "unnatural," "cooped-up," and "twisted" lives; the old farms of the countryside, on the other hand, were in his view places of wholesomeness, of "independence" and "sterling honesty."

Born on a Dearborn farm in 1863, the future motor mogul was to remain a farm boy at heart long after he left his father's homestead for an apprenticeship in a Detroit machine shop at age sixteen. Until his death in 1947, he was ever an advocate of the puritan morality and simple, homely virtues extolled in the McGuffey Readers on which he and many other children of his generation were raised. These texts were the standard fare in the one-room schoolhouses Henry attended from ages seven to fifteen. A few months after completing sixth grade, he left the farm for the city, and that, with the exception of a brief stint at a Detroit commercial college, was to be the extent of his formal schooling.

The Henry Ford Museum and Greenfield Village were just one manifestation of Henry's efforts to resurrect and preserve the past, to promote the

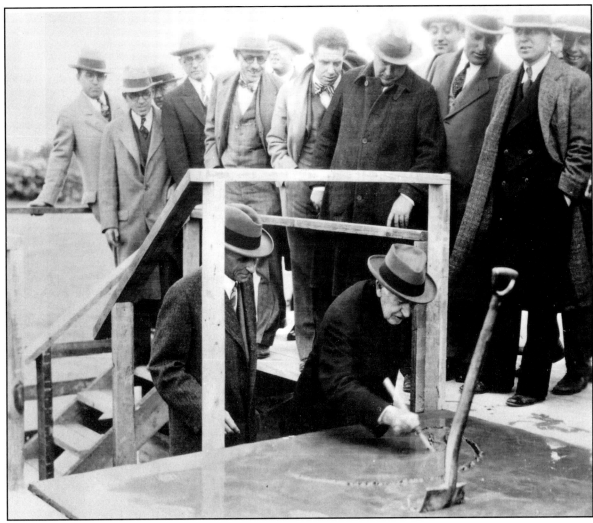

Henry Ford was a great admirer and friend of Luther Burbank, the renowned American horticulturist. Burbank died in 1926, and so when the cornerstone of the Henry Ford Museum was dedicated two years later, it fell to Thomas Edison to thrust Burbank's spade into the fresh cement. Here, Edison proceeds to inscribe his own signature as Henry Ford and other notables look on. The combination of Edison's signature and Burbank's spade symbolized Henry's belief that the nation's prosperity depended on the joining of industry and agriculture.

pioneer virtues of self-reliance and hard work, and to defy the ways of "city slickers" and the growth of the modern city. Among other things, he moved his own home and factory from the city of Detroit back to rural Dearborn, established a number of village industries (small water-powered plants in little Michigan villages where workers could take time off in the growing and harvesting seasons to return to their farms), sponsored a weekly radio show that promoted his beliefs, and developed a tractor that would allow small farmers to continue working their land.

Henry's passion for collecting Americana predated the opening of his museum and village by a good many years, and indeed it was in part the need for a place to house what he had collected that inspired him to build them. Another factor that contributed to their creation was the *Chicago Tribune* trial of 1919. Henry had sued the paper for libel because of an editorial that described him as an anarchist and an ignorant idealist. Although he won the case, he had asked for one million dollars in damages

and was awarded a total of exactly six cents. The worst of it, however, was that when the defense lawyers hammered away at his knowledge of American history, they made him appear an ignoramus. On the way home from this humiliating experience, Henry declared to his secretary, "You know, I'm going to . . . give the people an idea of real history. I'm going to start a museum. We are going to show just what really happened in years gone by."

Foreshadowing the now-accepted subdisciplines of social history and industrial archaeology, Henry Ford's brand of history would concentrate not on dates and battles or politicians and kings, but on the lifeways of common people and the often overlooked artifacts of technological progress. "When I went to our American history books to learn how our forefathers harrowed the land," he said, "I discovered that the historians knew nothing about harrows. Yet our country has depended more on harrows than on guns or speeches. I thought that a history which excluded harrows and all the rest of daily life was bunk, and I think so yet."

On September 27, 1928, Henry's old friend and greatest hero, the renowned inventor Thomas Alva Edison, arrived in Dearborn to dedicate the cornerstone of the Henry Ford Museum and to officiate at the dedication of his own laboratory from Fort Myers, Florida, which he had earlier donated to Greenfield Village. The museum and village together constituted the "Edison Institute," and in 1929 these two entities were joined by a third: a private coeducational school system operating out of seven buildings in Greenfield Village, among them the two one-room schoolhouses Henry himself had attended. Self-contained and completely funded by Henry Ford, the Edison Institute Schools emphasized vocational education and hands-on experience with everything from household utensils to industrial power plants. The students, never numbering more than 300, were the children of employees and neighbors. They were encouraged to study and use the institute's artifacts—to run the machines, play the musical instruments, don the costumes, work with the tools and materials of long-gone craftsmen—always, of course, under strict supervision. The schools operated in private from 1929 until 1933, when members of the public, guided by neatly dressed young men, were allowed on the premises for an admission fee of twenty-five cents. The Edison Institute Schools continued to function regularly until 1962.

Henry had begun collecting antique household furnishings and farm machinery soon after buying his father's farm in 1902, at which time—as a prelude to manufacturing passenger cars—he was struggling to perfect a racing car in Detroit. But his first serious effort at collecting Americana did not begin until one day in 1913, when Clara Ford, hearing children laughing on their way home from school, quoted a line from a McGuffey Reader: "Hear the children gaily shout." Henry chimed in with the second line, "Half-past four and school is out," but neither he nor Clara could remember which of the readers the rhyme was from. The quest that was thus initiated ended with the acquisition of an entire library of original McGuffey Readers—a purchase Henry was well able to afford, since by then, having perfected his moving assembly line, he had sold more than 250,000 Model T cars. The acquisition evidently whetted his appetite for collecting Americana—an activity that found its ultimate focus after the *Chicago Tribune* trial of 1919.

Soon after the trial ended, Henry began restoring his own family home in earnest, taking great pains to furnish it as it had been before his mother's death, an event that occurred when he was thirteen and that left him totally bereft. He even went so far as to have the earth around the house sifted for evidence of the pottery his mother had used. In the summer of 1919, Henry also took his second camping trip in the company of Thomas Edison, the naturalist John Burroughs, and the tire manufacturer Harvey Firestone. These excursions, which occurred annually from 1918 through 1924—a period when Henry was formulating his plans for an institution that would teach history as he wanted it taught—included visits to New England. They may well have influenced his decision in 1923 to buy the seventeenth-century Wayside Inn in South Sudbury, Massachusetts, a historic hostelry that over the years had received such guests as George Washington and the Marquis de Lafayette. Soon thereafter, Henry also purchased the old Botsford Inn outside Detroit, a place he and Clara had often gone dancing in their courting days.

In the course of restoring these properties and filling them with authentic furnishings, Henry had a small army of friends, company executives and dealers, and specially appointed agents scouring the entire country for objects of historic value. At Henry's bidding, these emissaries often bought not just a single object but an antique dealer's entire stock. New

England antique dealers came to think of Henry Ford as the man who sacked their corner of the country; it is said that at one time his agents bought up every hooked rug between Connecticut and Maine that was not presently being rocked on.

Needless to say, such wholesale buying resulted in a huge accumulation of antiques—far more than two inns and one homestead could reasonably accommodate. But for Henry, any such excess was quite acceptable; how else, he asked, was he going to illustrate the history of man's multifarious creations—from the kitchen stove to the best parlor furniture, the mighty steam engine to the workman's shoe—unless he had an example of the object in each stage of its development? Trainloads of the surplus—the rare and the priceless mixed with the commonplace—were soon pouring pell-mell into Dearborn. Before the museum and village opened in 1929, these objects were stored at a Ford tractor plant and in a hangar at the airport Henry and his son Edsel had built in Dearborn. Cataloguing, not to mention care, was haphazard—a historical fact that has never ceased to plague the curators of Henry Ford's collections.

Collections at the museum and village have never been static. It was Henry Ford's pleasure as he grew older to add new items and to alter the displays as the mood moved him. Curators in recent years, while retaining the best of the early collections, have increasingly relied on the introduction of new artifacts and the rotation of others to ensure that the displays retain their interest and educational value. Today, the Edison Institute (known as the "Henry Ford Museum & Greenfield Village," though its legal corporate name remains the Edison Institute) houses collections of more than one million three-dimensional objects. A research center housed in the institute's Education Building is the repository of over twenty-five million documents, including Henry Ford's personal papers and the records of the Ford Motor Company through 1950 as well as some later items. In 1992, when the heirs of Henry Austin Clark, Jr., donated Clark's collection of automotive literature—the largest such private collection in the country—to the Edison Institute, it added literally tons of material to the holdings of the Henry Ford Museum & Greenfield Village Research Center. The center also includes a large collection of photographs and prints, a library of books and periodicals, and the Edsel B. Ford Design History Program, established in 1986 to encourage the study of the industrial design process.

By the 1920s, Henry Ford's quest for antiques had become such a well-publicized fact that not only were many people offering to sell him their old treasures; a good many others were sending him an astonishing array of gifts—some of great historic value and others of a distinctly homegrown variety. It was the quantity of these gifts and the unusual and even unique nature of many of them that provided the inspiration for this book.

Just what proportion of the more than one million artifacts in Greenfield Village and the Henry Ford Museum were gifts rather than purchases has never been determined, but gifts account for considerably more than half of some collections. Why so many people would have been inclined to donate their valuables to a man who could well afford to buy almost any item he wanted or to the institutions he created is somewhat baffling. Although the Bible points out that "a man's gift maketh room for him, and bring him before great men," many of the early gifts were homemade, folk-art objects and were almost certainly not given in the hope of actually meeting the man; sheer admiration of what Henry Ford stood for in the minds of these early donors seems a more likely motivation. In recent years, some valuable gifts to the museum have no doubt been made with tax deductions foremost in mind, but for most donors, gratification at having their gifts on public display and preserved for posterity seems to be motivation enough.

This book describes only a small fraction of the gifts accepted over the years by Henry Ford and the Edison Institute. Many of the gifts included here were selected for inclusion because of their unusual nature, many others were chosen because they illustrate the scope and diversity of the museum and village collections, and still others were chosen because they are representative of a large collection donated by a single entity. By far the largest of these single-donor collections, consisting of thousands of items, was the gift in 1928–1929 of Thomas Edison and his associates, including the Edison Pioneers, an organization of former Edison employees founded in

1918 to pay tribute to Edison's inventive genius. Other such donors have included Edsel Ford, who until his death in 1943 contributed many fine pieces of ornamental silver; the Ford Motor Company, which has donated many historically important mechanical items; and the Firestone Foundation, which in 1983 donated not only farm buildings and furnishings but also an endowment to maintain these properties.

Although the author has been accused of being "hardware-happy," the content of the book tends to reflect Henry Ford's own emphasis on middle-class rural history as represented by the tools of agriculture, industry, and transportation. Also contributing to the alleged "hardware" bias are the enormous quantities of Edison memorabilia housed in both the museum and the village. Readers who visit these sites will find neither all the "hardware" nor all the many other types of gifts described in this book on display at any one time. Some will be in storage or on loan, and some will have been deaccessioned—that is, sold or scrapped to make way for better things.

Descriptions in this book of gifts are based largely on the observations of the curators who examined the objects either when they were first donated or at a later date. Unfortunately, because records of very early gifts are often far from complete, descriptions of some of these early gifts are necessarily lacking certain data, such as the date of the donation or the name of the donor. The photographs that accompany the descriptions are in almost every instance from the collections of the Henry Ford Museum & Greenfield Village. The accession and negative numbers accompanying the pictures are the museum's means of identifying each object and photograph.

ACKNOWLEDGMENTS

The officers and management of the Henry Ford Museum & Greenfield Village are hereby gratefully acknowledged for their endorsement of this project. In particular, the guidance of Steven K. Hamp and Judith E. Endelman is appreciated.

Without the support of the Office of Registrar and access to its accession files and computer database, this project would not have been at all practicable. Sarah Lawrence, chief registrar, and assistants Linda Skolarus, Julie Kath, Erik Manthey, Nick Parsons, Doris Keehl, Lisa Korzetz, Richard Nettlow, and Louis Veith have been more than merely accommodating.

Research staff members Jeanine Head-Miller, Luke Gilliland-Swetland, Cynthia Read-Miller, Cathy Latendresse, Terry Hoover, Carol Wright, Joan Van Vlerah, and Joan Klimchalk have been especially helpful, as have my fellow volunteers "Hub" Beudert and Winthrop Sears, Jr.

Much of the success of this book must be credited to the several Edison Institute photographers who over the years have recorded on film museum and village artifacts and scenes. Their files of over 110,000 photographs have aided immeasurably in depicting the gifts described in this book. Photography for the past thirty years or so can be credited to Carl Malotka, Rudy Ruzicska, Al Harvey, and Tim Hunter.

Much of the verbal descriptive material accompanying the photographs in this book is to be credited to the many curators who over the years have examined the artifacts and noted pertinent facts about each one. These notes are often only initialed by curators, thus leaving their identity quite obscure. Their sizable contribution as a group, however, must be recognized. Present curators who have provided very much appreciated editorial assistance include John Bowditch, Donna Braden, Nancy Bryk, Bob Casey, Peter Cousins, Michael Ettema, Larry McCans, Randy Mason, Cynthia Read-Miller, Henry Prebys, William Pretzer, and John Scott.

Much of what is superior about this book can be credited to its publishing consultant, Alice Nigoghosian; to its editor, Sarah Evans; and to its designer, Mary Primeau.

And to the dozens of well-wishers who have supported us throughout this project, we offer many thanks.

CHAPTER 1
Gifts to Greenfield Village

LTHOUGH the oldest building in Greenfield Village is an early seventeenth-century stone cottage from England and the rest come from various parts of America, collectively they are somewhat reminiscent of a small, nineteenth-century New England town. Clustered around a central green are structures typical of life in that time and place: a place of worship, a general store, an inn, a courthouse, a town hall, and a one-room schoolhouse. Nearby are two other small schoolhouses, a number of substantial but generally modest residences, a variety of workshops and stores, a doctor's office, a post office, and a firehouse. The village also has two forges, some mills and industrial sites, a railroad depot, a covered bridge, and a seven-acre working farm.

This is, however, no ordinary village and no ordinary historic reconstruction, for what it contains—and does not contain—is a distinct reflection of Henry Ford's personal likes and dislikes. Agriculture and industry are well represented, as are places associated with people whom Henry Ford considered true American heroes and places for which he himself had a nostalgic fondness. The village cycle shop is the one where the Wright brothers built their first successful airplane. The courthouse is one in which Abraham Lincoln practiced law. As a teenager, Henry Ford had a part-time job repairing watches in what is now the village jewelry shop. Among the residences are the modest birthplaces of three of Henry's famous friends—Orville Wright, Luther Burbank, and Harvey Firestone—as well as his own. Also included are the humble homes of people relatively unknown to the world at large but who held a high place in Henry Ford's esteem, such as George Matthew Adams, whose house Henry acquired simply because he liked the man's newspaper columns, and John B. Chapman, who had been Henry's favorite teacher at the Scotch Settlement Schoolhouse and later at the Miller School. (In accordance with a common frontier practice, Chapman, a good-natured former cooper, was hired as a teacher not because he was erudite but because his huge size would enable him to cope with large, unruly boys. As one of Henry's schoolmates put it, "That man could have told Henry and me all he knew in ten minutes. But he weighed 275 pounds and it was the weight that really counted.")

On the other hand, some things are conspicuous by their absence from Greenfield Village. It would be curious indeed for such a flourishing nineteenth-century settlement to have had no bank, no lawyer's office, no tavern except for the inn's taproom, and no mansions to house its wealthy citizens in style. But since Henry Ford had little use for attorneys, despised financiers and alcohol equally, and shunned the lifestyle of the very rich, Greenfield Village contains no such establishments. Henry was not troubled by the possibility that his choices of what to include in his museum and village and what to exclude might produce a somewhat unbalanced view of history. As he explained in 1928 to the architect he hired to design his museum, "It is not yet an ordered collection, but all the relics have one thing in common: they are all things used by run-of-the-mill people, not by the elite. This is history, but not the history we get in textbooks where somebody cuts off somebody's head. The everyday lives of ordinary folk have been overlooked by historians. . . ."

Though immensely rich himself, Henry never could identify with the wealthy elite, a trait that led the press to characterize him as "a rich man with a poor man's tastes." Henry once noted that his wealth put him "in a peculiar position. No one can give me anything. There is nothing I want that I cannot have. But I do not want the things money can buy. I want to live a life, to make the world a little better for having lived in it."

Although Henry maintained he did not want the things money could buy, he certainly lavished a good deal of it on his museum and village. Gifts account for only about 25 percent of the village's hundred or so buildings. Among the multitude of things Henry bought for the village were the remains of the buildings at Menlo Park, New Jersey, where Thomas Edison spent five of his most productive years. Between 1876 and 1881, Edison and his research team at Menlo Park developed some of the most important of the 1,093 inventions that Edison ultimately patented, among them the phonograph and the incandescent electric lamp. Although a number of buildings donated to Greenfield Village came equipped with their original furnishings, no furnishings are more important than those that came as gifts from Edison's Menlo Park complex.

By the time Henry Ford had his first meeting with the "wizard of Menlo Park" in August 1896, Edison's name had long since become a household word. As chief engineer of the Edison Illuminating Company in Detroit, Henry had been sent to a convention of the Association of Edison Illuminating Companies in Brooklyn, New York. There at a banquet he had his initial encounter with the famous inventor, whom he had long admired from afar. It was a meeting Henry never forgot. Just two months earlier and about two months shy of his thirty-third birthday, he had demonstrated his own mechanical genius by driving the "Quadricycle," his first automobile, through the streets of Detroit. When the discussion at the banquet table turned to storage batteries for electric automobiles (which at least in that setting were thought to be the coming thing), someone asked Henry to explain how his gasoline carriage worked. Henry seized the opportunity, speaking in a loud voice for the benefit of Edison, whose deafness was well known. As Henry later recalled it, Edison

asked me no end of details and I sketched everything for him, for I have always found I could convey an idea quicker by sketching than by just describing it. When I had finished, he brought his fist down on the table with a bang and said: "Young man that's the thing; you have it. Keep at it! Electric cars must keep near to power stations. The storage battery is too heavy. Steam cars won't do either, for they have to carry a boiler and fire. Your car is self-contained—it carries its own power-plant—no fire, no boiler, no smoke, no

steam. You have the thing. Keep at it."

That bang on the table was worth worlds to me. No man up to then had given me any encouragement.

I had hoped I was right, sometimes I knew I was, but here . . . out of a clear sky the greatest inventive genius in the world had given me a complete approval.

Edison's statement was surprising, coming as it did from an ardent advocate of electrical power. Apparently, however, the conversation did not stick in his mind—or perhaps he never caught Henry Ford's name. In any case, in 1907 when Henry, then president of the four-year-old Ford Motor Company, wrote to Edison asking the great man for a photograph of himself, Edison scrawled "No Ans." across the letter. At that time, the Ford Motor Company was just one of over 150 automobile manufacturers, but when Henry made his next overture to Edison in 1912, his company was manufacturing more than 25 percent of all automobiles. Edison was quick to take up Henry's proposal that he manufacture batteries for the Model T, for which Henry promised him four million dollars in annual orders. Though Edison never did manage to produce a suitable battery, the friendship bloomed from there. Edison and his family traveled west to visit the Fords six months after the two men had struck their agreement, and when the Fords started building their Fair Lane home in Dearborn in 1914, it was Edison who laid the cornerstone. A year later, Clara and Henry built a winter home next to the Edisons' winter retreat in Fort Myers, Florida.

By 1918 Henry was taking annual camping trips with Edison, Harvey Firestone, and John Burroughs, outings that became increasingly less rustic and more elaborate—as well as more publicized—as the years wore on. The aging "vagabonds," as they called themselves, traveled in a caravan of cars and trucks with a staff of chauffeurs, cooks, and other servants; slept in comfortable cots in tents equipped with flooring, screens, and electricity; and dressed in three-piece suits and ties, deigning to remove their jackets and to roll up their trousers only when engaged in such high jinks as tree-climbing, sprinting, and pool-wading. The trips ended in 1924, ostensibly because of the amount of media attention they received. It seems likely, however, that at least two of the four men would have had no objections at all to the retinue of journalists and photographers

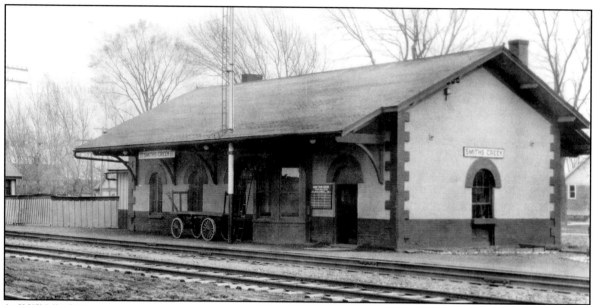

Acc.29.3059.1. Neg. B-7179.

who recorded their every move. Edison was an energetic and talented publicist, and, despite his shyness before large crowds, so was Henry Ford.

As a salute to his friend and idol, Henry Ford named the institute that encompassed his museum and village in Edison's honor. Thus, in September 1928, the eighty-one-year-old Edison found himself laying yet another of Henry's cornerstones. The Edison Institute had its formal dedication on October 21 of the following year, with Edison, President Herbert Hoover, and a host of other celebrated persons in attendance, among them Secretary of the Treasury Andrew Mellon, Henry Morgenthau, John D. Rockefeller, Jr., Madame Curie, Will Rogers, and Orville Wright. The date was the fiftieth anniversary of Edison's invention of the incandescent electric lamp. Henry and Clara Ford and Edison and his wife, Mina, met the presidential party at the train station in Detroit and traveled with them in an antique train drawn by a wood-burning steam locomotive back to Greenfield Village. There they alighted at the reconstructed Smith's Creek Station—the very same depot where almost seventy years earlier, the fifteen-year-old Edison had been ejected from a train after his chemical experiments had set a baggage car afire.

Edison was touched, but perhaps not quite so touched as when he first viewed his Menlo Park buildings, which Henry had faithfully reconstructed, right down to sifting the earth around the laboratory for

Thomas Edison's first job, as a newsboy and candy vendor on the Grand Trunk Railroad between Detroit and Port Huron, ended here at the Smith's Creek Station in 1863. A quick-tempered trainman, incensed to find that young Edison's experiments with phosphorus had set the baggage car on fire, boxed the boy's ears and threw him off the train. The Grand Trunk Railroad presented the depot to Henry Ford in early 1929, and before the Edison Institute opened in October of that year, Henry saw to it that the building, complete with living quarters for the stationmaster, was carefully restored to its 1860s appearance.

artifacts and personally mending them. Henry had even had seven freight cars full of the stony, red clay soil of Menlo Park shipped to Dearborn. Francis Jehl, a member of the Edison team that had developed the incandescent lamp, was on hand to observe Edison's reactions:

> The first thing he noticed was the ground. "Why, Ford," he said, you got Jersey earth, Jersey clay here!"
>
> He went upstairs to his old laboratory [and] proceeded to make a thorough inspection of the place. . . . Examining the various instruments with which he had created his wonders and finding them all satisfactorily placed, he went to Mr. Ford and patted him on the shoulder, saying: "Ford, you have made this place perfect! I myself could not have done it better. It is the old laboratory of '79 when the lamp was born."

In the olden days, when Edison would be in extremely serious mood he usually wound up with a dash of humor; and so it was in this instance. "Ford," he continued, "you have made this place 99.9 percent perfect." Mr. Ford was anxious to know wherein it lacked the remaining one-tenth of one percent. Edison with a twinkle in his eyes . . . responded, "Look at that floor of yours, Ford; it is nowhere as dirty as ours used to be!"

On the night of October 29, 1929, with practically every radio owner in America tuned in to the proceedings and electric lights all over the nation dimmed or extinguished, President Hoover made a speech in a candle-lit banquet hall at the Edison Institute. After he had finished, Edison went to his reconstructed Menlo Park laboratory and, assisted by Jehl, reenacted the moment his incandescent lamp had first flickered, and as he did, lights went on all across the nation. Although it was a moment of triumph for Henry Ford, it was in no way the culmination of his efforts to resurrect and preserve the past. Acquisition and reassembly of antique buildings at Greenfield Village went on unabated for many years, even in the depths of the Great Depression. The following pages describe not only Edison's Menlo Park buildings and their donated furnishings but also many of the historic structures that have been given to Greenfield Village over the past seven decades.

Seated at a bench in his reconstructed Menlo Park laboratory, Thomas Edison reenacts one of his early experiments as Henry Ford and Francis Jehl, Edison's former assistant, look on. The photograph was taken on October 21, 1929, the fiftieth anniversary of Edison's invention of the incandescent electric lamp and the day the Edison Institute was dedicated.

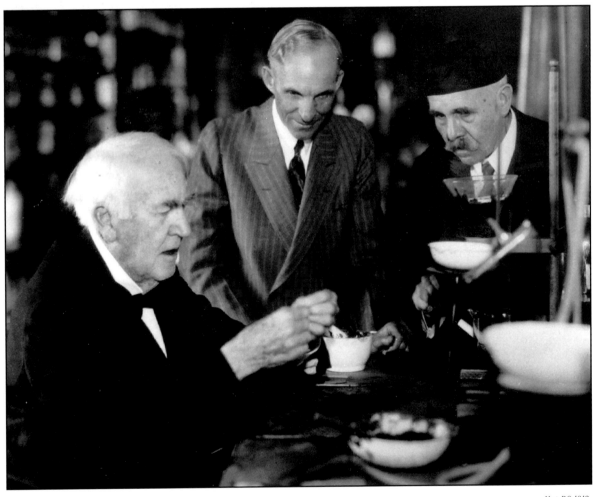

Neg. P.O.4842.

Edison's Menlo Park Complex

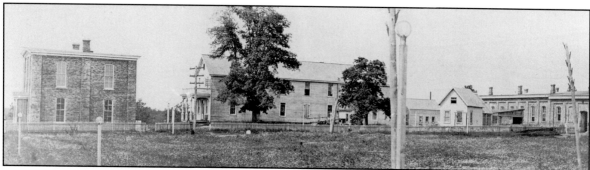

Acc. 29.3048.5.

Menlo Park, New Jersey, 1880.

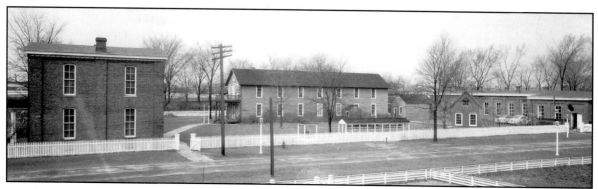

Acc. 29.3049.1. Neg. A.2545.

Menlo Park (restored), Dearborn, Michigan, 1930.

Although Thomas Edison patented 1,093 inventions in his lifetime, it is often said that his greatest invention was one he didn't patent: the industrial research laboratory. At the time he began erecting his complex of buildings at Menlo Park in 1876, few, if any, industries made use of scientific research in developing new products, and the idea of teamwork in such a context was unknown. Invention was still generally an individual operation, with the person who conceived the idea performing all the detailed research and experimentation needed to bring the idea to fruition. At Menlo Park, Edison not only brought science, technology, and business together in a systematic and organized way but also turned the process of invention and product development into a team effort. In doing so, he created the model on which the large research and development laboratories of twentieth-century corporations are based.

Lacking knowledge of scientific theory himself but full of ingenious ideas for scientific applications that had the promise of commercial success, Edison had a talent for surrounding himself with skilled workers. The team of fifteen to twenty specialists he assembled at Menlo Park included scientists and mathematicians who supplied the analytical skills and theoretical knowledge needed to turn Edison's ideas into reality; assistants who provided general help around the laboratory; carpenters who made models out of wood; glassblowers who created the first fragile bulbs for the incandescent electric lamp; machinists who made prototypes and experimental apparatus; a draftsman who prepared official drawings to be sent to patent offices around the world; and a

bookkeeper, an accountant, and a secretary who saw to the business end of the operation.

Working together under Edison—who also had an undoubted talent for inspired leadership—this team turned the Menlo Park complex into an "invention factory." In little more than five years at Menlo Park, Edison patented 420 inventions, including some that had a profound effect on people's everyday lives. In addition to being the birthplace of Edison's phonograph and incandescent electric lamp, Menlo Park also spawned the carbon transmitter used both in telephones and radio microphones. Here, too, Edison devised an electric-generating system that by 1888 was delivering the electricity needed to light some 65,000 homes.

The top photograph on page 21 shows the Menlo Park complex as it appeared in 1880. The large clapboard structure in the middle was the laboratory—the first building in the complex to be constructed. To the right of the laboratory were three small wooden buildings known as the "carbon shed," carpentry shop, and "glass house." Edison added the two-story brick building at the far left in 1878 to serve as a business office and library. The one-story brick building at the right, also constructed in 1878, was the machine shop and powerhouse.

Although Edison maintained a residence and laboratory at Menlo Park until the end of 1885, he spent more and more time after 1881 in New York City, working on the development of his commercial electric-generating system. As early as October 1882, with much of the equipment from Menlo Park now in New York, the old "invention factory" was described as looking "terribly deserted." By 1887, when Edison moved his operation to a much larger complex in West Orange, New Jersey, cows were wandering around the yard of the Menlo Park complex, and a chicken farmer was making use of the laboratory building. Given the chemicals that had been spilled there, the chickens did not fare very well and the farmer moved them elsewhere. Local residents soon began helping themselves to the wood of the deteriorating building, using it to patch their barns, hen coops, and other outbuildings. What was left of the laboratory blew over in a storm in 1913, and in 1919 the office and library building succumbed to fire. The machine shop met a somewhat kinder fate. After serving as a cow barn and chicken coop, it was bought by a man who began dismantling it for its bricks, but because the well-built structure resisted his efforts, he gave up in disgust and left the building standing.

The glass-enclosed showcase containing artifacts from Edison's trash pile is surrounded by some of Menlo Park's stony clay soil, seven carloads of which were shipped to Greenfield Village.

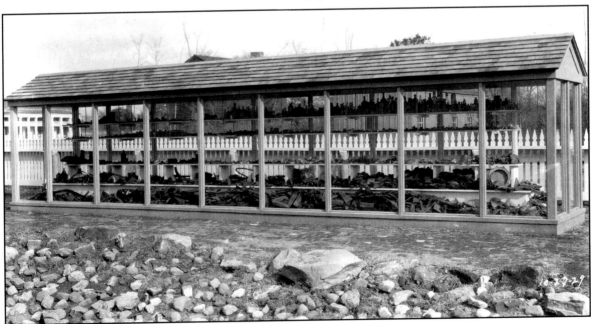

Neg. A-6176.

By 1928, when Henry Ford bought the land on which Edison's Menlo Park buildings had stood, the only one of the original structures to have escaped devastation was the "glass house." Because of this structure's association with Edison's invention of the incandescent lamp, the General Electric Company, the largest manufacturer of incandescent bulbs in the country, had salvaged it and moved it some years earlier to another site in New Jersey. General Electric donated the structure to Greenfield Village in 1929.

With Edison's help, Henry recovered as much of the original building material from the Menlo Park complex as he could, sometimes buying entire structures just to salvage a few pieces of the original lumber. Henry had the remains of the buildings shipped to Dearborn, together with the nearby Sarah Jordan Boarding House, which had housed most of Edison's employees. Also shipped off to Dearborn was Edison's old trash pile from outside the laboratory building. Quite the antithesis of his friend Ford when it came to neatness, Edison had left the dump full of hundreds of broken bottles, dishes, cans, and bits and pieces of laboratory apparatus. Picking some items up himself and eventually even repairing them, Ford directed his men to gather up the rest and crate them. These laboratory relics were later enshrined in a glass-enclosed showcase near the reconstructed main laboratory in Greenfield Village.

Menlo Park Laboratory

Laboratory, exterior.

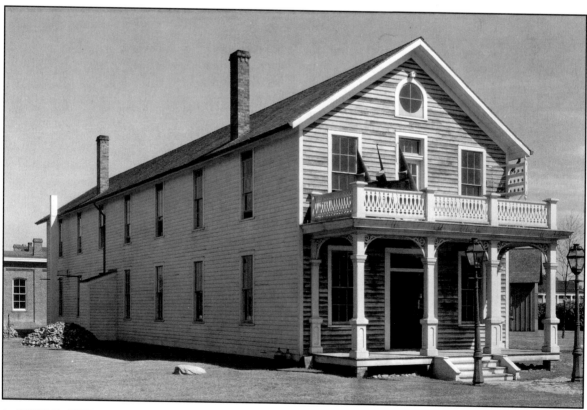

Acc. 29.3048.1. Neg. B74572.

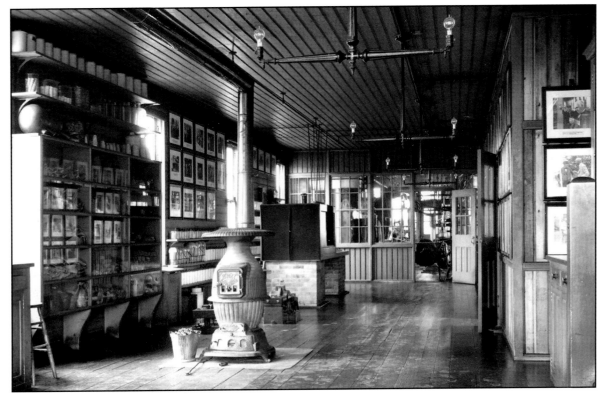

Laboratory, first floor.

When Henry began reconstructing the Menlo Park complex in Greenfield Village in 1928, he took great pains to see that the results would be completely authentic. Buildings were laid out according to exact foundation measurements taken from the Menlo Park complex and, after being reconstructed with the aid of photographs, were furnished with original or faithful duplicates of tools, equipment, and patent models, all placed as they had been fifty years ago. Edison himself not only supervised the reconstruction but, together with the Edison Pioneers, the Association of Edison Illuminating Companies, and the Electrical Testing Laboratories, also donated thousands of original items—furniture, laboratory apparatus, and a variety of other artifacts— which are now of inestimable value.

The first floor of the laboratory building was devoted to testing and measuring new products and processes. Originally, the first floor was also the site of Edison's office. Since it was a small room right next to the entrance to the building and had one wall of glass panes, it afforded him little privacy. Off the office,

however, was a tiny cubbyhole into which he would disappear whenever he wanted some peace. A larger first-floor room housed the original machine shop and its lathes and tools, and in it, Edison's machinist, a former Swiss clockmaker by the name of John Kruesi, made the prototype of the first phonograph in 1877. This room was also where the mechanical details of the carbon telephone transmitter were worked out in the same year.

The second floor of the laboratory was the heart of the Menlo Park complex. Its separate work stations for specific projects or skills are indicative of how Edison divided the mental labor of invention. Here Edison and his principal assistants often worked through the night, performing thousands of calculations and experiments and making seemingly endless drawings of models. During the day, carpenters made models based on these drawings, which the second-floor group tested and revised the next night. When Edison was impatient for the completion of an experiment—which was fairly often—the men worked around the clock, never under particularly pleasant

conditions. In the poorly insulated wooden building, they shivered in winter and sweated in summer, always amid the stench of countless chemicals. Often they worked for long stretches without pay, for Edison was notorious for always being behind in his bookkeeping. Nonetheless, morale in the laboratory was consistently high.

Each night around midnight, Edison and his assistants on the second floor took a "lunch" break, eating sandwiches, drinking coffee, smoking cigars, and generally letting off steam by swearing, singing, and playing the pipe organ in the back of the lab. The organ, used in more serious moments for experiments with sound, had been a gift to Edison from Hilbourne Roosevelt, an uncle of Theodore Roosevelt and a noted organ builder. Edison himself sometimes played it, using the "hunt and peck" method rather than his impaired sense of hearing. Around 1929, having had the original organ meticulously duplicated from photographs, Henry Ford wrote to Edison, advising him to practice his chords. Edison wrote

back, "I don't need to practice. I can play Yankee Doodle by heart."

Among the many pieces of original Edison memorabilia given to Henry Ford in the late 1920s is one that reveals something of the esprit de corps of the "insomnia squad" on the second floor of the laboratory. Although the press depicted Edison as a man who worked so feverishly that he never slept, or at least never went to bed, the fact was that the man could take a nap anywhere—and often did, a habit his sleep-deprived assistants emulated. Like Edison, they would when exhausted push aside the instruments on the table in front of them and lay down their heads. This behavior was met with complete tolerance—as long as the napper did not snore. At first, the assistants tried to cure snoring by giving the offender "a good whiff of concentrated spirits of ammonia." Later, however, one of them invented a contraption called a "corpse reviver," a soap box with a wooden tongue, ratchet wheel, and handle. Francis Jehl recalled that when the handle was turned rapidly, "the

Neg. B35073.

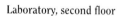

Laboratory, second floor

apparatus made a terrible racket. . . . the first snorer on whom it was tried literally jumped from the table, thinking a cyclone had struck the laboratory. I have had many ladies ask me. . . . where they could procure one."

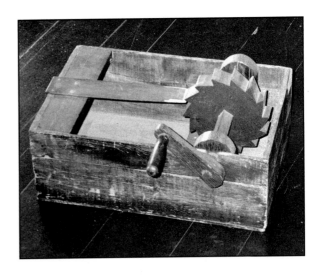

The well-worn "corpse reviver" was among the many artifacts that Thomas Edison, together with the Edison Pioneers, the Association of Edison Illuminating Companies, and the Electrical Testing Laboratories, donated to Henry Ford in 1928–1929. Photo by author.

Menlo Park Office and Library

Office, first floor.

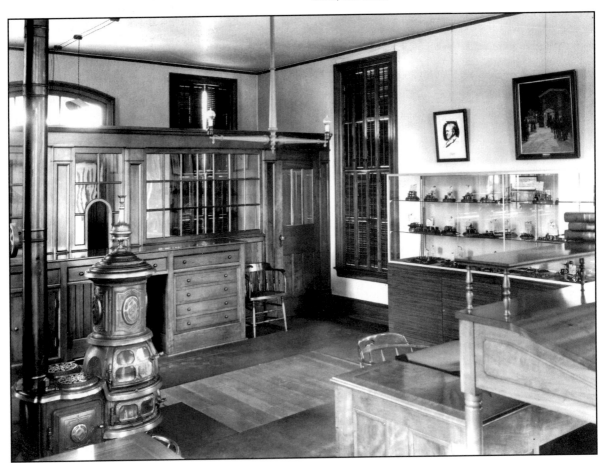

Neg. 0.19599.

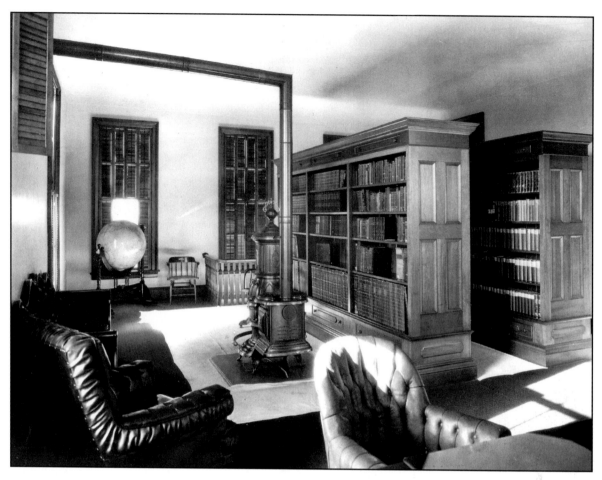

Library, second floor.

Although Edison's Menlo Park complex was a center of scientific research, it was hardly an ivory tower. The need for money—to buy equipment and supplies, to pay workers, and to cover the costs of the unending patent-infringement lawsuits—was a constant concern. Showing a profit was also a way of attracting investors. Edison made his profits not only by selling the manufacturing rights to his patented inventions but also by forming his own companies to make and sell Edison products. Although most of his 1,093 inventions were the result of teamwork, the patents were in his name—a fact that did not seem to bother his assistants at Menlo Park. It was not until later years that some former employees let their resentment be known.

Edison initially conducted his business dealings with the outside world from the little room on the first floor of the laboratory building. There, amid the hubbub of activity in the laboratory, he met with prospective investors, with lawyers to discuss patent problems and lawsuits, with journalists and others who could publicize his successes and promote his image as the "wizard of Menlo Park," and with his financial backers from New York. In 1878, having received some income from his sales of carbon telephone transmitters and much favorable publicity as a result of his invention of the phonograph, Edison, with the backing of New York bankers, proceeded to build a two-story brick building where he could receive his visitors in quiet, spacious surroundings.

The first floor of the new building provided office space for the accountant, the bookkeeper, and the draftsman, who produced the precise drawings needed to accompany patent applications; shown here is the outer office with the door to the accountant's office in the far corner. Edison's private office was on

the second floor, as was his personal secretary's. Also on the second floor were a conference room and a comprehensive technical library. Edison was an avid reader of scientific journals, and his librarian, Otto Moses, fluent in German and French, often translated articles for him. Another part of Moses's job was to provide Edison with reports on current scientific research.

About the time the new building was completed in October 1878, major stockholders of the Western Union Telegraph Company—where Edison's mentor and attorney, G.P. Lowry, was general counsel—agreed to underwrite Edison's experiments with electric lighting by providing $300,000 for the formation of the Edison Electric Light Company, which was to have its experimental and legal head-quarters at Menlo Park. For Edison, this was a major step toward the implementation of his master plan to charter Edison illuminating companies in cities throughout America.

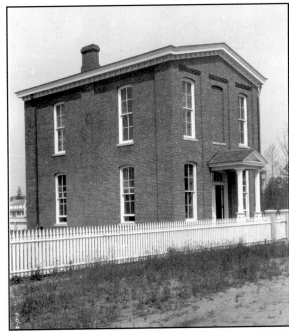

Office and library, exterior.
Acc. 29.300048.2. Neg. B.5159.

Menlo Park Machine Shop and Powerhouse

Machine Shop and Powerhouse
Neg. A.6259.

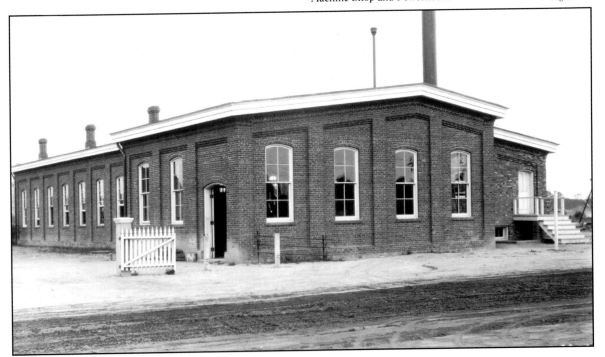

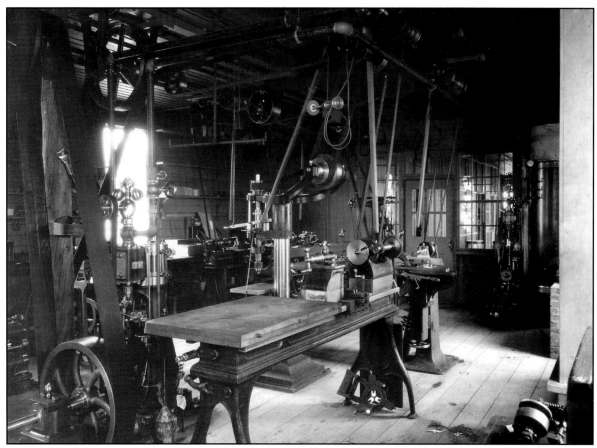

Menlo Park Machine Shop.

By 1878, when Edison ordered the construction of his brick office and library building, the machine shop on the first floor of the laboratory building was no longer adequate to meet the needs of the operation, and so Edison ordered the construction of a new brick machine shop as well. The New York firm of Babcock & Wilcox designed the shop and installed one of its boilers to power the machinery. The boiler, the ninety-second one that Babcock & Wilcox produced, was later moved to Edison's complex at West Orange, where it remained in operation until 1928, when Edison donated it to Henry Ford.

The shop at Menlo Park not only housed machine tools—lathes, milling machines, drill presses, planers, and grinding wheels—but also was soon serving as the electric-generating plant for the entire complex. Here, immediately after his successful experiment with an incandescent electric

lamp in October 1879, Edison set about creating a system for generating and distributing the electricity that would power such devices. Using the machine tools at his disposal—including the horizontal lathe shown in the photograph—Edison developed an improved electric dynamo, or generator, an important element in his proposed commercial electric-generating system. To put his system into operation, he also had to devise wiring, insulation, sockets, switches, underground conductors, regulators, meters, and solutions to innumerable other problems.

On December 31, 1879, with the area around the Menlo Park complex wired and a steam engine in the machine shop driving three direct current dynamos, Edison gave a successful public demonstration of his system for generating electricity. Edison later built a series of eleven dynamos, which furnished power for his own buildings as well as some residences around Menlo Park. After spending two

years perfecting the system, Edison opened his first large-scale commercial electric-generating plant, the Pearl Street Station in New York City, in 1882.

The firm of Babcock and Wilcox was very proud of having equipped the Menlo Park Powerhouse which had enabled Edison to establish electricity as a primary source of power. On the one hundredth anniversary of Edison's demonstration of his electrical generating system, Babcock and Wilcox in 1979, long after Henry Ford's death, completely reconditioned the entire Menlo Park Powerhouse at no cost to Greenfield Village.

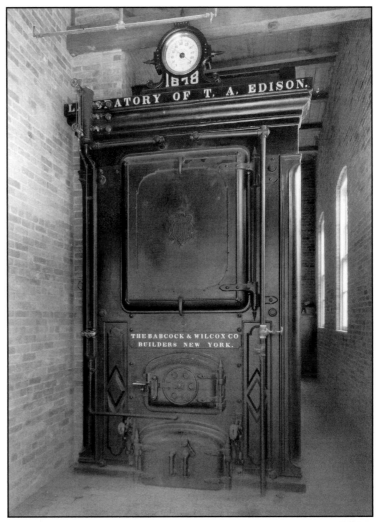

Power plant boiler Acc. 29.3048.3.

Menlo Park Carpentry Shop

Although Edison was involved in developing advanced technologies, he nonetheless had to rely on several traditional crafts. Here, in this small clapboard shed behind the laboratory, his carpenters, following the often hastily sketched drawings from the laboratory, used hand tools and age-old methods to build wooden models of the world's latest inventions. Kreusi and his crew in the machine shop used the models as guides in constructing prototypes of the devices.

The carpentry shop also housed machinery for making gas, which was used in the Bunsen burners of the laboratory and machine shop and in the apparatus of the glass house. Until Edison wired the buildings for electricity, the gas made in the carpentry shop also supplied light for the Menlo Park complex.

Menlo Park Carpentry Shop Acc. 29.3084.4 Neg. B.9858.

Menlo Park Carbon Shed

Edison's invention of the carbon telephone transmitter in 1877 is what made the telephone commercially practicable. In the telephone that Alexander Graham Bell had invented the year before, the same instrument served as both receiver and transmitter, and the transmission range was therefore extremely limited and often of poor quality. When Edison added his carbon transmitter to the telephone receiver, it extended transmission for hundreds of miles. Edison soon sold the rights to his invention to the Western Union Telegraph Company of New York City, which in 1878 entered into a fierce but losing competition with the newly formed Bell Telephone Company of Boston. After Western Union retired from the telephone field, it licensed Bell to use the Edison carbon transmitter.

In the small wooden shed shown here, Edison employed a battery of kerosene lamps to produce carbon soot for his telephone transmitters. With the wicks always turned up high, the lamps smoked continuously night and day. Edison enjoyed telling the story of a newspaperman who, after wandering into the carbon shed, had rushed to him with the news that all the lamps there were smoking and he had better send someone out to trim the wicks right away. Edison had assured him there was a

Carbon shed exterior Acc. 29.3048.5. Neg. A.5700.

method to the apparent madness.

Edison assigned the job of tending the lamps and scraping off the carbon that built up on their glass chimneys to Alfred Swanson, the night watchman for the Menlo Park complex. After scraping the carbon, Swanson used a hand press to form it into small buttons for use in the telephone transmitters. This process was a bit more difficult than it may sound, for each button had to weigh precisely 300 milligrams and be of an exact shape. The smoking and scraping processes, too, required careful attention to detail. Later, Edison also used the carbon produced in this shed for the filaments in his electric lamps.

Carbon shed interior Neg. 0.17032.

Menlo Park Glass House

When Edison first began his experiments with incandescent electric lamps, he had to have someone take the fragile filaments in a suitcase to Philadelphia, where a glassblower encased them in bulbs. The inconvenience of this arrangement and the many broken filaments that resulted prompted Edison to create his own glassblowing shop. For this purpose, he converted a small shed behind the laboratory building; this structure, with a skylight in its roof, had previously served as a photographic studio and drafting room. Here, in 1879, the glassblower whom Edison hired, a German by the name of Ludwig Boehm, crafted the bulbs used in the experiments that produced the first successful incandescent electric lamp. Thereafter, Boehm went on to produce incandescent lamps in quantity, which in those days meant about twenty-four in as many hours.

Boehm, with his pince-nez and dapper clothing, thick accent, quick temper, and apparently total lack of humor, was an object of some fun for the "boys" on the second floor of the laboratory. Boehm not only worked in the glass house but also slept in a loft there, and after finishing work at six o'clock, he liked to relax by playing a zither and yodeling. The night owls from the laboratory would sometimes silently gather outside the shed and join in, setting up

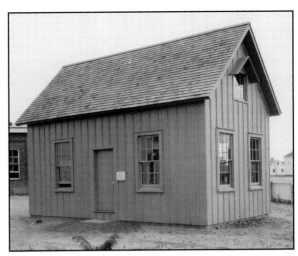

Acc. 29.3049.1 Neg. 0.5792.

a sudden and dreadful caterwaul that evoked a stream of guttural invectives from Boehm—much to the amusement of the "boys." Another of their favorite tricks was to rouse Boehm from his slumbers by leaning out the window of the second floor of the laboratory and tossing stones onto the roof of his abode. Boehm, of course, reported all these incidents to Edison, who, although he managed to solve many other problems in his lifetime, somehow never did manage to identify the villains.

Edison's Fort Myers Laboratory

Just a few steps away from the Menlo Park complex in Greenfield Village is the building Thomas Edison used as a laboratory during his winter vacations in Fort Myers, Florida. Here he worked on perfecting his inventions and also devoted considerable time to practical botanical research, especially the identification of rubber-yielding plants. In 1928, after using the structure for more than forty years, Edison donated it, together with its furniture, chemicals, and machinery, to Henry Ford, who had an iden-

tical lab built for Edison on the original site. This photograph shows Edison and his wife and Henry and Clara Ford, the Edisons' winter neighbors since 1916, in front of the laboratory before it was moved to Greenfield Village.

The removal of the structure caused something of a stir in Fort Myers. Civic organizations, pointing out that it was a proud and historic landmark in their town, protested that the building should not "be moved to any city disassociated with

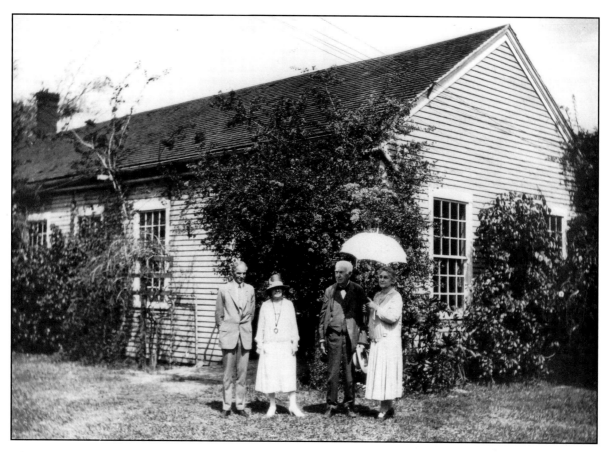

Edison's Fort Myers Laboratory

Acc. 28.998.1. Neg. 188.5545.

its real history." Edison apparently wavered, but Henry persisted, and ultimately Edison told the citizens of Fort Myers that their protest had come too late and he would keep his promise to give the building to Henry Ford.

Samuel Edison, Thomas Edison's father, built the Fort Myers laboratory during the winters of 1884 and 1885. Samuel, who had been in the lumber business in Milan, Ohio, when his son was born in 1847, had the lumber for the project cut in the forests of Maine and shipped by rail and boat to Florida. Known for his physical stamina—a trait he evidently passed on to his son—Samuel Edison was six feet tall and broad of shoulder. He is said to have run almost 180 miles to the U.S. border after a political revolt in his native Canada failed in 1837. Tramping through wilderness and hostile Indian territory in bitter winter weather, he allegedly never paused for sleep and

dispensed almost entirely with food until after crossing the frozen St. Clair River into the United States.

After the Fort Myers Laboratory was rebuilt in Greenfield Village, one of the articles Henry Ford placed there was a late Victorian mantel clock that neither ran nor told time. Edison had years earlier replaced its face and pendulum with cross-sections of logs—symbolic of his aversion to "watching the clock" when working and his belief that time should be measured by accomplishment rather than in hours and minutes. The story is told that while he was working on the invention of the stock ticker about 1869, Edison locked his men in the workshop until the desired improvement was achieved. At Menlo Park, of course, working around the clock—with time out for catnaps—was part of the routine.

Edison's "Building No. 11"

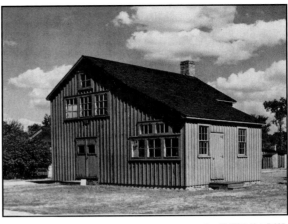

Acc. 40.582.1. Neg. B.185.

Neg. B-1927.

This building, part of the laboratory complex Edison built in West Orange, New Jersey, about 1887, was devoted primarily to the production of phonograph records, including those for Edison's "Talking Dolls." Soon after inventing the phonograph at the Menlo Park complex in 1877, Edison had patented these popular wind-up toys, but his electrical work had precluded his devoting much time to their development until after the move to West Orange. About fourteen inches high, the dolls had miniature phonographs inserted in their backs and, when wound, recited a variety of rhymes in a childish voice. The production and testing of phonograph records for five hundred of these dolls each day is said to have created an unbelievable babel in "Building No. 11" during the 1890s. By 1912 the building was being used for the manufacture of wax cylinder and disk records.

Building No. 11 was a gift to Henry Ford from Thomas A. Edison, Inc. It was installed in Greenfield Village in 1941, ten years after Edison's death.

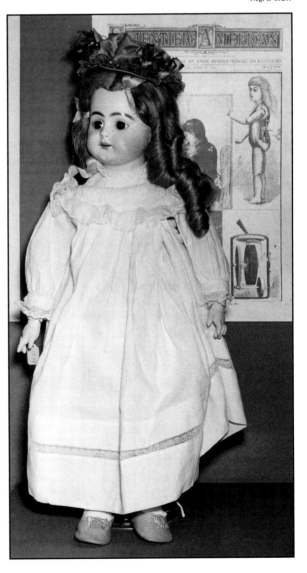

A. F. Bishop, an illustrator for *Scientific American,* gave this example of Edison's "Talking Doll" to the Henry Ford Museum in 1932.

Cape Cod Windmill

This Dutch-style windmill was built on the north side of Cape Cod in 1633, just thirteen years after English Puritans, following a period of exile in Holland, landed at Plymouth, Massachusetts. Before 1900 the windmill was moved at least three times—in 1750, 1782, and 1894—finally winding up on the south side of Cape Cod in the town of West Yarmouth. Moving the structure—with its two millstones weighing three and a half tons and its sails measuring fifty-four feet across—required a team of eighty oxen and the efforts of a number of men. The practice was, however, a fairly common one in the 1700s. Builders of mills were in short supply in those days, and it was often more economically expedient to move an existing mill to a growing settlement than to wait for a millwright to appear.

Known as the Farris Mill because a Captain Samuel Farris had once been its owner, the windmill, thought to be the oldest on Cape Cod, is undoubtedly one of the oldest in America. Inside the three-story "tower" is a winding staircase leading from the ground floor up to the revolving roof. On the second floor are the huge millstones that were used to grind corn, wheat, and other grains into meal or flour. Before the grinding could begin, the miller had to spread the enormous sails with canvas and tote the grain up to the second floor, where he dumped it between the millstones; the ground cornmeal or flour fell into bins on the floor below. Windmills like this were common sights in early coastal settlements, where strong sea breezes provided the power needed to propel a mill's machinery. Settlers living where wind was not a dependable source of power relied chiefly on watermills built along rushing streams or rivers.

In November 1935, when the Ford Dealers Association of America announced that it had bought the Farris Mill from Dr. Edward F. Gleason of Hyannis and that it was going to ship the structure to Dearborn as a gift to Henry Ford, Cape Codders set up a hue and cry. The town fathers of West Yarmouth called a special meeting, petitions were circulated, and newspapers ran such headlines as "Cape Cod Tilts with Mr. Ford over Windmill" and "Ford Asked to Leave Old Mill on Cape Cod." Even summer residents, such as the Boston merchant A. Lincoln Filene, chimed in with suggestions that Ford be asked to give the mill back to the town as a memorial to its connection with America's founding.

Acc. 35.898.1. Neg. B.2591.

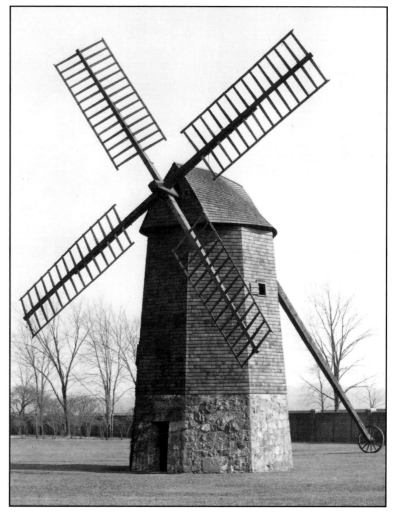

Amid the outcry of protest and resentment, Dr. Gleason, a former Boston surgeon, pointed out that the sentiment for keeping the old mill on Cape Cod had come a bit late. Paying rather hefty taxes on the property, he had about eight years earlier offered to give the mill and some six acres of surrounding land to the town, with the idea that it could be turned into a memorial park. The selectmen had refused the gift on the grounds that the town was too poor to assume the care of the property; apparently, too, the selectmen had been concerned about a loss of tax revenue.

Believing that a museum setting would best preserve the windmill from the ravages of time and vandalism, Gleason and two descendants of the mill's early owners wrote to Henry Ford urging him to accept the Ford Dealers' gift. One of the descendants, however, expressed her preference that the windmill be installed at Henry Ford's Wayside Inn in Massachusetts so that it would at least remain in New England "where it surely belongs." As it turned out, the windmill was installed at Greenfield Village in the summer of 1936, and there it still stands today.

Samuel Daggett's Saltbox

Samuel Daggett, whose great-grandfather had emigrated to the New World from England in 1637, was born in the coastal town of Marshfield, Massachusetts, a short distance north of Plymouth, in 1723. Soon thereafter, Samuel's father moved his young family inland to a sparsely settled section of Connecticut, several miles east of the Connecticut River. Lacking coastal or river routes and being remote from main roads, this part of New England was relatively slow to develop. Whereas numerous towns had been established along the coast and in the Connecticut River Valley before 1700, this area did not develop until after about 1715, and the settlement pattern that evolved here was quite different from the nucleated one in earlier towns. The area was settled by land speculators, who, eager for a rapid return on their investment, wanted to develop the wilderness quickly. Thus, rather than grouping small house lots around a commons or central green, they created large individual farm lots and spread them out over the countryside. The center of these dispersed towns, or townships, was wherever the church happened to be, and around the church there were usually no more than four or five houses, if any at all.

It was in one such town, known originally as Coventry but incorporated in 1848 under the name of Andover, that Samuel Daggett built the saltbox house shown here around 1750. A housewright by trade, Samuel framed numerous of the other isolated farmhouses in the vicinity, but this one he built for himself and his own family on eighty acres of land,

half of which had been deeded to him by his father. The saltbox, a direct descendant of rural houses in medieval England, was a highly popular architectural style in colonial Connecticut. Unlike the more sophisticated Georgian house of the mid-1700s, the saltbox does not have a balanced facade; its asymmetry reveals the layout of the interior, where little effort is made to disguise the wooden structural members.

By 1951, when Daggett's old saltbox came to the attention of Mary Dana Wells, it was in a sadly dilapidated state. Mary Wells had it moved to Union,

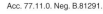

Acc. 77.11.0. Neg. B.81291.

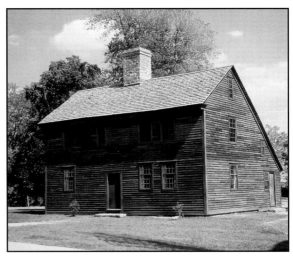

a town in northeastern Connecticut near the Massachusetts border, where she restored it, furnished it with antiques, and used it as her residence. In 1977 she gave the house, together with most of its furnishings and an endowment fund to maintain it, to the Edison Institute to be placed in Greenfield Village. At that time, the household furnishings alone were valued at $625,000.

Noah Webster's House

When Noah Webster moved into this house in New Haven, Connecticut, in 1823, he was sixty-five years old and a well-known American figure. As a student at Yale in the mid-1770s, Webster had become an ardent believer in the democratic ideals of the American Revolution. The new nation that emerged at the end of that revolution was far too dependent on Europe, especially England, to suit Webster's tastes. The revolution would not be over for him until the United States had established its own independent culture—one in which a literate, intelligent people would rise above the decadence and moral decay of monarch-ridden Europe. Advocating a nationwide system of education for all children as the best way of achieving that goal, Webster, after graduating from Yale in 1778, eked out a living as a schoolteacher—then a poorly paid occupation

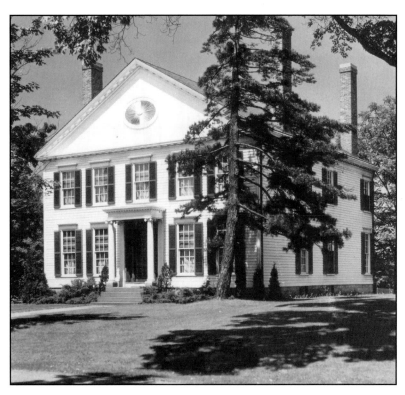

Acc. 36.812.1. Neg. 0.19033.

attracting few college graduates but many others "infamous for the most delectable of vices," chief among them drinking and swearing. He later wrote books in which he outlined his goals for a distinct national language and culture, political essays advocating a strong central government, numerous textbooks, and a well-known reference work. He was also instrumental in founding Amherst College.

Although today we usually think of Noah Webster as the author of the *American Dictionary of the English Language,* his contemporaries were more likely to think of him as the author of the "Blue-Backed Speller." First published in 1783, this textbook, whose formal title was *Grammatical Institute of the English Language,* was used to teach American schoolchildren reading and spelling for more than half a century. It was as popular in its day as the McGuffey Readers were in theirs, and it was laced with many of the same patriotic and moral lessons. The first edition sold out in nine months, and before Noah Webster died in 1843, the Speller had been reprinted at least 404 times; plagiarism was

so prevalent that Webster became a proponent of copyright legislation.

Webster's dictionary, on the other hand, was a little slow to take hold. Although it was reprinted twice in his lifetime, it did not achieve fame until after George and Charles Merriam bought the unsold inventory of the 1840 reprinting and in 1847 marketed a new edition at six dollars a copy. The monumental work of 70,000 entries helped standardize spelling and punctuation in America and, by reducing regional idiosynchrasies, made communication easier. In it, Webster included words coined in America, such as *chore* and *whittle,* and simplified spelling by removing the *k* from *musick* and *publick* and the *u* from *honour* and *colour.*

It was in part money from the sales of the Blue-Backed Speller that in 1822 enabled Webster to hire David Hoadley, the well-respected architect of many fine Connecticut churches and homes, to design a house that would accommodate the many members of the Webster family: Noah himself and his wife, Rebecca, their seven children, and numerous grandchildren and great-grandchildren, who were always welcome for long visits in the Webster home. The Neoclassical style in which Hoadley designed the house was then at the height of its popularity, a reflection of the new republic's wish to identify itself with the ideals of the ancient republics of Greece and Rome. Rather ironically, though, when the aging Webster moved into this finely proportioned house in 1823, his youthful liberalism and political optimism had faded. Disillusioned by political events and increasingly convinced that people were fundamentally weak and unable to govern themselves, Webster had undergone a religious conversion, reverting to the strict Protestantism that had characterized his upbringing on a Hartford farm. In the final twenty years of his life, he withdrew more and more into the sanctuary of his home, seeking solace in the company of his family and his writing. Before he died in his study at the age of eighty-four, he had finished his monumental dictionary and in 1833 had completed his edition of the King James version of the Bible for American readers, in which he took care to remove "occasional coarse phrasing."

After Webster's death, the house remained in the Webster family for many years but by 1918 was serving as a dormitory for Yale students. The house came to Henry Ford's attention in 1936, after Yale, in an attempt to cut maintenance costs, had turned it and several other old buildings over to a wrecking company to have them razed. Responding to the pleas of preservationists, Henry persuaded Yale to call off the wreckers and to turn the historic house over to him to be moved to Greenfield Village. There it was eventually restored to the period of Webster's occupancy.

Firestone Farmhouse and Barn

Peter Firestone built this brick farmhouse and wooden barn in 1828 in Columbiana, Ohio, just a few miles from the Pennsylvania border. Harvey Firestone, Peter's great-grandson, was born in the house in 1868, grew up there, and, after becoming a successful tire manufacturer, used it as a summer retreat. The farm meanwhile remained a working one. Among the guests Firestone entertained here were his summer camping companions, Henry Ford and Thomas Edison. Though neither Henry Ford nor Harvey Firestone lived to witness it, their grandchildren, William Clay Ford and Martha Park Firestone, were married in June 1947, two months after Henry's death. In 1965, almost thirty years after Firestone's death, his family and the local historical society restored the house and opened it to the public for tours, but because of the farm's remote location, it failed to attract many visitors.

In 1983, acting through the Firestone Foundation, Harvey Firestone's two surviving sons, Raymond C. and Leonard K. Firestone, both then in their seventies, gave the house and barn, together with furnishings and a sizable endowment for maintenance, to Greenfield Village as a way of perpetuating their father's memory. Disassembling the buildings, moving them some two hundred miles, and reconstructing them in Greenfield Village took over two years, in the course of which workers made an interesting discovery. Research had shown that the house had been extensively modernized sometime in the 1880s, but the exact date was not known until a work crew discovered a note tucked beneath a staircase. Signed, dated, and hidden by fourteen-year-old Harvey Firestone as the renovation was going on, it revealed that the work had taken place in 1882. The property, restored to its appearance after the 1882 renovation, has operated as a working sheep farm in Greenfield Village since 1985.

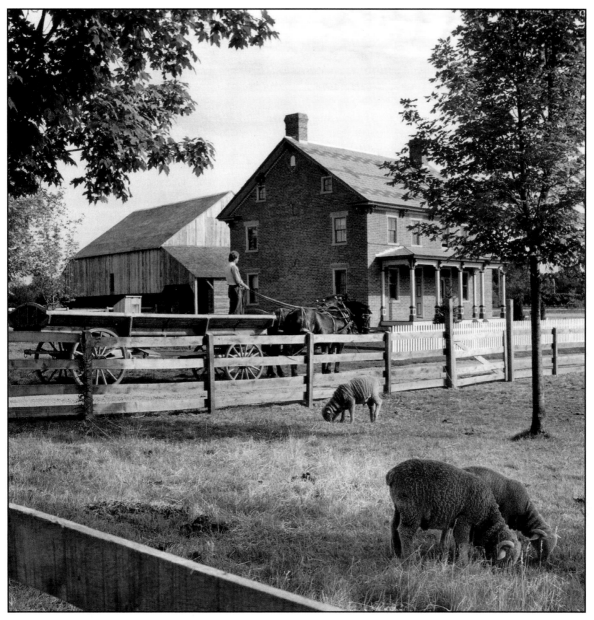

Firestone farmhouse and barn

Ackley Covered Bridge

In the 1800s, when wood in America was plentiful and cheap, covered bridges were common. Their roofs, of course, protected pedestrians from the elements, but what was probably more important, they protected the wood of the substructure and thus lengthened the life of the bridge. Covered bridges nonetheless required considerable maintenance, and they were also hard on horses in winter when these animals had to draw sleighs over bare wooden floors. When engineers began using steel and concrete in bridge construction, the covered bridge seemed doomed to extinction.

The covered bridge shown here was built in 1832 over a branch of Wheeling Creek near the town of West Finley in southwestern Pennsylvania. It replaced an earlier swinging, or "grapevine," bridge—one over which William Holmes McGuffey, author of Henry Ford's favorite schoolbooks, may have often walked; McGuffey was born seven or eight miles away in West Finley Township in 1800. The new span was called the Ackley bridge because most of the sturdy oak timbers used in building it came from trees felled on the farm of Joshua Ackley; born in 1802, Joshua Ackley was the son of one of the first settlers in the area. According to legend,

Amerindians were still living in this part of the country in 1832, and, perceiving the new covered bridge as a further intrusion on their domain, they fired arrows and rifle balls at the workers and their foreman, a local man by the name of Daniel Clouse.

In 1937, when the 105-year-old bridge was about to be torn down to make way for a new one of concrete and steel, Elizabeth Lucille Ackley Evans, a direct descendant of Joshua Ackley and a distant relative of William Holmes McGuffey, bought it from the Pennsylvania State Highway Department and offered it to Henry Ford for use in Greenfield Village. Since Henry had three years earlier purchased McGuffey's birthplace, he was undoubtedly delighted to accept this gift from the same part of the country. The covered bridge was dedicated in Greenfield Village in 1938, with hundreds of invited guests—including numerous Ackleys and McGuffeys—in attendance. Also among the guests was eighty-four-year-old Charles Richardson, who in 1878–1879 had been Henry Ford's last teacher at the Scotch Settlement Schoolhouse. When asked about his famed former pupil, Richardson responded, "He was an awfully good boy. Sometimes, though, he was more interested in mechanics than in his studies."

Acc. 37.799.1. Neg. 0.19030.

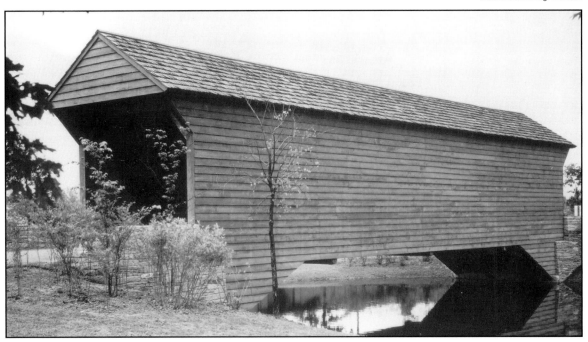

Dr. Howard's Office

This clapboard building was constructed as a one-room schoolhouse for the children of the rural town of Tekonsha in south-central Michigan in 1839. It is typical of the simple Greek Revival style used in southern Michigan during the first half of the nineteenth century. The schoolhouse may appear a far cry from Noah Webster's elegant Neoclassical house, built the decade before in New Haven, Connecticut, but among the features these two buildings have in common is "nogging": rough bricks placed between the interior and exterior wooden walls to provide insulation, as well as protection against fire and infestation from rodents. If the students and teachers at the Tekonsha schoolhouse were aware of the nogging, they were no doubt grateful, for the one-room schoolhouse, like most others of the period, was heated by just one wood-burning stove.

The Tekonsha schoolhouse became known as the Windfall School soon after the Howard family, migrating here from upstate New York in 1840, established a farm called Windfall on the land just behind it. The inspiration for the name came from a large tract of wind-fallen trees that the Howards found on the property. In 1855, when the town of Tekonsha built a new school, Dr. Alonson B. Howard, who had inherited Windfall from his parents, bought the little schoolhouse, partitioned it into three rooms—a waiting room, office, and laboratory—and began using it for his medical practice. In those days—and indeed until well into the twentieth century—most physicians had their offices in or near their homes.

A member of the first class in medicine at the University of Michigan, Alonson Howard received

his medical degree in 1851 at the age of twenty-eight. He evidently soon became a legendary figure in Tekonsha and the surrounding communities. Demand for his services was so great that, in addition to seeing patients in his office and making house calls on horseback, he rode a train circuit between Marshall, some ten miles to the north, and Coldwater in the south, and along the east-west railroad line from Jackson to Battle Creek. Like most country doctors at that time, he treated everything from toothache to tuberculosis, performed any kind of surgery that was needed, and was paid sometimes in cash, but very often in grain or tallow or in labor for his farm. His standard fee for sitting all night with a patient was two dollars; for regular house calls, he charged a quarter. The cost of any medicine was included in the fee. The story is told that after attending a woman in childbirth for forty-four hours, he charged five dollars, which he received in the form of a slab of pork and a dozen plump hens for his table.

In addition to his formal medical training, Dr. Howard was well-versed in herbal medicine. He concocted remedies himself from herbs and root extracts, a practice he learned from local Indians as a youth and that evidently inspired him to become a doctor. Howard had been seventeen when he and his family arrived in Tekonsha, the former site of an Amerindian village, and about ten miles away, at Athens, Michigan, was an Indian reservation. Attesting to Dr. Howard's fondness for his Indian neighbors, he and his wife, Cynthia, gave their two sons the Indian names of Manchie and Camer.

Dr. Howard used the little building as his office for twenty-eight years. Immediately after his death in 1883, his wife sent his instruments to their son Manchie, a physician in Perry, Arkansas, and then padlocked the building. It remained almost exactly as Dr. Howard had left it until 1956, when Howard Washburn, Alonson and Cynthia Howard's great-grandson, donated it and its contents to Greenfield Village. There it stands, complete with herbs, root extracts, patent medicines, instruments, and medical and financial records, testimony to the practices of a "saddlebag" doctor of more than a century ago.

Susquehanna Plantation House

Henry James Carroll, a planter whose forbears came to America in the mid-1700s, built this six-room house about 1845 in St. Mary's County, Maryland. Situated on a bluff overlooking the Patuxent River as it flows into the Chesapeake Bay, the simple structure was typical of others in this tidewater area. Called the Susquehanna Plantation because of the Susquehannock Indians who had once inhabited the area, the property by 1860 consisted of the house, 700 acres of land, and a number of outbuildings, including a dairy and thirteen slave quarters. Carroll, whose family was by then the fifth wealthiest in the county, owned sixty-five African-American slaves. Records from 1860 show that Carroll's slaves were valued at $49,000, while the total value of his land, buildings, and crops was $53,000.

Living in the house in 1860 were Henry Carroll and his wife, Elizabeth, both born in 1818, Henry's son Philip from a previous marriage, and Henry and Elizabeth's five children, who ranged in age from thirteen to two. The nineteen-year-old Philip shared the management of the plantation with his father. The sixty-five slaves—representing fifteen African-American families and including a number of skilled craftspeople, such as blacksmiths, carpenters, coopers, seamstresses, and shoemakers—provided the labor needed to make the plantation profitable and largely self-sufficient. The Carrolls fed themselves and their slaves from produce grown on their own land. In addition to kitchen gardens, they had fields devoted to wheat, corn, oats, hay, and tobacco—an important cash crop. They also owned pigs, cows, chickens, sheep, oxen, mules, and horses.

Although southern plantation owners like Carroll ruled over small kingdoms that were relatively independent of the outside world, these planters were at the same time deeply dependent on the labor of their slaves. They were likely to put a higher priority on accumulating slaves and land than

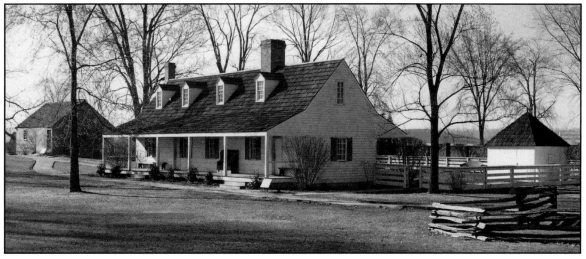

on acquiring fine furnishings and other personal belongings. Carroll's personal property in 1860 was valued at only $15,000.

Samuel D. Young of Grand Rapids, Michigan, whose wife was a native of St. Mary's County, bought the Susquehanna Plantation in 1913. In 1942, when the government acquired the site and built the Patuxent Naval Air Station on it, Young and his wife presented the plantation house and dairy to Henry Ford so that these reminders of a vanished way of life could be preserved. As the top photograph shows, the house was then in a deteriorating condition. The other photograph shows it after restoration in Greenfield Village.

H.J. Heinz's House

In 1854, when Henry John ("H.J.") Heinz was ten years old, he helped his father, a brickmaker who had immigrated from Germany in the 1840s, build this house on a hillside near the Allegheny River in Sharpsburg, Pennsylvania. Soon thereafter, H.J. made the first of the "57 Varieties" for which his name became so well known. Using horseradish grown in the family's truck garden along the river, the boy grated and bottled it in vinegar in his mother's new basement kitchen. It was not his first business endeavor. At eight, he had begun peddling the surplus from his parents' garden at their earlier Sharpsburg residence, toting it around to neighbors' kitchen doors in handbaskets. He did so well that he soon had to transport the produce in a wheelbarrow. After moving to the new house, his parents gave him three-quarters of an acre to farm on his own, and when he was twelve, he enlarged the plot to over three acres; now counting local merchants among his customers, he also bought a horse and cart.

The horseradish that Heinz bottled as a boy found a ready market. At the time, the pungent root was regarded as a sure remedy for grippe, catarrh, and dyspepsia; it also added zest to the dreary monotony of the food that Americans in northern climes ate for seven or eight months of the year: salted or smoked meats, root vegetables, dried fruits, and the like. Scrubbing, scraping, and grating horseradish, however, was a job that bruised the knuckles and made the eyes burn. Housewives who wanted to avoid this misery could buy the commercially prepared horseradish then on the market, but it was

Acc. 53.47.1. Neg. B.7152.

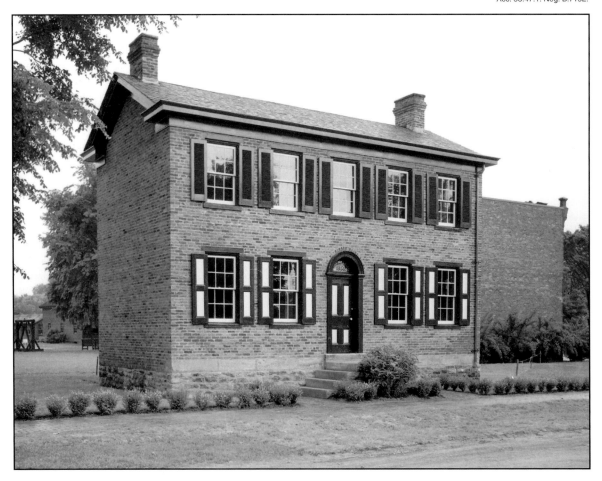

lumpy and contained leaves, tough fiber, and turnip filler.

H.J. Heinz's early success with his horseradish convinced him of two things: housewives would buy products that relieved them of tedious kitchen chores, and if properly packaged and promoted, a superior product, because of its intrinsic merit, would be a commercial success. By age sixteen, H.J. was employing several women to help him bottle his horseradish and making three wagon deliveries a week to grocers in Pittsburgh, just across the Allegheny River. The product was in its way as great an innovation as Clarence Birdseye's frozen foods.

At twenty-one, after attending a business college in Pittsburgh, H.J. became a part owner of his father's brickyard, but his real interest lay in truck gardening and selling preserved food. Four years later, in 1869, he went into partnership with L.C. Nobel to manufacture horseradish for distribution to Pittsburgh grocers. Since H.J.'s parents had recently moved to a more spacious house, the new partners installed their factory in the former Heinz residence. They remained there until 1875, by which time they had at least 160 acres under cultivation and were producing a "variety" of bottled products that were distributed well beyond Pittsburgh. Needing more space, Heinz and Nobel moved their operation to a factory building in Pittsburgh.

A nationwide financial panic after the move resulted in the company's bankruptcy, but by 1876 H.J. Heinz was back in business with a younger brother and a cousin as partners. The new company manufactured horseradish, of course, but it also made pickles, ketchup, and many other condiments. The new venture flourished, thanks in no small part to H.J.'s remarkable flair for promotion. He was undoubtedly the only American industrialist ever to install an 800-pound, 14-foot, 150-year-old live alligator in a glass tank on top of his factory; he maintained he had been enthralled when he first saw the alligator in Florida and wanted to share his pleasure with his employees. He was also the first industrialist to invite the public to tour his plant; by 1900 some twenty thousand people a year were trooping through. A pioneer in the field of advertising, he handed out—among dozens of similar items—green watch charms made in the shape of a pickle with his company's name emblazoned on them; anyone who accepted and wore this emblem thus became—wittingly or not—a soldier in Heinz's advertising campaign.

When it became embarrassingly apparent that the Heinz exhibit at the Chicago Exposition of 1893 was attracting very few visitors, H.J. hired small boys to dart through the throng handing out cards that offered a free gift to anyone who visited his exhibit. Although the gift turned out to be the pickle-shaped watch charm, the ploy was so successful that police had to be called in to handle the crowd. Perhaps H.J.'s most successful promotional undertaking was the 900-foot-long "Heinz Pier" that he built in Atlantic City, New Jersey, in 1898. Before it was destroyed in a hurricane in 1944, more than fifty million people had walked through it and gazed at the Heinz exhibits. Each was offered, and most accepted, a Heinz pickle pin. It was H.J. himself who in 1896 coined the company's famed "Heinz 57 Varieties" slogan; although the company was by then producing well over a hundred different products, H.J. thought the "57" had a certain magic. Apparently, he was right.

Certainly not the least of H.J. Heinz's remarkable qualities as an industrialist was his concern for the people who worked for him. To implement his goal of a "community of contented workers," he provided his employees with a clean, pleasant working environment and some benefits that are extraordinary even today: dressing rooms with hot showers, weekly manicures, free medical and dental care, a two-bed emergency hospital, five dining rooms, music and art for enjoyment at lunch, a roof garden, free courses in self-improvement, a library, even an indoor pool and gym. In addition, wages were fair and hours were relatively short. Not surprisingly, the company experienced no strikes during H.J.'s lifetime; when he died in 1919, he had more than sixty-five hundred people working for him. H.J. was also a vigorous supporter of the movement to outlaw the use of excessive and harmful amounts of preservatives in canned goods, a movement that in 1906 resulted in the passage of the Pure Food and Drug Act.

In 1904 H.J. Heinz had the house in which he had launched his career towed on a barge five miles down the Allegheny River to his main plant in Pittsburgh. There, packed with Heinz memorabilia, it served as a company museum until 1953, when the H.J. Heinz Company presented it and its furnishings to Greenfield Village.

Charles Steinmetz's Cabin

Charles Proteus Steinmetz was born in Breslau, Germany, in 1865. Afflicted from birth with a painful spinal deformity, he was also endowed with an extraordinary intellect. Although Steinmetz's father, a lithographer, was not well off, he managed to provide the boy with an education. At the University of Breslau, Charles—or Karl, as he was then known—studied mathematics, for which he had already demonstrated his genius. Becoming intrigued with electrical engineering, he began to study that as well. In 1888, just as he was about to receive his doctor's degree, the Bismarck government threatened to imprison him because of his socialist views and his affiliation with the outlawed Social Democratic party. The young man fled to Switzerland and a year later arrived in New York, a penniless immigrant. Soon thereafter, to blend in better with his adopted land, he changed his given names of "Karl August Rudolph" to "Charles Proteus." *Proteus,* the name of a Greek sea god capable of assuming different forms, was a nickname given him by friends at the University of Breslau.

Steinmetz's first job in America was as a draftsman in an electrical machinery shop in Yonkers, New York. Within a few months, he had, at his employer's request, established an experimental research laboratory. It was here that he performed the first of the many electrical marvels for which he became world-renowned, in this case demonstrating the amount of power lost in electric motors because of magnetism. Steinmetz's reputation as an electrical and mathematical genius soon spread among electrical scientists, and in 1893 the newly formed General Electric Company offered him a job—an offer the company never regretted making. It was owing largely to Steinmetz that General Electric attained its early dominance in the field of electrical engineering. Among his many contributions to that field—and to General Electric—was the development of methods for calculating alternating current phenomena as applied to electrical circuits.

Steinmetz's work earned him rapid promotion within General Electric and recognition throughout the world as the dean of electrical phenomena. Within two years of starting at GE, he was made consulting engineer at the company's facility in Schenectady, New York, and in 1901, just twelve years after landing in New York as an impoverished immigrant, he was elected president of the American Institute of Electrical Engineers. In 1903, after receiving a Ph.D. from Union College in Schenectady, he became a professor of electrical engineering there and for the next ten years gave a well-attended, two-hour lecture each day of the academic year.

In 1896 Steinmetz built the little cabin shown on page 47 on the banks of Viele Creek, a tributary of the Mohawk River, at a site about eight miles outside Schenectady. It had few conveniences other than electric lights, which ran off a large storage battery that Steinmetz recharged once a week. Steinmetz furnished the cabin with a hammock for sleeping, a crude pine work table, and a straight-backed chair. Kneeling on a pillow on the chair seat with the table in front of him spread with papers, he worked on some of the more than two hundred electrical devices and control systems that he ultimately patented. He also did a good deal of work while drifting along Viele Creek in a canoe—something he evidently enjoyed doing even though he could not swim a stroke. The canoe was fitted out with a work board, writing supplies, a slide rule, and a kneeling cushion, and while floating along in it, he wrote a series of textbooks on electrical engineering.

Life at Steinmetz's cabin was not all work. Friendly and sociable by nature, he liked to play cards and sometimes invited friends for a game of poker. His definition of a poker club was a "society for the equalization and distribution of wealth"—the principles that had resulted in his exile from Germany some years earlier. Notorious as a practical joker, he greeted some guests with a cold-water shower; he kept a watering can above the door of the cabin triggered for such occasions.

Three years before his death in 1923, an event at the cabin provided Steinmetz with the inspiration for his final studies. After a lightning bolt struck the cabin, damaging, among other things, a mirror, he spent hours assembling the hundreds of pieces of broken glass and observing the path of lightning on their silver backing. Noting that this was "just the evidence needed to begin some laboratory investigation," he went back to the private laboratory that GE had built for him in 1901 and created a light-

ning-generator—a feat that led to his being hailed as a "modern Jove" and "the man who made lightning." He also formulated an explanation of lightning phenomena and in 1922 invented a lightning arrestor to protect electrical power lines from lightning damage, a great boon to utility companies.

Although Steinmetz never married, he legally adopted Joseph LeRoy Hayden of Schenectady as his son and heir. In 1930 Hayden donated the cabin, together with Steinmetz's handwritten manuscripts describing his life's work, to Henry Ford for preservation in Greenfield Village.

Luther Burbank's Garden Office

Luther Burbank, eminent horticulturist, was born on a farm near Lancaster, Massachusetts, in 1849. From an early age, he evinced an interest in natural science. At nineteen, he read Charles Darwin's *On the Origin of Species by the Means of Natural Selection*, and, as he later recalled, it marked a turning point in his life. Soon thereafter, he began his career as a plant breeder on a seventeen-acre tract of land that he had bought in Lunenberg, a short distance north of Lancaster. There he established a truck garden and raised seeds and vegetables for market. In 1873, after experimenting with potato seedlings, he took advantage of the variations among them to produce what became known as the Burbank potato—the first of his many contributions to the improvement of plant life. In 1875, drawn by California's temperate climate and extended growing season, he moved to Santa Rosa, about forty-five miles north of San Francisco.

Burbank remained in California for the rest of his life, devoting himself to the study of plant life and endearing himself as an eccentric but benevolent figure to his neighbors in Sonoma County. He was particularly interested in developing horticultural methods and products that would be of immediate benefit to people. Through experimentation, he discovered that by grafting seedlings onto the branches of mature trees, he could speed natural processes. A dramatic example of his use of this method occurred in the spring of 1881, when Warren Dutton, a San Francisco businessman who wanted to go into the dried-fruit business, asked Burbank to raise 20,000 plum trees for him by the autumn. Burbank proceeded to plant seedlings of the fast-

growing almond tree. At the end of June, he grafted plum seedlings onto the trees, and by autumn he had the orchard Dutton wanted.

With the money that Dutton paid him, Burbank in 1882 bought forty acres in Santa Rosa, where he planted experimental gardens, devoting seven acres exclusively to a magnificant spread of flowers. Eleven years later, he established a large experimental farm at nearby Sebastopol, though he continued to live in Santa Rosa. On these tracts, he performed some of the feats for which he became so well known: acclimatizing foreign plants to American conditions, domesticating wild plants, and cross-breeding plants to combine and emphasize particular characteristics in a new species. Through selection, Burbank also added desirable qualities to existing plants, giving them better color, larger blooms, and improved flavor and aroma. By the time he died in 1926, Burbank had produced and improved more varieties of fruit, flowers, vegetables, grains, grasses, and trees than any person before or since. One important effect of his work was an increase in the amount, quality, and variety of food available to the average family.

Burbank built the little office shown here in a corner of his forty-acre experimental tract in Santa Rosa in 1906. Here he conducted his nursery business, kept his accounts and botanical notes, and did much of his extensive writing. Henry Ford and Thomas Edison were both greatly interested in Burbank's experiments in plant development and use, and when they traveled west in 1915 to the Pan American Exposition in San Franciso, they stopped at Santa Rosa to visit him. A little over two years later, Henry sent Burbank "Fordson No. 1," the first tractor that Henry and Edsel Ford ever produced.

In 1928, two year's after Luther Burbank's death, his widow, Elizabeth Waters Burbank, gave the office to Henry Ford for the museum and village he was then planning. She also donated many of its original furnishings—books, manuscripts, photographs, and a closet full of gardening tools—as well as the spade that Edison thrust into the cornerstone at the dedication of the Henry Ford Museum, but despite Henry's pleas, she adamantly refused to part with the remains of Luther Burbank's dog, Bonita.

Buckminster Fuller's Dymaxion House

In 1927 Buckminster Fuller, American engineer, designer, and architect, began drawing plans for a house that could be mass-produced and completely prefabricated in a factory. He experimented with the design for the Dymaxion Dwelling Machine, as he called it, for many years, revising and perfecting his ideas. In 1944, as it was becoming apparent that World War II was not going to last forever and that when it ended so would many war-related industries, the president of the aircraft workers' union invited Fuller to present his ideas for a factory-built house to the management and workers of the Beech Aircraft Corporation, which was then engaged in manufacturing fighter planes. The upshot of this meeting was that in October 1945, just two months after the war ended, workers at Beech Aircraft's plant in Wichita, Kansas, produced the first prototype of Fuller's Dymaxion House.

Looking rather like a flying saucer, the house, eighteen feet in diameter, was made mainly of very light pieces of aluminum, none of them weighing more than ten pounds. The entire structure weighed only six thousand pounds and was supported by a central mast. The pieces were compact enough to be shipped from the factory in one cylindrical container (shown at left in photograph on page 50) and could be put together on site by six workers in the space of a day. Because it was mass-produced, the price of a finished house was low—supposedly $6,500, including assembly, in 1946.

The house's aluminum skin was unpainted, and its panoramic windows, made of acrylic, were riveted in place; a large rotating ventilator on the roof provided interior air circulation. The house had a living area with a fireplace, a kitchen, and two pie-wedge bedrooms, each with a small bathroom.

Among the house's innovative features was a central vacuum-cleaning system. Space-saving features included revolving closets and electrically operated retractable cupboards.

When the first prototype of the Dymaxion House appeared in October 1945, it was the focus of much media attention and an immediate hit with the American public. Within seven months, the factory had 37,000 unsolicited orders and was making plans to produce 60,000 houses a year. *Fortune* magazine, comparing the potential impact of the Dymaxion House with the impact the automobile had had years earlier, predicted that sales might reach 250,000 a year. As it turned out, none of this was to be. Fuller was then fifty years old and had suffered through two previous business failures. When his financial backers and the stockholders of his company urged him to forge ahead with production, he took an uncharacteristically cautious stance, insisting on more time for research and development. As a result of the delay, his company fell apart, and only two prototypes of the house were ever built—both of them for the United States Army Air Corps. Thus ended the plans for the house that might have given employment to hundreds of former munitions workers and that just might have revolutionized the house-building industry.

In 1991 the family of William L. and Marjorie M. Graham, owners of the only Dymaxion House prototype still in existence, donated it to the Henry Ford Museum and Greenfield Village. Assembled in Wichita in 1948, the house was later attached to a large, conventional home. At the time of the donation, it was valued at $550,000. It is scheduled to be reassembled in 1995, in time for the centennial of Buckminster Fuller's birth.

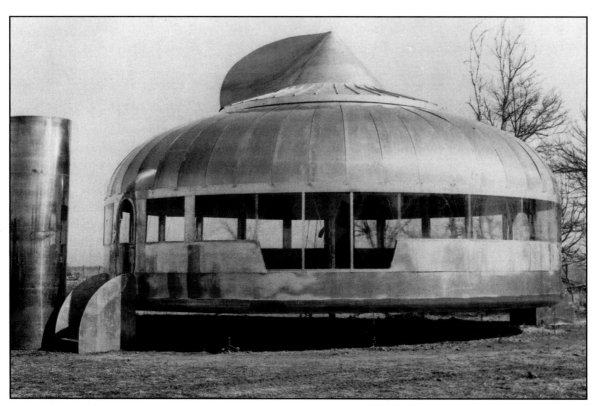

Acc. 91.401.1. Photo: © 1960, The Estate of Buckminster Fuller; Courtesy of Buckminster Fuller Institute, Los Angeles

CHAPTER 2
Agricultural Equipment

ENRY FORD'S passion for acquiring antique farm machinery evidently bordered on mania and was also reputed to be something of a trial to his friends. It is said that in the early 1920s he could not drive by an old plow or harrow rusting away in a field without stopping to examine it. Those riding with him soon learned to be on the lookout for such items in the hope that if they spotted the thing first, they could divert Henry's attention to a less compelling object on the other side of the road. Despite the best efforts of his motoring companions, however, Henry had by the 1930s amassed what was no doubt the most complete collection of agricultural implements in existence.

When it became known that Henry Ford, whose cars, trucks, and tractors almost singlehandedly destroyed the patterns of nineteenth-century farm life, was so avidly collecting artifacts of bygone days on the farm, the *New York Times* wrote that it was as if Josef Stalin had gone in for "collecting old ledgers and stock-tickers." Henry's fascination with antique farm implements may seem even more puzzling in view of his aversion to the drudgery that farming entailed. Apparently, however, it was not mechanized farm work that he objected to, but the tedium of the chores that had to be done by hand. As a child, he did such tasks only grudgingly and spent every moment he could attempting to mechanize operations on his father's farm. His opinion of farm life in general was that "considering the results, there is altogether too much work."

It was, in fact, Henry Ford's desire to relieve what he called the "excessively hard labour of ploughing" that stimulated his interest in tractors and in a roundabout way led him into the automobile business. In 1876, at the age of thirteen, he had his first glimpse of a self-propelled vehicle—a steam engine that could be used for sawing wood, threshing grain, or husking corn. Although he had seen many such engines being hauled from farm to farm by horses, this was the first vehicle he had ever seen that moved under its own power. It apparently set him to thinking about "some kind of a light steam car that would take the place of horses." Although the idea of developing a horseless carriage for transportation was a common one in the 1880s, to Henry this idea "at first did not seem so practical . . . as the idea of an engine to do the harder farm work, and of all the work on the farm ploughing was the hardest." Moreover, a tractor was more in line with what he described as his "constant ambition": "to lift farm drudgery off flesh and blood and lay it on steel and motors."

In the early 1880s, Henry spent several happy summers working on steam engines much like the one that had so enthralled him at age thirteen, first shepherding a Dearborn neighbor's Westinghouse portable engine around to local farmers who were renting it and later traveling through rural Michigan and Ohio servicing steam engines for the Westinghouse Company. He wiled away winter days in these years in a workshop on his father's farm developing a "farm locomotive," a sort of primitive tractor powered by a homemade steam engine. A few years later, as a married man of twenty-eight, he began his romance with the internal combustion engine, a romance that in 1896 resulted in his building the "Quadricycle," his first automobile. Although the horseless carriage thus took precedence, Henry, as soon as his automobile company began making money, resumed his experiments with tractors. In 1917, in the midst of World War I, he finally realized his ambition of relieving farm drudgery by producing the Fordson tractor, a machine that revolutionized work on small farms.

That Henry Ford was at heart "a farmer with a bent for mechanics," as *Fortune* magazine once described him, was evident in other ways as well. Although he was often hard up for cash in the early

years of his automotive career, he was never tempted to sell the eighty acres of land his father had given him when he became engaged to Clara Bryant in 1886; indeed, he began adding to this plot about 1900 and by 1909 had amassed about two thousand acres. During the two years of his engagement to Clara, Henry cleared his initial acreage of timber, using a steam-powered circular sawmill—and delighting in illustrating for his neighbors, or anyone who cared to watch, how his machine could do work that generally required several teams of horses and quite a few men. So impressed were his neighbors that when Henry finished clearing his own land, they hired him to clear theirs.

Never a conventional farmer, Henry turned his farmland into an arena for testing tractors. He also had no use whatsoever for chickens, horses, or cows and conducted a lifelong vendetta against them. "Chicken," he wrote, "is fit only for hawks," and "considering all the bother of attending them and the expense of feeding, [horses] do not earn their keep"; as for the output of cows, "milk is a mess." Henry preferred the soybean as a source of milk—and for much of the rest of his diet, too, as his dinner guests often learned to their sorrow. He had high hopes for that versatile legume, and in the 1930s, he managed to cover half of Dearborn with soybean fields. In addition to occasionally wearing soybean suits and ties, he built gearshift knobs, trunk lids, and other car components out of soybean plastic. He was hopeful that soybeans would be the salvation of his village industries, which were foundering because of the expense of shipping raw materials out to the country and shipping the finished products back. Although the soybean was a raw material that could be grown on site, Henry's hope did not materialize.

The idea of making farmers more self-sufficient must have occurred to Henry at least as early as 1916. In that year he established the "Henry Ford & Son Laboratories" to carry out "medical, botanical, and chemical research," and the lab's first major project was to develop a tractor fuel that farmers could make themselves from corn, potatoes, or other crops.

Although Henry hated the drudgery of farm life as a child, farming had actually become considerably easier in the hundred years before his birth. About the time of that event in 1863, with the Civil War's having created both a shortage of farm labor and an increased demand for food, Henry's father invested in a McCormick reaper, one of the machines that had already created a revolution in American farming. Like the automobile and many other inventions, the reaper evolved through the efforts of many individuals, but it was Cyrus McCormick, a Virginian, who in 1834 patented the first successful one. The McCormick reaper that Henry's father bought could harvest in a day the same amount of grain that ten men could harvest with scythes. Among the many other significant labor-saving devices that created a revolution in nineteenth-century American agriculture was the John Deere plow. Devised in 1837 by a Vermont-born blacksmith to cut through the thick, loamy soil of the Midwest, the Deere plow opened the prairies to wheat cultivation.

As early as 1913, Henry Ford had amassed a fairly representative collection of the farm implements that contributed to the nation's growth, among them old grain separators, threshers, and portable steam engines. By 1930 his greatly enhanced collection—"world class," as current jargon would have it—was being used to teach agricultural history to the students of the Edison Institute. Of the many hundreds of artifacts in the agricultural collections of the Henry Ford Museum & Greenfield Village, most were purchased by Henry Ford or his agents. The gifts described in the following pages are, to a limited extent, representative of the overall collection.

Replica of John Deere Plow

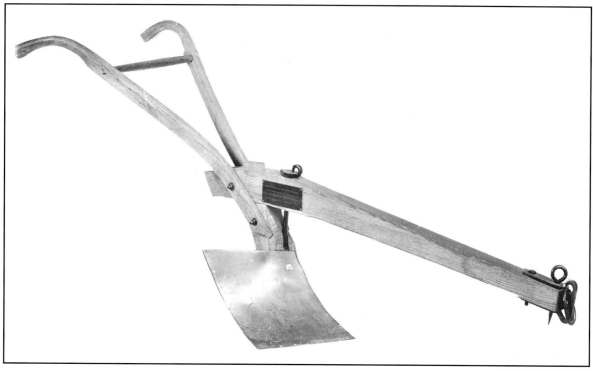

The plow shown here is a twentieth-century replica of the one John Deere devised in 1837. Although by then numerous improvements to the plow had enabled farmers in the East to till their land with a fair amount of ease, the tough, sod-covered soil of the fertile Great Plains defied even the best of the cast-iron plows used by eastern farmers; moldboards came out of the Midwest earth gummed with thick black soil. John Deere, a Vermont blacksmith who moved to Illinois in the 1830s and soon became an authentic American folk-hero, solved the problem by creating a plow in which the share and moldboard formed a single unit made of sharp-cutting steel. Not only did Deere's plow enable farmers to break through the prairie sod; it also reduced the animal power required to turn the soil.

This copy of the John Deere plow is about seven feet long and a little more than two feet wide. Its steel one-piece share and moldboard is concave and diamond-shaped. Horse-drawn, the plow was controlled by the farmer who walked behind it holding onto its wooden handles. The replica, which was donated to the Henry Ford Museum by Deere and Company of Moline, Illinois, in 1952, has a plaque that reads: "Replica of first steel plow built by John Deere in Grand Detour, Illinois, in 1837. The original plow from which this replica is copied is now in the Smithsonian in Washington, D.C."

Bull-Tongue Plow

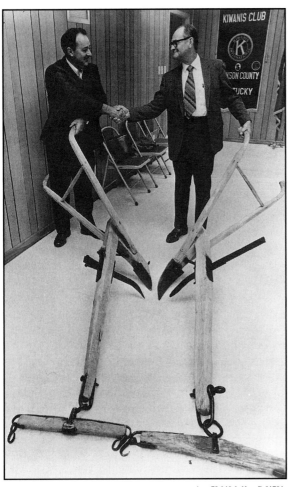

Acc. 72.149.1. Neg. B.64784.

The bull-tongue plow was in common use in the South very early in the nineteenth century, and perhaps even before. Although it died out in most places around 1890, it persisted in use on isolated mountain farms in Appalachia until well into the present century. The two bull-tongue plows shown here were still being used in eastern Kentucky as late as 1968. The photograph shows Robert Donigan (on the right) of Tyner, Kentucky, presenting the plow on the left to a representative of the Smithsonian Institution in 1972; Donigan and his wife later presented the other plow to the Henry Ford Museum.

In a written statement describing the gift he and his wife were making to the museum, Robert Donigan noted that the men in his family had been using bull-tongue plows since the early 1800s. When these implements rotted or wore out, new ones were made on rainy days by the local blacksmith or the mountain farmers themselves. This particular bull-tongue was made about 1923 by Donigan's father and a neighbor. The vertical knife-coulter in front of the iron "bull-tongue" shovel, or plow point, was for cutting through roots and separating dense turf or heavily rooted vegetation. The "single-tree" at the end of the beam held the harness traces of a mule, preferably a well-trained one.

The Donigan family originally used the bull-tongue plow to eliminate roots and stumps from newly cleared land, but, as Robert Donigan put it, "with my tractor and [bulldozer], it hardly pays to keep a well-trained mule to pull the bull-tongue some few hours each year." Donigan continued to use the bull-tongue "to lay out the rows for garden and truck patches" even after he acquired modern equipment, but with "the departure of the last mule from the farm in 1968," the bull-tongue went into "complete retirement." Donigan's hope in giving it to the Henry Ford Museum was that it would "remind viewers of its important role in the development and growth of agriculture in the Appalachia region."

Bog Plow

Used to cut peat from bogs, this plow dates from about 1870. Such implements were once common in Ireland—the birthplace of Henry Ford's father—where homes were traditionally heated by burning bricks of dried peat in stone fireplaces. Even today, homes in some parts of Ireland are still heated in the traditional manner. American farmers found a variety of other uses for the bog plow, among them clearing brush, cutting corn, and harvesting celery. Neither the maker nor the donor of this particular bog plow is known; it is, however, recorded as an early gift to the Henry Ford Museum.

The bog plow's steel cutting blades, each fifty-two inches long, are suspended from a sixty-five-

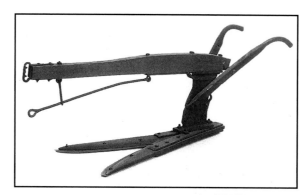

Acc. 00.3.16435. Neg. B.91405.

inch beam by a massive cast iron standard. A tow loop projects from an iron draught rod attached to the standard.

Spike-Tooth Harrow

George W. Hall of New Haven, Michigan, patented this spike-tooth harrow on October 1, 1867, under the title "Improvement in Double Rotary Harrows." He was one of several inventors who in the 1860s attempted to design a harrow that could pulverize and smooth soil more efficiently than existing models.

Hall's unusual device has two iron-rimmed wooden wheels, each forty-six inches across, with a tongue attached to the hub of each wheel. The wheels are held together by an iron bar but otherwise are free to rotate. There are forty spikes in all, twelve on each wheel rim and one on each spoke. Hall arranged the spikes on his harrow with better soil pulverization in mind. His design also allowed the wheels to swing themselves free when a spike caught on an obstacle. William Johnson of Wayne, Michigan, gave the spike-tooth harrow to Henry Ford for his museum collection in 1928.

Acc. 28.204.1. Neg. A.3299.

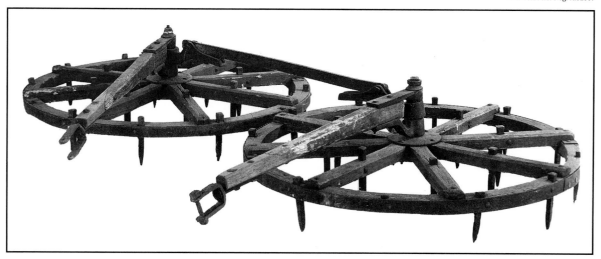

Prototype of Avery Corn Planter

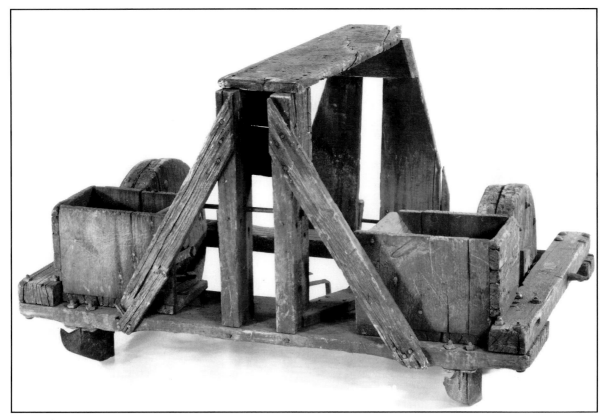

Jethro Tull's horse-drawn mechanical seed drill was one of the inventions that set off an agricultural revolution in England in the early 1700s. With Tull's machine, a farmer could do a much lighter seeding than he could by hand-sowing and yet still obtain high yields. The seed drill shown here—a horse-drawn corn planter—is a much later device than Tull's. R.H. Avery conceived the idea for it while being held by the Confederates in the infamous Andersonville Prison during the Civil War; he reputedly drew plans for the device by sketching them in the ground with a pointed stick. Consisting of a rough wooden box four feet wide joined by iron bolts, Avery's planter was designed to drill two holes at once; mechanisms on both wooden wheels activated a slide at the bottom of each hopper, allowing the seed to fall to the ground.

Avery had originally planned to begin manufacturing corn planters as soon as he was released from Andersonville, but when he was finally freed after nine months, the possibility of obtaining free land attracted him to Kansas. It was not until 1874, in the town of Sterling, Kansas, that he built the prototype shown in the photograph. In 1877, he moved to Galesburg, Illinois, where he and his brother went into the business of manufacturing corn planters based on his prototype; they eventually made a variety of other farm implements as well. The Avery Company, which presented its prototype corn planter to Henry Ford at some unrecorded date, remained in business until 1924.

"New Yorker" Reaper

By the 1850s Cyrus McCormick's harvester was becoming an increasingly common sight on the prairies of the Midwest. After patenting his machine in 1834, McCormick had bought the rights to the cutting bar on a reaper that Obed Hussey patented in 1833. The machine that resulted—the McCormick-Hussey reaper—had a reciprocating cutting bar and a reel that moved the cut grain onto a conveyor belt. Although the cut grain then had to be bound by hand, the labor that this device saved meant that farmers could grow crops on a larger scale than ever before. After being displayed at the Great Exhibition of London in 1851, the McCormick-Hussey reaper quickly gained in popularity. It dominated the market until the 1870s, when machines that could both cut and bind the grain were introduced.

The "New Yorker" grain reaper shown here, which the Globe Iron Works of Brockport, New York, built about 1852, so closely resembled McCormick's machine that litigation ensued. McCormick won the case, and in 1853 D.S. Morgan and William S. Seymour, owners of the Globe Iron Works, were forced to suspend manufacture of their machine. Made mostly of wood, the New Yorker reaper has a metal cutting bar with slightly upturned fingers designed to ride over bumps. A hemp rope, rather than a chain, was used to drive the wooden rake and reel. Perched above the drive wheel on the right is a wooden seat with metal supports.

D.S. Morgan's son, Gifford Morgan of Brockport, New York, presented the New Yorker reaper to Henry Ford, together with the complete business records of D.S. Morgan & Company. The date of the gift is unknown.

Acc. 00.1198.1. Neg. A.5507.

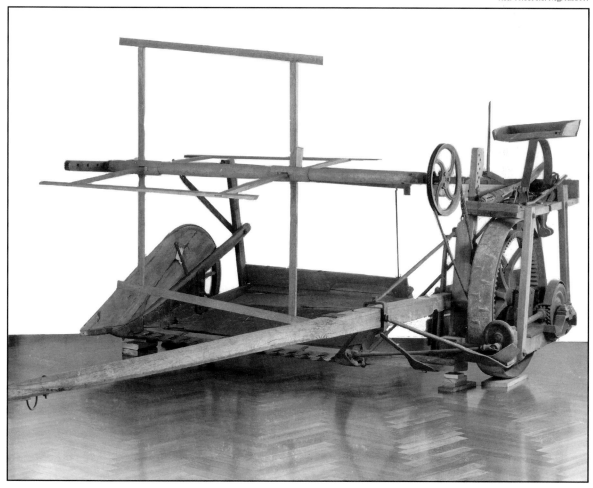

Porcupine Thresher

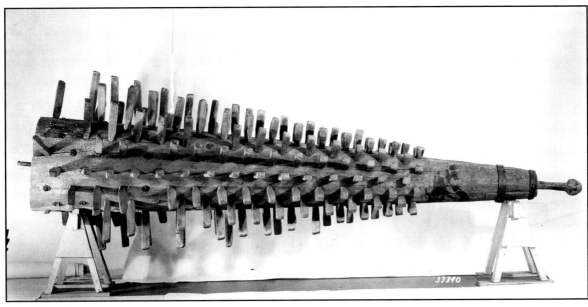

Threshing was one of the last farm operations to be mechanized in England, which was generally ahead of the United States in technological development. Since harvested grain could be stored and threshed during the slow winter months, there was usually no shortage of human labor to perform the task and hence no compelling need for mechanization. By the 1830s, however, threshing machines had become so popular in England that farm workers, claiming that the threshers robbed them of their winter employment, were in a rebellious mood.

The thresher shown here, known as a spiked roller or as a "porcupine" thresher, was made in the United States about 1820. Such devices were used primarily in central New York and parts of Maryland and Delaware. The roller consists of a conical log, eleven feet long and set with wooden pegs. The knob at the small end of the log was either pocketed into a free-turning post set in the center of the threshing area or connected to a pivot in the center of the threshing floor. A horse attached to the large end drew the log about in a circle, while the pegs beat the heads from the stalks of grain strewn about the floor.

The maker of this thresher is unknown, as are the donor and date of the gift. Records of the Henry Ford Museum, however, indicate that it was a donation.

Hay Baling Press

In 1861, when this hay baling press was patented, hay was normally carried loosely on horse-drawn wagons to its destination—usually the hay mow of a barn on the farm or in a nearby town—and it was often a messy business, with hay spilling every which way over the sides of the wagon. The hay press was designed to package hay into compact, rectangular bales so that it could be more efficiently transported.

This primitive hand-operated press, ninety-six inches high and forty-two inches wide, is painted blue and marked with the maker's name—R. Wakeman of Port Deposit, Maryland—and the date of the patent. A lever operates a ratchet wheel with ropes that run over a pulley at the top of the press and attach to a sliding frame within it. Hay was dropped through the doors at the top and pressed up from below. Slits in the side allowed wire to be passed around the bale, and the pressed and wired bale could then be removed from the top. John F. Meigs of Havre De Grace, Maryland, donated the device to the Henry Ford Museum in 1931.

Acc. 31.571.1. Neg.B.9931.

Milk Cart

When tilted backward, this three-wheeled, hand-pushed cart from England delivered milk from a spout at the bottom of the large, upright brass container. Other, smaller containers on the cart held from a pint to several gallons of milk. The milk cart was part of a collection of more than fourteen hundred dairy-related items given to the Henry Ford Museum in 1971 by David R. Gwinn, former president of the Pennbrook Dairy Company of Philadelphia. Gwinn was forced to move his collection when the building in which it was housed was bought by the Bell Telephone Company.

Gathered over a forty-year period, Gwinn's collection amply illustrates the history of the dairy industry. It includes, among other things, milk bottles from all over the world, milk pails and cans, antique milking machines, milk wagons, cream skimmers and separators, cowbells, butter molds and churns, a machine for filling midget cream bottles, and hundreds of books, periodicals, and catalogues pertaining to dairying.

Acc. 71.1.106. Neg. B.58395.

Hand Milking Machine

Patented in 1865 by the American Cow Milking Machine Company of New York City, this hand-held device could milk all four quarters of a cow's udder at once. Eight inches high, it has four rubber teat cups sitting on top of metal chambers. When the scissor handles were moved back and forth, the chambers filled with suction, thereby drawing the cow's milk into the chambers. On the next stroke of the handles, the milk was forced from the chambers and out through a spout. The machine was part of the large collection of dairy items that David R. Gwinn of Philadelphia gave to the Henry Ford Museum in 1971.

Acc. 71.1.300. Neg. B.58399.

Acc. 71.1.306. Neg. B.58390.

Foot-Pedal Milking Machine

This strange-looking device, a manually operated milking machine, was patented by William M. Mehring of Carroll County, Maryland, on February 8, 1899. Mehring must have been a busy man, perhaps intent on perfection, for he patented other "cow milkers" in 1892, 1896, 1905, and 1908. This particular model is designed to milk two cows simultaneously. When seated, the operator pushed on the foot pedals to manipulate the vertical pump. The moving pump created suction in a pair of rubber tubes (only one tube is shown in the photograph), each of which was connected to four teat cups. The suction drew the milk from the cow's udder, and the milk flowed out of the machine through the spout at the top of the pump cylinder. The foot-pedal milker is but one of several milking machines in the collection of dairy items donated to the Henry Ford Museum in 1971 by David R. Gwinn of Philadelphia.

Thresher-Separator

Before Andrew Ralston of Hopewell, Pennsylvania, patented a thresher-separator in 1842, farmers were using a machine called a "bunty" to thresh grain; they then had to run the threshings through a separate fanning mill to separate the grain from the chaff. Ralston's machine combined the two operations.

The thresher-separator shown here, built sometime before 1868, was based on Ralston's patents. Its maker was Robert B. McClure of the R.B. McClure Agricultural Works of West Middleton, Pennsylvania. The machine is twenty-one feet long overall and has a thirty-inch threshing cylinder featuring an endless belt with little rakes. The rakes dragged the threshed grain across a perforated metal sheet. As the grain and chaff fell through the holes in the sheet, the straw was carried out of the machine. After the grain was winnowed and cleaned, a cup-and-belt elevator raised it above the machine where it was dumped into a long spout to facilitate top-filling of grain bins or granaries.

Robert McClure's thresher-separator is recorded as a very early gift to Henry Ford from McClure's grandson, Dr. Roy D. McClure of West Middletown, Pennsylvania. Dr. McClure, who served for many years as Chief Surgeon at the Henry Ford Hospital in Detroit, was Henry Ford's favorite physician.

Acc. 00.10.1. Neg. A.1556.

Whipple's Butter Churn

Samuel J. Whipple of Orville, California, patented his rectangular butter churn on January 21, 1868, and July 17, 1885. As proclaimed in faded red lettering on the side of the square wooden box that constitutes the churner, it was awarded the sweepstakes gold medal in St. Louis in 1883. The churn is pictured here attached to a treadmill, a device that was powered by animals and that did away with the human labor involved in churning butter. The churn, painted yellow and embellished in black, is suspended from a wooden stand by means of pins. As the treadmill moved, the box turned corner over corner, churning by simple agitation. David R. Gwinn of Philadelphia donated both the churn and the treadmill to the Henry Ford Museum in 1971, together with the rest of his dairy items.

Acc. 41.186.1. Neg. B.896.

Smokehouse

Smokehouses were common sights on farms from about 1840 to 1900. This one is a very early and unusual example. Made perhaps even before 1840 at Haydens Mill in Tecumseh, Michigan, it was hollowed out of a single sycamore log four feet in diameter. John Clarkson brought it to his farm in Ann Arbor, Michigan, about 1920 to keep it from being burned as firewood, and in 1941, rather than letting it decay in his yard, he gave it to Henry Ford for his museum.

Cylindrical in shape, the smokehouse has a wooden floor with a slightly raised outer edge, a wood-shingled peaked roof, and a small door with two strip hinges and a wooden loop handle. The food to be smoked was hung from crossbars in the top half of the structure. The holes visible in the photograph were drilled to support the crossbars; there are twenty-four such holes in all.

Acc. 71.1.176. Neg. B.58394.

Concrete Farm Silo

In 1907, a year after he started the Smith Silo Company in Paw Paw, Michigan, Hiram Smith patented a concrete stave silo. He seems to have been a rather prolific inventor, for he had other patents pertaining to the manufacture of cement blocks, molding machines, shakers, curing trucks, and scaffolding for use in constructing silos. The structure pictured here, which Smith erected on a farm outside Paw Paw in 1909, is the lower portion of the first concrete stave silo ever built. The advantage of the concrete silo over the traditional wooden one is that it has a longer life; the disadvantage is that it is more expensive.

In testimony to the longevity of concrete silos, Hiram Smith's first one was still standing on its Paw Paw site sixty-six years after it was built. In 1975 the Smith Silo Company (which moved to Oxford, Michigan, in 1930) disassembled the structure and erected a new silo for the owner of the farm. A year later, Arthur Smith, Hiram's grandson who was then president of the company, donated the world's first concrete stave silo to the Henry Ford Museum, where the lower portion of it was installed in the agricultural section.

Acc. 76.16.1. Neg. B.82617.3.

Steam Traction Engine

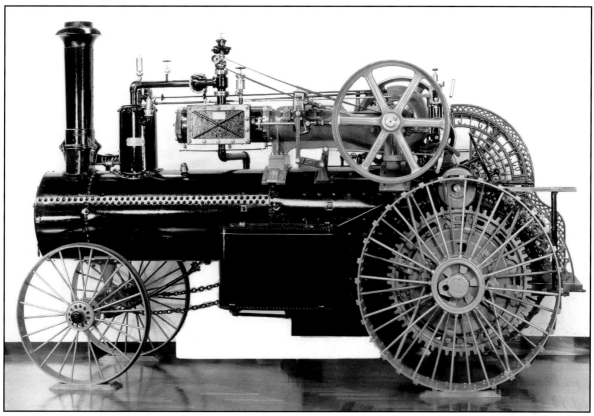

Meigs Brothers, proprietors of the Malcolm Meat Market in Malcolm, Iowa, bought this steam traction engine in 1890 and subsequently used it as a power plant for threshing grain in Plymouth County, Iowa. The engine was designed to burn wood, coal, or straw as fuel. It originally had ten horsepower, but that was increased to fifteen in 1896, when a Woolf compound replaced the original cyclinder. Merrill C. Meigs of Chicago donated the steam traction engine to the Henry Ford Museum in 1928.

The maker of the engine was the J.I. Case Threshing Machine Company of Racine, Wisconsin. Founded in 1842, Case was for years the leading manufacturer of threshing equipment in the United States. The company added steam engines to its product line in 1870 and traction engines in 1876. By the time it switched over entirely to the manufacture of gasoline tractors in 1926, it was the largest maker of farm steam engines in the country, having produced nearly 36,000 of them.

Steam engines were particularly dear to Henry Ford's heart, and he collected them by the dozen, acquiring, among many others, a replica of the first one he ever saw, when he was a boy of thirteen. He had fond memories of the summers he spent as a young man working on his neighbor's Westinghouse portable engine and servicing steam engines for the Westinghouse Company. With the help of Westinghouse, he tracked down his neighbor's old portable to a Pennsylvania farm, where it lay rusting away. He brought it back to Dearborn, had it spruced up, put water in the boiler, fired it up, and threshed with it again on his sixtieth birthday.

Fordson Tractor No. 1

Henry Ford, ever a farmer at heart, spent many years developing a tractor that would alleviate the "excessively hard labour of ploughing," but other manufacturers managed to beat him to the punch. Soon after the first successful gasoline tractor was built in the 1890s, companies in the United States, Germany, and Britain were making tractors, and by 1907 about six hundred were in use worldwide. Henry Ford, however, was the first manufacturer to mass-produce lightweight, inexpensive tractors, thereby ensuring that they would become standard equipment on small farms. In 1915, when stockholders of the Ford Motor Company objected to Henry's using company funds to expand into tractor production (since it would deny them special dividends), he formed his own company—Henry Ford and Son—for this purpose; his tractor thus became known as the Fordson.

Heralded as the Model T of farm power, the Fordson was designed to meet the needs of the small farmer. It had a light, compact body, a simple engine, a low price ($495 in 1928), and could pull two plows. As the first Fordsons began rolling off the assembly line in 1917, they were shipped to Britain, where World War I had created a severe food shortage. At the end of the war, the Fordson fast became popular among American farmers and by the early 1920s had captured 75 percent of the market. By 1928 Henry Ford and Son had sold more than 700,000 tractors worldwide, but declining sales resulted in the shutdown of U.S. production. Thereafter, Fordsons were manufactured in Cork, Ireland, and, throughout World War II, in England. The Fordson remained in production far longer than the Model T.

The Fordson tractor shown here was the first one off the assembly line in 1917. Henry Ford sent it to his friend Luther Burbank in Santa Rosa, California, but in 1920 shipped him another in exchange for this historic one. Fordson No. 2 went to Thomas Edison, and No. 3 was sent to another of Henry's friends, Arthur Brisbane, editorial chief of the Hearst organization.

Acc. 00.136.291. Neg. 833.20231.

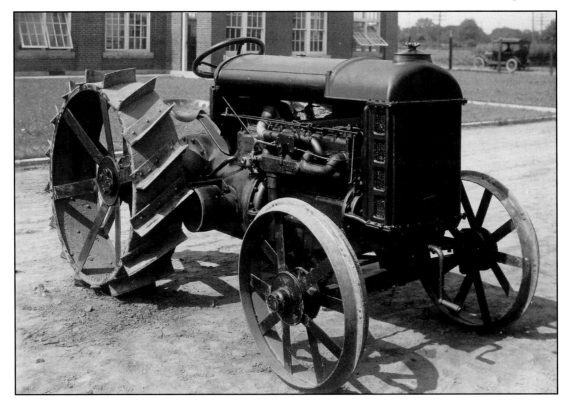

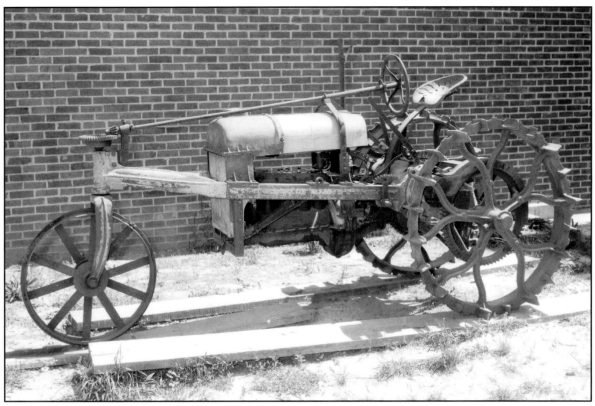

Model T–Kit Tractor

For small farmers, a disadvantage of the four-wheel tractor was that it could not maneuver between rows of plants; the lightweight motorized cultivator, on the other hand, could not perform the jobs of the heavier tractor. In 1922, recognizing the need for an all-purpose tractor, Samuel W. Raymond, an authorized Ford and Fordson dealer in Adrian, Michigan, who was married to Clara Ford's sister, produced the light, three-wheel tractor shown here. Harold Raymond of Adrian donated it to the Henry Ford Museum in 1973.

Inexpensive, the Raymond tractor came as a kit; the farmer bought the frame and wheels from Raymond and then put in his own Model T engine, transmission, and differential (the Raymond tractor in the photograph is missing its crank, spark coil, and gas tank). Although Raymond claimed that his kit tractors would eliminate whatever horses the Fordson had not already eliminated from American farms, he produced fewer than 150 of them between 1922 and 1925, when he retired from the tractor business.

Many of the Raymond tractor's features anticipated those of the McCormick-Deering Farmall, the first commercially successful cultivating tractor. The Raymond had an adjustable hitch, a mechanism for raising and lowering its rear wheels singly or together, and independent clutches in the rear wheels that made it more maneuverable.

Massey-Harris Combine

Combines—harvesting machines that cut, thresh, and clean grain—were in limited use on American farms as early as 1840. During the nineteenth century, they were first powered and propelled by horses and later by steam engines; in the early twentieth century, tractors and gasoline engines took over these functions. The appearance in 1938 of the Massey-Harris Model 20, a self-propelled combine, was the crowning achievement of what has been referred to as North America's first agricultural revolution. Manufactured by the Massey-Harris Company of Toronto, the self-propelled combine required only one operator and was cheaper to run and more maneuverable than the tractor-towed combine. Moreover, because it had no tractor ahead of it packing down the uncut grain, it reaped a larger harvest.

The Massey-Harris Company manufactured the Model 20 from 1938 to 1940, during which time some nine hundred of these models were produced. A massive machine twenty-four feet long and seventeen feet wide, the Model 20 had a sixteen-foot cut and a thirty-seven-inch threshing cylinder; it was powered by a six-cylinder Chrysler industrial engine. After World War II ended in 1945, Massey-Harris's production of self-propelled combines increased, as these machines quickly gained in popularity and virtually eliminated the tractor-towed combine. In 1953 Massey-Harris merged with Harry Ferguson to form the Massey-Ferguson Company of Des Moines, Iowa.

The Massey-Harris Model 20 shown here was presented to the Henry Ford Museum in 1975 by Henry L. Oldham of Blackwell, Oklahoma. Its subsequent restoration was a gift of the Massey-Ferguson Company.

Acc. 75.131. Neg. B.76995.

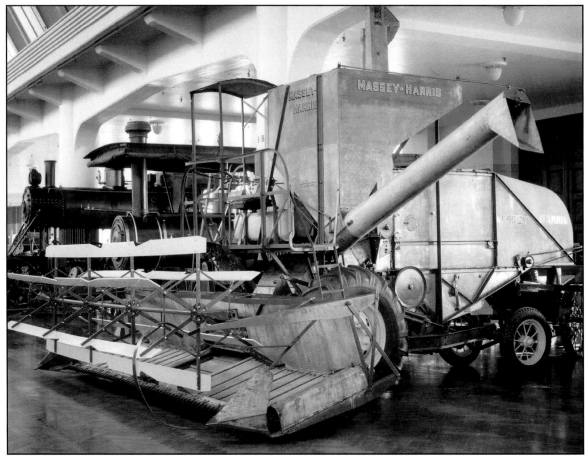

Acc. 75.133.1. Neg. B.112089.

Rust Cotton Picker

Cotton was the last major agricultural industry in America to be mechanized. Throughout the nineteenth century and well into the twentieth, farm workers in the South used mules and hoes to plow and cultivate cotton fields and expended back-breaking labor on harvesting them. By about 1940, tractors had begun replacing the mules on southern farms, and it was not long before mechanical cotton pickers, which could harvest as much in a day as seventy-five to a hundred people, completed the process of revolutionizing the cotton industry. Between 1940 and 1960, as agricultural mechanization reached its peak in the South, millions of farm hands migrated to northern cities—some because they had lost their livelihoods to mechanization, others lured by well-paid jobs and the promise of greater civil rights.

The machine shown here, built by the Ben Pearson Manufacturing Company of Pine Bluff, Arkansas, in 1950, was among the first commercially successful self-propelled cotton pickers. Its inventor was John Daniel Rust, who was born in 1892 on a poor cotton farm in Texas. Rust was an inventor with a social conscience. While dreaming of a mechanical device that would end the arduous labor of cotton picking, he was also concerned that such a machine would throw thousands of people out of work. By 1927 he had developed a picker that used a smooth, moistened spindle to pull the cotton from the ripe boll, and over the next two decades, as he struggled to perfect the machine—obtaining a series of over forty patents in the process—he also thought about how to cushion the unemployment the machine would cause.

In 1944, after the Allis-Chalmers Manufacturing Company agreed to produce his cotton pickers on license, Rust set up the World Foundation, a philanthropic organization for aiding displaced workers to which he donated the profits from his patents. In 1951, after the Ben Pearson Manufacturing Company began producing his machines—and he at last began realizing some sizable profits—Rust set up the John Rust Foundation to succeed the World Foundation. Unfortunately, Rust's fears about displaced workers were well founded. By 1965 mechanical cotton pickers had put 250,000 seasonal laborers out of work. In Texas alone, the seasonal workforce declined from 182,000 in 1961 to 53,000 in 1964.

Allan R. Jones of Porterville, California, bought the Rust cotton picker shown here in 1950 and used it for twenty-five years. After retiring it, he restored it and gave it the name of "Grandma." In 1995 Jones presented "Grandma" to the Henry Ford Museum.

Cat Ten Tractor

In 1906 the Holt Manufacturing Company of Stockton, California, produced a gasoline "crawler," a track-type vehicle designed to provide traction in soil conditions where wheeled machines would bog down. Holt's crawlers performed so successfully for the Allies during World War I that they are said to have inspired the military to develop tanks. In 1925 Holt merged with the C.L. Best Company of San Leandro, California, to become the well-known Caterpillar Tractor Company of Peoria, Illinois.

Although the Henry Ford Museum does not have an original Holt crawler, it does have a "Cat Ten," which, with a width of 52 inches and a length of 100 inches, is the smallest machine the Caterpillar Tractor Company ever built. Cat Tens were manufac-

tured in San Leandro between 1928 and 1932. With a four-cylinder engine of only ten horsepower and its small size, the Cat Ten was especially suited to use in orchards and on garden farms. Its price tag of $1,100, however, meant that it could not compete with the small wheel-type tractors then on the market; like the Cat Ten, these machines ran on gasoline, but their purchase price was much lower. Caterpillar met the challenge in 1931 by introducing a diesel-powered model that was less expensive to fuel than the tractors that ran on gas.

The Cat Ten tractor in the photograph was donated to the Henry Ford Museum in 1978 by the Michigan Tractor & Machinery Company of Novi, Michigan.

CHAPTER 3
Horse-Drawn Vehicles and Cycles

HENRY FORD was no horse lover. Part of his aversion to these animals no doubt stemmed from an incident that occurred when he was nine years old. He had been riding a high-spirited colt named Jennie when a cow suddenly loomed up out of a ditch. Jennie bucked and threw Henry, but his foot caught in the stirrup, and he had a most uncomfortable ride all the rest of the way home. Not only did he forever after consider horses "not worth their keep"; he was also not the least remorseful about their possible extinction. In 1909, when a man who had just motored into New York City from the countryside—terrifying horses, cows, chickens, and himself along the way—suggested to Henry that his motor cars were creating a social problem, Henry replied:

> No, my friend, you're mistaken. I'm not creating a social problem at all. I am going to democratize the automobile. . . . When I'm through, everybody will be able to afford one. . . . Horse[s] will have disappeared from the highways [and] be driven from the land. Their troubles will soon be over.

Henry was, of course, almost right. The horse population of America diminished so fast in the wake of automobiles and gasoline tractors that it caused a minor agricultural revolution, as thousands of acres previously devoted to hay were switched to other crops. In 1872, when Jennie dragged Henry home by the foot, there were eight million horses in the land. Fifty years later, after the U.S. Census Bureau had recorded enormous declines in the horse population, Henry jubilantly noted in one of his "jotbooks"—the logs in which he wrote down his random thoughts—that "the Horse is DONE."

Nevertheless, in another of the paradoxes for which Henry Ford was famous, he had by 1924 amassed an impressive collection of horse-drawn vehicles. On July 4 of that year, he and his wife organized a parade in Dearborn entitled "Pageant: Carriages of Two Centuries." Henry and Clara rode dressed in costumes of the 1860s in a horse-drawn carriage surrounded by a fleet of horse-drawn chaises, gigs, coaches, buckboards, buggies, and wagons. In addition, Henry saw to it that Greenfield Village offered both horse-drawn carriage rides and a riding school.

Henry Ford's disdain of horses seems to have put him at a disadvantage in his early courting days. When he set off for country dances at about the age of twenty, he went by foot no matter what the distance. He is said to have then wanted to marry a farm girl by the name of Christine Gleason, but she turned him down to marry a young blacksmith who owned a fine span of chestnut horses and an elegant carriage.

Cycles, being mechanical devices, seem to have occupied a somewhat higher place than the horse in Henry's esteem. Just when the first cycle came into existence is uncertain, but these machines went through many configurations before they gripped the imagination of Americans—including Henry Ford's—in the 1890s. The earliest cycles required the "riders" to push them along with their feet. The French photography pioneer Nicéphore Niépce built such a device in the early 1800s, and at around the same time in Germany, Baron Karl von Drais de Saverbrun came up with a slightly better version. Other inventors copied and improved on the draisine, as it was called, but it was not until the 1830s that a Scotsman named Kirkpatrick McMillan built a cycle operated by a treadle attached to its rear axle. It was the first cycling machine riders could propel without touching their feet to the ground.

The next significant advance in cycles

occurred in a Paris workshop between 1855 and 1863, when Pierre and Ernest Michaux and their employee Pierre Lallement developed a machine with a rotary crank and pedals attached to the front wheel. Whether the Michaux brothers or Lallement conceived the idea of the pedal-operated rotary crank is disputed, but the type of cycle they built became known as the velocipede. The Michaux brothers seem to have received most of the credit for the pedal-driven velocipede, and Lallement soon immigrated to America. Settling in Connecticut, he proceeded to build the first American velocipede—also quite aptly known as the "boneshaker"—and in 1866 he patented his design of the rotary crank.

Velocipedes enjoyed a brief vogue in America, but they were heavy—often weighing eighty to one hundred pounds—and also structurally unreliable, and by 1869 the craze had begun to subside. At the same time, a new type of cycle was being introduced in England and France. Known as the "ordinary," it weighed thirty to sixty pounds and had a high front wheel, over which the rider perched, and a low rear wheel. When the ordinary was displayed at the Centennial Exposition in Philadelphia in 1876, it enchanted American viewers, and within a year or so, a number of U.S. manufacturers were in the business of making "ordinary" bicycles.

One major problem with the ordinary was that if the rider took his eyes off the road for a second and the front wheel happened to encounter even a small rock, the rider went sailing over the handlebars, and it was a long way to the ground. Since neither the city streets nor country roads of the time provided suitably smooth surfaces, cycling accidents were numerous and serious. About the most any cyclist—or equestrian, for that matter—could hope for even in good, dry weather was that the local municipality had sent out the water sprinkler to dampen down the dust. During rainy seasons, mud and ruts made the roads impassable.

It was not until after the introduction of the so-called safety bicycle about 1887 that the American mania for bicycling became widespread. The safety's wheels were low and of equal size, and the machine was propelled by an endless chain running between the pedal-driven sprocket and the rear axle. By bringing the rider closer to the ground, the safety bicycle reduced the potential damage resulting from a "header," but it did nothing to alleviate the jolting that accounted for the sobriquet "boneshaker."

The solution to that problem was the pneumatic tire, first patented in England in 1845 by Robert W. Thomson. In 1888 John Dunlop, an Irish veterinary surgeon, adapted the pneumatic tire to cycles by fitting rubber hoses to the wheels of his son's tricycle and filling them with air. Although the result was more comfort than cyclists had yet known, even safety bicycles with pneumatic tires were of little use on early ungraded roads full of stones and ruts. Cyclists also had to deal with the extreme displeasure of the nation's many horse owners, whose beasts frequently went mad with fear at the sight of a cyclist careening along the road. Nonetheless, by the 1890s America's first romance with a speed machine was in full bloom.

Henry Ford bought his first bicycle in 1893. In that year, at the age of thirty, he was promoted to chief engineer at the Edison Illuminating Company in Detroit, where he had been working as a technician since moving back to the city two years earlier. He had taken the job to learn all he could about electricity, knowledge that he needed to build the horseless carriage he was working on in his spare time. Because his new position required him to be constantly on call to respond to mechanical failures, he kept his boots by his bed and his bicycle at the ready in front of his house, three blocks away from the plant. The new job also meant that he had no regular hours, so he was able to devote more time to building his machine. Finished in the early hours of June 4, 1896, Henry's first horseless carriage looked more like two two-wheelers lashed together than a proper motor car, for its chassis consisted of a frame and bicycle seat mounted on four bicycle wheels. A length of bicycle chain transferred power from the engine to the rear wheels. Appropriately enough, Henry called his machine the Quadricycle.

Henry's acquaintance with the world of bicycling continued even after the national craze for speed had shifted to racing cars. In 1901 he built a racing machine and, driving it himself, won a well-publicized race by defeating the U.S. racing champion. The following year, he found a partner willing to back him in his racing-car endeavors in the person of Tom Cooper, a world-renowned cycling champion eager to get in on the latest national craze. The first person to race one of Ford and Cooper's machines was another well-known cyclist, Barney Oldfield, who had already earned a reputation as a daredevil. As he accepted the job, Oldfield, who had never even driven

an automobile before, said, "I might as well be dead as dead broke." Never lifting his foot from the accelerator, even on turns, Oldfield set a new American speed record—five miles in five minutes and twenty-eight seconds—in Ford and Cooper's "999." Oldfield's subsequent career as a car racer made his name synonomous with maniacal speed.

Curiously, given Henry's views on the subjects, the Henry Ford Museum has far more horse-drawn vehicles than cycles. The Wohlbruck Collection alone, which the museum purchased in 1936 from Mrs. W.C. Wohlbruck of San Jose, California, included about a hundred and forty horse-drawn conveyances, whereas the museum has in its collections only eighty-six bicycles. The museum's motorcycle collection is even smaller—a total of twenty-six—but that may seem less curious, given that Henry Ford seems to have had no particular interest in them. Motorcycles are excluded from the Old Car Festival held each fall in Greenfield Village, while nearly a hundred "wheelmen" ride bicycles and tricycles of every description.

Model of Napoleon's Coach

In 1933, when he was seventeen years of age, Charles W. Gadd of Spokane, Washington, spent 1,800 hours building this little model of one of the Emperor Napoleon's coaches. He painstakingly made each part from scratch. His tools included a small forge for melting and casting brass parts and a tiny power saw that he made from parts of an old sewing machine. He also made a hand-held, burred chuck like the one his dentist used. The dental burrs enabled him to carve dies for stamping ornamental leaves out of thin sheet metal. He carved the eagles and other wooden decorations by hand out of boxwood. Concealed steps on the coach fold down, the doors open and close, and the body is suspended on four functioning springs and has an undergear that swivels on a fifth wheel and king pin. Gadd even tufted the upholstery with hand-tied French knots.

Gadd entered his model in a national competition sponsored by the Fisher Body Division of the General Motors Corporation in 1933. It won the top award, entitling him to a full four-year scholarship at any university in the United States. After graduating from the Massachusetts Institute of Technology in 1937, Gadd spent the next thirty-nine years as a member of GM's research staff. When he retired, the U.S. Department of Transportation presented him with an award "in recognition of and appreciation for extraordinary contributions in the field of motor vehicle safety engineering." In 1992 Gadd's wife, Frances Y. Gadd, donated the model of Napoleon's coach to the Henry Ford Museum, where it is now exhibited alongside full-sized, high-styled GM cars.

Acc. 92.147.1. Neg. B.109880.

Coachee

Vehicles of the kind shown here were used in America both as public conveyances and family carriages as early as 1773, and they continued in use throughout the early 1800s. Known as "caravans" or "coachees," they were soon nicknamed "Jersey wagons" because so many of them were used as public conveyances in New Jersey on the stage route between Philadelphia and New York.

Coachees were light in weight and suspended on heavy leather straps, or thorough-braces, to absorb the jolts occasioned by the very poor roads of the day; many also had C springs. Their tops were made of canvas, painted to provide water-proofing, and most had side curtains that could be rolled down to shut out rain or snow. Coachees were distinguished from the public stage wagon, a larger but almost identical vehicle of the same era, by having a rear door and a movable rear seat.

The coachee shown here dates from about 1812 and is said to be the second carriage to journey west of the Allegheny Mountains to Meadville, Pennsylvania. Its original owner was Harm Jans Huidekoper, who settled in Meadville in 1805 as agent for the Holland Land Company and who himself became a large landowner. The vehicle is green with yellow striping and has leather upholstery and a faded red canvas top; its side curtains are also made of red canvas. A wrought iron mounting pedal in the rear leads to a wooden platform. The rear door has a silver-plated handle with two scallop shells as decoration. The front wheels are forty inches in diameter; the rear ones, fifty-four.

When the Henry Ford Museum inquired about buying the coachee in 1930, Earle C. Huidekoper, a descendant of the original owner, replied that it was not for sale but that Mr. Ford was welcome to it if it "fit in with his collection." Huidekoper expressed the hope that the coachee "be preserved, not later discarded as undesirable."

Albany Cutter

Cutter is an American term coined about 1800 denoting a light sleigh with one seat that could accommodate two or three passengers; it was usually drawn by one horse. The sleigh shown here is an example of the so-called Albany cutter. A highly decorated sleigh that appealed to well-to-do families, the Albany cutter was the creation of James Goold of Albany, New York, who in 1831 designed and built the coaches for the first steam-propelled train in New York state.

The body of this particular Albany cutter, which was built about 1865, is painted red and adorned with gilt scrolls, yellow floral patterns and

As cutters and other sleighs came into more common use during the nineteenth century, road commissioners in northern communities were charged with the important task of "snow-rolling" municipal streets. When the snow was packed down with heavy rollers, horses did not tire as quickly as when they had to break their own path through the snow. If the hard-packed surface became slippery, the horses' shoes had to be equipped with sharp calks to help them keep their footing. One disadvantage of the calks was that the horseshoes tended to clog with snow and ice, and drivers had to stop occasionally to clean them with small "snowball hammers."

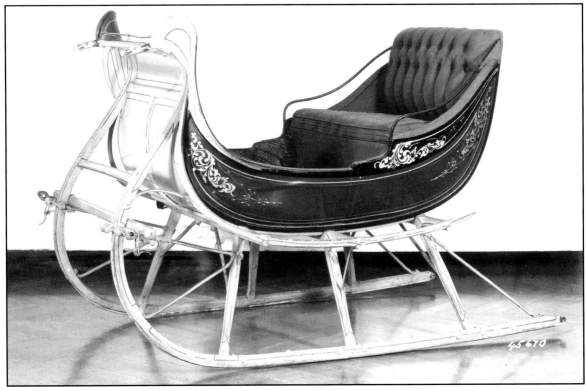

Acc. 31.873.1. Neg. A.2779.

striping, and black trim. A further note of elegance is provided by two carved wooden birds' heads that project from the dash. Along more utilitarian lines, the height of the dash kept the passengers dry, as the horse trotted along kicking up snow. The cutter has iron runners painted yellow and braced with metal rods.

In 1931 David M. Anderson of Watertown, New York, read about a collection of carriages that had been shipped from the Sudbury Inn in Massachusetts to Henry Ford for use in his Dearborn museum. Thinking that Ford might be interested in the Albany cutter, which he had bought forty years earlier, Anderson offered it to the museum.

Pleasure Wagon

Pleasure wagons, which developed in rural New England in the early 1800s, were meant for everyday use in the country. They could carry passengers as well as small quantities of goods. When more space for goods was needed, the entire seat, mounted on supports attached to the frame, could be easily removed, and the hinged back of the pleasure wagon could be lowered to facilitate loading. The design apparently evolved in part from the design of the light farm wagon, and, in turn, it influenced the design of later vehicles, such as the spring wagon, which also had a removable seat. The pleasure wagon's lines were echoed in those of the Concord wagon, which was a stepping stone toward the development of the buggy.

Some pleasure wagons had tops, but most were open, like the one shown here. Most were also colorfully painted and decorated, although their finish was generally duller than the finish applied to carriages. The two bottom panels on this particular pleasure wagon, which was made about 1820, have oblong designs in blue, green, and yellow on a black background; the top panel features red and yellow fruit, as do the back and sides of the seat. This versatile little vehicle is five feet high, less than six feet wide, and, including the shafts, just over thirteen feet long.

Josephine F. Prescott of Portsmouth, New Hampshire, gave the pleasure wagon to Henry Ford in 1928. It had belonged to her great-uncle, Jonathan Fitts, who was born in South Hampton, New Hampshire, in 1804 and who died in 1890. Miss Prescott had made the gift expecting that the pleasure wagon would stay in New England at the Wayside Inn, which Henry Ford had been restoring, and was disappointed to learn that it was to be shipped to Dearborn. When first offering her gift to Henry Ford, Miss Prescott wrote, "With 'several scores' of vehicles already in your collection, I hardly think the wagon is unique enough to warrant its being acceptable." It is now prominently displayed at the Henry Ford Museum alongside more imposing vehicles.

Acc. 28.415.1. Neg. A.2089.

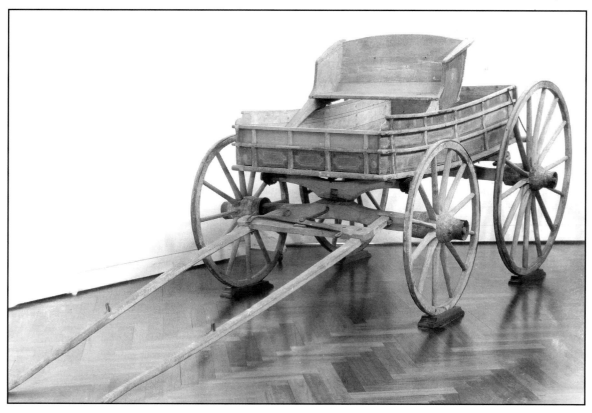

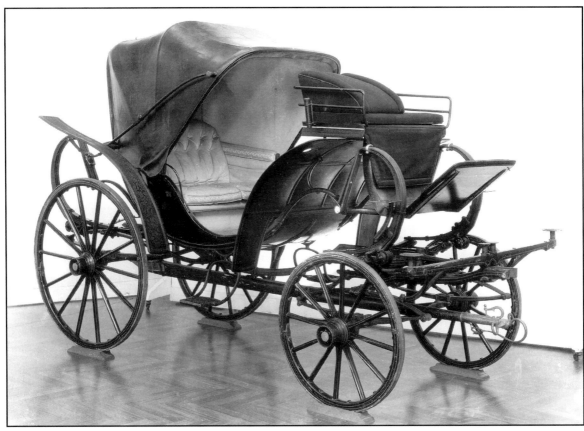

Acc. 30.1165.1. Neg. A.2083.

Victoria Carriage

The Victoria carriage originated during the 1820s in England, where it was called the "George IV phaeton." By the 1840s, the French had adopted it and renamed it in honor of England's new queen. The Victoria soon became popular on both sides of the Atlantic as a luxurious park carriage. It was well-suited to this function, since its open sides allowed the ladies of the day to display their finery to full advantage during afternoon drives in the park.

The Victoria shown here was built about 1875 by J.W. Brewster & Company of New York City, one of the world's most prestigious carriagemakers. In 1862, competing against manufacturers from all over Europe and America, Brewster had displayed its Victoria at the London Exhibition, where it won first prize. Brewster & Company not only survived into the automotive age but prospered as well. By the 1930s, its custom automobile bodies ranked with the best, and many were being sold to the Ford Motor Company to fit the Lincoln chassis.

The elegant Victoria in the photograph is over eleven feet long. It has a dark green body with olive striping and a black leather top. The owner's monogram appears on both sides of the carriage. Leather fenders and a one-piece dash protect the passenger seat, which is upholstered in buff-colored cloth, tufted and ornately edged. The body is suspended on thoroughbraces attached to four C springs, which rest on four fully elliptical springs. An interesting spiked device at the rear was probably intended to keep small boys from hitching rides.

Byram L. Winters of Smithboro, New York, donated the Victoria to the Henry Ford Museum in 1930, together with two other Brewster carriages. He had evidently used all these vehicles at one time or another for driving around Central Park in New York City. His hope in giving them to the museum was that "such a beautiful and perfect exhibit may be preserved."

Rockaway, Carryall, and Cutter

This picture was taken in front of the home of Sophia Banker White on Staten Island, New York, around 1927, just before Mrs. White donated all three vehicles in the photograph to Henry Ford. In 1930, after selling the house in which five generations of her family had lived, as well as the twenty-five acres of land surrounding it, Mrs. White also donated a number of antique household furnishings to Henry Ford's new museum.

Dating from about 1875, the two carriages, drawn by matched teams of horses, had supplied transportation for several generations of Mrs. White's family. She is pictured here at the far left in a carriage

rockaways were being manufactured at the rate of 3,166 in 1900; in the same year, only 846 of the more stately broughams were built. A light, low vehicle, the rockaway was distinguished by the projection of its fixed top over the driver's seat.

Sitting in the driver's seat of the middle vehicle in the photograph is the White family's coachman of forty-four years. That carriage, too, is a rockaway, but of a more informal type known as a carryall. At the far right is the family cutter. Its great curving dash indicates it was built very late in the nineteenth century. Roomy enough to allow passengers to stretch their legs and wrap themselves

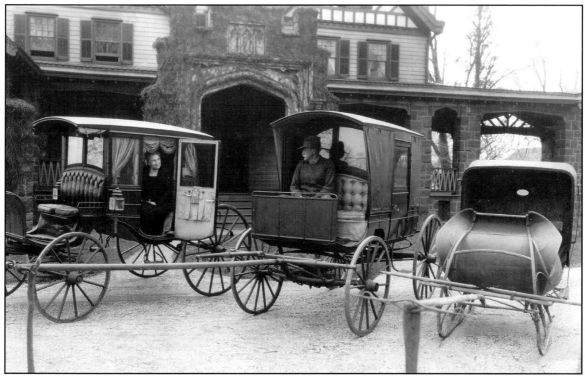

Acc. 27.34.

known as a rockaway. Of American origin, the rockaway was a popular middle-class vehicle and was also often found in the stables of more affluent families. First produced in 1830 on Long Island, New York,

comfortably in fur robes, it is similar to a type of sleigh known as a Portland cutter. With a foldable leather top, the sleigh is also reminiscent of the "Doctor's cutter" of the late 1800s.

Miniature Brougham

This odd little vehicle, scarcely eight feet long and less than five feet high, was made in England about 1875 and, despite its size, is an excellent example of the carriagemaker's craft. It has a bow front window with red curtains, movable windows in each door, a small rear window, and a suspension system with four fully elliptical springs. Its owners were General Tom Thumb (born Charles Sherwood Stratton in Bridgeport, Connecticut, in 1838) and his wife Lavinia, midgets who became world-famous in the nineteenth century as stars of the Barnum & Bailey Circus. Queen Victoria allegedly presented the vehicle to the diminutive couple while they were in Aberdeen, Scotland, on tour with the circus.

Drawn by two small ponies and driven by a midget coachman in a tall silk hat, the little brougham transported Tom Thumb and his wife on triumphal tours of European capitals, where they were received by royalty, and in Barnum & Bailey parades all over America. After Tom Thumb died in 1883, the miniature brougham was sold at auction to William G. Smalley of Walpole, New Hampsire, who in 1922 gave it to the University of New Hampshire. In 1935 the university donated it to the Henry Ford Museum.

Acc. 35.687.1. Neg. B.34511.

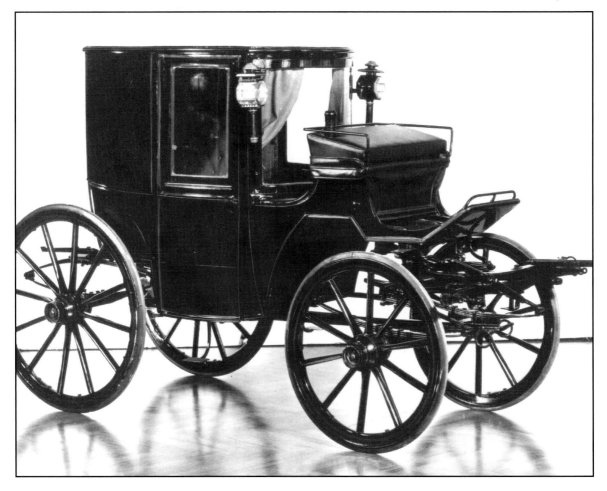

Acc. 00.136.301. Neg. A.2855.

Cotton Cart

Unimpressive looking but serviceable and sturdy, two-wheel drays like the one shown here were used to haul freight around American towns from the mid-1600s into the automotive era. This particular cart, dating from about 1890, came from Mobile, Alabama, where it was used to haul bales of cotton. It appears to have had a long life; license plates from 1927 and 1928 attached to the end of the cart indicate it was still in fairly steady use at that time.

The open platform of the cart is made of unpainted wood and braced with metal. Projecting from the rear are two timbers, topped with metal strips, with an upright iron pole in each. When the horse was in place between the shafts, the rear timbers sloped gently toward the ground and served as a loading ramp. Eight equally spaced holes in each rear timber allowed the drayman to adjust the upright poles to the size of the containers he was to carry. The poles are painted red, as are the forty-two-inch wheels. The cart's tires and axles are made of metal. Its wheel hubs are stamped with the name of their maker: the Studebaker Brothers Manufacturing Company of South Bend, Indiana, a firm that later became well known for its role in the automobile industry. The cotton cart was one of many items donated to the Henry Ford Museum in its early years by Ford dealers and the Ford Motor Company.

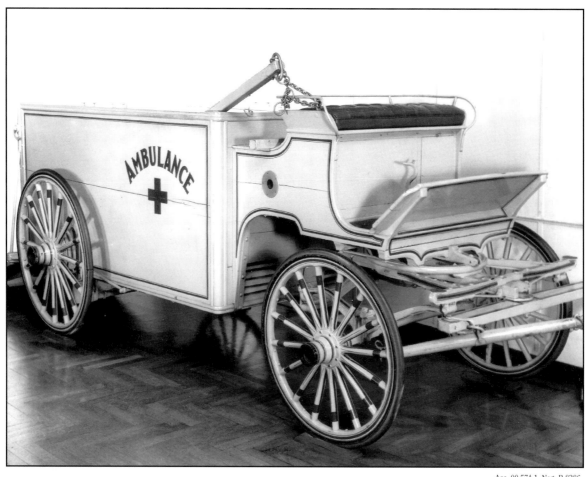

Horse Ambulance

Dr. Elijah E. Patterson, a veterinarian of 591 Grand River Avenue, Detroit, used this unusual vehicle in the early 1900s to carry sick horses to a local animal hospital. The horses thus transported were in all likelihood a cut above "old Dobbin." At some unknown date, Elijah Patterson presented his horse ambulance to Henry Ford.

Built around the turn of the century, the wooden wagon is shown here restored and newly painted. Body, gears, and wheels are yellow with red trim; the inside is white. Behind the driver's seat, which has a brown leather cushion and metal rail, is a cable and wheel for securing the horse. A heavy tailgate drops to form a ramp. The horse ambulance has platform springs and hard rubber tires. It is about fifteen feet long, six feet wide, and five feet high.

"Ben Hur" Bandwagon

In the last half of the nineteenth century and the early part of the twentieth, bandwagons carrying musicians were common sights in small-town parades throughout America. Although such vehicles often had as many seats as the one shown here, most were far less elaborate. This one carried its first band in style at the Pan-American Exposition in Buffalo, New York, in 1901. It was later used as a sight-seeing bus at Niagara Falls. Before being given to the Henry Ford Museum by an anonymous donor in 1929, it served as transport for the Cornet Band of Ypsilanti, Michigan—a town where Henry Ford was well known, since he employed many of its residents.

The "Ben Hur" bandwagon is seventeen feet long and over eight feet high. Its body is painted green and brown and is adorned with gold scrolls and lettering. Colorful oval paintings of bucolic scenes appear on both sides, while the rear sports a picture of Ben Hur driving a chariot. Six of the seven leather-trimmed seats are back to back. Beneath the seats, a storage compartment provided space for the musicians' instruments.

Acc. 29.2046.1. Neg. B.8382.

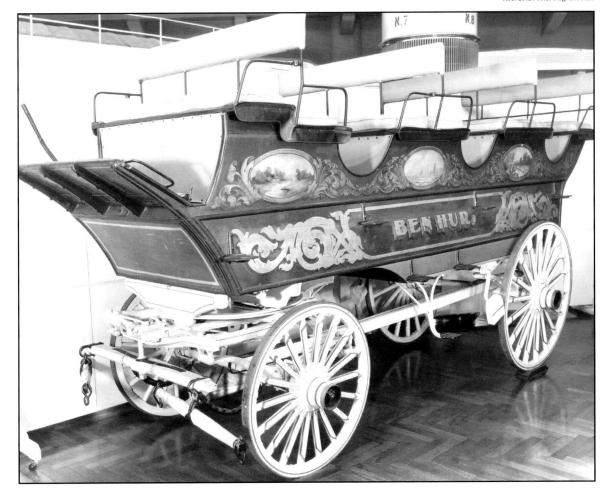

Dearborn Bandwagon

This unadorned bandwagon is far more typical of the old small-town parade than the "Ben Hur" wagon. It is also considerably older, having been used during the early 1860s to carry the Dearborn band on patriotic occasions. One member of the band was Henry Ford's uncle and namesake, who played the fife and who probably owned the wagon. Another was a Ford in-law, Crawford Kennedy. Kennedy played snare drums and when slightly inebriated was said to have been the star performer. Frank Ward, one of Henry Ford's first schoolteachers, played the flute for the band. Byron Otes played the bass drum, and Johnnie Kennedy was the alternate bass drummer.

One interesting feature of the Dearborn bandwagon is its sophisticated suspension system. Four fully elliptical springs support the wagon box, and two other such springs support each of the three seats—all presumably intended to suppress any sour note or misplaced drum beat as the wagon bounced over the rough streets of Dearborn. Henry Ford ignored this fully developed suspension system when he equipped his Model T with nothing but two stiff semielliptical transverse springs.

How Henry Ford came into possession of the Dearborn bandwagon—whether as a gift or a purchase—is unknown. But because the wagon is reputed to have come from the farm of John N. Ford, it was probably a gift, for John Ford would not accept money from his cousin Henry. The wagon was transferred from Henry Ford's farmstead to his museum in 1931, together with the band's fife and bass drum.

Tank Wagon

As petroleum products came into more common use in the late 1800s, tank wagons similar to the one shown here were used to make deliveries in both urban and rural areas. This particular tank wagon was built in 1892 and is one of more than six thousand that the Standard Oil Company used to deliver its products to farms in the Midwest. The first tank wagons carried only kerosene, which was used both for heating and lighting and for running early farm tractors and stationary engines. As gasoline

drive along his route. Delivering not only petroleum products but news as well, the driver was warmly welcomed at farms along the way. A manual counting device at the rear of the wagon allowed him to keep track of the amount of fuel he delivered at each farm.

Fully loaded, tank wagons were heavy and so were equipped not only with brakes but also with a pole fitted between the two horses. The front of the wagon was suspended on a pair of bolster springs, while the rear had truck springs, since most of the

Acc. 65.13.1. Neg. B.41732.

engines came into use on the farm, and particularly after 1910 when the automobile was becoming a more familiar rural sight, the tanks were divided into separate compartments so they could carry not only kerosene but gasoline and motor oil as well. The tank shown here was converted to three compartments sometime during World War I.

In rural areas, tank wagons and the horses used to draw them were sheltered at small stations along a railroad line. There, the Standard Oil driver, who also acted as salesman, filled the 350-gallon tank and, stowing large cans of special lubricants called "Mica Axle Grease" and "Polarine Motor Oil" in a box at the back of the tank, set off on the one- or two-day

weight was carried on the rear axle. The wagons were about eleven feet long and four feet wide. The one shown here is painted green and has gold, red, and white lettering on each side; the undercarriage and wheels are bright red.

The tank wagon had a rather long life. Although motor trucks were in common use by the mid-1920s, horse-drawn tank wagons were still making rural deliveries because they could more easily negotiate the muddy roads of the countryside. The one in the photograph was in use for some thirty years, going out of service about 1922. The Standard Oil Company donated it to the Henry Ford Museum in 1965.

Mail Wagon

After the U.S. Postal Service inaugurated rural free delivery in 1896, vehicles like this became common sights along country roads. Mail carriers purchased these wagons themselves at a cost of between $50 and $125, depending on quality. Light in weight with a top of painted duck, the mail wagon was designed for fluctuations in the weather. Sliding side doors with glass insets could be left open or shut, and a window at the front could be dropped open in warm weather. When it turned cold, the driver could shut the window, and two slots for reins just above it ensured that the vehicle was entirely enclosed. The driver sat on a seat just behind the window, which was surrounded on three sides by numerous pigeonholes. A heavy box for parcels and other mail was secured to the rear of the wagon with chains and bolts.

An unusual feature of the mail wagon shown here is a tiny coal-burning stove with a stack that protrudes through the roof. The wagon belonged to August Edinger of Kimmswick, Missouri, who, when he offered it to the Henry Ford Museum in 1933, wrote, "This wagon was bought in 1902—was on the road . . . until I bought a Ford in the year 1925. The wagon is in good order. If you want it, come and get it."

Acc. 34.150.1. Neg. A.2851.

Dump Wagon

The Industrial Revolution stimulated the construction not only of numerous factories and roads but of private dwellings as well, for as more and more people migrated from rural areas to cities, they created an urban housing shortage. All this construction required that enormous quantities of earth be moved off site, and before mechanical means were invented, the labor involved in loading dirt onto a wagon and unloading it at a dump site had to be done by hand. The steam shovel, which took over the function of loading the wagon, was a significant technological advance. Perhaps equally significant, though less spectacular, were dump wagons with mechanisms that facilitated unloading.

The dump wagon shown here, built about 1900, has the most common type of unloading mechanism: bottom doors secured by chains, which dropped open when the driver pressed a pedal. After dumping his load and as he was heading back for the next one from the steam shovel, the driver pulled back and forth on the upright lever beside his seat, turning a ratchet that slowly tightened the chains beneath the bottom doors. The dump wagon was a common sight on construction projects until about 1930, when the modern dump truck took over its function. This one was given to the Henry Ford Museum in 1929 by an anoymous donor. It is about thirteen feet long and six feet high. Its front wheels are three feet across, and its rear ones, four feet.

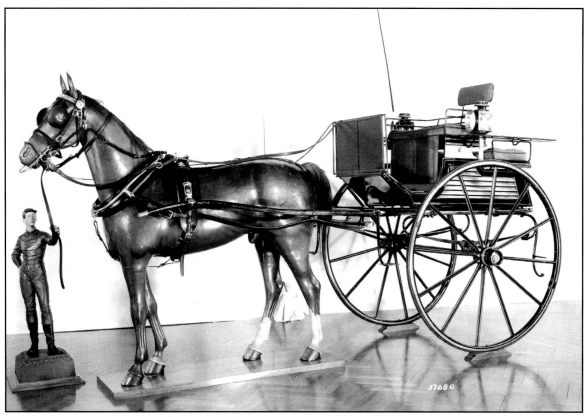

Acc. 29.560.1. Neg. A.2773.

Dog Cart

The two-wheeled dog cart, also known as a trap or a tandem cart, originated in England during the 1700s as a vehicle for carrying hunters and their dogs on shooting expeditions. The dogs rode under the seats in a louvered box that provided ventilation. Dog carts eventually came to be used for a variety of other purposes, including the sport of driving tandem (i.e., one horse in front of the other), for which the dog cart was the preferred vehicle. Dog carts were also built as pleasure vehicles for families, rather than to transport dogs, and on such vehicles, the ventilating louvers were merely decorative.

The dog cart shown here was built about 1890 for James C. Cunningham by the company he inherited from his father: James Cunningham & Son of Rochester, New York, a well-known manufacturer of fine carriages, hearses, and wagons. In 1929 Cunningham's firm, then known as the Cunningham Carriage Company, donated the dog cart to the Henry Ford Museum. Designed to carry small dogs only, it has a black wooden body with mustard louvers and striping, a black leather dash, tan corduroy cushions on both seats, front and rear mounting pedals, and a pair of side lamps. The initial *C* is emblazoned on both sides of the front seat.

Break

The break (sometimes incorrectly referred to as a tallyho or four-in-hand) originated in Europe as a heavy, open vehicle used to break, train, and exercise horses. The term *break* eventually came to denote a variety of vehicles designed to carry large numbers of passengers on sporting excursions and other pleasure trips.

Unlike some other types of breaks, the "roofbreak" shown here has elevated seats that provided passengers with a fine view of sporting events. Eleven feet long and eight-and-a-half feet high, it has a folding ladder that assisted passengers in mounting and dismounting. Its body contains louvered storage lockers for picnic baskets and other paraphernalia. The long lever at the right front served as the brake. The vehicle was built about 1880 by the Van Tassell & Kearney Company of New York City for Trainor Parks, founder and owner of the Bennington & Rutland Railroad.

In 1928 Thomas F. Nash of North Bennington, Vermont, gave the break to Henry Ford—but only after some haggling. Nash first offered to sell it for $1,000, then $300, then $150. Henry said he wouldn't buy from someone who didn't offer the best price first, and at that point Nash apparently threw in the towel—together with the break.

Acc. 28.57. Neg. A.2789.

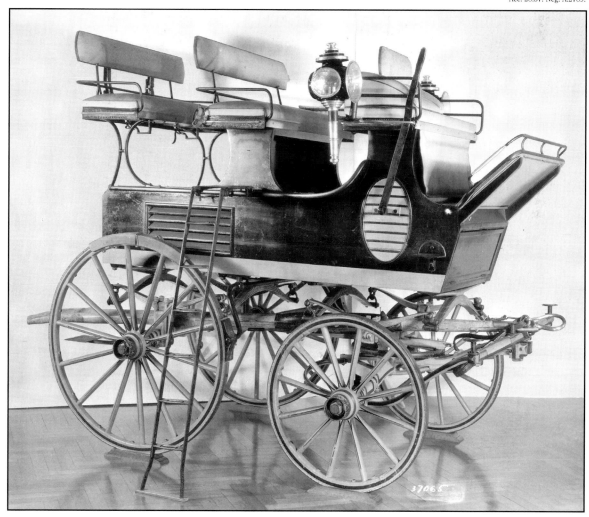

Acc. 00.204.22. Neg. A.2840.

Bike Sulky

According to legend, the famed horse "Nancy Hanks" was hitched to this sulky when she trotted a mile in 2.04 minutes in Terre Haute, Indiana, on September 28, 1893. Lending some credence to the legend is the probability that the sulky was built about 1893; moreover, with its bicycle-like wheels, it does bear a striking resemblance to the "bike" sulky that Nancy Hanks ran with that day.

A plate on the rear of the sulky's caned seat reads: "A. Bedford, Coldwater, Michigan." Alma Bedford, a manufacturer of carriages and bicycles, was one of the first to build a bike sulky. The conventional high-wheeled sulkies were difficult to maneuver in turns, and drivers were delighted with the new vehicles, which allowed them to perch high over small wheels that had ball bearings as well as pneumatic tires.

Although the date of the gift is not recorded, the sulky was donated by Raymond C. Dahlinger. Both Dahlinger and his wife, Evangeline, a well-known Michigan horsewoman, were on Henry Ford's private payroll. The Dahlingers had their own race track in Dearborn, and though Henry Ford himself took no interest in horse racing, he did encourage Evangeline to teach equestrianship at his Greenfield Village schools.

Pickering & Davis Velocipede

In 1868 Pickering & Davis of New York City began manufacturing velocipedes under Pierre Lallement's patent of 1866. The Pickering & Davis model featured precision-made, standardized parts, which were easy to replace, and it was sturdier, lighter, and cheaper than the velocipedes then being produced in Europe. It had a metal crank and foot pedals to drive the three-foot front wheel; wooden wheel hubs, spokes, and rims surrounded by metal tires; a painted metal frame; oiled bearings and axles; and a leather seat on a brass spring. Ivory grips on the handlebars could be rotated to tighten a cable that applied the rear brake.

Other American companies, including a number of carriagemakers, were soon also manufacturing velocipedes, but at fifty pounds, the Pickering & Davis was far lighter than most. The popularity of velocipedes was, however, short-lived. Their frequent involvement in accidents led some cities to ban them, and by 1871 they were remembered only as a sporting fad.

Irving O. Clement of Seal Harbor, Maine, gave this velocipede to the Henry Ford Museum in 1935. His reason for making the gift is unknown, but he may have been a friend of Edsel Ford, Henry's son, who bought a summer home at Seal Harbor soon after his marriage to Eleanor Clay in 1916.

Acc. 35.870.1. Neg. B.33260.

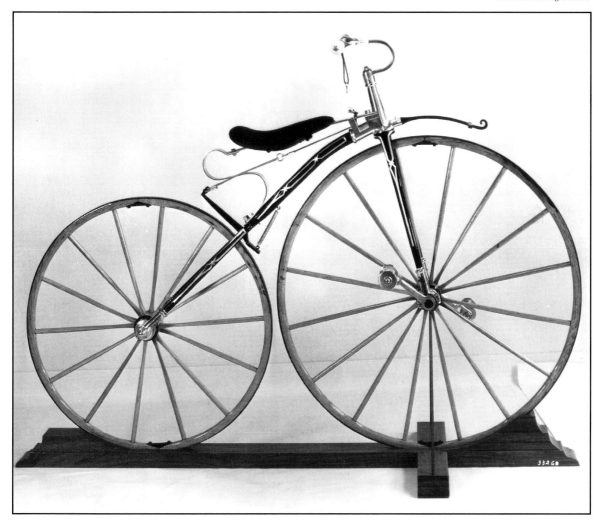

The "Ordinary"

The hand-operated friction brake over the rear wheel and the wooden spool pedals on the bicycle shown here identify it as an early version of the "ordinary"—so called because it was for a number of years the most common bicycle around. Built about 1880, the ordinary has a hand-forged metal frame, wooden wheels, and metal tires. The front wheel has a diameter of forty-six inches; the rear one is eighteen inches across. Dr. Samuel L. Scher of Mamaroneck, New York, donated the ordinary to the Henry Ford Museum in 1968, together with 674 other items, mostly automotive in nature.

Acc. 68.19.64. Neg. B.65443.

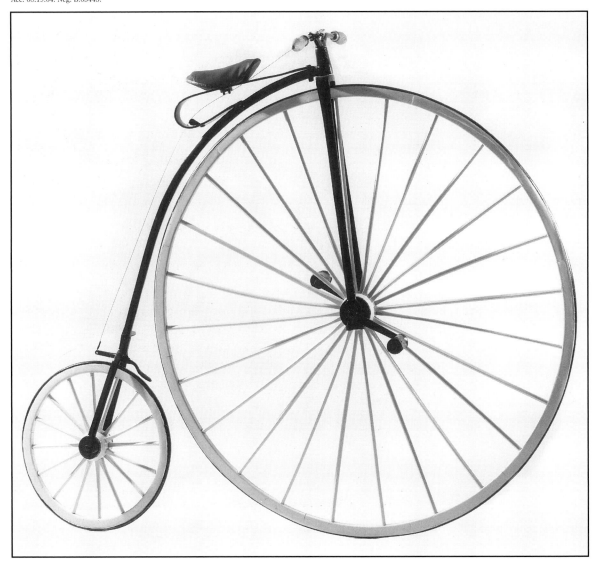

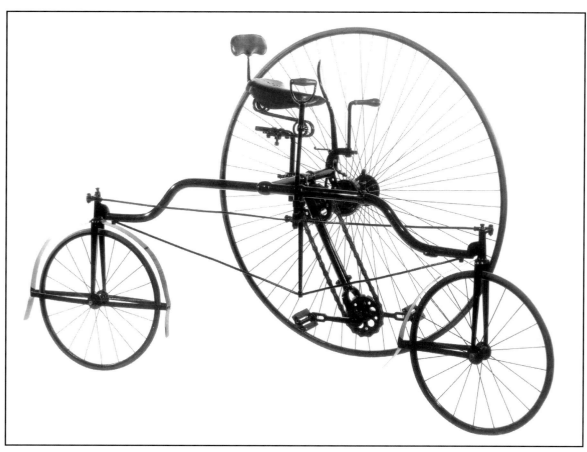



Acc. 65.58.1. Neg. B.47749.

Rudge Rotary Tricycle

Ladies of the 1870s at first had to watch the fascinating new sport of cycling from the sidelines, for the high wheel on the ordinary bicycle meant that they could neither mount nor ride it with decorum. Responding to this need, inventors produced various kinds of adult tricycles that could be easily mounted and operated. One such inventor was an Englishman named James Starley, who initially built a bicycle that could be ridden sidesaddle. With a small rear wheel set off to one side of the large front one, Starley's bicycle proved to be an awkward machine, and he therefore added a second small wheel, creating the unusual type of tricycle shown here. Its forty-seven-inch drive wheel is on one side of the rider, and a pair of twenty-two-inch wheels is mounted fore and aft on the other side in outrigger fashion. The small wheels are steered by a spade-handled tiller with a rack and pinion gear. Pedals and drive chain are placed in the center, beneath the seat,

making it more convenient to mount and ride than the ordinary bicycle.

Starley's tricycle was first manufactured in 1876 by Haynes and Jefferies of Coventry, England. After Haynes and Jefferies emerged as the Rudge Cycle Company in 1885, the vehicle was marketed as the Rudge Rotary Tricycle, and—although it weighed seventy-five pounds and was thirty inches wide—it was touted as "a light. . . . and handy machine that will go through any doorway without taking it apart." Unfortunately for the ladies, Rudge also specified that its tricycle was "fit for gentlemen's use only," presumably because of its weight. Meanwhile, however, James Starley had about 1880 introduced his "Rover," one of the first safety bicycles, whose lower wheels made mounting much more convenient. The tricycle in the photograph was given to the Henry Ford Museum in 1965 by Julius Kasco of Troy, Michigan.

























Royal Mail Tricycle

The Royal Mail Manufacturing Company of Birmingham, England, produced this tricycle about 1890. Like the Rudge Rotary Tricycle, it was designed for convenience in mounting and operating, and its drive chain and pedals are located in the center beneath the saddle seat. The operator used the upright rod to the right of the seat to steer the small front wheel. One of the handles to the left of the seat worked the brake on the chain drive; the other served

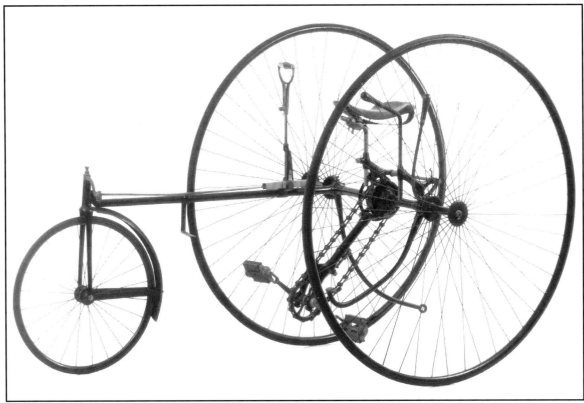

Acc. 34.450.2. Neg. B.74328.

as a handrest. Beneath the handrest is a curved metal lever with a footrest. All three wheels have metal rims and hard rubber tires. The tricycle is seventy-three inches long, thirty-eight inches wide, and forty-six inches high. It was donated to the Henry Ford Museum in 1934 by W.W. Griffiths of New York City, who had enjoyed a visit to the museum the previous year.

Punnett Companion Bicycle

The sociable idea of cycling right next to a companion dates back to 1869, when a side-by-side tricycle was built in England. It was not until 1896, however, that Albert Weaver of Hamilton, Ontario, patented the type of side-by-side bicycle shown here. Known as the Companion, the machine was made by the Punnet Cycle Manufacturing Company of Rochester, New York. Remarkably, one rider could weigh as much as a hundred pounds more than the other, and even though the Companion might list a little, it could still be easily ridden. One person could ride it—if in a rather unorthodox fashion—by placing either of the saddle seats in the center socket and using the inside pedals; since both handlebars steered, the solo rider grasped the inside handles.

Because of the wind resistance created by two side-by-side riders, the Punnett Companion was difficult to pedal. That shortcoming, together with frequent blowouts of the heavily weighted rear tire, contributed to the machine's demise. The Punnett Companion pictured here, however, manufactured about 1896, was in use as late as 1936. Fitted out with a few new parts, it was then owned by a bicycle rental shop in Seal Harbor, Maine, where Edsel Ford had a summer home. Edsel bought it for $100 and donated it to his father's museum.

Acc. 36.139.1. Neg. A.2332.

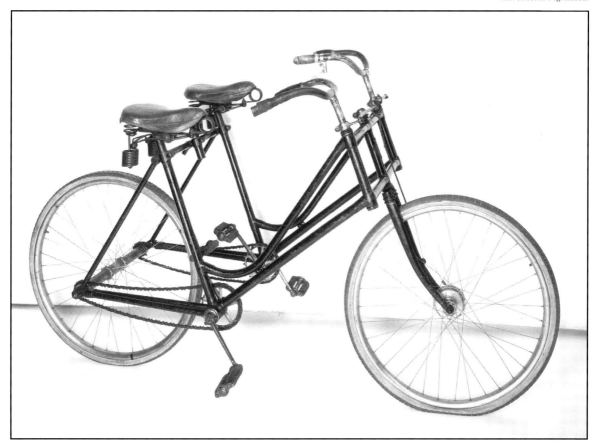

Ten-Person Cycle

Charles Metz, president of the Waltham Manufacturing Company of Waltham, Massachusetts, designed and built this curiosity in 1896, primarily as a way of promoting the superior qualities of his company's single and tandem bicycles. Known as the Oriten, the ten-person machine was exhibited with great fanfare at well-attended bicycle shows and races around the country. Thought to be the largest cycle and the only ten-person model ever built, the Oriten

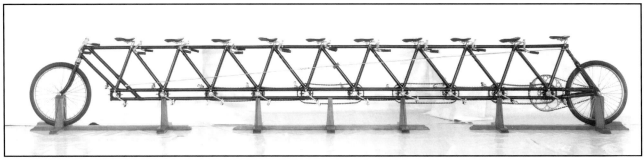

Acc. 34.179.1. Neg. A.2114.

is almost twenty-four feet long, weighs 305 pounds, and has a carrying capacity of 2,500 pounds. The rider at the front had to do all the steering, since all the other handlebars were stationary. The rider in the last position also had an important function, serving as a sort of bos'n and chief engineer for the rest of the crew. Under ordinary conditions, the Oriten had a speed of about forty miles per hour, but it could reach considerably higher speeds during spurts.

In 1925, when Harry K. Noyes of Boston purchased the Waltham Manufacturing Company's old bicycle plant, he found the Oriten hanging from the rafters, dusty and forgotten. Although Henry Ford's agents approached him several times over the years with offers to buy the Oriten, Noyes, the New England distributor of Buick automobiles, refused to sell. Finally, in 1934, he sent the strange vehicle as a gift to the Henry Ford Museum.

Barney Oldfield's Blue Streak

In 1935, apparently in the hope of reestablishing contact with Henry Ford, Barney Oldfield drove his Ford coupe from Los Angeles to Dearborn and personally presented his old racing bicycle to the Henry Ford Museum. He described the bike as follows:

Tribune "Blue Streak" bicycle, manufactured by Black Manufacturing Company of Erie, Pa. Date of year this bicycle was made—1898. Was formerly owned by Tom Cooper. I was riding this bicycle in races at Salt Lake City on the 8 lap Salt Palace track. At the closing of the racing season there in 1902, Mr Ford sent for me and I came to Detroit and drove the Ford 999 to world records and championships.

You know me

Barney Oldfield

Never as modest as he was fearless, Oldfield was fond of saying that he and Henry Ford had launched each other on their respective careers, Ford by building the 999 and Oldfield by driving it. "But," Barney would add, "I did much the best job of it."

Oldfield's Blue Streak is beautifully crafted, perfectly balanced, and weighs only nineteen pounds. It has a steel frame painted light blue, nickel-plated dropped handlebars, a direct chain drive (i.e., no free wheeling and no brakes), and pneumatic tires on one-inch wooden rims.

Acc. 35.738.1. Neg. 188.45159.

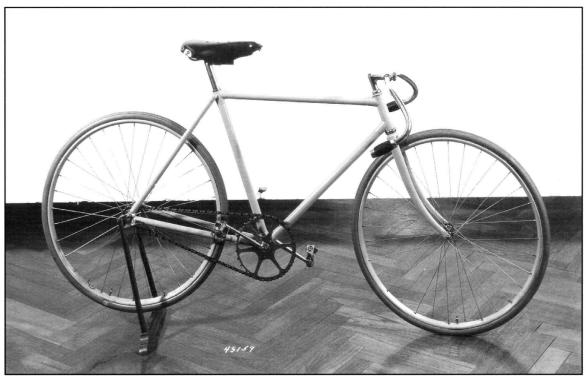

The Wright Brothers' St. Clair

As Orville and Wilbur Wright were developing the world's first successful airplane in their cycle shop in Ohio around the turn of the century, they were simultaneously manufacturing "St. Clair" bicycles. The bicycle proved to be a handy tool in aerodynamic experiments. By rigging a St. Clair out as shown in the photograph—that is, with a horizontal wheel and airfoils—and by riding it rapidly to create the effect of wind, the Wright Brothers were able to study such flight principles as air pressure and flow.

In 1937, after buying the Wright brothers' house and cycle shop and having them moved from Dayton, Ohio, to Greenfield Village, Henry Ford became personally involved in the search for a bicycle made by the Wrights, as did Orville Wright himself. The St. Clair pictured here was soon located in South Hollywood, California. Its owner was Thomas R. Coles, who had gone to school with the Wrights and

who had helped them when they started publishing a small paper in Dayton.

Thomas Coles, it seems, had originally bought a Van Cleeves—another, earlier bicycle model made by the Wrights—for $75 on an installment plan, putting $5 down and paying $1.50 a week. His Van Cleeves was, alas, wrecked about 1901 when a horse trod upon it, whereupon Orville Wright gave him the St. Clair in the photograph. Coles took the St. Clair with him when he moved to California in 1904, and he apparently tended it carefully, replacing parts as needed, for when he gave it to Henry Ford in 1937, the frame and sprockets were the only original parts of the machine. Once it reached Ford's museum, Orville Wright directed its rebuilding. The experimental apparatus was, however, not added to the bicycle until about 1957; the work was done by staff of the Henry Ford Museum who used old photographs and other documents as a guide.

Acc. 37.724.1. Neg. B.53298.

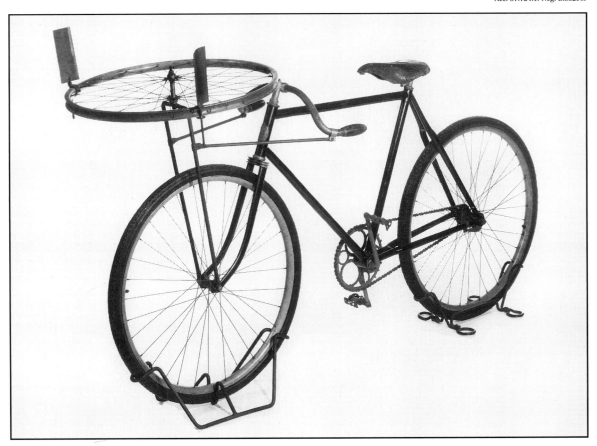

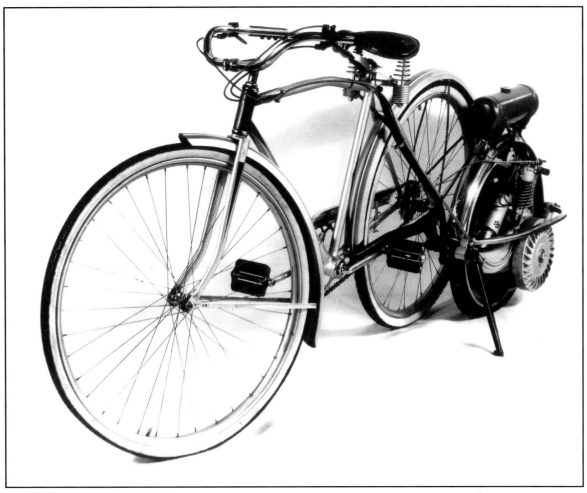

Bicycle with Motor Wheel

The "motor wheel"—shown here attached to a bicycle of unknown make—was invented about 1910 by an Englishman named Wall. It consists of a little one-cylinder, air-cooled gasoline engine fitted into its own small wheel, which is equipped with a rubber tire, a fender, and a fuel tank. The motor wheel could be attached to any standard bicycle or scooter, instantly converting these vehicles to motorcycles or motorscooters.

In 1914 Wall sold the American rights for his motor wheel to the A.O. Smith Company, which marketed it as part of a simple buckboard called the "Smith Flyer." Five years later, the Milwaukee-based firm of Briggs & Stratton, which is today one of the largest U.S. makers of small gasoline motors for lawn mowers and similar equipment, acquired the rights to the motor wheel. While continuing to manufacture the Smith Flyer, Briggs & Stratton also produced thousands of motor wheels for use with bicycles and scooters. With a price tag of $60, however, the Briggs & Stratton motor wheel cost considerably more than a good bike, which could be had for about $25. Not surprisingly, Briggs & Stratton stopped manufacturing motor wheels about 1924.

Raymond C. Dahlinger, manager of Henry Ford's farms and estates and of construction at Greenfield Village, donated the bicycle and the Briggs & Stratton motor wheel shown in the photograph to the Henry Ford Museum in its very early days.

Ingo Bike

After about 1900, commercial bicycle design became more or less standardized. Among the few manufacturers willing to hazard anything out of the ordinary was the Ingersoll Steel and Disc Company of Chicago, which in the early 1930s produced the "Ingo Bike" shown here. Hailed quite correctly by its manufacturer as an entirely new mode of transportation, the Ingo, alas, did not sell well.

Although it looks like a cross between a scooter and a bicycle, the Ingo was really neither. It involved no pedaling, and the only time a rider set foot to the ground was in the motion of pushing off. Standing on the flexible wooden platform, one or two riders—the maximum the Ingo could hold—pushed off with their feet, bent their knees slightly, and pulled back on the handlebar in rhythm with the rotation of the rear wheel, which was mounted off-center to create an eccentric motion. Advertisements of the Ingo suggested that prospective buyers

imagine themselves "carried along by perpetual motion with just the gentle body lift you experience in horseback riding. The rhythmic motion brings you into harmony with the world."

To demonstrate that the Ingo actually worked, its inventor is said to have ridden one from Chicago to Miami, at ten to twenty miles per hour, in twelve days—quite a feat on a machine that originally sold for $24.75.

The Ingo Bike shown here was donated to the Henry Ford Museum in 1962 by Linda Harrington of Crete, Illinois, whose father had bought it when he was a boy, some thirty years earlier. Coming across it while cleaning out her family's garage, and remembering the fun she had had with it, Ms. Harrington was loath to throw it away, and so the Ingo Bike came to be another artifact in "Henry's attic."

Avatar 2000

Like the Ingo Bike, the recumbent bicycle shown here was an innovative machine that won the hearts of its owners even though it met with limited commercial success. In 1981 John Riley, then of Iowa City, Iowa, bought the "Avatar 2000" from FOMAC, Inc., of Wilmington, Massachusetts, for $1,915 including shipping costs. By 1989 FOMAC was out of business.

Obviously a serious cyclist, Riley found the recumbent bicycle far more comfortable for long-distance rides than conventional models, reducing backstrain as well as fatigue. He rode his Avatar 2000 from 1982 until 1987 in a number of long-distance jaunts, including five seven-day trips across Iowa—a distance of 450 miles—and a 1,000-mile, three-week trip in Europe.

By 1987 other manufacturers had copied the basic design of the Avatar 2000, simplified its seat and steering assemblies, which Riley had found unecessarily complicated, and were undercutting FOMAC's price. Although Riley retired his Avatar in favor of another recumbent, he found certain features of the Avatar—relationship of seat to pedals and the seat back angle—difficult to improve on. Completely handcrafted, the Avatar has twenty-one speeds, a wheel base of sixty-three inches, and a weight of twenty-nine pounds. The distance between the seat and pedals can be adjusted to the length of the rider's legs by means of a sliding seat undercarriage mounted on two stainless steel tubes.

In 1989, recognizing that recumbent bicycles might never be widely popular but believing they deserved recognition, Riley offered his Avatar 2000 to the Henry Ford Museum in the hope that it would be displayed rather than stored.

Acc. 89.418.1. Neg.B.110758.

Acc. 61.20.1. Neg. B.54373.

Autoped Motorscooter

The Autoped was the first motorscooter made in the United States. Introduced about 1915 by a New York firm—the Autoped Company of America—it evoked considerable interest. A writer for the *Automobile Trade Journal* described it as a "unique vehicle" somewhat akin to a "huge roller skate."

Lacking a seat, the driver stood gripping the handlebar, which contains the throttle control. To apply the clutch and brake, the driver moved the lever of the handlebar back and forth. The tiny two-horsepower, single-cylinder engine mounted on the front wheel could propel driver and scooter along at a top speed of thirty-five miles per hour. Also mounted on the front wheel are a gasoline tank and a vertical muffler. The rear fender has a taillight, which was activated by a flywheel generator, and a bracket for a license plate. The scooter is a little more than four feet long and, when the handlebar is folded flat, less than two feet high. J.L. Chase of Grosse Pointe, Michigan, gave the Autoped to the Henry Ford Museum in 1961.

Charles Lindbergh's Excelsior Motorcycle

Charles A. Lindbergh, the "Lone Eagle" whose solo, nonstop flight across the Atlantic in May 1927 earned him national adulation, was one of Henry Ford's close associates. They first met when Lindbergh landed his *Spirit of St. Louis* at Ford Airport on August 11,1927. The young aviator offered to take Ford up for a spin in the famous craft and was astounded when he accepted, since Ford had previously always refused to fly, even in his own company's trimotored planes. Years later, after Hitler invaded Poland and war broke out in Europe in 1939, both men became the center of controversy because of their opposition to U.S. aid and arms sales to beleaguered Britain and France. In 1941 they met again when Lindbergh went to Dearborn to solicit Ford's financial support of the "America First Committee," a powerful isolationist group dedicated to keeping the United States out of World War II. A year later, after

Acc. 43.150.1. Neg. B.30516.

the Japanese had bombed Pearl Harbor and the United States had entered the war, Lindbergh signed on as an unpaid aviation adviser and test pilot at Ford's massive new Willow Run plant, which was churning out B-24 bombers for the war effort.

In 1919, a year after graduating from high school in Little Falls, Minnesota, Lindbergh bought the Excelsior motorcycle pictured here from a local hardware store, and from then until 1925, it was a very large part of his life. After tearing around Little Falls on it for a year, Lindbergh drove it to the University of Wisconsin at Madison, where he enrolled as an engineering student. While there, he apparently put the Excelsior through some hair-raising paces and, in the summer of 1921, drove it from Wisconsin south to Kentucky and Florida and back north to Minnesota. Finding himself ill-suited to college life—he evidently liked neither classes nor parties—Lindbergh in March 1922 started off on his Excelsior for Lincoln, Nebraska, where he fulfilled his lifelong ambition of learning how to fly. Bogging down in mud along the way and making about four miles in as many hours, he wound up shipping the motorcycle by rail to Lincoln. Later that year, he drove it to St. Louis, where he soon embarked on a barnstorming career. According to Charles A. Richard, another pilot who often flew with Lindbergh out of St. Louis, Lindbergh sometimes strapped the Excelsior to the outside of his plane and took it along with him on barnstorming trips.

Lindbergh apparently stopped using the Excelsior about 1925 and stored it in a friend's basement. Charles Richard acquired it in 1929, restored it, and in 1931 offered it to Lindbergh, who paid Richard $100 for it—$190 less than the original price. In 1943 Lindbergh, who was keenly interested in Henry Ford's collection of antique vehicles, donated the Excelsior to the Henry Ford Museum. The machine, which was built in 1919 by the Excelsior Motor Manufacturing & Supply Company of Chicago, was one of three gifts that Lindbergh made to the museum; he also donated his Franklin automobile and his "Stagecoach Darien," a house trailer.

Honda RC 161 Grand Prix Racing Motorcycle

The Honda RC 161 was a pioneer in the world of motorcycles. Built by the Honda Motor Company of Tokyo in 1961, it not only made history by dominating International Grand Prix competition, emerging victorious in nearly every race it entered; it also set the standard for motorcycle design for years to come. Radically different from all earlier motorcycles, the RC 161 had a 250 cc, four-cylinder, double overhead cam engine with four valves per cylinder, a six-speed transmission, and crankshaft speeds of up to 18,000 revolutions per minute—the ingredients of a virtually unbeatable racing machine. The RC 161 finished the 1961 racing season with a perfect score of forty-eight points; its closest competitor finished with a total of thirteen.

Today, more than thirty years after the Honda RC 161 was built, automobiles are beginning to feature the characteristics of its engine—double overhead cam, four valves per cylinder, and more revolutions per minute to provide high horsepower ratings from small piston displacement. In engines, the Honda RC 161 led the way. The American Honda Motor Company of Gardena, California, presented this "milestone" vehicle to the Henry Ford Museum in 1964.

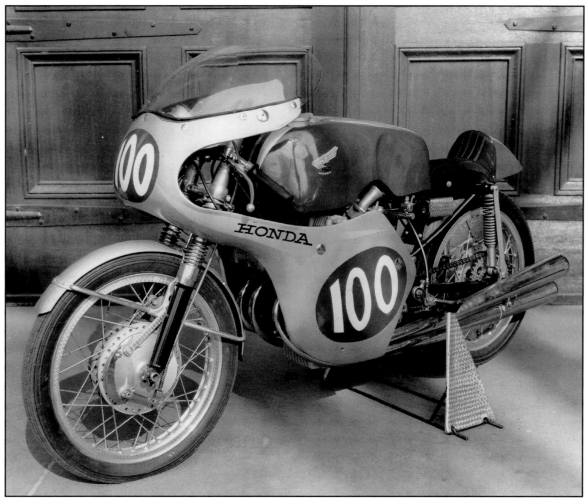

Acc. 64.74.1 Neg. B.37492.

CHAPTER 4
Automobiles and Trucks

O N JULY 15, 1903, E. Pfennig, a Chicago dentist, bought a Model A from the Ford Motor Company for $850. This seemingly insignificant event marked a turning point in Henry Ford's career—and a milestone in automotive history—for with it, the Ford Motor Company, teetering on the brink of bankruptcy with $223.65 in the bank, had made its first sale. Almost miraculously, by the following week, the company's bank balance had risen to $6,486.44, and Henry Ford was on his way. Until then, however, it had seemed nip and tuck whether Henry would ever fulfill his promise to "build a motor car for the multitude." Such a vehicle, he had vowed, would

> be large enough for the family, but small enough for the unskilled individual to operate easily and care for, and it shall be light in weight that it may be economical in maintenance.
>
> It will be built of honest materials, by the best workmen that money can hire, after the simplest designs that modern engineering can devise.
>
> But it shall be so low in price that the man of moderate means may own one and enjoy with his family the blessings of happy hours spent in God's great open spaces.

The Ford Motor Company was less than five weeks old when Dr. Pfennig's purchase rescued it from bankruptcy. Henry Ford and Alex Malcomson, partners since the previous summer, owned 51 percent of the company's shares but had put up no money. It had taken some doing to assemble the ten men who actually financed the operation, for Henry Ford's record up to that time was hardly one to inspire confidence in prospective stockholders.

With his building of the first Quadricycle in 1896 and a second, improved one a year or so later, Henry Ford had achieved some local fame, and on August 5, 1899, a group of wealthy and influential Detroiters—with shrewd eyes on the automobile boom then overtaking the nation—formed the Detroit Automobile Company, putting Henry in charge of the plant. Although Henry had a prototype for a passenger car in his second Quadricycle, he continued to improve the design, refusing to put the car into production until he had perfected it to his satisfaction. He did, however, manage to produce a novel type of vehicle for the Detroit Automobile Company: a gasoline-powered delivery truck. Although it was apparently a dismal failure—slow, heavy, unreliable, and complicated to manufacture— the truck had at least one successful run in the winter of 1900; a local newspaperman who witnessed it ran his story under the banner headline "SWIFTER THAN A RACE HORSE IT FLEW OVER THE ICY STREETS!"

Good publicity notwithstanding, the shareholders of the Detroit Automobile Company had soon had enough. In January 1901, having watched their expectations of quick profit vanish as Henry's tinkering continued to delay production of a passenger car—and having been further rankled by the astounding production figures of the "merry Oldsmobile" (425 in a single year)—they filed formal notice of the company's dissolution.

Not all the shareholders of the Detroit Automobile Company lost faith in Henry; a few continued to back him in his next endeavor, the building of a racing car. By 1900 all prominent car manufacturers were entering their vehicles in races, strutting their stuff in front of an enthralled public, and Henry, for once in his life, apparently decided to join the mainstream. Not only was building a winning racer a way to fame and some hard cash; if

he could master the problems inherent in building a car for speed, he reasoned, all should fall easily into place for his passenger car. Moreover, Henry seems to have been bitten by the racing bug, a condition that evidently did not last very long. As he emerged from the dust in the wake of his first race—in which he defeated the greatly favored and well-known auto maker Alexander Winton—he is alleged to have gasped, "Boy, I'll never do that again! That tight board fence was right here in front of my face all the time! I was scared to death."

The glory that attended Henry's well-publicized victory in October 1901 resulted in his faithful backers quickly rallying round to form the Henry Ford Company—a venture that lasted less than four months. Henry's preoccupation with racing cars and his continuing refusal to start producing a passenger vehicle soon drove the officers of the new company to despair. Henry resigned on March 10, 1902, "determined never again to put [him]self under orders." Out of the wreckage of the Henry Ford Company there immediately emerged another firm; using a new engine and Henry's designs, it produced a new car, known then and ever since as a Cadillac.

For the moment, Henry Ford was fresh out of Detroit backers and in need of money to continue building racing cars. To the rescue came wealthy and world-famous bicycling champion Tom Cooper, who had watched the Winton-Ford race with awe. The agreement was that Cooper would supply Henry with the money to build two identical racing cars and Cooper would own one of them. The powerful machines that emerged were named after two express trains of the day, the 999 and the Arrow. Because Cooper's nerve failed him when it came to automobile racing and Henry did not relish repeating his racing experience of the previous year, it fell to fearless Barney Oldfield, Cooper's fellow cyclist, to drive the 999 to a record-smashing victory in a five-mile race at Grosse Pointe, Michigan, in October 1902. Henry's arrangement with Tom Cooper seems to have ended on a somewhat sour note; in a letter Clara Ford wrote to her brother Milton two days after the race, she reported that Henry had caught Cooper "in a number of sneaky tricks."

Meanwhile, in August 1902, Henry had entered into a partnership with Alex Malcomson, a shrewd Detroit coal merchant. The $7,000 that Malcomson put up to finance Henry's building of a passenger car proved inadequate for the task, and

since Malcolmson's aggressive acquisition of local coal yards had led to his being heavily mortgaged at every large bank in Detroit, the only solution was to find stockholders. That task—an unenviable one, for Henry had by now alienated the pillars of Detroit's financial establishment—fell to Malcomson, who had to do much convincing and cajoling.

Had the company that evolved from Malcomson's efforts failed in July 1903, as it showed every sign of doing, Henry's chances of finding other backers would no doubt have been rather slight—and the future of the automobile might have been quite different. As it was, those who invested in the Ford Motor Company became very rich very fast, and Henry in 1913 went on to perform the feat that changed production the world over: implementation of the first moving automotive assembly line. By that time, the Ford Motor Company had already produced more than 250,000 of the legendary and much-loved Model Ts, which it introduced in 1908, and with the moving assembly line in place, workers began cranking the "flivvers" out at the rate of one every ninety-three minutes. As Henry had promised, his "car for the multitude" had a low price, and as sales increased, Henry lowered the purchase price even further. He even went so far as to share the wealth with his workers by inaugurating the eight-hour, five-dollar day. Such practices flew straight in the face of conventional business wisdom.

In his ambition to produce a family car for the "man of moderate means," Henry Ford was bucking yet another convention. The nabobs of Newport, Rhode Island, and other fashionable spots, who had been the first to evince an interest in actually buying automobiles, wanted a vehicle symbolic of their station in life. Most manufacturers cheerfully obliged, producing large, luxurious, expensive cars.

Still another of Henry Ford's unconventional undertakings was his manufacture of trucks; most early automotive manufacturers concentrated on producing passenger cars or trucks, but not both. After a hiatus following his first unsuccessful foray into truck manufacture with the Detroit Automobile Company in 1900, Henry returned to it in 1916, using the Model T engine to power the 209 trucks his company produced that year. By 1927, when Ford stopped making the the Model T and started tooling up for the second Model A, the company had produced 1,345,075 trucks. Classed as a one-ton vehicle, the standard Model T truck had a carrying

capacity surprisingly close to that of the modern Ford pickup, which, astounding as it may seem, outsold any passenger car in the United States in 1994.

The Henry Ford Musem's truck collection, although it covers a broad time period, is rather scant in comparison with its collection of more than two hundred automobiles. Among the approximately one hundred and thirty automobiles on display at any one time are numerous historic vehicles, as well as some late models of different makes. During Henry Ford's lifetime, cars manufactured by his serious competitors, such as General Motors and Chrysler, were conspicuously absent from the museum. Henry did, however, display a number of historic milestone vehicles which his Model T had long since driven from the marketplace. The Henry Ford Museum & Greenfield Village, now no longer affiliated with Ford Motor Company, displays in addition to these historic conveyances, a variety of outstanding vehicles of any American make whatever, many of these recent donations.

Acc. 88.427. Neg. B 105208.

1988 design concept of "Econo Car"

In response to the gasoline shortage of the late 1970s, Ford Motor Company developed this 2-passenger design concept study vehicle. It is a rendition between a full-sized clay model and a running prototype. Although it will roll, it has no engine, steering, or suspension system; but it does have a full interior with non-operating instruments and controls.

This "Econocar" was a design proposal for a very inexpensive, high-mileage student/commuter car using a small gasoline engine — and potentially a 100 mile-per-gallon vehicle to cope with the threatening fuel crisis.

Planned as a 1982 model, by the time the Econocar concept was developed to this stage, the gas shortage had subsided and Ford saw no market forsuch a small specialized vehicle. Painted in orange and trimmed in black, this "fiberglass property" was donated in 1988 to the Henry Ford Museum.

Selden's Motor Buggy

Acc. 63.22.1. Neg. B.41542.

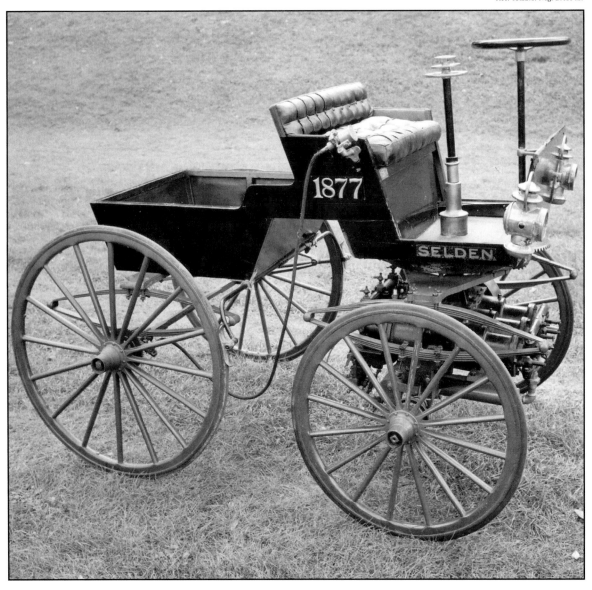

It is ironic that this vehicle found its final resting place in the Henry Ford Museum, for it was built solely to score a legal point against Henry Ford. Its maker was George B. Selden of Rochester, New York, a patent lawyer with a mechanical bent.

In 1877, having read all he could about the internal combustion engine then being developed in Europe, George Selden built such an engine and two years later drew plans for a carriage that it might propel. Although there was nothing original about Selden's idea for a horseless carriage, he was the first American to patent a gasoline engine in combination with a passenger vehicle. Without actually having built such a vehicle, Selden filed a patent application in 1879, phrasing it in such a way that he could claim the exclusive right to license and exact royalties from all future U.S. makers of gasoline-powered automobiles.

Because there was little interest in manufacturing automobiles in 1879—and thus little to be gained from the patent, which would cover licensing rights for seventeen years—Selden, through a series of legal maneuvers, forestalled issuance of his patent until 1895. For the next four years, only one manufacturer took any notice whatsoever of Selden's patent, and so Selden gained almost nothing from it until he went into partnership with a New York syndicate in 1899. When the syndicate threatened the largest U.S. auto makers with lawsuits for patent infringement, it encountered surprisingly little resistance. In March 1903, although most of the manufacturers thought Selden's claim was ridiculous, they agreed to pay royalties to Selden—but only on the condition that they control the patent's licensing rights. Calling themselves the Association of Licensed Automotive Manufacturers (ALAM), these manufacturers thus established a monopoly that could deny license to any and all competitors.

In the summer of 1903, with the Ford Motor Company only just launched, Henry Ford twice tried to join ALAM and was twice rebuffed. Furious, he publicly declared his intent to ignore the Selden patent, stating that the patent "does not cover any practicable machine, no practicable machine can be made from it, and never was." On October 22, 1903, the inevitable lawsuit began, and it dragged on for many years. In 1904, to prove that the idea he had patented was workable, George Selden built the buggy shown here and in June 1907, with court officials and lawyers looking on, put it through its paces at a New Jersey racetrack. Fired into life by an air compressor, the buggy sputtered, moved five yards, and died. Nonetheless, two years later, the court found in Selden's favor, declaring the Ford Motor Company in violation for manufacturing automobiles without a license.

Still refusing to pay tribute to ALAM, Ford appealed the decision. In 1911 he finally won the legal battle, when the appeals court ruled that no patent infringement existed because Ford, like all contemporary car makers, was using a four-cycle Otto engine, whereas Selden had used a two-cycle Brayton engine. Ford was soon hailed as a one-man trustbuster who singlehandedly liberated the entire auto industry from ALAM's monopoly. His bulldog stance hadn't hurt sales of his Model T, either; in 1910–11, the Ford Motor Company sold 34,528 "Tin Lizzies" and more than doubled that figure the following year.

After the appeals court found in Ford's favor, Herman Cuntz, patent attorney for ALAM, presented Selden's motor buggy to the Stevens Institute of Technology in Hoboken, New Jersey. There it languished until 1963, when the institute, pressed for space to store its sizable collection of antiques, donated it to—of all places—the Henry Ford Museum.

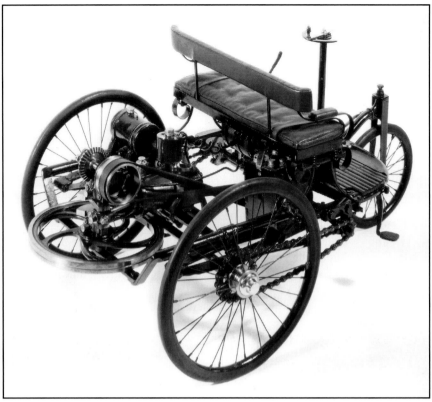

Acc. 38.504.1. Neg. A.3504.

Model of Benz's First Automobile

The first workable motor car powered by an internal combustion engine was built in 1885 by Karl Benz in Mannheim, Germany. Other successful self-propelled road vehicles had been built before then, but they were propelled by steam. As early as 1770, Nicholas Joseph Cugnot had developed a steam-driven artillery tractor in France, and by the early 1800s, Americans were also successfully applying steam to propulsion. In June 1805, Oliver Evans drove his steam-powered *Orukter Amphibolus,* soon hailed as the world's first self-propelled amphibious vehicle, around the streets of Philadelphia and thence into the Schuylkill River, into which it wobbled on wooden wheels, only to sail triumphantly away by means of a stern paddlewheel.

Colorful as some steam-propelled vehicles were, they were also heavy, cumbersome, and complicated to operate. Convinced that gasoline-powered vehicles were the wave of the future, Karl Benz in 1871 risked his life's savings on the gamble. Renting a small shop in Mannheim, he set to work developing

a four-cycle internal combustion engine. The car that he eventually produced in the spring of 1885 had a rear-mounted engine. The flywheel was in a horizontal position because Benz feared that at high speed (the car made ten miles per hour), centrifugal force would interfere with the steering. For the chassis, he built a light tricycle, which together with the engine weighed 580 pounds. The car had at least three features still found in automobiles: an electric ignition, water cooling, and a differential gear. To start the engine, the driver simply pulled on the flywheel.

The working model shown here, an exact replica of Benz's first automobile, is one-fifth the size of the original. It was made by apprentices in the Mannheim plant of the Daimler-Benz Company, a firm formed in 1926 by the merger of Karl Benz's company and the company of another German automotive pioneer, Gottlieb Daimler. On July 30, 1938, the Daimler-Benz Company presented the model to Henry Ford as a gift for his seventy-fifth birthday.

Replica of Ford's First Quadricycle

On Christmas Eve of 1893, Henry Ford walked into the kitchen of his rented home on Bagley Avenue in Detroit, where his wife was preparing for the next day's festivities, and blithely asked her to drop everything to help him fire up the little internal combustion engine he had just carried in from the shed in the backyard. Though none too pleased, Clara obliged. Henry clamped his homemade engine to the kitchen sink, attached a wire from the kitchen light to a spark plug, and, as Clara dripped gasoline into the intake valve, he spun the flywheel. After a false start and an adjustment or two, the engine roared into life, spewing smoke, shooting flames, and nearly shaking Clara's sink from its foundations.

After two and a half more years of experi-mentation in the backyard shed, Henry, in the small hours of a June morning in 1896, was ready to take his first automobile for a ride. To his chagrin, he found he had overlooked something: the car was too wide to fit through the doorway. It is doubtful that anything could have deterred Henry at that point. Seizing an axe, he battered down the door frame and the bricks around it, and with the help of Jim Bishop, a friend from the Edison Illuminating Company, he rolled the vehicle out onto the dark street. With Bishop bicycling alongside him, Henry set off on his historic ride. The next morning, as Henry and a neighbor were starting to repair the shed, the Fords' landlord appeared. He was, needless to say, not pleased with the condition of his shed, nor was he

Acc. 63.159.1. Neg. B.34117.

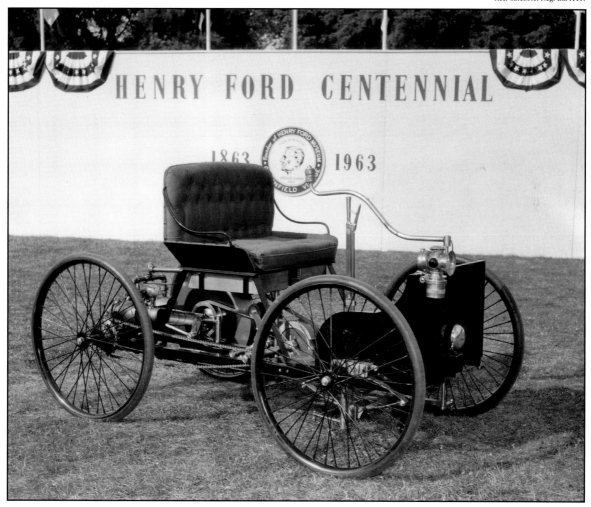

mollified by Henry's repairs. But after the words *horseless carriage* had penetrated his indignation and Henry had described the marvels of the new machine, he decreed that the door should be widened so that Henry could get his car in and out, thus ordaining what was no doubt one of America's first garage doors.

Henry's machine, which he called the Quadricycle because of its four bicycle wheels, was remarkably fast for a vehicle of the 1890s. Primarily owing to its light weight—little more than five hundred pounds—it could reach a top speed of about twenty miles per hour. Henry had fashioned the cylinders of the Quadricycle's air-cooled motor from the exhaust pipe of a steam engine and used a tiller for steering. For a car horn, he had connected a button at the end of the tiller to an ordinary doorbell, which was attached to the front of the vehicle.

Henry continued to make improvements to the Quadricycle—among other things, replacing the original bicycle seat with a buggy seat, strengthening the frame and wheels, and modifying the cooling system—for about six months, until he decided to begin working on a new model. Having driven the first Quadricycle about a thousand miles, he sold it to his friend Charles Ainsley for $200, and after that, it passed on to at least two other owners. In 1904 Henry bought it back for $65, and it is now on display in the Henry Ford Museum.

The vehicle shown here, also part of the museum's automobile collection, is a full-size, operable replica of the first Quadricycle. It was built by George DeAngelis of Greenoak Township, Michigan. DeAngelis, an engineer with the Ford Motor Company and an authority on the Model T and Model A, began the project in 1960 and completed it in time for the centennial of Henry Ford's birth in 1963. The Henry Ford Museum reimbursed DeAngelis for materials, but DeAngelis made a gift of his labor to the museum.

De Dion-Bouton Motorette

Acc.31.94.1. Neg. A.2601.

When Albert De Dion and Georges Bouton formed a partnership in the early 1880s, Parisians must have scratched their heads, for Count De Dion, aristocratic man about town, and Georges Bouton, locksmith's apprentice, made an exceedingly strange pair. Soon after the two began manufacturing steam-powered cars in 1883, De Dion's father, protesting against his son's investing family money in such a foolish venture, took the matter to the French courts. Fortunately, the courts were a bit more farsighted, and De Dion and Bouton were allowed to go on with their business, which eventually became a world-famous concern. Count De Dion is credited with having conceived the world's first automobile show, first road maps, and first printed literature for automobile sales. He is also credited with having invented the eight-cylinder engine, but it is quite likely that Georges Bouton had a hand in that development.

In the late 1880s, De Dion and Bouton began developing a single-cylinder gasoline engine, which soon became very popular. Before the turn of the century, their factory in France was shipping gasoline engines to budding auto makers the world over. About 1894 De Dion and Bouton started applying their one-cylinder engines to tricycles, and they soon progressed to four-wheel models. The four-wheel, three-passenger "motorette" shown here was built around 1900 in Brooklyn, New York, by a licensee of the French company; the model was produced in the United States from 1900 to 1904. Unlike Karl Benz's car, the De Dion-Bouton motorette had no gearbox or clutch; the engine was geared directly to the rear axle by a variable speed gear. The driver started the engine by rotating a crank on the side of the car and steered by moving the tiller handle at the top of the upright column between the facing seats; the column also contained the throttle control. When fully occupied, the vehicle's facing seats must surely have impeded visibility and would never have passed safety regulations today. With a weight of about seven hundred pounds, the vehicle had a top speed of twenty-two miles per hour. The motorette in the photograph has a red wooden body, black wooden fenders, and brown leather upholstery.

Clarence E. Belden of Bradstreet, Massachusetts, put 30,000 miles on the motorette before he retired it in 1916. He wrote to Henry Ford in 1931, wondering if Ford might like to have the vehicle and telling him he was welcome to it if he did. Belden added that he had lent it to a local Packard dealer to include in an exhibition that featured both the latest model Packard and an airplane. "The only trouble was," he wrote, "that it attracted more attention than the Packard."

Winton Automobile

Alexander Winton, a natural-born publicist from Cleveland, Ohio, was a leader in the U.S. automotive industry almost from the moment he turned from bicycle making to automobile manufacture in 1897. He attracted nationwide attention in 1899 when he made a record run between Cleveland and New York City in one of his single-cylinder cars, completing the trip—over atrocious and often even nonexistent roads—in forty-seven hours. Schoolchildren lined the streets of almost every town he passed, gaping at the strange vehicle, and when he reached New York and drove down Broadway, cheering throngs lined the sidewalks.

Winton made news of another kind—good news for Henry Ford—when he drove one of his cars in a race at the Grosse Pointe track on October 10, 1901. Winton, then the U.S. racing champion, was so heavily favored that a cut-glass punchbowl had been chosen as the prize; it was thought the bowl would look nice in the bay window of Winton's dining room.

As it turned out, Henry Ford, a relatively unknown upstart, took home not only the bowl but also some very useful publicity. Years later, Ford and Winton found themselves fierce opponents again, as Henry fought the Selden patent and Alexander Winton supported ALAM.

Winton's idea of car making was quite different from Henry Ford's. Winton cars were large and expensive; the one shown here sold for $1,500 in 1900. Winton advertised his product as "a marvel of simplicity" and "enduring quality." Whether it was that or not, it was the first automobile in the United States to have two seats facing in the same direction. It had a single-cylinder engine and ran at about fifteen miles per hour. Mrs. E.S. Dickey and Mr. A.C. Staley of Birmingham, Michigan, siblings of Wilmer C. Staley who was the original owner of the Winton in the photograph, donated the car to the Henry Ford Museum in 1937.

Columbia Electric Carriage

Many people in the 1890s believed electric cars were the way of the future, a view now being echoed one hundred years later. The popularity of these vehicles was, however, short-lived, for their disadvantages, especially when compared with gasoline-powered vehicles, soon became obvious. They could cruise only a limited distance before their storage batteries had to be recharged, and the cost of recharging was high. Moreover, the batteries were usually heavy, and, as a rule, the weight-to-power ratio was low, resulting in a rather slow vehicle. On the other hand, electric carriages were quieter, cleaner, and easier to operate than gasoline-powered vehicles; starting them did not require hand-cranking or firing, and they changed speeds easily. These features appealed to wealthy women, who were among the electric carriage's greatest fans. Clara Ford once owned one, which she recharged by inserting its plug into a socket in Henry's power-house at Fair Lane. Henry, too, had more than a passing acquaintance with electric-powered vehicles; about 1913, in collaboration with Thomas Edison and using Edison's experimental batteries, he built an electric car but soon decided the batteries were too weak to make the vehicle practical.

Regardless of the shortcomings of its motive power, the electric vehicle shown here is considered by many experts to be the most beautiful horseless carriage ever built. Known as the Mark V Victoria, it was the creation of William Hooker Atwood, a noted carriage designer in New Haven, Connecticut. The Columbia and Electric Vehicle Company of Hartford produced the first Mark V in 1899, and it built the one in the photograph in 1901. The company received some free publicity when President Theodore Roosevelt visited Hartford and toured the city in a Mark V Victoria. Evidently, however, old "Rough Rider" Roosevelt was not overly impressed

Acc. 31.282.1. Neg. B.4230.

with the horseless carriage; the White House did not get its first automobiles until 1909 when William Howard Taft entered office.

Looking much like the fashionable horse-drawn Victoria carriage, the Mark V had large boxes over its front and rear axles to carry the storage batteries. The driver sat at the rear overlooking the passenger compartment; the rear seat could also accommodate a footman. Weighing a hefty 3,250 pounds, the Mark V had a speed of about twelve miles per hour, and if traveling on flat terrain, it could go approximately thirty miles on a single charge. Like most early electrics, it was powered by two motors attached to the rear axle.

Edward B. McLean, publisher of the *Washington Post* and owner of the 1901 Mark V Victoria, lent the vehicle to the Ford Motor Company for use as evidence in a patent suit in the late 1920s. Subsequently, in 1931, after Henry Ford had expressed an interest in acquiring the Mark V for his automobile collection, McClean donated it to the Henry Ford Museum.

Baker Electric Automobile

Acc. 30.328.2. Neg. B.60195.

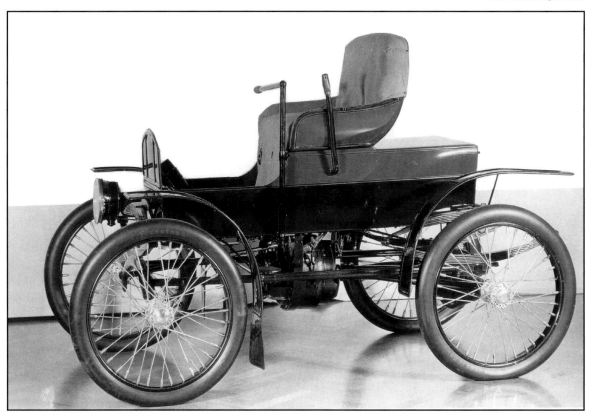

In 1895, when the national craze for bicycles was at its peak, Walter C. Baker established the American Ball Bearing Company in Cleveland, Ohio. Baker sold his ball bearings not only to bicycle manufacturers but to shipbuilders, carriagemakers, and manufacturers of electric motors and streetcars as well. His company was soon also making automobile axles and other car components. Baker was of an inventive turn of mind, and, seeing the commercial potential of the automobile, he developed an electric car in 1897. The Baker Motor Vehicle Company was founded the following year to assemble the automobile; as was the case with most early cars, the parts of the Baker electric were made by other companies.

Like the 1902 Baker pictured here—which Walter Baker gave to the Henry Ford Museum in 1935—the first model looked much like a horse-drawn buggy minus the horse. It weighed only 550 pounds, had an electric battery of ten cells, a three-quarter horsepower motor under the seat, and a steering tiller on the left side of the vehicle. Though it is difficult to say with certainty that Walter Baker was the first to introduce left-hand steering, he was certainly among the first. In 1904 he redesigned the car, putting the motor in the front so it looked more like the gasoline-powered autos of the day. Baker also gave his car a steering wheel, possibly another "first."

Thomas Edison admired Baker's ingenuity, and, being electricity's greatest proponent, he was particularly pleased that Baker had chosen to build electric cars, for at the time, it was a toss-up as to whether steam, electricity, or gasoline would be the prevailing motive power for road vehicles. Edison is said to have told Baker that with the electric batteries he was developing and the cars Baker was building, they could together eliminate gasoline-powered automobiles. Not surprisingly, Edison bought one of Baker's early electrics for his personal use.

The Baker Motor Vehicle Company was soon also producing large, luxury models with handsome interiors intended for wealthy customers; prices averaged about $2,000. A standard feature on these models was a shaft drive that Walter Baker had designed to replace the awkward chain drive found on most automobiles of the day, including the cheaper Baker models. The company advertised its top-of-the-line model aggressively, claiming it was "the most elegant" one on the market, "The Aristocrat of Motordom." The advertising was evidently effective; President William Howard Taft bought one for the White House in 1909. Walter Baker's racing cars, which he designed and drove himself, were another effective form of advertisement. In 1901 he built the "Torpedo," a streamlined racer that was allegedly once clocked at 120 miles per hour. The Torpedo came to a tragic end in 1902, when it crashed into a crowd at a time trial in New York and killed two spectators. In 1903 Baker built the "Torpedo Kid, " a similar but smaller machine.

Acc. 30.328.2. Neg. B.60195.

Riker Electric Racer

The Riker, one of the most respected early electric passenger cars, was built from about 1896 until 1902 in Elizabethport, New Jersey. The designer of the vehicle and the founder of the firm that produced it was Andrew Lawrence Riker, who believed wholeheartedly in his product and its future. To disprove critics who claimed electric vehicles were too slow, he built a number of electric racing cars, including the two-passenger "Torpedo" shown here, which he completed in 1901. The same year, on June 15 in Boston, the little car won the Larz Anderson Cup at the first annual race meet of the Automobile Club of New England. Five months later, Andrew Riker drove it to victory at the Long Island Automobile Club's race meet in New York; the Torpedo flashed across the finish line of a measured mile in sixty-three seconds, very nearly breaking a world record.

The body of the Riker Torpedo consists of a black board, with the batteries in a box beneath it. Circles of fabric served as seats for the steersman and for a second man who controlled the two electric motors that drove the rear wheels.

Despite his racing victories, Andrew Riker lost his bet on the electric car—though with the present renewed interest in electric automobiles, he, Walter Baker, Thomas Edison, and all the other early promoters of electric vehicles may still be proved right. By 1902 Riker's company was not in good financial health, and he began designing a gasoline-powered vehicle, which was eventually produced in Bridgeport, Connecticut, by the Locomobile Company, where Riker was vice-president and chief engineer until 1921. In February 1930, four months before his death, he presented the Torpedo racer to the Henry Ford Museum, together with six other early Riker electric vehicles.

Old "999"

This is the car that cigar-chomping Barney Oldfield drove when he thundered around the Grosse Pointe track in the Manufacturers' Challenge Cup Race on October 25, 1902, setting a new American speed record and, as he liked to say, launching both himself and Henry Ford on their respective careers. Named after a record-breaking New York Central express train, the eighty-horsepower, bare-bones "999" had the largest engine yet produced in America, and it made a roar at least as earsplitting as any locomotive. Henry Ford, who had built the 999 for himself and an almost identical racer called the "Arrow" for his financial backer Tom Cooper, said of his handiwork:

> The roar of those cylinders alone was enough to half kill a man. There was only one seat. One life to a car was enough. I tried out the cars. Cooper tried out the cars. We let them out at full speed. I cannot quite describe the sensation. Going over Niagara Falls would have been but a pastime after a ride in one of them.

Summoned by telegraph from the Salt Lake City bicycle track, Barney Oldfield, whose favorite mottoes seem to have been "I'll try anything once" and "Never look back," arrived in Detroit a week before the Grosse Pointe race, never having driven a car before. He practiced hard and learned fast, but Henry Ford was still concerned for his safety. Barney told him, "Well, this chariot may kill me, but they'll say afterward that I was going like hell when she took me over the bank." The dirt track at Grosse Pointe was, in fact, unbanked, but it did have curves and they never phased Barney. With the bliss born of ignorance, he kept the accelerator flat to the floor and the tiller at a stiff angle as he rounded the turns of the oval track, and he left his nearest competitor a full half-mile behind at the finish line. His time for the five-mile race was five minutes and twenty-eight seconds.

The tiller on the 999 was two-handled because steering the monster at high speed took the muscles of two strong arms. Henry Ford's explanation of why he used a steering tiller rather than a wheel conveys some of the realities of car racing in the early part of this century:

> You see, when the machine is making high speed, and the operator cannot tell because of the dust . . . whether he is going perfectly straight, he can look at this steering handle. If it is set straight across the machine he is . . . running straight.

Although Henry Ford reaped inestimable benefits from the publicity showered on the 999 after Barney Oldfield's first triumph in it and for some time thereafter, the car was at the time of the race actually Tom Cooper's property. For some unknown reason—perhaps because Clara Ford did not approve of Tom Cooper and the racing crowd—Henry had sold it to him just two weeks before. Cooper drove the 999 in a number of meets during the 1903 racing season, but after that, it never raced in competition again. In 1904 Cooper sold it, together with the Arrow, to a man who planned to exhibit the racers in shows around the country.

What happened to the 999 next is obscure, and there are two different versions of how it was found. According to one version, Barney Oldfield spotted it in a junkyard in Santa Monica, California, about 1910, but since he didn't have the money to rescue it, he contacted the Los Angeles Ford dealer about it. According to the other version, a mechanic from the Los Angeles dealership found it in a backyard in Santa Barbara about 1919, and Barney Oldfield then verified its identity. At any rate, according to both versions, the 999 eventually ended up, completely restored, in the showroom of the San Francisco Ford dealer, William L. Hughson, another former bicycling champion who in 1903 had become Henry Ford's first dealer. When Senator Morgan of New Jersey asked to borrow the 999 to use in his election campaign in 1926, Hughson agreed but stipulated that afterward the car be shipped to Henry Ford as a gift for the museum he was planning.

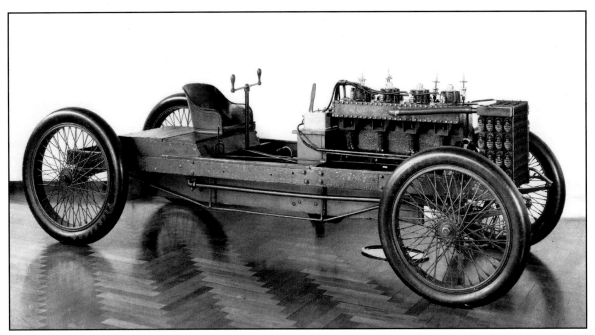

Old "999"

Acc. 19.3.1. Neg. A.2583.

"Old Pacific"

Acc. 35.455.2. Neg. A.2693.

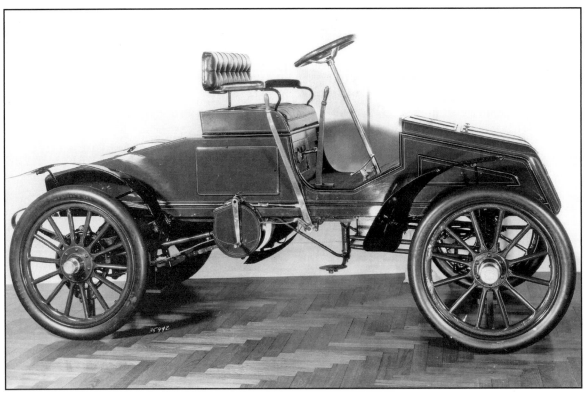

"Old Pacific"

Driving their cars at breakneck speeds around racetracks was not the only way early auto manufacturers promoted their products. They also entered their cars in hill climbs, for which there were elaborate trophies, as well as in an ongoing race to be the first to drive across the continent. The winner of the transcontinental race was that publicist par excellence, Alexander Winton. On May 23, 1903, H.N. Jackson, driving a Winton car, set off from San Francisco and arrived in New York City sixty-five days later. Because Jackson often found himself out of fuel in out-of-the-way places and because roads, if they existed at all, were often nothing more than cart tracks, the Winton had to be shipped by wagon and rail part of the way.

The Packard shown here was the second vehicle to complete the transcontinental trip—and the first to do so entirely under its own power. It beat the Winton's record by three days, leaving San Francisco on June 20, 1903, and arriving in New York on August 21. A standard Packard Model F touring car, "Old Pacific," as the vehicle was soon affectionately known, had had its tonneau removed before being shipped to the West Coast. The driver was E.T. (Tom) Fetch, Packard's plant foreman, who was accompanied by Marius C. Krarup, a journalist. They went well-armed with lengths of logging chain to get the wheels out of muddy ruts, and a pick and shovel to carve roads out of hillsides. Old Pacific had a one-cylinder, twelve-horsepower engine under the seat, a weight of 2,200 pounds, and a top speed of forty miles per hour.

In 1903, when it built Old Pacific, the Packard Motor Car Company was located in Warren, Ohio. Later the same year, it moved to Detroit, joining a growing number of manufacturing firms which were finding Detroit's protective policy toward employers a hospitable environment. The Packard Motor Company, long famous for its high-quality, luxury automobiles, remained in business in Detroit until 1956. The company donated Old Pacific to the Henry Ford Museum in 1935.

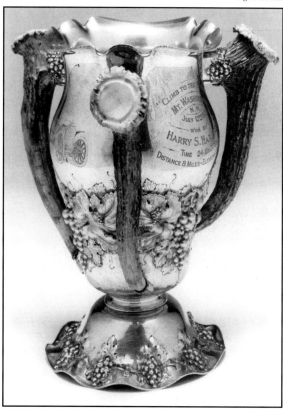

Neg. B.100752.

The engraving on the front of this sterling silver trophy reads: "Climb to the Clouds, Mt. Washington, N. H., July 12th, 1904, won by Harry S. Harkness, Time 24 min. 37 sec., Distance 8 miles, Elevation 6293 feet." Henry Austin Clark, Jr., of Glen Cove, New York, donated the trophy to the Henry Ford Museum in 1986.

Stanley Steamer

The Stanley Steamer was certainly not the only early steam-powered car, but it is surely the best remembered. It was a product of New England, as most cars were before auto manufacturers began popping up in Ohio, Indiana, and Michigan. From 1897 until their retirement in 1917, F.E. and F.O. Stanley, twin brothers, manufactured their cars in Newton, Massachusetts. The Stanley Motor Carriage Company remained in business until 1926, by which time only 18,000 Stanley Steamers had been produced. The company could have made and sold many more, but the Stanley twins insisted on meticulously handcrafting their products.

F.E. and F.O. Stanley eschewed advertising and seldom paid for an ad. They did, however, enter their vehicles in well-publicized races. The Stanley Rocket set a world record of 127 miles per hour at Ormond Beach, Florida, in 1906. Although the 1910 Stanley shown here was not built for that kind of speed, it could do an astonishing 70 miles per hour. (According to a rumor widely circulated in the early 1920s, anyone who could hold the throttle on a Stanley wide open for one minute could have the car free.) The Stanley accelerated rapidly, ran silently and smoothly, and eliminated the need for shifting gears. Its double-acting two-cylinder engine, equivalent in power strokes to an eight-cylinder internal combustion engine, was mounted horizontally under the car and geared directly to the rear axle. With no gearshift or clutch to worry about, the driver used the throttle to control both forward and reverse speeds. The boiler was located under the hood, and a gasoline tank was beneath the rear seat. The disadvantages of the machine were that it took time to get it "steamed up," it could travel only a limited distance before the driver had to stop and fill the boiler with water, and its engine, like all steam engines, was not energy-efficient.

The Stanley Steamer was especially popular in areas where extra power was needed to climb steep hills and mountains. One of the best-known Stanley models was the Mountain Wagon; seating from nine to twelve passengers, it was widely used by summer hotels and resorts. Other steam-powered cars—among them the White Steamer—were just as adept as the Stanley at hill-climbing, but they quickly faded from memory, while the legend of the Stanley Steamer lives on. Since advertising was not part of the Stanley twins' modus operandi, the car's reputation derived largely from the word spread by fond owners. The owner of the 1910 Stanley Steamer pictured here was Elden Stonefelt of Peoria, Illinois, who gave it to the Henry Ford Museum in 1935 in the hope that "it would be preserved for the future generation to see."

Acc. 35.495.1. Neg.A.2633.

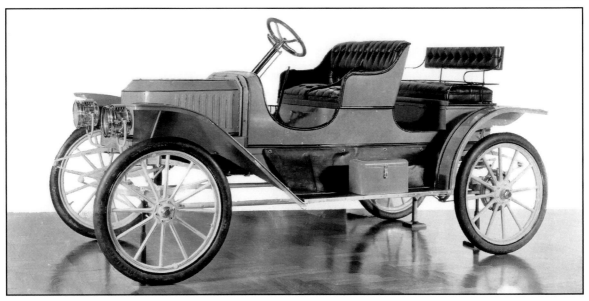

Henry Ford's X Engine

Acc. 55.6.42. Neg. 189.34565.

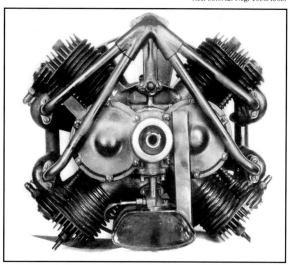

When Henry Ford celebrated his sixtieth birthday in 1923, his company was selling 57 percent of all cars produced in the United States and almost 50 percent of all those produced anywhere in the world. Given these figures, it is perhaps understandable that Henry resisted any and all attempts to change the Model T. Many Ford executives, however—foremost among them Henry's son Edsel—were painfully aware that even as the Model T's sales were peaking, its popularity was on the wane. Other companies, notably General Motors, had been developing more stylish, smoother-running cars in the same price range—with the result that fashion and comfort were now becoming common factors in automobile purchases. Meanwhile, the Model T had remained relatively unchanged since its introduction in 1908. Although in 1923 it had an electric self-starter, Harvey Firestone's low-pressure balloon tires, and the option of a closed-in, weatherproof body, it was still noisy, ungainly, and "available in any color so long as it's black"—a slogan based on Ford's insistence on the faster-drying black paint.

While other companies in the 1920s began introducing a model with a slightly new body design each year, Henry staunchly maintained that his company would always strive to provide the customer with a car that would "last forever. . . . We want the man who buys one of our products never to have to buy another." Despite the logic inherent in Henry's view, GM's Chevrolet had by 1926 caused the Model T's share of the market to drop to 34 percent.

Although Henry would not tolerate any discussion of changes to the Model T or of a car to replace it, he had not been completely oblivious to the threat from the competition. His solution, pictured here, was not a matter of design, but of engineering. As early as 1920, he had put his engineering staff to work on developing the X engine. Somewhat akin to the aircraft radial engine, the X engine had eight powerful cylinders, four facing up and four down. It was a revolutionary concept, since all automobile engines to date had had their cylinders lined up side by side, and it seems to have obsessed Henry for more than five years. The hard fact, however, was that the X engine's bottom cylinders inevitably became clogged with oil and road dirt, and Henry's engineers never were able to find a solution to this problem.

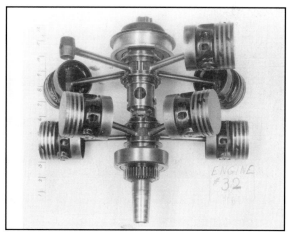

Neg. 189.34508.

By August 1926, when Henry finally gave up on his single-minded idea for retrieving Ford's share of the market, it was too late. It took the Ford Motor Company a full six months of down time in 1927 to tool up for the production of an entirely new Model A, and it was twelve months before the assembly line was running at full capacity. By 1930 GM was out in front of Ford in the sales race and has remained there ever since.

The Ford Motor Company donated the X engine shown here to the Henry Ford Museum in 1955. Built about 1925, it was the thirty-second experimental engine that Ford engineers constructed between 1920 and 1926.

Yellow Taxicab

In 1910 John D. Hertz started a Chicago taxi service called Yellow Cab; he painted his cabs yellow because he thought the bright color would help attract fares. In 1915, when he decided to begin making his own taxis, he founded the Yellow Cab Manufacturing Company. Although the yellow cab was his stock-in-trade, he was willing to sell taxis in any color a customer specified. Since he often sold to cab operators on credit or for a share of future profits, he wisely included with each purchase a manual on how to operate a cab company effectively. Hertz's business flourished, and by 1923 Yellow Cab was producing not only taxis but trucks and buses as well. After Hertz sold the company to General Motors in 1925, he went on to establish what is reputedly the largest of all car-rental companies, Hertz Rent-a-Car, which is now owned by the Ford Motor Company.

The 1925 taxi shown here was among the last produced by the Yellow Cab Manufacturing Company. Cabs in those days were more ruggedly built than passenger cars, and this one is no exception. It has a heavy trucklike frame, sturdy springs, a four-cylinder, forty-two-horsepower engine, and distinctive disc wheels and cowl-mounted headlights. It was once owned by Harrah's Club in Reno, Nevada, and there is some evidence that earlier it was owned by Warner Brothers and used as a prop in Hollywood movies. A curator from the Henry Ford Museum discovered the yellow taxi at the Reynolds Museum in Wetaskiwin, Alberta, in 1988. Ford Bryan of Dearborn, Michigan, financed its purchase for the museum.

Acc. 88.333.1. Neg. B.103320.

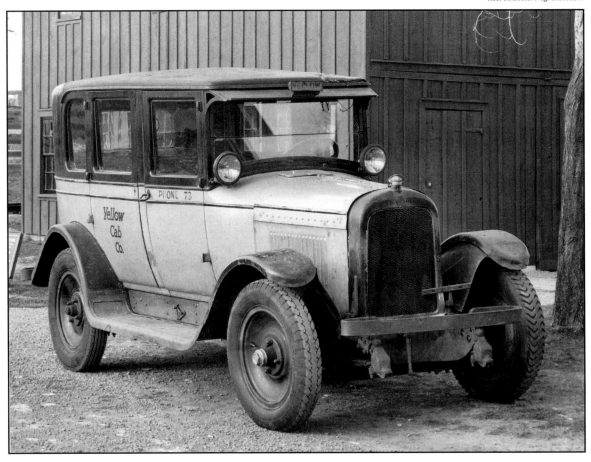

J.P. Morgan's
Rolls-Royce Phantom I

Ever since Rolls-Royce produced its first automobile in Derby, England, in 1907, its name has been synonomous with excellence. The 1907 model ran so smoothly and silently that Rolls-Royce called it the Silver Ghost. Similarly, when the company introduced a new six-cylinder model in 1926, it called it the Phantom I. By that time, owning a Rolls-Royce had become an unmistakable symbol of personal affluence and social status on both sides of the Atlantic.

Soon after the Phantom I came on the market in 1926, J. Pierpont Morgan, fabulously wealthy New York financier, imported the chassis of the vehicle shown here. When it reached New York, Morgan engaged Brewster & Company, a firm famous

glass panel separates the chauffeur's section from the rear compartment, which is upholstered in buff corduroy. Monograms with a stag's head adorn the rear doors.

Although Henry Ford had little respect for Wall Street, he and J.P. Morgan were friends. Morgan ended one letter he wrote to Henry in 1941 by saying, "May I close by expressing my very real sympathy with you in your labor troubles, which I understand are now in a fair way of being settled. How much trouble it makes when the government mixes politics with all it's [sic] business!" On another occasion, Morgan—one of the richest men in the world—called Henry to complain that a Ford dealer had offered him only $100 on a trade-in; Henry stood up

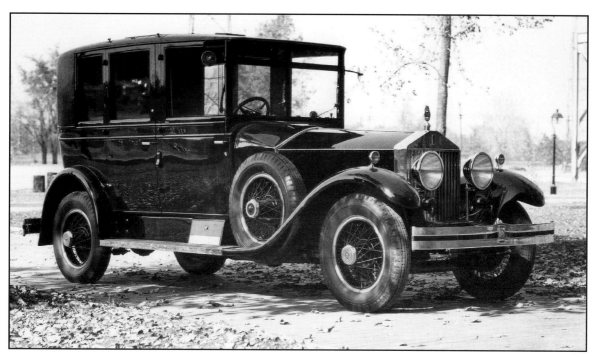

Acc. 38.472.1. Neg. A.2643.

since 1810 for its fine custom coachwork, to build a limousine body for the Rolls-Royce chassis. Painted dark green with maroon and black trim, the limousine has black fenders and a leather top. With two folding seats, it seated seven passengers. A sliding

for his dealer but offered Morgan fast delivery of the new model, which seems to have placated him. Morgan gave the limousine pictured here to Henry Ford in 1938.

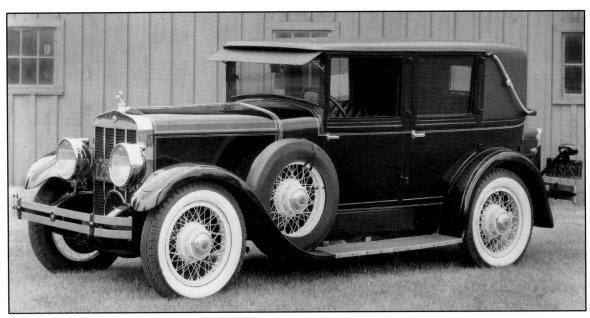

Acc. 40.222.1. Neg. B.33539.

Charles Lindbergh's Franklin

Soon after Charles Lindbergh made his historic nonstop flight from New York to Paris in 1927, the H.H. Franklin Company of Syracuse, New York, presented him with this sedan, part of a 1928 series that the company had christened the "Airman." The gift was only one of many tributes heaped on Lindbergh, but it is one of which he became quite fond. Years later, he wrote:

> The Franklin car was a present from the Franklin company because, they said, my flights in the "Spirit of St. Louis," with its air-cooled engine, had increased the sales of their car—the only car built in the United States, at that time, with an air-cooled engine. . . .
>
> I drove this car a great deal in connection with my flying activities. . . . I drove my wife in it on the first date we had—to Long Island for a flight in a De Haviland "Moth"—and on a good many dates thereafter both before and after we were married. I liked the car very much, and it gave us excellent service.

Its gift to the much-lionized Lindbergh also gave the H.H. Franklin Company "excellent service." The company took dignified but full advantage of its association with him in national advertising, pointing out, among a host of other things, that Lindbergh had proved the superiority of the air-cooled engine.

From the time Franklin produced its first car in 1901 until 1928, when it inaugurated its Airman series, Franklins were known as much for their ugly hoods as for their comfort and reliability. They were also relatively expensive; the 1928 model cost $2,790. Nonetheless, the company managed to stay in the business of making autos with air-cooled engines much longer than other American manufacturers of similar vehicles. When Franklin finally did stop making cars in 1934, it became a major producer of air-cooled aircraft engines.

In 1940, after using his Franklin for many years, Charles Lindbergh gave it to Henry Ford for his museum. The two men had known each other since 1927, when Lindbergh took Ford up in the *Spirit of St. Louis* for his first airplane ride. At the time Lindbergh gave the car to Ford, both men were under fire because of their pacifist views. Two years later, with the United States at war, Lindbergh became an unpaid adviser and test pilot at Ford's Willow Run bomber plant.

Bugatti Royale Cabriolet

The Henry Ford Museum has repeatedly refused offers of large amounts of money for this Bugatti Royale. It is an extremely rare vehicle, for only six Royales were ever made. There is just one other in the United States, and it recently sold for nine million dollars. The story of how the Royale came to the Henry Ford Museum is an intriguing one indeed.

Dr. A. Josef Fuchs, a surgeon and gynecologist in Nuremberg, Germany, ordered the car in 1931, and it was built and delivered to him in 1932 at a cost of $43,000. The famed Alsatian firm of Ettore Bugatti in Molsheim, France, produced the chassis. Karosseriefabrik Ludwig Weinberger, a coachbuilding firm founded in Munich in 1898, crafted the cabriolet, or convertible, body. The gigantic Bugatti had a 174-inch wheelbase and an extremely powerful engine capable of great speed. When the finished product was unveiled, it was hailed as a masterpiece, "probably the most fantastic car ever to be produced."

Dr. Fuchs apparently came from a very wealthy family and had refined tastes and a variety of interests. His offices in Nuremberg consisted of a waiting room, an operating room, and an apartment decorated with Persian rugs and original oil paintings. In yet another apartment, he kept a grand piano, and he is said to have once been a concert pianist. He had also been an amateur race-car driver but by the early 1930s had given that up in favor of flying. After trading in his racing cars, he had bought a custom-built airplane.

Fuchs was forty-two years old when Adolf Hitler came to power in January 1933. Within two months, Hitler had suspended freedom of speech and freedom of the press, and within six months, Nazi authorities had forbidden Fuchs to treat "sick benefit patients on account of unworthy conduct." It is unclear whether Fuchs was Jewish or not, but in any case he wasted no time in quietly planning his exit from the tyranny of Nazi Germany. It did not seem extraordinary that the wealthy doctor would want to fly to Italy via Zurich, Switzerland, for the purpose of buying a new airplane, nor did it seem extraordinary that he would send his Bugatti Royale to the factory in France for a checkup.

After he took off from the airport in

Acc. 58.86.1. Neg. A.8937.

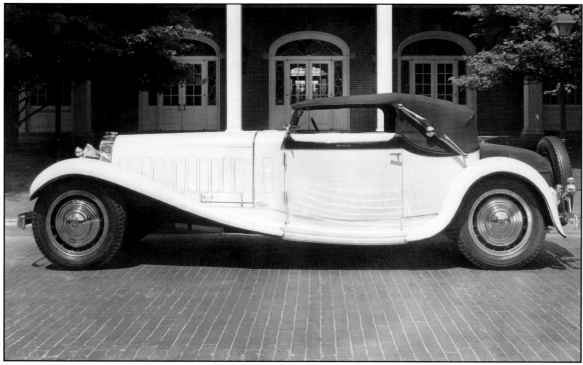

Nuremberg, Fuchs settled for a while in Switzerland and then emigrated to China. In June 1935 he applied to the U.S. Consul in Shanghai for an immigration visa to enter the United States. After considerable delay, he was refused. Dr. Fuchs had treated two known Shanghai narcotics smugglers, and on this basis, the U.S. Visa Department made the following judgment in November 1936:

> While there is no proof that Dr. Fuchs is connected with the narcotics traffic, he may have guilty knowledge of it. He is a somewhat unscrupulous eccentric but highly skilled surgeon specializing in obstetrics and gynecology with his own private clinic. Such a combination spells professional abortionist. Politically he is leftist and considers the American officers of the consular service who refused him a visa "silly and stupid swine." His supreme egotism would be likely to get the better of him and a person so wanting in respect of law and order would be likely to become a public charge through incarceration in a penal institution as a result of some illegal act.

The department's legal adviser concurred: "In view of the questionable associations of this man and his close association with dope dealers there is reason to believe he is one himself—I would not give this shabby individual the benefit of the doubt—birds of a feather flock together." These statements are from documents in the National Archives in Washington.

Ultimately, after the Shanghai police had attested that their records contained nothing detrimental to the doctor's character and after much persistence on the part of the U.S. Consul General in Shanghai, Fuchs was granted a visa and arrived in Seattle in April 1937. Interestingly, Fuchs ultimately became a naturalized U.S. citizen, which would not have been possible had the authorities had one hard fact against him. The customs officer who examined Fuchs's belongings upon his arrival noted that "included in his baggage was a large Bugatti automobile."

Fuchs settled on Long Island, New York, where he went through some rough times. Unable to practice surgery because of board requirements, he became a general practitioner. He moved from a spacious house to a smaller one. Several lawsuits were brought against him, he suffered from ulcers and depression, and adding to his troubles, the engine block on the Bugatti Royale froze and cracked during its first winter on Long Island. Fuchs was apparently unable to afford the repairs, and the car, being too large for his garage, sat in his backyard covered by a canvas sail, where it continued to deteriorate. In 1943 it was hauled to a junkyard in New York City. Charles A. Chayne, then an executive with General Motors in Detroit, had first seen Fuchs's Royale at a race on Long Island in 1937, and when a friend told him of its whereabouts in 1943, he immediately arranged for its rescue and eventually restored it. The car was back on the road by 1947, and Chayne and his wife drove it for the next decade. In 1958 the Chaynes donated the Bugatti Royale to the Henry Ford Museum in the hope that more people would be able to enjoy it and the vehicle would receive proper care.

Survival Car I

In 1952 the Liberty Mutual Insurance Company of Boston launched a project aimed at reducing the number of fatalities and injuries caused by automobile accidents. Cornell University's Aeronautical Laboratory in Buffalo, New York, then a leader in crash-injury research, lent its design and research expertise to the project. Among the innovations that the project spawned were the concepts of "packaging" passengers for safety, simulating accidents to analyze how injuries are incurred, and using dummies in auto-crash testing.

One of the two "survival cars" that eventually came out of the project is pictured here. The tanklike vehicle—basically a 1961 Chevrolet Bel Aire—incorporates some sixty-five safety features for preventing accidents or reducing injuries when accidents do occur. The car has, among many other things, roof roll bars, bucket seats with headrests, seat belts, a hydraulic steering mechanism, a collapsible steering wheel, and folding doors that will withstand a crash. Although auto manufacturers thought the safety features on the survival cars would not sell, more than fifty of them are standard equipment on today's automobiles. Liberty Mutual, which sought no patents on the research or designs developed for the survival cars, donated both vehicles to the Henry Ford Museum in 1992.

Acc. 92.172.2.

Lincoln X-100

President John Fitzgerald Kennedy was riding in this limousine when he was assassinated in Dallas on November 22, 1963. A tragic day in American history, the event also altered the way future presidents would transport themselves in public. When President Kennedy was shot in "X-100," as the Secret Service called the parade vehicle, it was completely unarmored and open; although it had a removable bubble top, the top was not in place. Designed to make its occupants as visible as possible, it even had a rear seat that could be raised some ten inches.

After Kennedy's assassination, President Lyndon Johnson had the car remodeled. Hess & Eisenhardt of Cincinnati, Ohio, which had created the original vehicle from a 1961 Lincoln convertible, undertook the work and, in collaboration with the Ford Motor Company, added armor plate, bulletproof glass, and a transparent, bullet-resistant top permanently fixed to the vehicle. The remodeled limousine weighed 9,800 pounds, a full ton more than the original. Lyndon Johnson used the car for the first time in late 1964. It remained in use until 1969, when President Richard Nixon replaced it with another armor-plated Lincoln.

The Ford Motor Company, which has been providing U.S. presidents with Lincoln limousines since 1939 and which had leased the Lincoln X-100 to the White House, donated the vehicle to the Henry Ford Museum in 1978.

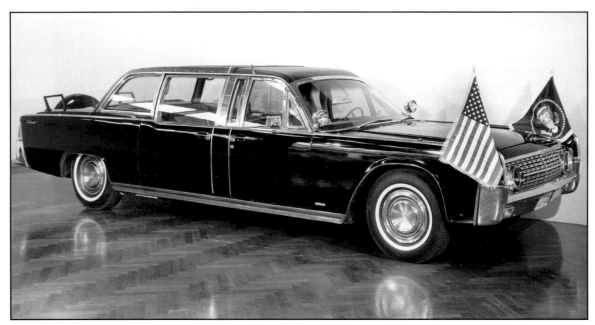

Acc. 78.4.1. Neg. B.90245.

Lotus-Ford Racer

In England in the late 1940s, Colin Chapman began designing the Lotus, a lightweight racing car with a rear-mounted engine. The Lotus soon became known for its excellent ability to hold the road. In 1962 Chapman and engineers from the Ford Motor Company started collaborating on a car that they hoped would successfully challenge the heavy, front-engined, Offenhauser-powered roadsters that had dominated the Indianapolis 500 Race since World War II. In 1963 Chapman and Ford entered two Lotuses in the Indy 500. Powered by lightweight Ford V-8 engines and driven by Jimmy Clark and Dan Gurney, they finished second and seventh—results that shook the racing-car establishment and quickly led to a change in the design of racing cars.

Two years later, forty-five of the sixty-eight cars entered in the Indianapolis 500 had rear-mounted engines, and twenty-two of those were Ford V-8 engines. The time trials of the 1965 race were spectacular. Records were broken every hour, and for the first time, speeds of over 160 miles per hour became commonplace. Jimmy Clark once again drove for the Lotus team, and he dominated the race, leading the pack for all but ten of the 200 laps in the Lotus-Ford racer shown here. The car's skin-riveted, stressed aluminum body is painted British racing green and has a six-inch yellow stripe. The double overhead camshaft engine developed 510 horsepower at 8,600 revolutions per minute, and the car had a top speed of well over 200 miles per hour. The Ford Motor Company donated the historic racer to the Henry Ford Museum in 1977.

Acc. 77.21.1. Neg. B.77240.

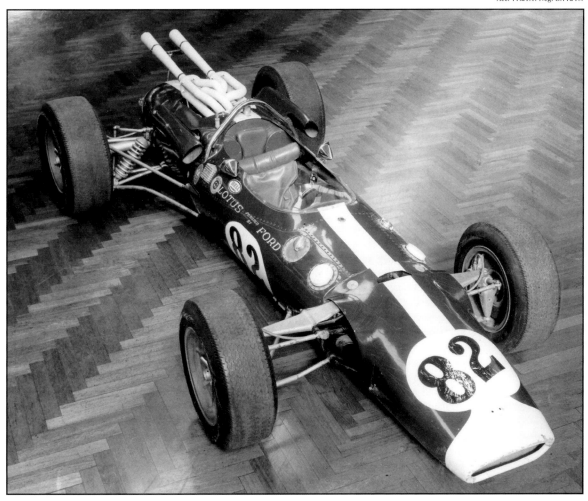

"Sunrunner"

In July 1990, General Motors sponsored the first "GM Sunrayce U.S.A.," a competition in which solar-powered cars built and driven by students raced from Florida to Michigan, a distance of 1,600 miles. The "Sunrunner," created by a team of 140 engineering students from the University of Michigan in Ann Arbor, covered the distance in eleven days and came in an hour and a half ahead of its closest competitor. Four months later, in November 1990, the Sunrunner placed third in the World Solar Challenge, a 1,900-mile race across the Australian Outback; competitors included automotive companies, private individuals, and students from Germany, France, Japan, Australia, and the United States.

The Sunrunner is powered by a solar array of 14,057 silicon cells covering an area of 140 square feet. The wattage thus produced—a peak of 1,400 watts—is applied to a battery that drives a two-horse-power electric motor; the motor, in turn, drives the right rear wheel. The chassis is aluminum alloy; the body is made of Kevlar/Nomex. The vehicle weighs 520 pounds.

When the members of the University of Michigan's solar car team decided to retire the Sunrunner, they felt it should be displayed "in a distinctive institution because of its several unique features." The team donated it to the Henry Ford Museum in 1990.

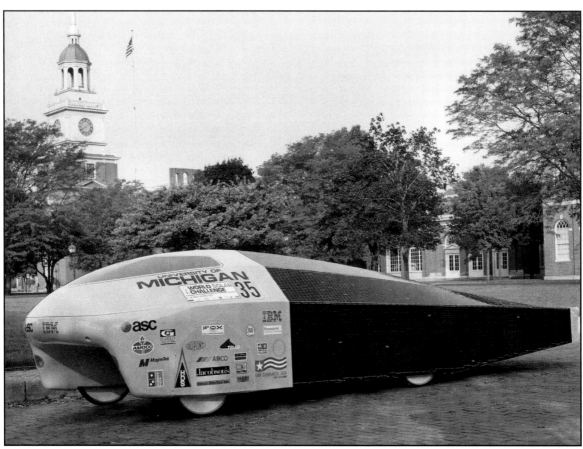

Acc. 91.6.1. Neg. B.107263.4.

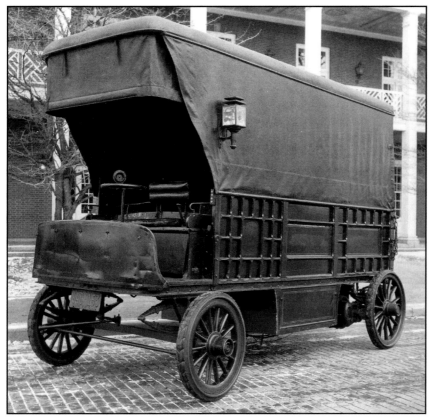

Electric Delivery Truck

Before the advent of suburban malls, where customers park their cars, shop, and then tote their purchases home with them, most shoppers rode on trolleys or buses to downtown stores, which routinely did customers the kindness of delivering their purchases to their homes. Around the turn of the century, a few large department stores began switching from horse-drawn delivery wagons to motorized trucks. B. Altman & Company, once a proud Fifth Avenue establishment, was one of the first department stores in New York City to do so. B. Altman decided on using electric-powered delivery vehicles—presumably because they were considered clean, quiet, and fast—and it acquired its first one in 1898. By 1900 the company had a fleet of twelve electric trucks, including the one shown here.

This vehicle, about fourteen feet long and weighing over six thousand pounds, was considerably bigger than the others in B. Altman's fleet. It was built to transfer large numbers of parcels from Altman's department store in midtown Manhattan to a "stable" in Harlem, where the company kept six or eight trucks for making deliveries in that part of the city. The truck made the six-mile trip twice a day. Manufactured by Fredrick R. Wood & Sons of New York, it had a Westinghouse motor and could travel twenty to thirty miles on a single charge of its battery. With various alterations, it remained in B. Altman's service for over twenty-five years, a longevity not enjoyed by any similar vehicle in New York in that era (or probably any other era, for that matter).

B. Altman's use of electric trucks attracted much scientific attention. Among those who evinced an interest was Thomas Edison, who knew the founder of the company personally. Edison asked permission to experiment with one of Altman's electric trucks to see if he could develop a new type of storage battery that would extend its radius of travel. After "several thousand experiments," Edison's laboratory evidently "evolved a superior type of equipment"—but not superior enough to ensure the future of electric vehicles.

By 1932 B. Altman's old electric van, which had once made the six-mile trip between midtown Manhattan and Harlem twice daily, had somehow come into the possession of the United Parcel Service of New York City. Writing to the sales manager of the Ford Motor Company on May 27, 1932, Russel K. Havighorst of UPS noted that the vehicle "has no commercial value, but before we destroy it, it occurred to us that Mr. Ford might be interested in adding this to his very extensive museum"—hence, another artifact in Henry's attic.

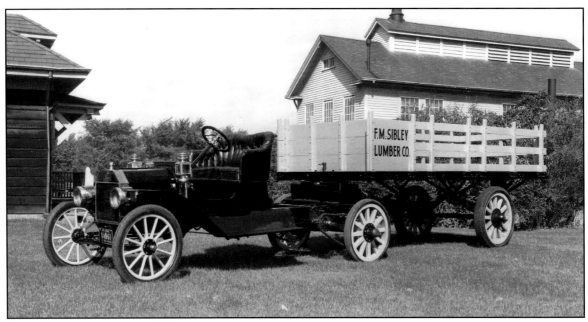

Converted Model T and Trailer

The truck-trailer combination shown here is an ancestor of the tractor and "semi" rigs that now rumble over American highways by the thousands. In 1913, three years before Ford began manufacturing trucks, Frederick M. Sibley, a Detroit lumber dealer, converted his 1911 Model T car into a one-ton truck with chain-driven rear wheels. To do so, he used the "Smith Form-a-Truck" unit newly introduced by a Chicago firm. The vehicle, however, wasn't capable of hauling Sibley's boat to his new summer place in upper Michigan, and Sibley wasn't happy about the length of time it would take a horse and wagon to get there. In 1914 he went to see August Freuhauf, a Detroit blacksmith, about his problem. Freuhauf removed the flatbed of Sibley's converted vehicle, installed a hitch, and attached a sturdy two-wheeled wagon by means of a pole that acted as both tongue and brace. The "semi-trailer," as Freuhauf called it, performed so well that Sibley ordered a long platform trailer to deliver lumber to his customers. Freuhauf soon had orders from other businessmen for trailers like Sibley's, and, abandoning his forge, he embarked on the manufacture of "semis."

The company that August Freuhauf founded, the Freuhauf Trailer Company of Detroit, donated the trailer to the Henry Ford Museum in 1962. The converted Model T was a gift from the Ford Motor Company in 1952. The brass lamps on the Model T are part of a large collection of automotive items that Dr. Samuel L. Scher of New York City gave to the museum in 1963.

Nash Quad Truck

Charles W. Nash was president of the Buick Motor Company from 1910 to 1912 and of General Motors from 1912 until 1916. After leaving GM, Nash bought the Thomas B. Jeffery Company of Kenosha, Wisconsin, and renamed it the Nash Motors Company. Jeffery had manufactured trucks as well as passenger cars, and although it was unusual at that time for a manufacturer to produce both cars and trucks, Nash continued Jeffery's practice. The Quad truck, which Jeffery had introduced in 1913, was a well-engineered vehicle with four-wheel ("quadruple") drive. A durable workhorse, the Quad was ideally suited to the requirements of U.S. Army engineers who, even before World War I began, were looking for "a truck that would travel 24 hours a day if necessary but which would also go anywhere a four-mule team would go." In 1918, its first full year of production, Nash Motors built more than 11,000 Quads, most of them for the army, and it thus established itself for a brief time as the largest truck manufacturer in the world.

Nash advertised its one-and-a-half-ton Quad with the apt slogan, "It drives, steers, and brakes on all four wheels." In the Quad, power was applied to all four wheels simultaneously, and patented differentials ensured that any one wheel would drive the truck regardless of the traction afforded by the other three; it was therefore almost impossible to stall the vehicle. All four wheels were used for steering, and all four were equipped with brakes, which greatly reduced the possibility of skidding. The Quad could easily negotiate mud and mire—a key factor in its popularity not only with the army but also among ordinary citizens, for before World War I, more than 90 percent of the nation's two million miles of roads were unpaved. Despite the Quad's success, Nash in 1919 decided to concentrate on passenger cars, and by 1928 it was no longer producing trucks.

The Nash Quad shown here was built around 1918. It was an early gift to the Henry Ford Museum, and neither the name of the donor nor the date of the donation is known.

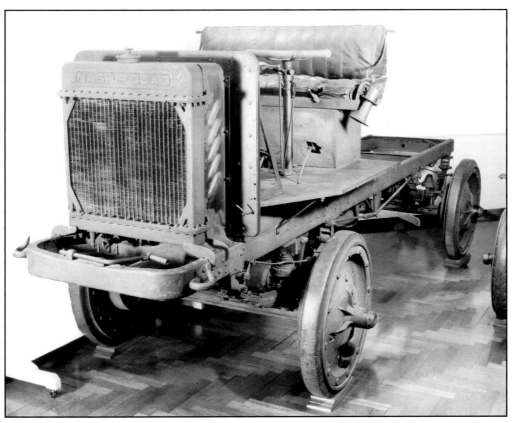

Acc. 00.3.13569. Neg. B.2760.

Fire Truck

The American LaFrance Fire Engine Company delivered "Old Betsy," as this venerable machine is called, to officials of the village of Wayne, Michigan, on June 19, 1928. A pioneer in the manufacture of motorized firefighting equipment, LaFrance was established in 1873 in Elmira, New York, by Truckson LaFrance, descendant of a family of French Huguenots. The company, which began by making steam-powered fire engines, built its first gasoline-powered fire truck in 1910 for the town of Lenox, Massachusetts. It was the first piece of fully motorized fire apparatus made and sold in the United States. In the same year, realizing that conventional gasoline engines were not suited to fire apparatus, LaFrance began designing its own six-cylinder engine.

By the time Wayne's fire department retired its LaFrance truck to parade and stand-by service in 1958, Old Betsy had carried firefighters to more than nine hundred blazes. Weighing six and a half tons and powered by a six-cylinder, 130-horsepower, T-head engine, the truck could pump a thousand gallons a minute and had a top speed of sixty miles per hour. It was equipped with right-hand steering, three wooden ladders, and four lengths of hard-suction hose. The City of Wayne, Michigan, donated the fire truck to the Henry Ford Museum in 1978.

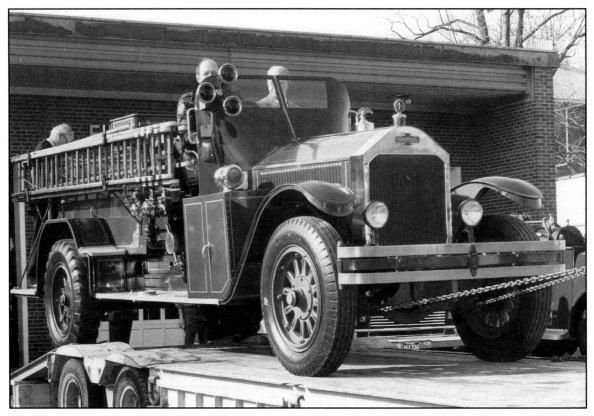

Acc. 78.78.1. Neg. B.82303.1.

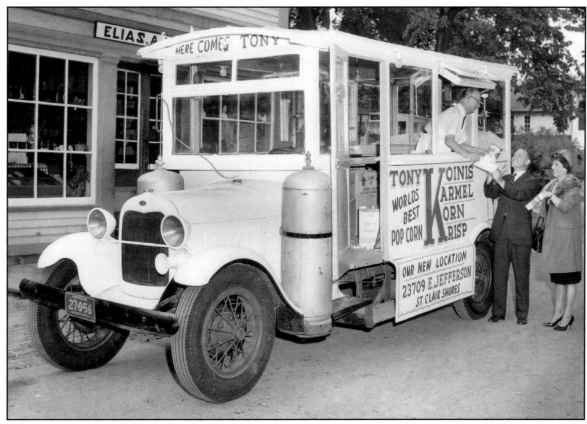

Acc. 62.166.1. Neg. B.33994.

Popcorn Wagon

Ernest "Tony" Koinis, who came to the United States from Greece in 1907, set up his own popcorn business in Toledo, Ohio, in 1914. By 1928 he was in Detroit, converting his new Model A truck to a popcorn wagon, which he proceeded to park on a street corner in the suburb of Grosse Pointe. Although the wagon was a traffic hazard and a local ordinance prohibited itinerant vendors, Tony managed to stay in business in Grosse Pointe for almost thirty years—though with quite a few interruptions occasioned by his running legal battle with the local authorities. Finally, in 1957, Tony moved his truck to the adjacent, and presumably more hospitable, town of St. Clair Shores. In 1962, after deciding to build a permanent popcorn stand in St. Clair Shores, Tony donated his wagon to Greenfield Village, where it was immediately put to work selling popcorn to visitors. It continued in that role until 1985, when Greenfield Village sold it at auction.

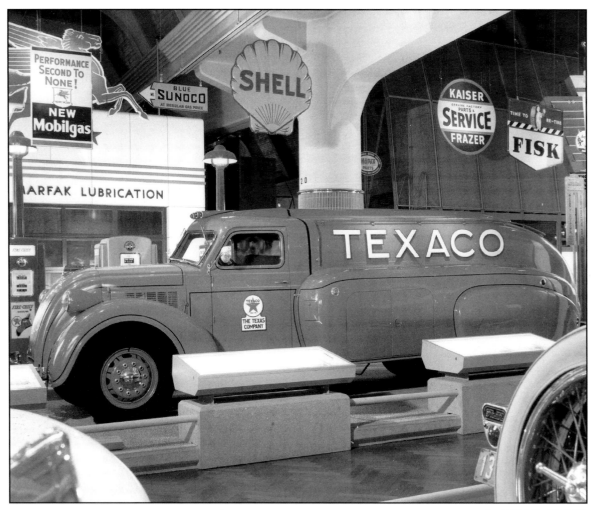

Acc. 84.159.1. Neg. B.103149.2.

Airflow Tank Truck

This streamlined 1939 Dodge Airflow tanker is the epitome of high style in heavy-duty haulers. The Chrysler Corporation made 265 of these vehicles between 1934 and 1940; by the mid-1980s, only five or six of them were still in existence. Custom-built, they were patterned after the very popular Airflow automobiles that Chrysler produced from 1934 until 1937. The airflow design is said to have influenced Ferdinand Porsche's design of the Volkswagen beetle. The tank truck shown here has a six-cylinder engine, a five-speed transmission, and hydraulic brakes. The tank itself has five compartments that can hold up to 1,175 gallons of fuel.

Chrysler delivered the Airflow tanker to the Texas Company (later Texaco) in New York City on September 21, 1938. It was rotting away in Indiana when Donald A. Crane of Saginaw, Michigan, came upon it and bought it in 1973. Unable to restore the vehicle himself, Crane donated it to the Henry Ford Museum in 1984. It was subsequently reconditioned at a cost of $60,000—an indication of how highly the museum valued it.

Wienermobile

The first Oscar Mayer Wienermobile made its appearance on the streets of Chicago in 1936. Sporting a thirteen-foot-long hot dog, the "product-mobile" soon proved its promotional worth, attracting attention wherever it went. In the early 1950s, Oscar Mayer commissioned the Gertenslager Company of Wooster, Ohio, to build a fleet of five Wienermobiles, which were subsequently used to promote Oscar Mayer products at public functions in various parts of the country.

Although other companies also used "productmobiles," the Wienermobile became the best known and most enduring of them all. The one shown here, built in 1952, is from the first fleet of five Wienermobiles, and in 1988 Oscar Mayer commissioned yet another fleet of six. The 1952 Wienermobile used a Dodge chassis to carry its twenty-two-foot-long metal hot dog. In 1969 the vehicle was rebuilt with a Chevrolet V-8 engine.

The Oscar Mayer Foods Corporation of Madison, Wisconsin, donated the Wienermobile to the Henry Ford Museum in 1991. As the director of the museum accepted the gift, he noted that the Wienermobile "reflects an innovative combination of transportation and product promotion that brings together two of America's greatest loves—cars and hot dogs."

Acc. 91.143.1. Neg. B.107185.1.

Acc. 88.381.1. (trailer); 88.381.2. (tractor). Neg. B.104203.

Tractor Trailer

After World War II, the type of tractor trailer shown here became a familiar sight on American highways. It presents an interesting contrast to the Model T-trailer combination that Detroit blacksmith August Freuhauf rigged up for Frederick Sibley in 1914. This "semi-trailer" was, in fact, built in 1946 by the firm that Freuhauf founded, the Freuhauf Trailer Company. The Federal Motor Truck Company, also of Detroit, assembled the tractor in 1952 and sold it to Coles Express of Bangor, Maine, a family-owned freight carrier in business since 1917. Coles Express donated the tractor to the Henry Ford Museum in 1988; Freuhauf donated the trailer at the same time.

CHAPTER 5
Touring Vehicles and Highway Icons

IN RECENT YEARS, the Henry Ford Museum has acquired a number of objects pertaining to the history of recreational travel. Among these objects are a variety of camping vehicles, a tollbooth, a gas station, a tourist cabin, and advertising signs ranging from small, painted "Burma Shave" boards to the huge single arch of an early McDonald's and the flashing neon lights of a Holiday Inn—the "cultural icons" of twentieth-century America. Although part of living memory, many of these reminders of the sights and sounds associated with touring America by automobile have already disappeared from the roadsides. As the years go on, their nostalgic value can only increase.

These items are all part of a large, permanent display installed in the museum in 1987 to illustrate the history of the automobile and its impact on American life. The exhibit, entitled "The Automobile in American Life," demonstrates not only the development of the automobile but also the roadside amenities that arose to cater to the motorist.

A scene from "The Automobile in American Life" display

Tollgate Sign

Dating from about 1875, this tollgate sign is certainly one object in the Henry Ford Museum's collection of touring items that is not part of living memory. It was donated to the museum by C.B. Titus of Rochester, Michigan, in 1937. The sign sets forth the fines for avoiding tolls and the "rates of tolls" imposed by "an Act of the Legislature of Michigan," approved "Feb. 9th, 1853." It was posted on the main road to Chicago, about five miles west of Detroit and less than three miles from Henry Ford's birthplace. Another tollgate was located three miles farther east, and another three miles to the west.

Early toll roads in Michigan were built by private individuals, who recouped the expense of the construction by collecting the tolls. Very often, however, they spent nothing on maintenance, and as a result, the roads became all but impassable, but the owners collected the tolls nonetheless. The roads were frequently made of planks laid lengthwise. In 1926, noting that "if there was ever a road hard to travel on, it was a plank road out of repair," Clyde M. Ford of Dearborn recalled what happened to the property of one plank-road owner in the area:

The Plymouth Road . . . continued to get worse with the toll going on just the same, until there were no planks in sight, only mud; and the end of the collecting toll came one night when a rope was put around the old house which served as the keeper's quarters for the toll gate, and there were plenty of strong arms and backs on hand to pull the thing over. Later, a company was formed of the Fords and others, . . . and they built a new gravel road and maintained it by each drawing a certain number of loads of gravel per year. This continued until the County took over the road in 1910.

Acc. 37.176.1. Neg. B.27340.

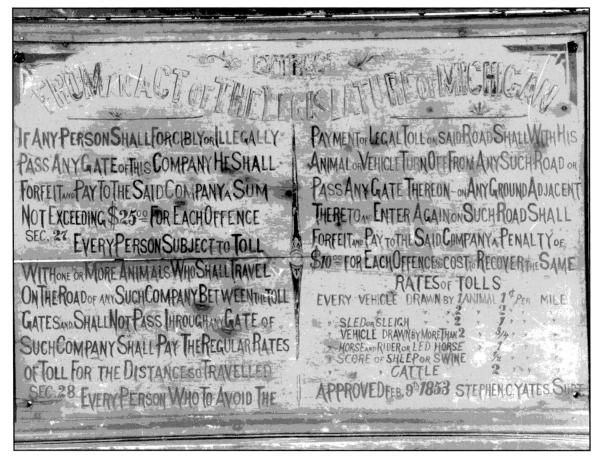

Acc. 88.238.1. Neg. B.103633.5.

Tollbooth from the Merritt Parkway

When Connecticut opened the Merritt Parkway in 1937, the road was toll-free. A few years later, the state imposed tolls and installed temporary booths. In the early 1950s, those booths were replaced with ones of a unified design, and the booth shown here was installed at that time. Blakeslee, Arpaia, Chapman, Inc., of Branford, Connecticut, donated the tollbooth to the Henry Ford Museum in 1988. It has since been restored and erected in the museum's exhibit on the "Automobile in American Life."

"Gilkie" Camp Trailer

Camp trailers became very popular during the late 1920s. E.P. Gilkinson & Sons of Terre Haute, Indiana, manufactured this high-quality model, known as the "Gilkie," about 1921. The Gilkie's tent folded down into a box mounted on a two-wheel trailer. Ann Bauduc of New Orleans donated the Gilkie in memory of her late husband to the Henry Ford Museum in 1987. Shown here on display in the museum with camp chairs and picnic gear, it has a 1929 Ontario license plate and a sign reading "Camp Wahoo."

Acc. 86.128.1. Neg. B.102863.

Motor Home of 1923

This was one of the first mobile homes ever seen in the United States, and it probably had a longer life than most such vehicles. The body, custom-built by a small shop in St. Louis in 1923, was mounted on a Model T truck chassis. Amenities included a trundle bed, a cast iron wood-burning stove, and a graniteware sink. The original owners of the vehicle were John Stanton Chapman and Mary Isley Chapman, a husband-and-wife writing team. The Chapmans traveled through twenty-four states in their "Nomad," as they called it, gathering material and inspiration for children's books, magazine articles, and some forty or fifty novels, which they published under the name "Mariston Chapman."

In 1928, wanting more speed and power from their motor home, the Chapmans had the body remounted on a truck chassis built in Detroit by Graham Brothers (a name that was soon dropped in favor of Dodge Brothers, which bought out Graham in 1927 and which in 1936 shortened its own name to the still-familiar one of Dodge). The Graham chassis included a six-cylinder, fifty-horsepower engine.

When the Chapmans finally sold their motor home at an antique car show in Cincinnati in 1970, the new owners hitched the vehicle to their car and started off for Arizona. Their car, however, broke down, and they ended up hitching it to the motor home, which took them the rest of the way. The "Nomad"—as Mary Chapman gleefully noted in a letter she wrote to its third owner, Robert D. Miller of Wapakoneta, Ohio, in 1976—was still roadworthy at age forty-seven. She was also pleased to note that although Thomas Edison, Henry Ford, and Harvey Firestone may have built "house cars" for camping trips about the same time she and her husband purchased theirs, the "Nomad" traveled much farther than those vehicles and was owned by people of moderate means who had no connection to the automotive industry. Robert D. Miller donated "Nomad" to the Henry Ford Museum in 1981.

Burma Shave Signs

From the 1920s through the 1940s, Burma Shave signs were a very effective form of highway advertising. While driving by the signboards, young and old alike enjoyed reading their witty rhymes. The Burma-Vita Company, a division of ASR Products Company of Minneapolis, made this set of six signs as a gift for the Henry Ford Museum in 1965. They read: "Within this vale / of toil / and sin / your head grows bald / but not your chin / Burma Shave." Shown here at an auto show in Detroit's Cobo Hall in 1965, they are now part of the museum's "Automobile in American Life" exhibit.

Acc. 65.75.1. Neg. B.42345.

Tourist Cabin of 1930

Before Holiday Inns and other motel chains came into existence in the 1950s, cabins such as this offered the traveler just about all there was in the way of roadside lodging. This one, twelve-feet square, was part of a group of four cabins built about 1930 in Brooklyn, Michigan, on U.S. Highway 12, which was then the main road between Detroit and Chicago. In 1986 Bernie and Helen Reinink, the current owners of the "Lore Mac Cabins," as they were called, donated the cabin to the Henry Ford Museum. Frequent visitors to the museum themselves, the Reininks believed their gift would enhance the "Automobile in American Life" exhibit the museum was then planning. The cabin came to the museum equipped with a metal bed, a semicircular pedestal table, a ceramic lamp, a ceiling lamp, some wicker chairs, a plywood vanity, a Bible, and assorted other furnishings.

Elsie Farley, whose parents were the original owners of the cabins, and Dale Maier, who also knew the place in its early days, shared their memories of the cabins in a letter to the museum in 1986:

The walls of the cabins were covered with a beaver board material. The lower half was also covered with a plywood which was stained a rather dark brown. . . . We both remember how the beaver board was inclined to buckle a little—made like some waves in the wall covering. . . .

The bedspreads were all white chenille

spreads. . . . The chenille was in a pattern—and not heavily endowed with chenille—they looked quite inexpensive.

The first window coverings were pull down shades and curtains. . . .

The original heating was with small pot-bellied stoves. They used corn cobs and newspapers to start the fire, then added wood, or coal.

There was linoleum on the floor with throw rugs by the bed.

There was a commode under the bed. We both think they were a white enamel, rather

round pail type with a lid and a wire handle.

There were no pitcher and bowl sets in the cabins. They had to go to the shower room which was in another building. There was Men's and Women's shower rooms with shower, stool and basin. They used to white-wash the shower room walls, ceilings and floor of shower. Always looked so clean.

We're not sure what they charged for the cabins—we think it was probably $2.50 for the single cabin and perhaps $4 or $5 for the double.

The cabins were open all thru the winter.

"Stagecoach Darien"

Although Henry Ford bought this "Stage-coach" trailer for his museum to demonstrate trends in modern travel, he and Clara Ford are said to have used it on at least one occasion. Built in 1935 by the Ideal Manufacturing Corporation of Mishawaka, Indiana, the twenty-three-foot-long Stagecoach is more fully equipped than most other house trailers of that era. It has electric lights, a stove, ice box, sink, kitchen cabinet, bathroom, convertible beds, storage closets, and an oil heater vented through the roof.

In 1942 Charles A. Lindbergh, who was then working at Ford's Willow Run B-24 bomber plant as an unpaid aviation consultant and test pilot, mentioned to Henry Ford that he was thinking of buying a trailer so that he and his wife, Anne Morrow Lindbergh, would have a place to work on their manuscripts without distraction. Henry promptly gave the Lindberghs the Stagecoach trailer, and for the next fifteen years, they did all their writing in it and also traveled in it with their family through some thirty-six states. When the Lindberghs moved to Darien, Connecticut, they began calling the trailer "Stagecoach Darien."

In 1957, noting that the trailer was beginning to show signs of fatigue and that it would be difficult to keep it in good condition outdoors for much longer, Charles Lindbergh returned it to its original home, the Henry Ford Museum.

Acc. 57.72.1. Neg. B.20015.

Texaco Gas Station

Built in 1937 in Kingston, Massachusetts, this gas station underwent some modernization in 1960, when new signs, pumps, and porcelain exterior paneling were added. Cumberland Farms, Inc., of Canton, Massachusetts, gave the station to the Henry Ford Museum in 1987. It was reconstructed at the museum with funds donated by the Texaco Philanthropic Foundation of Houston. It is fully equipped with tires, cans of motor oil, filters, fanbelts, a cash register, a clock, and various other items, all given to the museum by individual donors. The large "banjo" Texaco sign was a gift of Texaco Refining and Marketing, Inc.

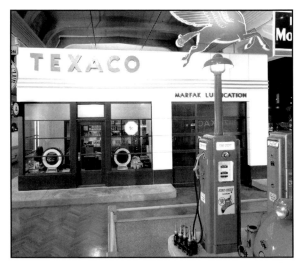

Acc. 87.213. Neg. B.103150.2.

Acc. 87.155.1. Neg. B.102709.7.

"Now smile...
like you owned a *Nash*"

NATIONAL 3M

Advertising
The Automobile

Neg. B.5103241.3.

Automotive Billboards

These ten-by-twenty-foot bill-boards have been a prominent part of the "Automobile in American Life" exhibit at the Henry Ford Museum since 1987, when the exhibit first opened. The New York firm that designed the exhibit included four billboards in its rendering of the display, and the Minnesota Mining & Manufacturing Company of Minneapolis, manufacturer of photomurals, optical reflecting tapes, and other products, paid for the construction of all of them. In addition to the Ford and Nash signs shown here, the exhibit includes two others advertising the Packard and the Volkswagen. Beneath the billboard displaying the 1949 Ford are some of the museum's classic cars, all of which were also gifts to the museum: in the foreground, a 1934 DeSoto Airflow; behind it, a 1940 Lincoln Zephyr; and on the right, a 1940 Lincoln Continental convertible and a 1937 Cord roadster.

Holiday Inn Sign

When Holiday Inns Inc. opened its first motel in 1952 and for at least ten years thereafter, its primary customers were families traveling by automobile on the new interstate highways, and almost 95 percent of them came to the inns without reservations. One of the drawing cards for these passersby was the Holiday Inn's green, yellow, and orange neon "Great Sign," so called because of its imposing size and high roadside visibility. Forty-three feet tall with a flashing arrow and blazing star, it was hard to miss. By the mid-1980s, Holiday Inns' clientele had changed, and so had its sign. Less than 3 percent of its customers were "walk-ins" without reservations. No longer needing such a prominent sign, the company switched over to a smaller one that was considerably more energy-efficient and that also cost a good deal less to build—$23,000 as opposed to $35,000 for the "Great Sign."

In 1987 Holiday Inns Inc. of Memphis, Tennessee, donated the "Great Sign" shown here to the Henry Ford Museum. Dating from 1960, it was the first Holiday Inn sign to be erected in Michigan. At the same time, Holiday Inns also gave the museum a fully furnished motel room of 1952 vintage. The photograph shows Steven K. Hamp accepting these gifts on behalf of the Henry Ford Museum & Greenfield Village.

Acc. 87.157.1. Neg. B.10656.8.

Drive-In Movie Sign

The Mulholland Sign Company of Kalamazoo, Michigan, made this sign in 1954 for the Douglas Auto Theatre, a drive-in movie in Kalamazoo that stayed in business until 1984. Twenty-one feet long and over ten feet high, the sign is trimmed in flickering neon lights that alternately display the silhouette of a car popular in the mid-1950s and one dating from the early 1920s. In 1987, after buying the property where the drive-in had been located, Kalamazoo College donated the sign to the Henry Ford Museum. It is now at the entrance of the museum's theatre, which shows films depicting the vicissitudes of automobile travel over the decades.

The automobile appearing in the foreground, an example of "Car Culture" of the 1950s, is a 1949 customized, 270 horsepower Mercury convertible, modified by Barris Kustom Industries of North Hollywood, California. Price as a stock Mercury was $2409; the customized version cost $3900. The vehicle was on loan to the museum for some time with prospects of its becoming a gift, but final arrangements called for a payment of $35,000.

Acc. 87.84.1. Neg. B.101654.5.

Acc. 87.153.1. Neg. B.102710.7.

Volkswagen Camper

The Volkswagen camper, the first factory-built, self-contained camper most Americans ever saw, evolved from the famous Volkswagen "beetle," which was conceived as part of Hitler's plan for the future of Nazi Germany. When Hitler decreed in 1933 that Germany must have a *volkswagen* ("people's car") for the ordinary workingman's family, Ferdinand Porsche was chosen to design it. After World War II, the inexpensive VW beetles with their rear-mounted air-cooled engines quickly became popular all over Europe, and by 1949 they had begun arriving in America.

At about the same time, Volkswagen began producing a boxy minibus using the same mechanical components as in the beetle, and the minibus eventually spawned the Volkswagen bus. In the 1960s, the economical and practical VW bus, whose sides could be easily decorated with murals and decals, was much in vogue among members of the "hippie" generation. The bus was also available as a camper, with conversion done by Westphalia of West Germany. The camper shown here sold for $2,737 in 1959. Volkswagen advertised its campers as vehicles "for getting away from it all. . . . For the pennywise traveler, low fuel consumption, good performance, ruggedness—indoor comfort, your own living room, bedroom, kitchen, bar—rain can't spoil your trip—no hunting for a motel." Volkswagen of America, Inc., of Troy, Michigan, donated the 1959 camper to the Henry Ford Museum in 1987.

McDonald's Sign

By 1958 McDonald's had sold its 100 millionth hamburger, all of them under the single, neon-lit arch of the original McDonald's sign. The McDonald's sign shown here, twenty-six feet high and reading "Licensee of McDonald's Speedee Service System—Hamburgers, over 200 Million Sold," was installed in August 1960 in Madison Heights, Michigan, at the second McDonald's franchise in the state. McDonald's used the "Speedee," single-arch sign at all its fast-food outlets until 1962, when it switched over to the somewhat less spectacular "golden arches." Daniel Shimel and Ann Brodberg, owners of the McDonald's franchise in Madison Heights, donated the sign to the Henry Ford Museum in 1987. It is shown here as it appears in the museum, with a 1956 Chevrolet convertible beneath it.

Acc. 86.137.1. Neg. B.102693.1.

Acc. 95.23 Neg. 68391.R2.8A; photo courtesy of Buck Miller/CBS

Charles Kuralt's Last Motor Home

This is the last of the six motor homes Charles Kuralt of CBS News used before he retired from his popular televison series, "On the Road." The series began in 1967, when Kuralt and his crew set out in a battered recreational vehicle to see rural and small-town America. They ultimately visited every state in the union many times, logged more than a million miles, and won numerous awards for their human-interest stories. Kuralt's last motor home, almost thirty feet long, with a fiberglass body and a Chrysler industrial V-8 engine, was built about 1972 by the FMC Corporation's Motor Coach Division in Santa Clara, California. Roomy as it may look, much of its interior was devoted to storing television equipment. The CBS/Broadcast Group of New York City donated the vehicle to the Henry Ford Museum in 1995.

CHAPTER 6
Railroads, Boats, and Aircraft

WHEN HENRY FORD was born in 1863, much of the Midwest was unsettled land. A single pair of railroad tracks that started in the East snaked across the vast, empty horizon of the Great Plains and ended in Nebraska. Six years later, the nation's attention was riveted on a remote spot in Utah, where on May 10, 1869, after three years of sweat and toil over the Rockies and the Sierras, gangs of Irish laborers from the East Coast and Chinese workers from the West met to join the transcontinental railroad. It was the crowning achievement of more than thirty years of American railroad building. Spurred by the commercial success of canals—and especially by the opening of the Erie Canal between Buffalo and New York in 1825—railroad companies in the early 1830s had begun competing for the business of transporting passengers and freight.

As early as 1838, the first railroad tracks west from Detroit had reached Dearborn, and by the time Henry Ford's father arrived there from County Cork, Ireland, in 1847, trains were running regularly between Detroit and Kalamazoo. Several different railroad companies had by then run their tracks into Detroit, and the world's first rail ferry was floating trains back and forth over the Detroit River between Detroit and Windsor, Ontario. In 1863 other tracks began covering Detroit's streets, as horse-drawn railway streetcars made their first appearance. By 1879, when sixteen-year-old Henry Ford left the farm in Dearborn for his first taste of city living, more than twenty miles of streetcar rails covered the streets of Detroit. When he returned to the city in 1891 after nine years on the farm, electric trolleys had begun supplanting Detroit's horse-drawn streetcars.

Henry, who had quite a soft spot for things familiar to him from his youth, evidently liked streetcars and had a particular attachment to trains. In 1920 he bought his own railroad—the Detroit,

Toledo and Ironton (D.T. & I.), an almost defunct line of 456 miles running from the Ohio River north to Detroit and crossing the tracks of several other railroad companies in the process. Rejuvenated under Henry's management, the D.T. & I. brought West Virginia coal to the massive plant he was then developing on the Rouge River and transported finished products out of it. Henry envisioned the Rouge plant as a self-sufficient industrial complex that could make its own steel and be completely independent of the vagaries of auto-part suppliers—a vision that reached its full fruition in 1927, when the Rouge plant began producing the second Model A.

Not only did Henry soon find owning a railroad a profitable business; it also suited his idea of fun and relaxation. Instructing his chauffeur to drive until they caught up with one of the D.T. & I. trains, Henry would flag it down, climb aboard the coal tender, and with his chauffeur driving down the road alongside the tracks, he would play his Jew's harp—a tiny instrument he carried about in his pocket—in peace, though hardly in quiet. When Henry climbed down into the engineer's cab to take over the locomotive controls—as he often did—his chauffeur would inevitably find himself left behind in the dust.

Henry's association with boats seems to have been on a somewhat more businesslike level, although he evidently had no antipathy to boating. While working in the machine shops of the Detroit Drydock Company as a boy of seventeen, he would often wander down to the riverfront on a Sunday to watch the yachts and sailboats. On one of those Sundays, he and a friend began making a boat, but as Henry's attention wandered off to other things, it never got into the water. Later in life, Henry owned a pleasure boat that his friend John Hacker, a noted naval architect, had designed for him, and when he was fifty-four, he paid $250,000 for a second-hand

steam-powered yacht called the *Sialia*. He seems, however, to have made that purchase mainly for business reasons. Almost immediately after taking possession of the *Sialia* in 1917, Henry steamed off in it for Cuba to look into the availability of iron ore for his proposed superplant on the Rouge.

As it turned out, World War I ensured that the first product to come out of that plant was not an automobile but a boat, a submarine chaser called the Eagle. Between July 1918 and August 1919, the still-incomplete Rouge plant turned out sixty of these boats for the U.S. Navy. By 1924 Henry had a fleet of giant freighters, barges, and tugs plying the Great Lakes, bound for the Rouge plant with iron ore from his mines in upper Michigan and coal taken aboard at Toledo from his mines in Kentucky and West Virginia. Henry occasionally took his family on short vacation cruises on some of his company's huge freighters, perhaps to please his son Edsel, who, unlike Henry, was a boating enthusiast.

Edsel was also more enthusiastic about aircraft than his father. Born in 1893, Edsel grew up as the accomplishments of the Wright brothers and Glenn Curtiss, another famous aviation pioneer, were gripping the imagination of the nation. At age sixteen, Edsel convinced his father to allow him and a young employee of the Ford Motor Company to build a plane with a Model T motor. Completed in 1910, the plane had a few very short test flights before its crankshaft broke and it was blown into a tree. Although the accident left the pilot—not Edsel (who, like his father, never flew a plane)—relatively unscathed, Henry immediately put a stop to the experiments. Nonetheless, Edsel continued urging his father to keep an eye on aviation developments. Henry, ever interested in anything to do with transportation, ultimately did become involved in the booming new field, and for a while, with Edsel at his side, he attempted to turn Detroit into the nation's aviation center.

During World War I, the Ford plant in Highland Park, where the Model T was manufactured, produced Liberty airplane engines for the U.S. government at the remarkable rate of seventy-five a day. Two years after the war ended, Henry had a brief flirtation with dirigibles, and although he got only so far as building a dirigible mooring tower at Dearborn, his investigations did lead him to predict that flights across the Atlantic would be a reality within five years. His first serious entry into the field of aviation began in 1922 when he and Edsel, together with several other Detroit car makers, invested in a company that was building a commercially feasible monoplane with an all-metal body—the first such craft produced in the United States. In 1924 William B. Stout, the head of that company, appealed to Henry and Edsel to build an aircraft factory with an adjacent airport where he could service and test his planes. Henry agreed to do so, providing that the other stockholders in Stout's company sell out to him. Stout managed to arrange that, and in 1925 the Ford Airport opened in Dearborn.

The Ford Airport was highly innovative. It provided the country's first regularly scheduled passenger flights and the first U.S. airmail service. It had paved runways, hangar space for visiting planes, and the first passenger terminal ever built. The first airport hotel—the Dearborn Inn—opened just across the road from the Ford Airport in 1931. After several instances in which pilots lost their way in bad weather and had to make forced landings, Henry

Neg. B.110870.

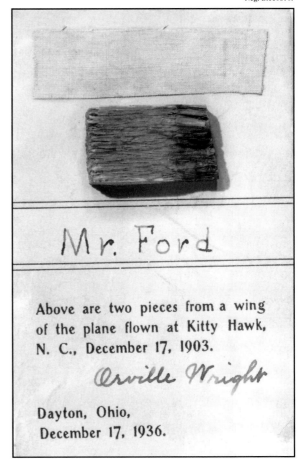

Mr. Ford

Above are two pieces from a wing of the plane flown at Kitty Hawk, N. C., December 17, 1903.

Orville Wright

Dayton, Ohio,
December 17, 1936.

The Gorham Silver Company of Providence, Rhode Island, made this trophy, which Edsel Ford donated to the National Air Commercial Reliability Tours, in 1926. Three feet high, it is now on display in the Henry Ford Museum.

Ford saw to it that an aircraft radio beacon was devised and installed in a corner of the airfield. The same navigational device was used at airports in Cleveland, Chicago, and Buffalo. Although the radio beacon was patented, Henry was glad to have it used freely and never accepted any royalty payments for it.

The Ford Airport also became the focal point in the National Air Commercial Reliability Tours. Conducted each year between 1925 and 1931 under the sponsorship of the Detroit Aviation Society, these tours always originated and ended at the Ford Airport. Representing all the leading aircraft manufacturers, the contestants flew long distances (4,121 miles in 1927) and landed in many cities along the tour route. The idea behind the tours, derived from earlier automobile contests, was to bring the airplane to the people; stimulating public interest in flying would, it was hoped, foster the growth of the aviation industry and the construction of airports. In 1926 Edsel Ford, who was very active in promoting the tours, provided an elaborate silver trophy that was awarded to the winner of each year's tour.

After William Stout's aircraft company became a division of the Ford Motor Company in July 1925, Henry and Edsel Ford embarked on the manufacture of their own planes. The most notable of these was the Ford Tri-Motor. Known familiarly as the "Tin Goose," the Ford Tri-Motor was the darling of the early airlines until the mid-1930s, when the Douglas DC-3 took over. Ford also manufactured a tiny monoplane called the "flivver," which once held the world's endurance record for small airplanes (986 miles). Only two of these were ever built. In 1928 the second flivver crashed off the Florida coast, and Harry Brooks, Henry's favorite pilot, was lost. Henry shelved the plans for the flivver planes, and four years later, in the midst of the Great Depression, he retired from the aviation business. A telling point about Henry's personal regard for aircraft is that the Ford Motor Company had produced a number of its famous Tri-Motors before Henry took his first plane ride, and that was with Charles Lindbergh in the *Spirit of St. Louis*, a Ryan monoplane, in August 1927. The Ford Motor Company returned to aircraft manufacture during World War II, producing more than 8,500 B-24 bombers and over 4,000 combat gliders.

Of the railroad and streetcar memorabilia housed in the Henry Ford Museum & Greenfield Village, the locomotives are probably the most impressive. There are twenty-seven of these recorded, and almost half are full scale. The railroad collection includes a locomotive from the D.T. & I; built in 1897 and called Engine No. 7, it was the one Henry Ford most enjoyed driving. The museum has relatively few boats but a sizable collection of aircraft. Although the museum does not have room to accommodate a B-24 bomber, it does have examples of several other historic aircraft. The items described on the following pages are representative of the scope and diversity of each of these collections.

Acc. 35.788.1. Neg. B.103408.1.

Reproduction of the "De Witt Clinton"

De Witt Clinton (1769–1828), New York's seventh governor, was a vigorous promotor of the building of the Erie Canal. The steam locomotive named after him was the third such engine to pull a train in America and the first to do so in New York state. The West Point Foundry of New York City, the country's first locomotive works, built the "De Witt Clinton" for the Mohawk & Hudson Railroad. It made its inaugural run on a hot August day in 1831. Traveling from Albany to Schenectady over rails previously used only by horse-drawn cars, the locomotive reached a top speed of thirty miles per hour while hauling a covered tender and five passenger cars. The first three cars were covered stagecoaches

on flanged wheels; the last two were open and had lengthwise planks on which the passengers sat facing each other. James Goold of Albany, creator of the popular horse-drawn sleigh known as the Albany cutter, designed and built the coaches.

The passengers on the first excursion included the governor of New York, the high constable of the state, industrialists, and other notables. They found the trip memorable—but not exactly comfortable. As they boarded the train, hundreds of spectators cheered, while others booed and hovered about, fully expecting the exotic engine to blow up in their faces any second. The conductor, seated in the rear of the tender behind barrels of

water and stacks of firewood, gave a blast on a large tin horn, and the train lurched off. Its overgrown stack emitted a dense cloud of smoke and was soon spewing cinders all over the passengers. Flying sparks burned through the tops of raised umbrellas, as passengers, flapping their coats to extinguish incipient blazes, dabbed at their neighbors' clothing, trying to remove stains left by the pitch-pine fuel. Adding to the passengers' discomfort, the train had to stop every six miles so the locomotive could be refueled and its humpbacked boiler rewatered, and each time it did, the coaches jerked violently, slamming the passengers about. To take care of the slack, rails were wedged between the coaches and tied with packing twine.

The reproduction of the De Witt Clinton shown here was made about 1893 from parts of the original at the locomotive shops of the New York Central Railroad, a descendant of the Mohawk & Hudson. Before the New York Central donated it to the Henry Ford Museum in 1935, the reproduction was displayed at Grand Central Station in New York City and at various exhibitions around the country. Only slightly more than sixty-six feet long, the train and locomotive together weigh 25,020 pounds. The reproduction does not include the two open cars that made up the rear of the original train.

"Torch Lake" Locomotive

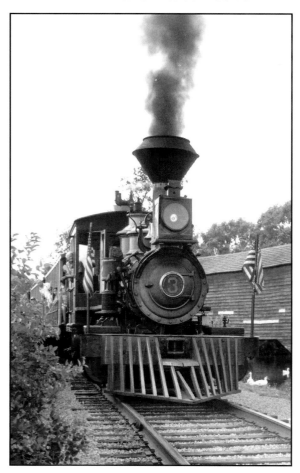

Acc. 69.85.1. Neg. B.78146.

The Mason Machine Works of Taunton, Massachusetts, built about seven hundred locomotives similar to the one shown here between 1853 and 1890, when the firm went out of business. Founded by William Mason, a textile manufacturer who went into locomotive manufacture more as a hobby than a business, the company became famous for its "Bogey" engine, a single-truck unit that allowed the frame and running gear to swivel and negotiate sharp curves. With its short wheel base and maneuverability, the Bogey was ideal for use on logging and mining tracks, where conventional engines had difficulty handling curves and uneven roadbeds.

Mason built this particular locomotive in 1873 for use on the Hecla and Torch Lake Railroad in the copper country of northern Michigan. The "Torch Lake" is the only locomotive with a Mason Bogey still in existence. It hauled copper ore from the mines of the Calumet and Hecla (C & H) Corporation on the Keweenaw Peninsula for fifty-nine years, with time out for repairs and remodeling after it was damaged in a roundhouse fire in 1910. In 1932 C & H decided to retire the "Torch Lake" and preserve it as a relic. In 1969 C & H, by then part of the Universal Oil Products Company with offices in Evanston, Illinois, donated the venerable locomotive to Greenfield Village, where it has been pulling cars filled with tourists ever since.

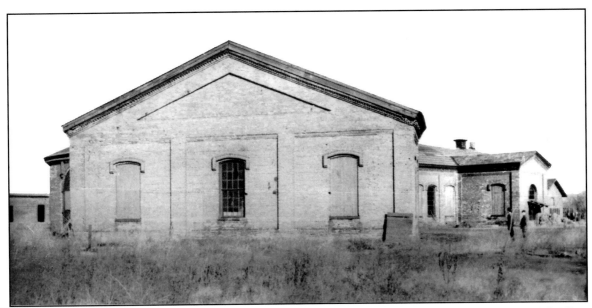

Acc. 92.24.1. Neg. B.110869; photo courtesy of Richard Carver, Marshall, Michigan.

Railroad Roundhouse

Marshall, Michigan, now a town of well-preserved vintage homes and storefronts, was once a thriving railroad center. There, in April 1863, men from the Michigan Central Railroad met to form the nationwide Brotherhood of Locomotive Engineers, an organization that is still in existence. About 1882 Marshall became the site of the six-stall roundhouse shown here. It was built by the Detroit, Toledo, and Milwaukee Railroad, which stored and repaired its locomotives in the structure for many years. By the 1930s, however, the Detroit, Toledo, and Milwaukee, like other railroads, was not only feeling the effects of the Great Depression; it was also losing a share of its freight and passenger business to the trucks and buses that had by then become familiar sights on American highways.

The roundhouse was abandoned sometime during the 1930s, and by 1992 it was in a state of total disrepair. Just days before it was scheduled to be demolished, the Henry Ford Museum & Greenfield Village obtained the permission of the owner, Nick Heemsoth of Marshall, to remove some of the roundhouse's important architectural elements: roof trusses, doors and door posts, windows and window sills, and several thousand bricks. Drawings made of the roundhouse as it was being taken down will be used as a guide when the building is eventually reconstructed at Greenfield Village from the salvaged materials. Of course, projects like this one are sometimes delayed until funding is available.

Railroad Handcar

In 1877 George Sheffield of Centreville, Michigan, built a three-wheeled railroad handcar, which he called a "velocipede." He used the handcar to commute along the tracks of the Michigan Central Railroad to his job in Three Rivers, six miles away. On one of his trips, he noticed a broken rail, flagged down an oncoming train, and thus averted a potentially serious accident. Railroad officials, taking notice of Sheffield and his velocipede, decided that such a vehicle would be useful as an inspection car, and they asked Sheffield to build more of them. This he did for the next forty-five years as head of the Sheffield Velocipede Car Company in Centreville.

Depending on who was driving them and why, handcars could be fast. On one occasion in Michigan's Upper Peninsula, an engineer pulled his train out of a station, mistakenly thinking the conductor was aboard. The conductor immediately grabbed a handcar and by the next station had caught up with the train. The handcar shown here, which Sheffield built about 1880, can travel at thirty to thirty-five miles per hour. It has a wooden frame, metal foot pedals, a carrier behind the seat and a small tool box in front of it, and two crosspieces on the pump handle. Its third wheel, smaller than the other two, is attached to the main frame by a simple crossbar. The Michigan Central Railroad donated the Sheffield handcar to the Henry Ford Museum in 1940. It is now sometimes seen being pumped vigorously along the railroad tracks at Greenfield Village.

Acc. 40.81.6. Neg. A.3401.

Edison's First Electric Railroad

In 1878 Thomas Edison traveled with a party of astronomers and other scientists to the Wyoming Territory to witness the "Transit of Venus." En route, he noticed that farmers in the Midwest sometimes transported wheat by wagon for some two hundred miles. It occurred to him that an electric "tram-road" could perform this task, and if the trams could be automatically controlled from stations along the way, it would eliminate the expense of manning them. Back home in Menlo Park, New Jersey, Edison began working on this idea.

By the spring of 1880, Edison had an electric locomotive ready to roll on a railroad track one-third of a mile long. Electricity supplied by two generators in Edison's machine shop was carried to the rails by underground wires; the completion of the circuit from one rail to the other activated the locomotive. On May 13, all of Edison's assistants who could find room packed themselves aboard the locomotive and train, which consisted of a flatcar for freight, an open car with park benches facing each other, and a boxcar with windows; the boxcar was nicknamed the "Pullman." The switch was thrown, the engineer engaged the friction gearing, and they were off. Everything went well until the friction gearing was wrecked when the engineer activated it too suddenly. It was not long before Edison had solved the gearing problem.

On June 26, 1880, the *Scientific American* reported that its representatives, together with a dozen other passengers, had ridden on Edison's electric train, zooming up and down grades, over humps and bumps, and around sharp curves at twenty-five to thirty miles an hour. The following month, noting that Edison's locomotive was "noiseless, dustless, and smokeless," the *New York Herald* asked "Why not apply it to New York's elevated railroad?" A few days later, the *New York Graphic* showed a sketch Edison

Neg. 0.5787.

had made of a proposed 100-horsepower locomotive to be used on a stretch of the Pennsylvania Railroad in New Jersey.

Thousands of people from all over the world made pilgrimages to Menlo Park and rode in Edison's electric train. Some had unforgettable experiences. Edison eventually lengthened the track to about a mile, and its curves were so sharp and its grades so steep, that the train, ripping along at speeds of up to forty-two miles per hour, occasionally derailed. Although there were no fatalities, there were some narrow escapes. The railroad stayed in almost continual use until September 1881, when Edison began building another as a demonstration model for the Northern Pacific Railroad, which hoped to install an electric train in the "wheat regions." Edison built the model, but the train never ran in the "wheat regions" because the Northern Pacific went into receivership.

Edison's first electric locomotive and its "Pullman" were among the thousands of gifts that Thomas Edison, the Edison Pioneers, the Association of Edison Illuminating Companies, and the Electrical Testing Laboratories made to the Edison Institute in 1928 and 1929. The photograph shows Francis Jehl, Edison's former assistant, at the controls of the locomotive after it arrived in Greenfield Village. The canopied car was not part of the original equipment.

Baldwin Locomotive and Passenger Train

Pulled by a 1914 Baldwin locomotive, the early twentieth-century passenger train shown here steamed into Greenfield Village in 1979 under its own power. The train consists of a baggage car; a combination car with baggage, smoking, and parlor compartments; a Pullman car; and a caboose.

The company that built the locomotive—the Baldwin Locomotive Works of Philadelphia—has a history that spans the entire era of steam locomotives. Founded in 1831 by Matthias W. Baldwin, a former watchmaker, the company produced its first steam locomotive a year later. For the next one

Acc. 79.15.1-79.15.5. Neg. B.83296.7.

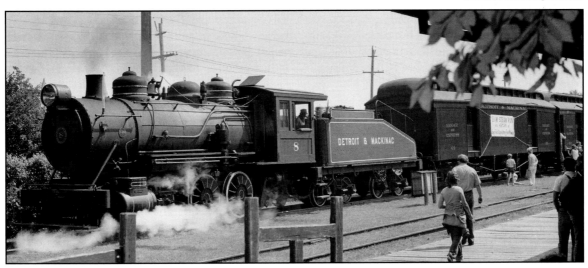

Neg. B.83291.

hundred years, Baldwin experienced phenomenal growth. By 1861 it had built two thousand locomotives and controlled about 40 percent of the market. By the 1890s, it occupied a nineteen-acre site and was employing almost three thousand workers. The company continued to thrive until the depression of the 1930s. Although it managed to rally during World War II, postwar prosperity passed it by, for steam locomotives were by then obsolete. Baldwin produced the last of more than seventy thousand locomotives—a small industrial diesel switcher—in 1956. The 1914 Baldwin shown here functioned as a switcher for Michigan Alkali, predecessor of the Huron Portland Cement Company, until 1969, when the Detroit & Mackinac (D & M) Railway Company bought it and restored it in its yards in Tawas City, Michigan.

The baggage car was built as a coach sometime between 1915 and 1920; it was converted in the D & M car shops during the 1920s. The combination coach was also built between 1915 and 1920. The caboose, built about 1912, is similar to all those that D & M conductors and brakemen used from 1900 to as late as 1964. It contains a coal-burning stove, a table where the conductor did his paper work, two chairs, a foot stool, a wash basin, a water tank, and some flags and flares. Painted on its side is a turtle, which was for years the D & M's mascot.

The lavishly appointed Pullman car dates from about 1901. The first such car, invented by George Mortimer Pullman in Chicago, made its appearance in 1865. George Pullman was adept at both advertising and public relations, and by 1880 some seven hundred of his cars were in service on U.S. railroads. They included sleepers, day coaches, and dining and parlor cars. Pullman's firm, the Pullman Palace Car Company, built the combination

parlor and sleeping car shown here at a cost of more than $40,000 for the president of the Munising Railway Company. It later was sold to the Boyne City Railroad and finally to the D & M. It has kerosene chandeliers, built-in sofas, and four Pullman berths—all part of the original car. The Pullman was appraised at $125,000 in 1980.

The train and locomotive were donated to Greenfield Village on behalf of the D & M by Mrs. Charles A. Pinkerton, Jr., and Charles Pinkerton III of East Tawas, Michigan, the widow and son of the railway's longtime president. The D & M, which ultimately ran from Bay City along the shores of Lake Huron to Cheboygan, Michigan, began in the early 1870s as a narrow-gauge, short-line logging railroad. It subsequently linked itself to a major line, absorbed a few other logging roads, changed its name several times, and when the logging industry finally depleted the timber of northeastern Michigan in the late 1880s, it managed to survive and even prosper by transporting vacationers to resorts along Lake Huron. On Sundays during the summer months, its excursion trains sometimes carried as many as two thousand people. After Charles Pinkerton, Jr., became president of the railroad in 1945, the D & M switched from steam locomotives to diesels. In 1950 it discontinued passenger service, but thirty years later it was still a profitable freight carrier.

Before his death, Charles Pinkerton, Jr., wrote to the Henry Ford Museum, noting that the cars and locomotive had been carefully restored, but since "there seems to be little, if any, interest on the part of those now operating the railroad," he wanted to place them where they would receive good care and "be enjoyed by those interested as time progresses." In 1980 the value of the Baldwin locomotive and four cars was assessed at $442,500.

Detroit and Mackinac Pullman, interior.

Neg. B.96694.1.

Detroit Tunnel Crane

In 1909 the Detroit Tunnel Company built a mile-long electrified tunnel beneath the Detroit River to connect railroad lines in Detroit with those in Windsor, Ontario. The tunnel was first used by the New York Central Railway System, later by Penn Central, and finally by Conrail, which still uses the tunnel for its freight traffic. The railroad crane shown here, designed and built in 1914 by the Industrial Works of Bay City, Michigan, was used to make repairs in the tunnel and to salvage wrecks. Unlike other railroad cranes of the same era, which were steam-powered, this one was electrically driven. If the electrical power in the tunnel failed, the crane could also function on steam or compressed air piped in from the end of the tunnel. Including the boom, the crane is fifty-eight feet long. It can make a complete 360-degree turn and lift a load of 110 tons within a radius of seventeen feet.

The logo of the Penn Central Corporation was applied to the Detroit tunnel crane about 1970, a few years before the government-sponsored Conrail system took over a number of failing railroads, including Penn Central. In 1986 Conrail donated the tunnel crane to Greenfield Village, where it now demonstrates its lifting power each fall during a village celebration called "Railroad Days."

Caboose

In the 1840s, Nat Williams, a conductor on the old Auburn & Syracuse line, ran his passenger-freight train from a boxcar at the end of the train. This boxcar is said to have been the first caboose, the rear car where a train conductor did his paperwork, usually in the company of one or two brakemen. The caboose was used to store flags, lanterns, and tools, and it usually had some facilities for sleeping and eating. The term derives from *kabuse*, a Dutch word denoting a ship's deckhouse in which cooking was done. It was apparently first used in reference to trains in 1885, when the Buffalo, Corning and New York line began calling its conductors' cars "cabooses." The caboose, once a symbol of the romance of railroading, has virtually disappeared from modern trains.

Henry Ford bought the caboose shown here as part of his effort to rejuvenate the Detroit, Toledo and Ironton (D.T. & I.), the ramshackle railroad he acquired in 1920 to haul raw materials and finished goods in and out of his plant on the Rouge River. It was one of forty cabooses that Henry ordered from the Standard Steel Company in 1925. Some of those cars remained in service until the early 1970s.

When Henry bought the D.T. & I. for $5 million, his executives were aghast. Broken engines, badly worn rails, and defective roadbeds abounded; cars, shops, and stations were in disrepair; and employee morale was low. But Henry's efforts soon paid off. He bought new equipment and ordered workers to repair the tracks and roadbeds, rebuild locomotives, clean and varnish cars, and scrub the newly painted white walls of the roundhouses once a day. He also raised the workers' wages and introduced the eight-hour day. As a result, the D.T. & I. was the only railroad that did not go out on strike in 1921. Moreover, as the dilapidated railroad shaped up physically, it also began to make a profit, and Henry decided to lower the freight rates. When the Interstate Commerce Commission forbid him to do this, Henry sold the D.T. & I. to the Pennroad Corporation in 1929 for more than seven times what he had paid for it. Said Henry, "I learned you could own a railroad, but you couldn't run it. The Interstate Commerce Commission did that for you."

In 1972 the D.T. & I., then associated with the Ann Arbor Railroad Company in Dearborn, donated the caboose in the photograph to the Henry Ford Museum. The D.T. & I. has been owned by the Grand Trunk Western Railway, a Canadian corporation, since 1980.

Acc. 72.163.1. Neg. B.64524.

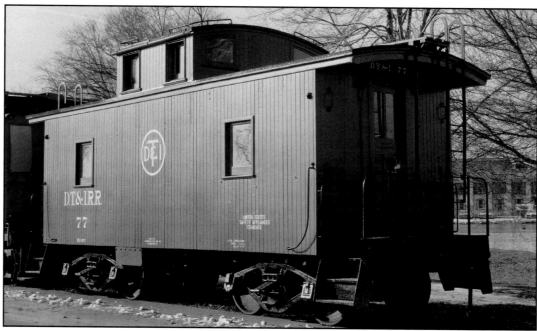

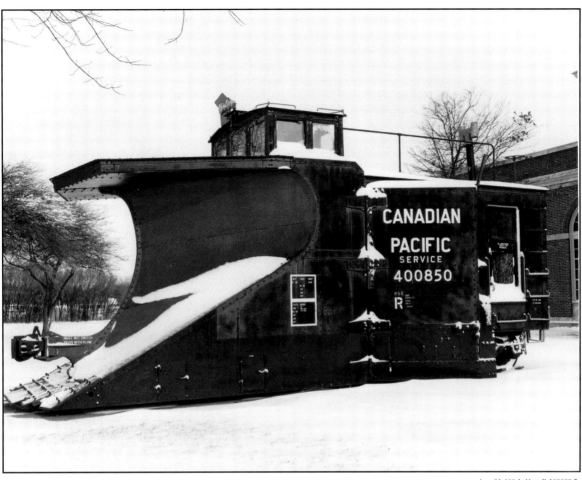

Acc. 91.400.1. Neg. B.108089.5.

Railroad Snowplow

To avoid having trains derailed by snow-covered tracks, early railroad workers cleared snow by shoveling it away manually or by attaching metal blades to the locomotive's cowcatcher. Today, snow-plows such as the one shown here, although rarely seen in action, are an essential part of any railroad that operates in northern regions. This one cleared the way for locomotives on the Canadian Pacific's tracks through rural New England and Canada from 1923 until 1990. It was one of thirty-six railroad snowplows that the Canadian Pacific's Angus Shops manufactured in Montreal between 1920 and 1929.

Built without an engine, the twenty-ton, wedge-type plow was pushed by one or two locomotives, depending on the depth of the snow. Since its movable wings threw snow to both sides, it was generally used on single-track lines. Movable blades at the front of the plow cleared the area between the rails, and the plow operator could raise them at crossings to avoid damaging the tracks. The wings and blades were controlled hydraulically by means of compressed air tanks located in the cab. The tanks also provided air for the whistle that the plow operator used to signal the locomotive engineer.

In early 1991, the snowplow was inspected and approved for continuing service. Because of its age and obsolesence, however, the Canadian Pacific Rail System decided to retire it and later the same year donated it to the Henry Ford Museum.

Diesel-Electric Locomotive

In 1913, after almost ten years of experimentation, the General Electric Company of Schenectady, New York, produced a prototype of a sixty-ton gasoline-electric locomotive. Its gasoline engine and electric control system were far from ideal. By 1916 Hermann Kemp of General Electric had solved the problem of the control system, and in 1920 General Electric began a nationwide search for a suitable internal-combustion engine. In 1923 the Ingersoll-Rand Company of Phillipsburg, New Jersey, came up with the answer: a six-cylinder, 300-horsepower diesel power plant. On December 7, 1923, General Electric and Ingersoll-Rand tested an "oil-electric" locomotive for the first time.

This event signalled the start of a new era in railroading; the days of the lovable but uneconomical steam locomotive, which had dominated American railroads for almost a hundred years, were numbered.

The diesel-electric was reliable, durable, inexpensive to run, and easy to maintain. General Electric began assembling the locomotives at its plant in Erie, Pennsylvania, in May 1925. Ingersoll-Rand supplied the engines; ALCO (American Locomotive Company) supplied sturdy, boxlike bodies. Ingersoll-Rand took responsibility for marketing the locomotives, which it did with vigor. Smoke-abatement laws passed by New York City and Chicago in 1925 helped the sales effort, as did the low cost of operating the machines. Between 1925 and 1937, when Ingersoll-Rand retired from the locomotive business, 121 of these units were produced, and their basic features are still in use today. The diesel-electric locomotive shown here was built in 1926. Ingersoll-Rand owned it for all of its working life, which extended into the late 1960s. In 1970 Ingersoll-Rand donated the historic machine to the Henry Ford Museum.

Acc. 70.96.1. Neg. B.104150.1.

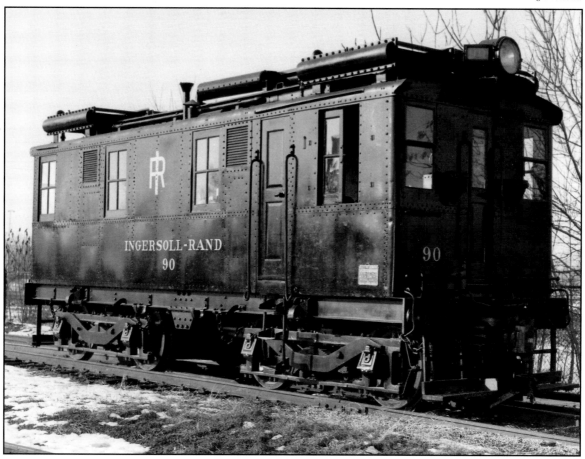

"Allegheny" Locomotive

This coal-burning behemoth, 125 feet long and weighing 600 tons, was among the last and most powerful of the steam locomotives. The Lima Locomotive Works of Lima, Ohio, built it in 1941 for the Chesapeake and Ohio Railway Company of Cleveland at a cost of more than $250,000. In its arduous working life, the locomotive traveled 407,008 miles over the Allegheny Mountains, hauling

presenting it to the museum, the president of the railroad company noted that it "would show future generations what a steam locomotive looked like at the acme of its development, and will serve as a reminder of the role it played in shaping our history. . . . Preservation of this C & O locomotive also honors coal for its distinguished record in American transportation history."

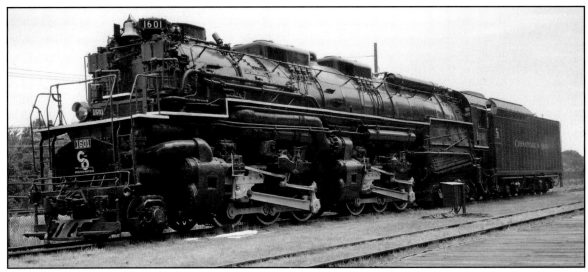

Acc. 56.50.1. Neg. B.12970.

coal from Kentucky and West Virginia east to Tidewater Virginia and north to the Great Lakes. It could pull 160 cars, each loaded with 60 tons of coal, at speeds of forty to fifty miles per hour. The tender itself carried 25 tons of coal and 25,000 gallons of water. The Lima Locomotive Works produced sixty of these "Alleghenys" for the Chesapeake and Ohio between 1941 and 1948, and they represent the peak of development in steam locomotives.

The Chesapeake and Ohio, a carrier of coal, was one of the last railroads to convert to diesels. It retired this coal-burning steam locomotive in 1954 after a mere thirteen years of service, and in 1956 the Allegheny became part of "Henry's attic." In

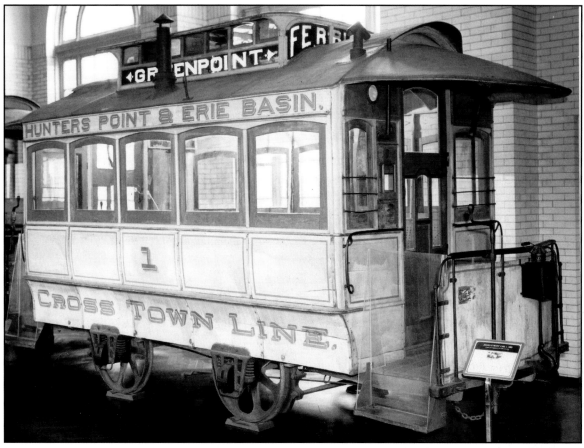

Horse-Drawn Streetcar from Brooklyn

Horse-drawn streetcars came into use in major American cities in the mid-1800s. J.M. Jones & Company of West Troy, New York, at one time allegedly the only U.S. firm devoted entirely to the manufacture of streetcars, built this one-horse car for the Brooklyn City Railway Company about 1868. It was in daily service in Brooklyn for the next twenty years, by which time traffic had become so heavy that the railway company decided to replace it with a larger two-horse vehicle.

In May 1928, when publicity of his passion for antiques was at its peak, Henry Ford sailed into New York harbor at the end of a European jaunt. Shortly thereafter, he was the center of much attention as H. Hobart Porter, president of the Brooklyn City Railway Company, presented him with this streetcar for his proposed museum. The company enjoyed some favorable publicity, too, as Henry oblig-

ingly proceeded to drive the streetcar through the streets of Brooklyn. Jericho, the old white horse drawing the car, initially refused to respond to Henry's cluckings and "giddaps." Camera men on hand to record the occasion shouted, "Wave the whip, Mr. Ford!" "I wouldn't hit that horse for anything," Henry answered—at which point Jericho lumbered into motion.

Almost eighteen feet long, the Brooklyn streetcar had seats for sixteen passengers in summer and fifteen in winter, when one seat on the starboard side gave way to a coal stove. A sign inside the vehicle lists, in both English and German, "Rules for Passengers." One rule prohibited the transport of "barrels, boxes, lumber, iron, or merchandise of a heavy bulky nature." The fare for adults was five cents.

Birney Electric "Safety" Streetcar

By World War I, almost all municipal transit companies were using electric streetcars, often in tandem, and each car had its own conductor. The war created a problem for these companies, for not only did the cost of maintaining and replacing streetcars climb but labor became scarce as well. In 1917, perceiving a need, Charles O. Birney, an engineer with the Stone and Webster Company in Boston, designed an inexpensive, lightweight electric streetcar in which one person could serve as both motorman and conductor. It was a calculated return to the single-unit vehicle of earlier days. Its rounded roof without the traditional transoms was both strong and cheap to build, and with its stressed-skin body, it weighed only 13,000 pounds, as compared with the 30,000- or 40,000-pound weight of its predecessors. With its weight advantage and a twenty-five-horsepower motor that supplied perky acceleration, it was also faster than its predecessors.

Because it was designed for one-person operation, the "Birney Safety Car," as it was called, had several built-in precautions. An interlock kept the car from moving when either its front or rear door was open, and a "dead-man" controller stopped the car when the motorman-conductor took his hand off the control. Birney Safety Cars were mass-produced from 1918 until the early 1920s and saw service on almost every small transit line in the United States, as well as on the less heavily traveled routes in large American cities. The vehicle was sometimes referred to as "the Ford of the streetcar world." The popularity of Birney Safety Cars was, however, relatively short-lived. Even a light snow would cause them to stall and jounce off the tracks, and as the population of cities increased, their small size became a problem. They were also hard on the people who had to operate them singlehandedly. It was not unknown for a Birney Safety Car operator to abruptly abandon his job, walking away and leaving a car full of stranded passengers.

Nonetheless, Birney Safety Cars were durable. The one shown here, built about 1921 by the J.G. Brill Company of Philadelphia, was the last to operate in the United States. It was finally taken out of service in 1951, when its owner, the Municipal Railway System of Fort Collins, Colorado, switched to

Acc. 53.34.1. Neg. B.4528.

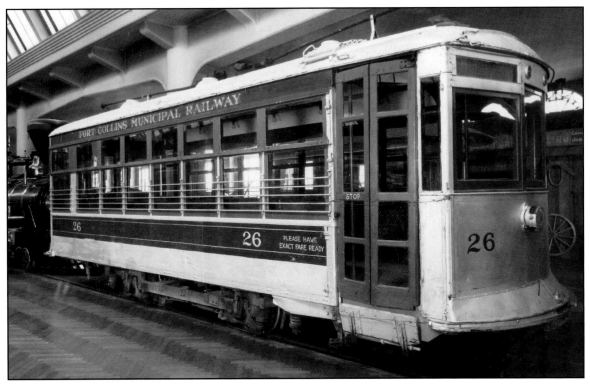

buses. It was first used in Grand Rapids, Michigan, and in the 1940s by a small transit company in Marion, Indiana, which sold it to the Fort Collins system in 1948. After Fort Collins retired it, the Midwest Chapter of the National Railway Historical Society acquired it and in 1953 donated it to the Henry Ford Museum. It arrived in Michigan in time to take part in a parade on August 16, 1953, celebrating the ninetieth year of rail transit in the city of Detroit.

Peter Witt Electric Streetcar

Acc. 54.48.1. Neg. B.8451.

In 1921, to eliminate the delays in streetcar service caused by the time spent in collecting fares as passengers boarded the vehicles, Peter Witt, a Cleveland Traction Commissioner, designed a "pay-as-you-pass" streetcar. Passengers boarded at the front of the car without paying and remained there, hanging onto straps in a large standing area in the center of the car or perched on long seats at the sides, until they paid the conductor who was stationed in the middle of the car. They could then either exit through the center door or proceed to the rear half of the car, which had conventional seats on both sides of a narrow aisle. The rear of the car had no door, and passengers who were traveling only a few blocks generally stayed in the front rather than walking all the way back to vacant seats in the rear.

The streetcar shown here is one of many Peter Witt cars used in Detroit from 1921 until 1954, when the transit system switched to buses. Built in 1931 by the St. Louis Car Company in Missouri, the car weighs 37,000 pounds and was powered by four General Electric motors. It is a little more than fifty feet long, and when it was used on a busy route, it no doubt pulled a trailer of about the same length. When the streetcar went out of service in 1954, the municipal transit system gave it to the Detroit Historical Museum. Because the museum did not have the facilities to preserve or display it, it traded it to the Henry Ford Museum in May 1954.

Model of the Clipper *Great Republic*

During the first half of the nineteenth century, American shipbuilders developed the clipper, the fastest sailing vessel the world had yet seen. Capable of speeds of up to eighteen knots, the original clipper, known as an "extreme" clipper, was a long, slender vessel with a sharp bow, three backward-slanting masts, and rectangular sails. After about 1854, as wood became more expensive and railroads started to cause freight rates to drop, shipbuilders developed the "medium" clipper, a modified version that lacked the speed of the earlier vessels. Although most clippers were built in shipyards in New England, the first large extreme clipper—the *Ann McKim*, which weighed 494 tons—was built in Baltimore in 1833. The usual run for American clippers was between ports on the East Coast and China, Australia, or San Francisco.

The tea trade with China was one factor that created a need for faster sailing vessels. Because tea quickly lost its flavor in the holds of ships, London merchants offered prizes to the vessels that were first to deliver the Chinese tea crop each year. The *Cutty Sark,* which covered 363 miles in one day, held the record for tea-carrying clippers. The California gold rush also fostered the construction of clipper ships; within a four-year period, 160 of them were built and transported 90,000 people from the East Coast around Cape Horn to California. When gold was discovered in Australia, British-owned clippers transported 400,000 people "down under." By 1870, however, the building of the Suez Canal and the introduction of fast steamships had led to the decline of these graceful greyhounds of the sea.

The *Great Republic,* shown in a scale model here, was the largest extreme clipper ever to set sail. Built in 1853 by Donald McKay in East Boston, Massachusetts, the four-masted vessel was 335 feet long, 53 feet in the beam, 38 feet deep, and registered at 4,552 tons. Its masts were bigger than any built before or since. The main mast measured 240 feet from top to bottom and at its base was 44 inches across.

Acc. 69.60.1. Neg. B.53138.

When launched, the *Great Republic* attracted worldwide attention not only because of its size but also because of its fine construction and majestic lines. After being rigged, the ship was towed to New York to take on cargo for Liverpool. Just as it was ready to sail, embers from a nearby warehouse fire set it ablaze, and it burned to the water's edge. Although it was rebuilt without an upper deck and with fewer spars and reduced sail, it was still the largest ship afloat—and also one of the fastest. On its maiden voyage, it sailed from New York to Liverpool in twelve days, and it made its first voyage from New York around Cape Horn to San Francisco in ninety-two days. By 1869 it was British-owned and had been renamed the *Denmark*. The rechristened ship met its end in 1872 when, en route from Rio de Janeiro to St. John, New Brunswick, it foundered in a storm off Bermuda and was abandoned.

Walter J. Hansen built the model of the *Great Republic* on a 1:100 scale. It was given to the Henry Ford Museum in 1969 by Mrs. Edward Tardiff and David Hansen of Detroit.

Ship's Figurehead

This figurehead adorned the prow of the *Forest Queen*, a passenger and package-freight steamboat built in 1855 at Samuel Ward's shipyard in Marine City, Michigan. Three hundred feet long and with a speed of twenty-one miles per hour, the *Forest Queen* made the run between Detroit and Port Huron from May 1856 until 1866, when the vessel was dismantled and made into a barge. According to Minnie G. Kenyon, daughter of Phineas Kenyon who was the captain of the *Forest Queen*, an Indian known simply as "Joe" had carved the wooden figurehead and given it to her father as an ornament for his steamboat. Two years after the *Forest Queen* was dismantled, the figurehead was installed on the bow of the *Northwest*, a ship belonging to the Detroit & Cleveland (D&C) Navigation Company. The *Northwest*, however, was not built to carry a figurehead of this shape, and it was soon removed and placed in the D&C's office building in Detroit. In 1934 the company donated it to Henry Ford for his museum.

Herreshoff Catboat

The catboat, a broad-beamed, shallow-draft vessel, is still a favorite of recreational sailors in New England. The one shown here, launched in 1860 in Bristol, Rhode Island, and christened the *Sprite*, is twenty feet long and has a small cabin. It was designed by an eighteen-year old named John B. Herreshoff. Blind from the age of fourteen, John built the *Sprite* with the help of his father, Charles F. Herreshoff, an experienced builder of sailboats. John went on to build several more boats and by 1864 was employing a dozen or more men in the manufacture of fishing vessels and yawls. In 1874 he built the fifty-six-foot *Lightning,* the U.S. Navy's first torpedo boat. Five years later, he and his younger brother Nathaniel, who had studied at the Massachusetts Institute of Technology and spent nine years at the Corliss Steam Engine Company, formed the Herreshoff Manfacturing Company and began building steam-powered yachts and launches, as well as large steam-driven torpedo boats. The company also built some famous sailing vessels, among them numerous sloops that successfully defended the America Cup. In the early 1900s, two Herreshoff schooners raced in Europe and beat everything there, including Kaiser Wilhelm's *Meteor*. By 1915, when John Herreshoff died, he and his family had built more than nine hundred vessels, and their name had long since become world-famous.

Acc. 30.1594. Neg. A.3252.

James B. Herreshoff, John and Nathaniel's oldest brother, was the last owner of the catboat *Sprite.* In 1929 Nathaniel, then in his early eighties, offered the catboat—the oldest Herreshoff boat still in existence—to the Henry Ford Museum for safekeeping; it arrived in Dearborn the following year.

Herreshoff Catamaran

The Herreshoff Manufacturing Company of Bristol, Rhode Island, built this catamaran in 1933. It was designed by A.S. Herreshoff, who based it on a catamaran designed in 1876 by his father, Nathaniel Herreshoff. Thirty-three feet long and weighing thirty-five hundred pounds, the *Amaryllis,* as it was called, has cedar-planked hulls connected to the cockpit and the backbone structure by sixteen universal joints. This arrangement allowed the hulls to pitch independently while still keeping them parallel and upright. Each hull has a centerboard, rudder, and seven watertight compartments. The top of the mast, not shown in the photograph, was thirty-five feet above the water; stainless steel rigging originally supported nine hundred square feet of sail. Once timed at slightly over nineteen miles per hour, the *Amaryllis* was described as "probably the fastest sailboat in the world."

K.T. Keller, an executive of the Chyrsler Corporation, and a group of his friends were the original owners of the *Amaryllis.* In 1938 the "Amaryllis Racing Syndicate"—whose members included Keller, Walter Chrysler, Edsel Ford, and A.G. Herreshoff, the brother of the boat's designer and a Chrysler executive—donated the *Amaryllis* to the Henry Ford Museum. The racing syndicate made the presentation so that "the knowledge and engineering skill shown in the design and construction of this unique high speed sailing craft" would be preserved and "future development . . . fostered."

Acc. 38.783.1. Neg. A.3248.

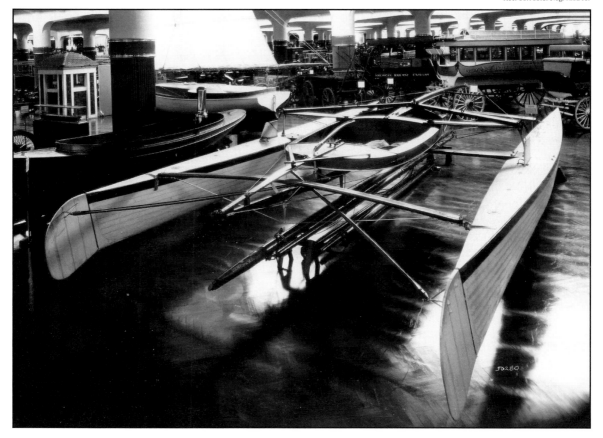

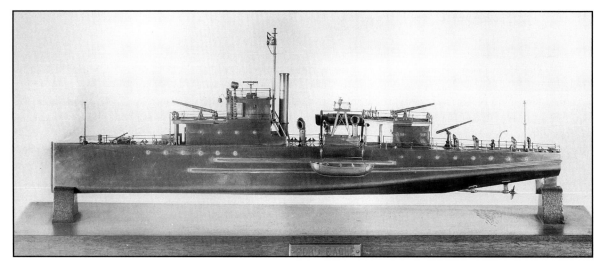

Model of the Eagle Boat

After the United States entered World War I in April 1917, Henry Ford became a "fighting pacifist," offering his time and production facilities to the government for the war effort and vowing to "operate without one cent of profit." President Woodrow Wilson appointed Ford to the U.S. Shipping Board, which by early 1918 had a design ready for the Eagle, a fast, fully armed craft two hundred feet long that could search out and destroy German U-boats. All naval and commercial shipyards were by then too busy to handle the construction, and the contract was therefore offered to Henry Ford. He agreed to produce a total of 112 Eagles—the first by August 1, 1918, 10 the next month, 20 the next, and 25 on a monthly basis thereafter. He proposed to do this on the Rouge River, from which the boats could sail to the Atlantic by way of the Great Lakes and the St. Lawrence River. His Rouge plant was at that point still a dream, but with an appropriation from Congress, the river was dredged and widened, marshes were drained, and an enormous facility for mass-producing boats was rapidly constructed.

Henry Ford beat his first deadline; the first Eagle was launched on July 10, 1918. Thereafter, the work fell behind schedule, and by the time of the armistice on November, 11, 1918, only twelve boats had been launched. By January 1919, however, the Ford Motor Company was mass-producing the Eagles at the rate of two a week. A reduced contract called for only sixty Eagles, and the last of these was launched in August 1919. Although few Eagles saw service in World War I, eight of them were still in commission during World War II and were used as submarine patrols inside continental waters. The U.S. Navy sold the last of its Eagles in 1947.

Tony Pajalic, a tinsmith for the Ford Motor Company, made this precise, twenty-five-inch brass and copper model of the Eagle about the time the boats themselves were being constructed. It was a very early gift to the Henry Ford Museum from the Ford Motor Company.

Hacker "Dolphin" Speedboat

John L. Hacker was a renowned boat designer who worked in the Detroit area from 1901 until his death in 1961. In 1904 he created a sensation when he built a speedboat capable of doing twenty-three miles per hour. By the mid-1920s, Hacker had developed a revolutionary type of speedboat called the "Dolphin." In contrast to traditional round-hulled boats, which plowed through water, the Dolphin had a V-shaped hull that allowed it to plane

1970. Twenty-six feet long, the mahogany-planked craft easily seated seven people, and, powered by a 185-horsepower marine engine, could cruise at thirty-five miles per hour. The museum sold the boat at auction in 1982.

Hacker designed such record-breaking speedboats as *Miss Pepsi* and *My Sweetie*. He also designed three racing boats for Edsel Ford and a seventy-two-foot cruiser for Edsel's father. Among his

Acc. 70.101.1. Neg. B.59514.

on water at high speed. The Hacker Boat Company built the Dolphin shown here in 1925 and sold it the following year to John C. Wright of Grosse Ile, Michigan. Wright used the *Jay-Cee II,* as he christened the boat, for over forty years before donating it in excellent condition to the Henry Ford Museum in

many other accomplishments, he was the first to use an outboard rudder and to place the wheel of a speedboat aft. During World War II, he applied his ideas to the design of rescue boats for damaged ships and aircraft.

Model of *Henry Ford II*

The *Henry Ford II* and the *Benson Ford*, both built in 1924, and the *William Clay Ford*, built in 1942, were among the Great Lakes freighters that Henry Ford acquired to transport raw materials to his plant on the Rouge River. Henry named all three ships after his grandsons, and, in his curious way, he did them the same honor with three blast furnaces at the Rouge. These vessels took on coal at Toledo, limestone at Rogers City in northern Michigan, and iron ore at Duluth, Minnesota. They ultimately dumped their cargo into huge bins at the Rouge plant, where it was converted into iron and steel.

The *Henry Ford II* could carry a cargo of 11,750 tons, only slightly less than that of the *Benson Ford*. For a while in the 1920s, these two ships were among the largest on the Great Lakes. Both were 612 feet long, 62 feet in the beam, and had a draft of 32

Company of Cleveland. In 1994, still in service after seventy years, the *Henry Ford II*, renamed the *Samuel Mather,* was taking on coal from West Virginia at Toledo and hauling it across Lake Erie to Ford's Rouge plant.

The scale model of the *Henry Ford II* shown here is a little more than six feet long. The pilot house is at the bow, and the power plant is aft; modern Great Lakes carriers have both facilities placed aft—a configuration much disliked by many veteran boatwatchers. Edward C. Caughell, a twenty-year-old sailor from Harbor Beach, Michigan, built the model in the winter of 1931-1932 as a way of passing time while the Great Lakes were frozen and he was out of work. Other residents of Harbor Beach, where the Fords had summer cottages along Lake Huron, urged young Edward to show his model to

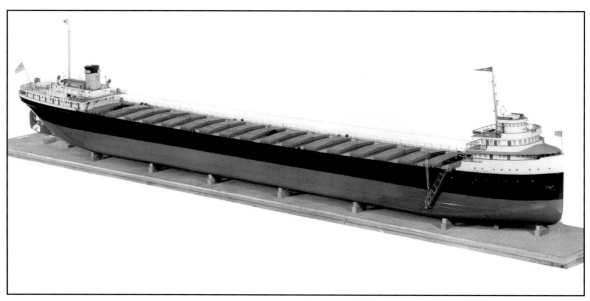

feet; powered by diesel engines, they had a top speed of fourteen knots. Although very similar, the ships were built by different yards: the *Henry Ford II,* by the American Shipbuilding Company of Lorain, Ohio, and the *Benson Ford*, by the Great Lakes Engineering Works on the Rouge River.

By 1989 Ford's Great Lakes fleet was greatly depleted, and the last of the carriers—including the *Henry Ford II*—was sold to the Interlake Steamship

Henry Ford. On April 30, 1932, having just put the finishing touches to the model, Edward finally wrote the letter. In it, he not only asked Mr. Ford if he would like to have this model but also offered to make models of Mr. Ford's other ships, saying he thought he could do better since this was just his first attempt. Eleven days later, the model was installed at the Henry Ford Museum.

Liberty Engine

After the United States entered World War I in April 1917, the government immediately instituted an aviation program aimed at ensuring Allied control of the skies over Europe. One of the first results of this program was the Liberty airplane engine. Within three months, some of the nation's foremost automotive engineers had designed and built a prototype twelve-cylinder, 400-horsepower motor. After intensive testing of every feature of the engine, the Liberty was declared ready for production, and the work was undertaken by various automobile manufacturers: Packard, Ford, Lincoln, Nordyke-Marmon, General Motors, and the Trego Motors Corporation.

Packard, the first manufacturer to begin production, built 5,000 Liberty engines between November 1917 and November 1918. The Ford Motor Company, which began by designing a machine tool that cut the cost of the engine's cylinders and greatly expedited production, ultimately produced 3,940 Liberties; within five months of accepting the contract, Ford had set up a partial assembly line and was producing the engines at the rate of 75 per day.

Henry M. Leland, who in 1902 had designed the engine for the Cadillac produced by the former Henry Ford Company, formed the Lincoln Motor Company for the production of airplane engines and built an entirely new factory for that purpose in record time. Lincoln produced the Liberty engine shown here in 1917. (After the war, Lincoln began producing an automobile high in quality but lacking in style; by 1922, when Ford bought the Lincoln Motor Company and Edsel Ford began improving the car's styling, Lincoln was facing bankruptcy.)

Liberty engines were used in French, British, and Italian war planes, as well as in the American De Haviland. Reliable and efficient, they had a major impact on aviation in the 1920s. The one in the photograph was in the hands of Thomas Knoblick of Hamburg, Germany, when the Ford Motor Company acquired it shortly after World War I. Years later, the company donated it, together with dozens of other early engines, to the Henry Ford Museum.

Acc. 00.136.316. Neg. A.3158.

Laird Racer

Early barnstorming pilots made significant contributions to the development of the aviation industry. Not only did they devise flying techniques; with their daredevil stunts, they also focused attention on air safety. One of the best-known of these early pilots was E.M. Laird of Chicago, who also became a successful airplane manufacturer. About 1928 the Ford Motor Company sent Laird a telegram offering to buy out his entire aircraft manufacturing company in Chicago and inviting him to join its growing airplane division. Laird refused, and, as the country entered the depression years, his company was still a well-known airplane manufacturer. In 1931 Major James H. ("Jimmy") Doolittle, one of the nation's most popular pilots, flew a Laird "400" coast to coast in a record-breaking eleven hours and fifteen minutes.

In 1915 Laird designed, built, and flew the biplane shown here. Its motor—an Anzani radial air-cooled engine with six cylinders and forty-five horsepower—was the forerunner of the modern radial engine. The plane had a takeoff distance of 125 to 150 feet and climbed at about 500 to 600 feet a minute. It had a top speed of sixty-five to seventy miles per hour. From the time Laird built the plane until just after World War I, he flew it to barnstorming engagements all over the Midwest. One of the first pilots to "loop the loop," he used the plane to perform this novel air stunt for the first time in June 1916. The following winter, Katherine Stinson, one of America's first licensed pilots, used Laird's plane in exhibitions that she gave in Canada, China, and Japan. In 1936 E.M. Laird donated it to Henry Ford, who was then making space in his museum for historic aircraft.

Curtiss "Seagull"

Glenn Hammond Curtiss, who started his career as a bicycle and motorcycle manufacturer in Hammondsport, New York, ultimately became one of the most important figures in the history of American aviation. To get around the Wright brothers' patent on wing-warping as a means of controlling an airplane in flight, Curtiss invented a movable wing edge, now known as an aileron. In addition to this outstanding contribution, Curtiss in 1910 became the first person ever to land an airplane on water and in 1911 was the first to take off from water. In the same year, after his planes had demonstrated the feasibility of taking off from the deck of a ship as well as landing there, the U.S. Navy ordered its first planes from Curtiss's firm. Curtiss earned the title of "father of naval aviation" when in 1912 he successfully adapted the design of a boat hull to an aircraft and invented the first real flying boat. Within a year, the Curtiss Aeroplane and Motor Corporation of Buffalo and Hammondsport had orders from various European governments.

After dramatic expansion during World War I, Curtiss's company reorganized to build "Seagull" flying boats for business and pleasure use. The Seagulls were an almost instantaneous success. The first one left the Curtiss plant in Garden City, New York, in April 1919, and a month later, a Curtiss NC-4 flying boat, a larger version of the Seagull, landed in Europe after a five-day, island-hopping trip. It was the first plane to make the transatlantic crossing. During the summer of 1919, a Curtiss Seagull began regular daily flights between San Pedro and Santa Catalina Island, California, and two Seagulls gave rides to more than twenty-five hundred people at the Curtiss facility in Atlantic City, New Jersey.

Powered by a Curtiss-built Hispano-Suiza V-8 engine rated at 150 horsepower, the Seagull shown here was built in 1919. It has a mahogany-planked hull, wings covered with yellow fabric, and an open cockpit that comfortably seated a pilot and two passengers. Henry Ford bought the flying boat for a personal employee, Evangeline Dahlinger. Evangeline, who was among the first licensed women pilots in Michigan, frequently used it to fly to her summer home on the St. Clair River. Her husband, Raymond C. Dahlinger, also one of Henry Ford's personal employees, presented the Seagull to the Henry Ford Museum sometime during the 1930s.

Acc. 00.204.20. Neg. A.3050.

Baumann RB Racer

Milton C. Baumann, a 1917 engineering graduate of the University of Michigan, designed this unique high-winged monoplane in 1920 to participate in that year's Gordon Bennett Air Race. The race was named after the publisher of the *New York Herald,* James Gordon Bennett, an enthusiastic supporter of various sporting events and the donor of many trophies. Because of a broken cable, Baumann's craft had to withdraw from the race after the first lap. Built in Dayton, Ohio, by the Dayton-Wright Airplane Company, then a subsidiary of General Motors, the plane was called the RB Racer — *R* for Howard Rhinehart who piloted it, and *B* for its designer. The RB Racer's wings featured a variable camber system, adjustable to produce maximum lift at low speeds and minimum drag at high speeds. It was the first airplane to use such a system and the first to have a retractable landing gear. Its fuselage was made of laminated wood, and it had no front window; the pilot, entirely enclosed in the fuselage, could see only through side portholes.

The original test pilot for the RB Racer was Major James H. Doolittle. Many years later, as the Dearborn Inn was celebrating its fiftieth anniversary in 1981, Doolittle, then eighty-four years old and a

Jimmy Doolittle, 1930.

Neg. 102.6.2.

lieutenant general, visited the Henry Ford Museum and told newspaper reporters a story that confirmed his reputation as a practical joker. While the RB Racer was being flight-tested, the public was sometimes allowed to watch, and for those occasions, Doolittle and friends had built a false landing gear on

Acc. 40.290.1. Neg. A.3041.

The fact that twelve men could stand on the wings of the RB Racer is evidence of its superior strength.

top of the fuselage and a false cockpit below with the head of a dummy protruding from it. As Doolittle buzzed the field with this paraphernalia in place, the crowd would stare in wonder at the aviator who dared to fly upside down only a few feet off the ground. The feat for which "Jimmy" Doolittle is best remembered, however, was the bombing raid he led on Tokyo in 1942, the first retaliatory strike after Pearl Harbor.

Baumann utimately gave the RB Racer to his alma mater, the University of Michigan, which in 1938 donated it to the Henry Ford Museum because it seemed a more fitting place for "display and preservation" of this historic relic. To ensure that it was refitted to its original specifications, the museum in 1940 asked Charles F. Kettering to direct some of the work. "Boss Ket," as he was known, was then general manager of GM's Research Laboratories Division in Detroit. A prolific inventor whose many achievements included the electric ignition for automobiles, Kettering was an energetic and well-liked man who, like Henry Ford, scorned the "experts" because of their tendency to come up with reasons why a thing could not be done. He was also scornful of committees, believing that determined individuals were behind most great advances. When Charles Lindbergh made his famous transatlantic flight in 1927, Kettering's wife remarked that it was wonderful that he had done it by himself. "It would have been more wonderful still if he had done it with a committee," Kettering replied.

Fokker Trimotor

On May 9, 1926, Lt. Commander Richard E. Byrd and his pilot, Floyd Bennett, made the first flight over the North Pole in this specially fitted Fokker monoplane—the first commercial trimotored craft ever built. Because Edsel Ford had been an enthusiastic and generous sponsor of the expedition, contributing $20,000, Byrd named the plane the *Josephine Ford,* after Edsel's two-year-old daughter. Made of wood and fabric, it was designed and built in Holland by Anthony H.G. Fokker, who brought it to the United States in 1925 and in it won the first National Air Commercial Reliability Tour, a 1,900-mile contest. When Fokker landed the plane at the Ford Airport in 1925, Edsel Ford was much impressed with it, as was Richard Byrd. Byrd had originally planned to use a Ford Tri-Motor for his polar expedition, but a fire at the Ford aircraft plant in January 1926 put an end to that plan. Bryd used the money that Edsel, John D. Rockefeller, Jr., and others had contributed to his expedition to purchase Fokker's plane.

For its historic flight, the plane was equipped with skis and pontoons for landing on snow and water and three 200-horsepower Wright engines that enabled it to cruise at 100 miles per hour and land at 45 miles per hour while carrying a load of about 10,000 pounds. Extra fuel storage boosted its range to 1,500 miles. With the temperature hovering at twenty degrees below zero, Byrd and Bennett made the 1,200-mile flight from King's Bay, Spitzbergen, to the Pole and back in fifteen hours. During Byrd's distinguished career, he made a second trip to the North Pole and five trips to the South Pole, gathering great stores of information for international geophysical studies.

Fokkers, which were made both in Holland and at a factory in Hasbrouck Heights, New Jersey, were used in many other pioneering flights. A U.S. Army Fokker made the first flight from California to Hawaii, a distance of 2,400 miles, in June 1927, and in the same month, under extremely poor weather conditions, Commander Byrd and two companions crossed the Atlantic in a Fokker called the *America.* As part of the crew that landed the Fokker *Friendship* in Ireland in June 1928, Amelia Earhart became the first woman to fly across the Atlantic.

In the fall of 1926, Edsel Ford bought the *Josephine Ford* from Commander Byrd for $30,000 with the intent of giving the plane to the Henry Ford Museum when it opened. Pressed for money to cover the costs of his expedition, Byrd expressed his pleasure that Edsel thought the plane of historic value and his regret that "circumstances are such that we are not able to present the *Josephine Ford* to you as an expression of our appreciation and gratitude for the great things you have done for us—and for the way you did those things."

Boeing Model 40

In 1927, as the nation's first regularly scheduled coast-to-coast airmail service was about to be inaugurated, the Boeing Aircraft Company of Seattle built a series of biplanes called the Model 40. The Model 40 was not only designed to carry mail; it also had seats for two paying passengers. Boeing Air Transport, an affiliate of the aircraft manufacturer, was awarded the San Francisco-to-Chicago leg of the transcontinental mail trip. That run was at the time the longest scheduled airline flight in the world, and it was also the only night flight to carry passengers as well as cargo.

The two passengers on Boeing Air Transport's Model 40s were crammed into a tiny cabin in the fuselage without benefit of safety belts, but they did have the modern comforts of forced-air heating and a dome light. The pilot, wearing helmet, goggles, and warm clothing, sat in an open cockpit. He had emergency flares and lights for night flying but no radio and few aids to navigation. The plane, which was powered by a Pratt and Whitney radial air-cooled engine with 410 horsepower, could carry about 1,200 pounds in any combination of mail and passengers. It had a cruising speed of 105 miles per hour and a top speed of 120 miles per hour. Because its cruising range was 350 miles, it had to make frequent stops for refueling. Nonetheless, Boeing Air Transport claimed the plane could fly coast to coast in thirty hours and forty-five minutes.

While the Boeing Model 40 shown here was flying the San Francisco-to-Chicago run, it was involved in a number of minor accidents, some of them no doubt caused by bad weather over the Rockies and the hazards of flying at night in an open cockpit with only the crudest of navigational instruments. In 1928, after the first accident, the plane was given a new Pratt and Whitney 500-horsepower engine and electric landing and navigation lights. In the early 1930s, as "seat-of-the-pants" flying was beginning to give way to a more structured approach, a 100-pound radio was installed in the plane. By 1933, however, the Model 40 was obsolete, and Boeing Air Transport sold it to National Air Transport of Chicago. National Air Transport converted the plane's rear mail compartment into a second cockpit and used the dual-control craft to train pilots. The following year, United Air Lines absorbed National, and in 1936 it retired the Boeing Model 40. Two years later, Captain Jack Knight, a veteran United Air Lines pilot who had flown the early mail-passenger planes, visited the Henry Ford Museum and noticed that the transportation collection was lacking an original mail-passenger plane. Within two weeks, United Air Lines had offered the Boeing Model 40 to the museum, and on May 18, 1938, Captain Knight himself flew it to the Ford Airport in Dearborn.

Acc. 38.160.1. Neg. A.3051.

Ryan Monoplane

The aircraft in which Charles Lindbergh made his solo, nonstop transatlantic flight started out as a standard monoplane built by the Ryan Aircraft Company of San Diego. In February 1927, Ryan began modifying the craft to meet Lindbergh's requirements for his madcap scheme of flying the Atlantic and completed the job two months later at a total cost of $10,580. The *Spirit of St. Louis* was test-flown in San Diego before Lindbergh flew it to New York via St. Louis. He left New York on May 21, 1927, and arrived in Paris thirty-three and a half hours later, having averaged 122 miles per hour. Overnight, the daring feat made him a worldwide hero.

In 1957, as actor James Stewart was preparing to star in a Hollywood movie about Lindbergh's historic flight, he discovered that an unused 1927 Ryan monoplane—the same kind that Lindbergh had flown—was being stored in a garage in Denver, Colorado. Stewart had the plane trucked to California, restored, and specially fitted out just as Lindbergh's *Spirit of St. Louis* had been; the result is shown here. The restoration entailed replacing all the wooden ribs and struts of the wings and all of the craft's wiring and rubber hosing. The special fitting included moving the pilot's seat aft, for in the orig-

inal craft, an oversized 425-gallon fuel tank had been situated between the pilot and a nine-cylinder Wright Whirlwind engine. Both the replica and the original had a periscope to give the pilot at least some illusion of forward visibility.

The only apparent difference between the original *Spirit of St. Louis* and its replica was that the latter had a second cockpit that afforded its pilot, James Stewart, better visibility than Lindbergh had had with his periscope; the federal government required that the rebuilt plane meet airport safety requirements. Before the movie was filmed, Stewart showed the rebuilt Ryan to Charles Lindbergh, who declared it an authentic copy. He even approved of the second cockpit.

On October 20, 1959, the thirtieth anniversary of the founding of the Henry Ford Museum & Greenfield Village, Stewart sent William Clay Ford, president of the museum's board of trustees, a telegram of congratulations. To it, he added, "In view of your museum's outstanding leadership in preserving our American heritage I would like to offer my airplane built under the supervision of General Lindbergh for the film *Spirit of St. Louis*."

Acc. 59.115.1. Neg. B.42450.

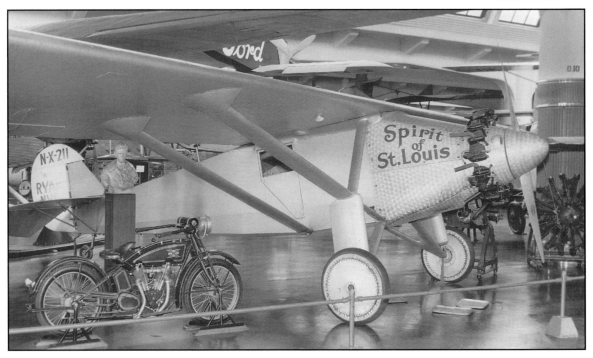

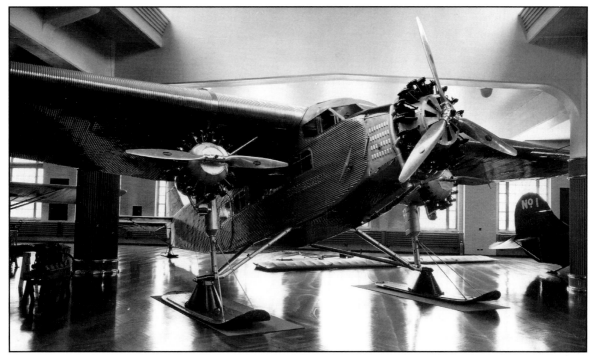

Acc. 00.240.3. Neg. A.3043.

Ford Tri-Motor

Between 1926 and 1932, the Ford Motor Company's airplane division built almost two hundred trimotored monoplanes. Its decision to start manufacturing these craft was somewhat startling, since in 1926 there were fewer than half a dozen multimotored planes in the nation. The all-metal Ford Tri-Motor was affectionately known as the "Tin Goose," because with a wing span of seventy-four feet and an overall length of about fifty feet, the plane appeared to waddle down the runway.

Waddle and all, the Tin Goose became to aviation what the Tin Lizzie had been to the automotive field. Extremely strong, durable, and about five thousand pounds lighter than the Boeing 80, its chief competitor, it combined the shape and size of Anthony Fokker's wood-and-fabric trimotor with a tough, corrosion-resistant corrugated skin made of an aluminum alloy. With three 220-horsepower Wright Whirlwind engines and big, thick wings that made it inherently stable, the Tin Goose transported eleven to fifteen passengers easily and in the greatest possible safety—though not always in the greatest of comfort. The earliest models were strictly bare-bones affairs, and though later models provided passengers with some modicum of comfort, the standard Ford Tri-Motor remained a functional craft designed to get people where they were going efficiently and safely and with the least amount of fuss.

More than a hundred airlines throughout the world ultimately flew Ford Tri-Motors, testimony to the Tin Goose's performance record (and to a memorable advertising campaign that Ford launched in 1927; the *Aero Digest* noted in 1928 that Ford's advertising had done "more to popularize flying . . . than all the stunts that ever have been stunted"). Long after Ford stopped making planes in 1932, the Tin Goose was still flying cargo and passengers in and out of some of the roughest terrain in the world. One particular Tin Goose flew a Mexican mountain route for sixteen years after World War II from a 1,200-foot runway at the bottom of a box canyon with walls 4,000 feet high. In 1985 an Ohio farmer and amateur pilot named Al Chaney bought a 1928 Ford Tri-Motor, which was evidently the oldest Tin Goose still in operation. Chaney proceeded to fly it all over the country, giving rides at different airports each weekend. He was still at it in 1988.

The Tin Goose shown here is a particularly

historic one. In November 1929, it transported Commander Richard E. Byrd, already famous for his flight over the North Pole, on the first flight over the South Pole—a flight that firmly established Byrd's reputation as one of the greatest explorers of all time. A month later, at age forty-one, Byrd was promoted to rear admiral by a special act of Congress; the act made him the youngest admiral in the U.S. Navy at that time. Byrd named his Ford Tri-Motor after Floyd Bennett, who had been his companion and pilot on the North Pole expedition in 1926. Bennett died just months before Byrd and his party left for Antartica in 1928. As Byrd flew over the South Pole, he dropped an American flag weighted with a stone from Bennett's grave.

The round-trip flight between Byrd's base camp near the Bay of Whales on the Ross Ice Shelf and the South Pole took almost nineteen hours. Among Byrd's important discoveries on this trip were the Ford Ranges and the Rockefeller Mountains, which he named after two of his benefactors, Edsel Ford and John D. Rockefeller, Jr. Inspired by Edsel Ford's belief in the scientific significance of Byrd's explorations, Rockefeller had contributed $50,000 toward the expedition; Edsel had contributed $90,000 in cash and materials.

Edsel Ford's contribution included the 1928 Ford Tri-Motor that made the historic flight. Outfitted with skis and pontoons, it was powered by a 525-horsepower Wright Cyclone engine and twin Wright Whirlwinds, each having 220 horsepower. After the successful flight, Byrd and his party returned home, leaving the plane in Antartica. Five years later, when Byrd returned to set up weather stations, the Tri-Motor, covered by a heavy accumulation of snow and ice, was still in one piece. Byrd sent it back to the United States, and Edsel Ford subsequently donated it to the Henry Ford Museum.

Diesel Airplane Engine

Most Ford Tri-Motors were powered by Wright Whirlwind gasoline engines, but in 1930 Ford introduced a model that was powered by three Packard diesel engines with a total rating of 675 horsepower. In 1927 Herman I.A. Dorner of Hanover, Germany, had given the Packard Motor Company of Detroit permission to adapt his diesel-engine design to aircraft, and within a year, Packard had flight-tested the first airplane powered by a diesel. The engine proved to be extremely economical; fuel costs were far less than those of a comparable gasoline engine. The diesel aircraft engine was, however, plagued with reliability problems, and because of the high tolerances required, it was expensive to manufacture. Although Packard was hard hit by the Great Depression, it persevered in its efforts to perfect the engine until 1933. Packard donated the diesel aircraft engine shown here, one of the relatively few ever produced, to the Henry Ford Museum at some unrecorded date.

Acc. 00.136.313. Neg. A.317034.

Pitcairn Autogiro

The autogiro was a response to the need for an aircraft that could take off and land in tight spaces. It was invented by a Spaniard, Juan de la Cierva, who made his first successful autogiro flight from Cuatro Vientas Aerodrome outside Madrid in 1923. The autogiro differs from a helicopter in that it uses a propellor for forward motion and a rotor simply to provide lift; the rotor is not geared to the engine but revolves by pressure of air. The autogiro cannot take off vertically, but it can make "jump" takeoffs by bringing the rotor blades to operating speed by means of a power mechanism in the engine

The company made the first sale of an American commercial autogiro to the *Detroit News* in April 1931. The newspaper used the craft for just over two years to carry reporters and photographers on special assignments. The forward cockpit seated two passengers and contained camera mounts; the pilot sat in the rear. The craft was powered by a 300-horsepower Wright Whirlwind engine. It made a total of 730 trips before it was exhibited at the Century of Progress Exposition in Chicago in May 1933. When it left Chicago in November of that year, it was flown directly to the Ford Airport in Dearborn, where

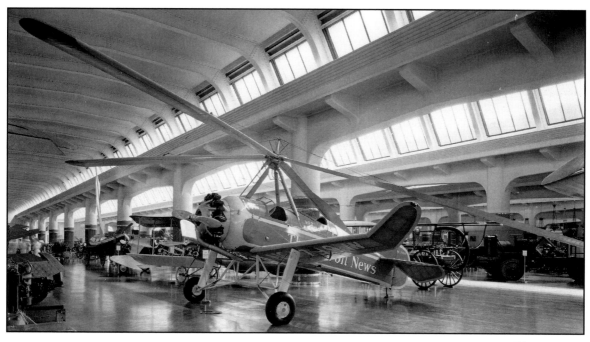

Acc. 34.278.1. Neg. A.3053.

and then increasing the pitch of the blades to create a circular lifting surface. The craft can descend in an almost vertical approach at about fifteen feet per second. Since its rotor is not powered, it cannot hover in mid-air or back up the way a helicopter can. Its short stubby wings provide slight lift in flight, but their primary purpose is to provide horizontal stability and a place to mount the ailerons used to turn the craft.

Because Spain had no aircraft industry, Juan de la Cierva licensed manufacturers in other countries to produce his autogiro. Pitcairn Aircraft of Willow Grove, Pennsylvania, was the U.S. licensee.

William E. Scripps, president of the *Detroit News* and an aviation enthusiast, presented it to Henry Ford for his museum.

Autogiros had several drawbacks. In addition to being unable to take off in a completely vertical fashion or to hover in mid-air, they could not carry heavy loads. Nonetheless, many major corporations found them a useful form of advertising, and they were flown by such famous aviators as Amelia Earhart. The U. S. Navy was also interested in them; it ordered three Pitcairn autogiros for evaluation on aircraft carriers.

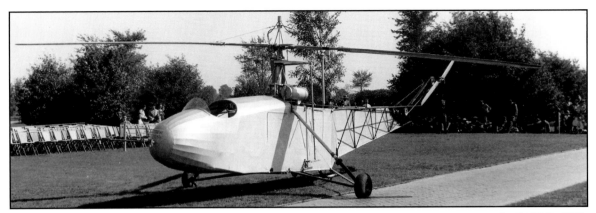

Acc. 43.140.1. Neg. B.5279.

Sikorsky Helicopter

Juan de la Cierva's invention of the autogiro in 1923 gave a much-needed boost to the development of the helicopter. Although efforts to build a rotary-blade aircraft had begun in Europe as early as 1907, progress had been limited by lack of a suitable engine and other technological factors, and by rapid advances in the development of fixed-wing aircraft. As airplanes met with one success after another, they, in effect, put experimentation with helicopters on the back burner.

Igor Sikorsky, a Russian who emigrated to the United States in 1919 after the Bolshevik Revolution, was one of the pioneers in the field of rotary-blade aircraft. Influenced by Leonardo da Vinci's drawings, Sikorsky had built and tested two helicopters in 1909 and 1910, but he had met with limited success. Although he never abandoned his idea for a helicopter, he put the work to one side, and from 1910 until the 1930s, he concentrated on designing and building airplanes of every type—land-based planes, amphibians, and flying boats. Among his early successes was the world's first four-engine plane, which he introduced in 1913; he built a fleet of seventy-five of these huge craft for the Russian government during World War I. After coming to the United States, he began designing and manufacturing the renowned S-42 China Clippers.

By 1938 Sikorsky was convinced that the light, high-powered engines then available would permit him to solve the problems he had encountered in his early helicopter experiments. At the United Aircraft Corporation in Bridgeport, Connecticut, where he had worked for the preceding ten years, Sikorsky proceeded to build the first practical helicopter produced in the United States. It made its first flight on September 14, 1939, hovering inches from the ground for just a few seconds. By November, Sikorsky had taught himself more about flying his new machine, and the flights were more sustained. However, the craft lacked adequate control, and it went through several remodelings until it emerged in 1941 as the machine shown here. Known as the VS-300A, it was initially powered by a 75-horsepower Lycoming engine and later by a 100-horsepower air-cooled Franklin. Its fuselage has a fabric skin covered with aluminum paint. It has one main lifting rotor with three blades and a single tail rotor that provided directional control and also countered the main rotor's torque—a configuration that became the standard in the helicopter industry. On May 6, 1941, the craft established a world endurance record for helicopters by remaining in the air for one hour and thirty-three minutes.

The VS-300A was the forerunner of a series of helicopters that have been used by the military and in civilian rescue work, firefighting, and other situations in which conventional aircraft cannot be used. Sikorsky was particularly proud that the first practical use of one of his helicopters—to transport blood plasma to victims of an explosion in 1944—"was for helping man in need rather than . . . spreading death and destruction." When the VS-300A had logged almost 103 hours, Sikorsky offered it to the Henry Ford Museum, and after it had been trucked to Detroit, he took it on its last flight, landing on the museum's front lawn on October 7, 1943, where he was greeted by Henry Ford and crowd of twelve thousand onlookers.

Douglas DC-3

The DC-3, immortal workhorse of the aviation industry, was Donald Douglas's response in 1935 to the president of American Airlines, who had made a plea for a better aircraft. Inexpensive to operate and almost uncannily reliable, the DC-3 revolutionized commercial aviation by making it both dependable and profitable. The Douglas Aircraft Company in Santa Monica, California, produced a total of 13,000 of these low-winged monoplanes, and at one time, they carried 95 percent of all commercial airline passengers. During World War II, the DC-3 performed as the C-47; coping valiantly under some of the most adverse conditions imaginable, it earned the affectionate nickname of "Gooney Bird."

On August 11, 1939, an especially memorable DC-3 rolled off the Douglas assembly line. Known as No. 728, the plane would log more flying hours over the next twenty-six years than any other aircraft up to that time in history. When Eastern Airlines, its original owner, sold No. 728 to North Central Airlines in 1952, the plane had 51,389 hours in the log book. When North Central retired it from scheduled service on April 26, 1965, it had flown 83,032 hours and more than 12 million miles—the equivalent of more than nine years in the air and twenty-five round trip flights to the moon. No. 728 had worn out an estimated 550 main gear tires, 25,000 spark plugs, and 136 engines. It had burned 8 million gallons of gasoline and taxied over 100,000 miles. And it was still ready for more.

After taking No. 728 out of scheduled service, North Central refurbished the plane and gave it a spanking new interior. Thereafter, until North Central donated the historic craft to the Henry Ford Museum in 1974, it served as a "VIP" airplane and performed promotional duties for the airline. No. 728 made its last flight on May 28, 1975, landing in Dearborn at the Ford Airport, which was by then a test track for the Ford Motor Company.

Acc. 74.140.1. Neg. B.71185.

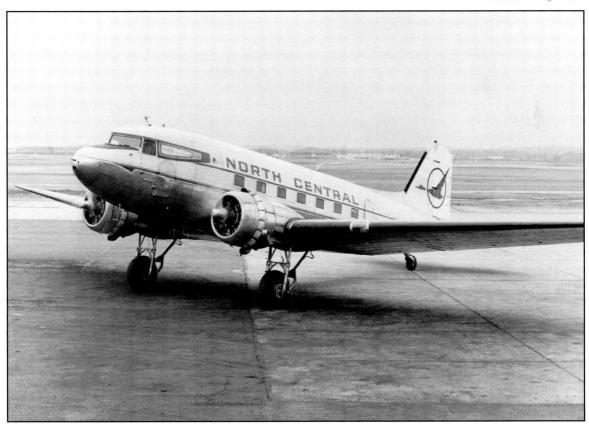

CHAPTER 7
Industrial Equipment

FROM A VERY EARLY AGE, Henry Ford was fascinated with mechanical things. His mother noted with pride that he was a "born mechanic"; his father was evidently not so pleased. In Henry's inimitable words, "I was always tinkering with wheels. My father used to give me Caesar." A water-powered gristmill near Henry's boyhood home, where he must often have watched in fascination as the paddle wheel dipped in and out of the Rouge, no doubt fostered his interest in mechanical engineering. It was, however, the ungainly steam engine that came puffing down a country road toward him one July day in 1876—the first self-propelled vehicle he ever saw—that set the course of thirteen-year-old Henry's future career. One of the things that made it move, Henry noted, was "a chain that made a connection between the engine and the rear wheels."

Years later, as an enormously successful manufacturer of automobiles, Henry kept an enlarged photograph of a similar old "road-roller" steam engine in a place where he could see it every day. He also managed to acquire such an engine for his museum. In one of his "jotbooks," he wrote that the "portable" steam engine he had seen in July 1876 was the thing "that showed me that I was by instinct an engineer." It may seem a far cry from a slow and lumbering old steam engine to the Model Ts that changed the face of rural America, but both the steam engine and the methods and machines that Henry Ford used to turn out automobiles in unprecedented numbers were outcomes of a long line of related technological advances.

In 1690 Denis Papin, a French theoretical scientist who also happened to invent the pressure cooker, made a steam engine—probably the world's first—to power water fountains on his patron's estate. Papin's engine was not a succeess, for the pressure in its pipes kept causing them to burst. Six years later, Thomas Savery of Devonshire, England, patented a steam device called the "Miner's Friend." Savery had a very specific application in mind. After years of being mined, mineral deposits near the surface of the earth in Britain had been depleted, but as miners dug deeper, the shafts filled up with water. To drain the water out, mine operators used horses to power mechanical pumps, but by the late 1600s, these devices were proving incapable of keeping up with the flow of water. If the problem was particularly severe, the pumping could require well over a hundred horses. (This expensive and troublesome arrangement gave rise to the modern "horsepower" measure. As steam engines evolved, their power was measured in the amount of work a horse could do in the same amount of time. The formula that evolved was that one horsepower was equal to 150 pounds being lifted at the rate of 220 feet per minute, or 2.5 miles per hour.)

Because Savery's device could pump water to only about twenty feet, it was not a success in the mines, though it was used to pump water in buildings along the Thames in London. In 1705 another Devonshire man, Thomas Newcomen, improved on Savery's pump. Newcomen's engine consisted of a vertical cylinder with a piston and piston rod fitted into it. The piston rod was chained to one end of an overhead beam; dangling from the other end of the beam was a pump bucket. The beam, resting on tilting pins on top of a masonry column, rocked back and forth when the engine was in motion. When the engine was idle, the pump bucket, being heavier than the piston, brought the latter to rest at the top of the cylinder.

To set the Newcomen engine in motion, the cylinder was filled with steam from a separate boiler. The steam valve was then shut, and another valve was opened to inject a spray of cold water into the steam-

filled cylinder. As the steam cooled and condensed, it created a partial vacuum beneath the piston. The heavier weight of the atmosphere above the piston drove it down into the cylinder, bringing the beam down and causing the pump bucket at the other end of the beam to rise, thus completing one work stroke. Although sturdily built, Newcomen engines were slow and inefficient and consumed large quantities of coal. Miners liked them, however, and in the course of the 1700s, these engines, also known as "fire engines" or "atmospheric engines," became common sights at mines all over Europe.

Since they were designed to pump water, Newcomen engines did not have any provision for the rotary motion needed to turn the wheels of other machinery. In 1781 James Watt, a Scot who began his career as a maker of scientific instruments at the University of Glasgow, solved this problem with a gear arrangement that connected a steam engine's rod to a wheel shaft. Thus, for the first time, steam engines could be used to drive the machinery of textile mills and other factories. Moreover, with Watt's steam engines, mills and factories no longer had to be located where wind or water power was available. Owners could build them wherever they wished. As it turned out, this was very often near cities that could supply cheap labor.

By the time Watt adapted his engine to factory work, he had made a number of other improvements that greatly enhanced the steam engine's performance and efficiency. In 1765, while repairing a Newcomen engine, he had realized that much steam was wasted in reheating the cooled cylinder after the cold water had been sprayed inside it to create the vacuum. Watt solved this problem with a separate condenser, which was kept constantly cool; meanwhile, the cylinder, with an insulating jacket, was kept constantly hot. This not only saved a good deal of fuel but also made the engine faster, since no time was lost in waiting for the cylinder to reheat. Among Watt's other improvements was a double-acting cylinder. By using steam to push the piston from both sides of the cylinder, rather than one as in earlier engines, Watt doubled the amount of work the engine could do. He also invented a "governor," a device that controlled the speed of the engine by regulating its throttle.

In 1773 with a successful toy manufacturer named Matthew Boulton as his partner, Watt formed a company to produce and sell his engines. The firm of Watt & Boulton soon became world-famous. The engine that it produced consumed much less fuel than a Newcomen engine with comparable power and was two to three times cheaper to run. But for all its advantages, Watt's engine, like Newcomen's, was still a low-pressure, "atmospheric engine"; that is, it operated close to the atmospheric pressure of 14.7 pounds per square inch. Watt never ventured into experimenting with engines that operated at high pressures, possibly because he was afraid of boiler explosions—not an unrealistic fear, since such explosions were common occurrences throughout the nineteenth century. It fell to other inventors to develop high-pressure steam engines for locomotives and ships; such engines operated at pressures several times that of the atmosphere.

By the early 1780s, when Watt introduced his double-acting, rotary-motion steam engine, the Industrial Revolution was well underway in Britain—the first nation in the world to experience it. Newcomen's engines had been enabling miners to supply the quantities of coal needed to fuel such a revolution. Watt's engines would quickly supply the power. A factory system was already in place, thanks to Richard Arkwright who in 1769 invented a "water frame" to make a type of yarn needed for weaving. Arkwright's water-powered frames held several hundred spindles and were so large that workers' cottages, where textile work had traditionally been done, could not contain them. After Arkwright's invention, the factories built for the textile industry often employed as many as a thousand workers.

Other factors also contributed to the phenomenal growth of British industry. Abraham Darby's discovery in 1735 that coke—purified coal—could be used in place of charcoal in iron smelting led to improved methods of making steel and cast iron and an abundance of these once scarce materials. High-quality steel and cast iron were used in making, among other things, vastly improved machine tools: lathes, boring machines, planers, grinders, and the like, which shape material into machine parts. Without such tools, Watt's steam engines might never have been seen in factories. John Wilkinson used his improved boring machine to make cylinders for Watt's engines; the precision of the boring ensured a fine fit between piston and cylinder, resulting in an effective vacuum and an engine efficient enough to drive industrial machinery. Another well-known machine-tool maker of the

late 1700s and early 1800s was Henry Maudslay. Some of the best machinists of the day trained at Maudslay's shop, among them Joseph Whitworth, who developed a system of gauges and a bench micrometer for measuring machine parts as well as machine tools. By the 1850s, as a result of Whitworth's measurement standards, parts and tools were accurate to within one-thousandth of an inch or better.

The standardized parts produced by improved machine tools were an essential ingredient in the development of mass production. Because the parts were standardized, they were interchangeable; thus, a factory worker could pick a part at random without having to waste time searching for one with the right fit. The speed of the assembly and the mechanization of various manufacturing processes meant that goods could be produced quickly, cheaply, and in quantity. The first demonstration of completely mechanized mass production occurred at the Portsmouth Naval Yard in England in 1802. Using forty-four machine tools developed by Henry Maudslay—one for each step of the manufacturing process—10 workers produced as many pulley blocks as 110 workers had previously done in the same amount of time. American manufacturers—especially gunmakers and clockmakers—were quick to pick up on this method of production. They were so successful at it that it became known as the American system of manufacture.

Around 1880, industry began undergoing some interesting changes. Some factories replaced their steam engines with internal combustion engines, which burned fuel internally rather than in a separate boiler. George Brayton developed a two-cylinder, two-stroke engine of this type in the United States in 1872. Nikolaus Otto of Germany designed a more successful single-cylinder, four-stroke internal combustion engine for industrial use in the late 1870s. It would not be long before Karl Benz and Gottlieb Daimler adapted the internal combustion engine to automobiles—an adaptation that, with Henry Ford's help, would eventually create yet another revolution in the way people lived.

Thomas Edison's invention of the incandescent electric lamp in 1879 also contributed to a change in industry—and, of course, to a change in people's lifestyles. The electric lamp led to the development of large, integrated networks of electric-generating stations, including hydroelectric plants, and these facilities offered factory owners yet another method of powering machinery. Henry Ford was a beneficiary of these developments. He not only bought or built more than thirty hydroelectric plants but also made use of electricity in applying the concept of an assembly line to the mass production of automobiles. Using electric machine tools to produce automobile parts and an electric conveyor belt to move cars along just slowly enough to allow workers to implant the parts, the Ford Motor Company in 1913 reduced assembly time for one car from twelve hours to ninety-three minutes. These production methods enabled Henry to lower the price of the Model T from $850 in 1908 to $360 in 1916. Its low price was not the only secret of the "Tin Lizzie's" success. It was eminently reliable, but when things did go wrong, owners could, thanks to the interchangeability of parts, easily acquire and install a replacement.

Both the Henry Ford Museum and Greenfield Village are well stocked with vintage power generators, industrial machines, and machine tools. The collection includes two historic Newcomen steam engines and a Watt & Boulton engine. It also includes machines that were less than twenty years old when Henry Ford bought them. Many people at that time undoubtedly regarded them as junk, but Henry had an eye for classic machines and a decided weakness for steam engines. Although he spared no expense in acquiring such items, even engaging agents in Britain and America to help him, some highly significant ones were gifts.

"Fairbottom Bobs": A Newcomen Steam Engine

"Fairbottom Bobs" is quite possibly the oldest steam engine in existence. It is of the Newcomen type and dates from about 1750, but just who built it is unknown. It was apparently first used at a mine in Norbury near the Cheshire-Lancashire border in England, but in 1764, when that mine was sunk deeper and a larger engine was required to pump it, this one was put up for sale. About a year later, it was installed some nine miles from Norbury at the Cannel Mine in the Fairbottom Valley of Lancashire, and there it pumped water until 1827,

when the Cannel Mine was shut down. The people of the Fairbottom Valley gave it the name "Fairbottom Bobs" because when it was working, they could see its beam ends bobbing up and down against the horizon like two bent old country people nodding over their teacups; when it was idle, slag heaps hid it from view.

After being abandoned in 1827, Fairbottom Bobs sank into a sad state of decay. The photograph below shows it as it appeared in 1886. By 1928, when Henry Ford and his British agent Herbert F. Morton

Acc. 29.1506.1. Neg. A.126188.

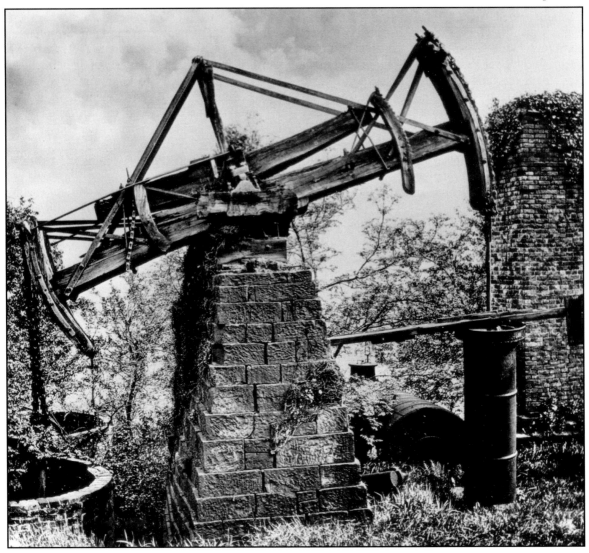

visited it, it was almost a hundred and eighty years old. It had been derelict for over a hundred years of those years and had deteriorated to a point that perhaps only Henry Ford could have envisaged its restoration. It even had a fair-sized tree growing out of the cut-stone column that supported what remained of its beam. Undaunted, Henry sent Morton off to find the owner and negotiate its acquisition.

At length, Morton determined that Fairbottom Bobs stood on land owned by the trustees of Lord Stamford, whose family had made a fortune in coal during the Industrial Revolution. When apprised of Henry's desire to preserve the old relic in his museum, the trustees decided to make him a gift of it. When Morton began dismantling the engine, however, local people began objecting strenuously to its removal; it was not until they were told that the engine would remain—but only on the condition that they fund its preservation—that the protest waned. Morton's troubles were still not over. As he was overseeing the restoration of the engine at the Henry Ford Museum, Henry protested that the new wooden beam, which Morton had taken some pains to have roughly hewn and adzed so it would look

authentic, was not "fine and straight." The compromise—accomplished in Henry's absence—was a "fine, straight" beam disguised by a thick coat of tar.

The photograph below shows Fairbottom Bobs after the restoration. The cylinder (barely visible to the left of the stone column) is eight feet long and has a diameter of twenty-eight inches. The pump rod (on the right) is six feet long and has an eight-inch bore. The pump is surrounded by a low brick wall, as it was in its original location, to keep people from falling in it. Minus the "haystack" boiler, the engine is thirty-five feet long, eighteen feet high, and ten feet wide. The wooden beam is, of course, a replacement, and the boiler came from another site, but most of the other parts, including the cut-stone column that supports the beam, are original. The engine was able to pump water at the rate of fourteen strokes per minute from a depth of 240 feet, the equivalent of about eleven horsepower. Its thermal efficiency was only about 0.05 percent—that is, only about 0.05 percent of the energy in the steam entering the cylinder was converted to mechanical energy to drive the piston.

Neg. B.110894.

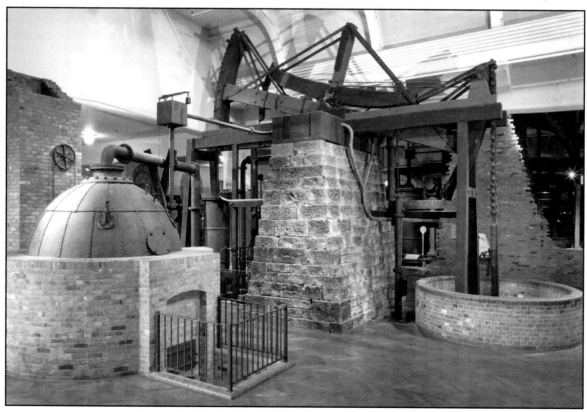

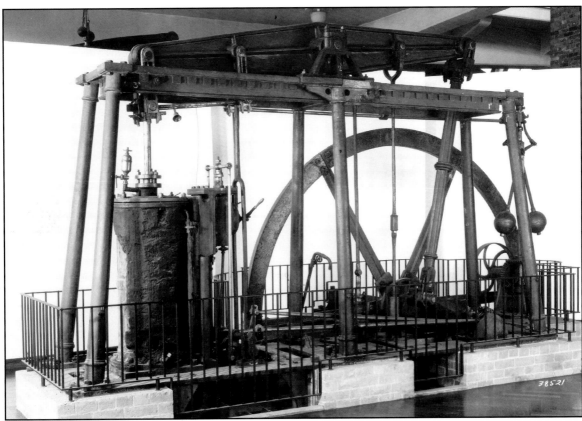

Walking Beam Engine of the Early 1800s

In 1769, even before he became James Watt's partner, Matthew Boulton managed to see to it that Watt's patent on his new version of the steam engine would not expire until 1800. This effectively barred a number of inventors from coming forth with their ideas for improvement, but after 1800 the gates opened. Among the engineers who stepped forth was Jonathan Dickson, who manufactured steam engines in London from 1808 until 1830. Dickson built the particular model shown here in 1811. Known as a walking beam engine, it provided the rotary motion needed to turn the wheels of other machinery.

Made completely of iron (except for an insulating coat of cow dung still clinging to its cylinder), Dickson's steam engine is typical of those that appeared just after the expiration of Watt's patent. With its six cast iron columns, lightly constructed bedplate, and elevated support and flywheel made of multiple pieces, an engine of this sort could be

shipped anywhere in the world with comparative ease. Many similar engines were shipped to sugar mills in the Caribbean Islands, where they were run mainly by slave labor. The engine is twenty-one feet long and ten feet wide; the flywheel has a diameter of twelve feet. It produced twelve horsepower and had a thermal efficiency of about 4 percent—almost ten times better than that of the Newcomen engine.

Just where this steam engine was first used after it left Dickson's shop is unknown, but from 1819 until 1928, it was in operation at the James Pearsall Silk Mill in Taunton, England. Herbert Morton was the intermediary in arranging for its transfer to the Henry Ford Museum. The deal that was struck was that the mill owners would give it to Henry Ford if he would supply them with an alternate source of power, which he provided in the form of a small twelve-horsepower electric motor. When Morton went to the mill to take the steam engine away, he noted that

after more than a century of service, it "ran as sweetly as a [new] sewing machine . . . , and it had been tended by men of the same family for many generations. When it came to stopping the old engine for the last time the old chap who looked after it very respectfully asked if I would do it myself—he didn't care to."

Walking Beam Engine of the Victorian Era

The Novelty Iron Works of New York City, a noted manufacturer of both stationary and marine steam engines in the mid-nineteenth century, made this stationary engine about 1855. With its Gothic Revival detail, it is a fine example of the decorative touch that engineers of the Victorian era brought to industrial equipment. Made almost entirely of cast and wrought iron, it is twenty-six feet long, thirty feet high, and weighs about forty-five tons; the massive bedplate alone weighs almost twenty tons. The entire frame was originally painted a buff-limestone color; the paint on the the cylinders was a glossy black or dark grey. All the other elements, such as connecting rods, were polished.

The accurate machining of the engine's parts is evidence that by the 1850s large American machine shops and the machine tools they used were as good as any in Britain or Europe. The bedplate was at one time perfectly flat, and a very large planer must have been used to accomplish this. The outer rim of the eighteen-foot flywheel was carefully and accurately turned in what must have been an enormous pit lathe. The engine, fitted with a condenser and air pump and capable of approximately 150 horsepower, is typical of its era.

The Tatham & Brothers Lead Works, subsequently the John T. Lewis & Brothers Company, bought the engine and installed it at its factory in Philadelphia about 1857. In January 1930, E.J. Rooksby, whose Philadelphia firm had been doing repair work on the engine for some thirty years, wrote to Henry Ford, informing him that Lewis & Brothers was closing the factory. Rooksby thought that Henry, with his "fondness for old relics, particularly in the mechanical line" and his early background as "a steam engineer," might be interested in acquiring the old walking beam engine. He added that he had read Henry's account of his "life and the development of the FORD automobile," and he wanted to thank him "for the inspiration and suggestion therein received." Little more than a month later, Edward F. Beale, president of Lewis & Brothers, offered the engine to Henry Ford as a gift. Removing it from the factory presented some difficulties, for the building had evidently been constructed around the engine, and in order to get the flywheel out, it had to be cut in two. That accomplished, the engine parts were shipped to Michigan and reassembled at Greenfield Village.

Acc. 30.489.1. Neg. B.58333.

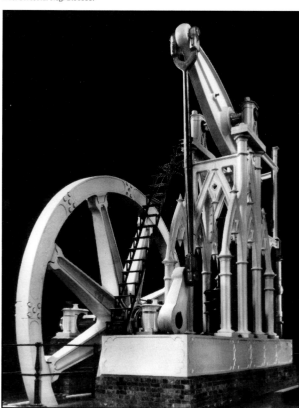

Corliss Steam Engine

George H. Corliss, owner of the Corliss Steam Engine Company of Providence, Rhode Island, introduced the type of steam engine shown here in 1848. This particular one, thirty-eight feet long, twelve feet wide, and producing about 300 horsepower, was built in 1859. An even larger Corliss steam engine was the centerpiece of the celebration of modern technology at the Philadelphia Centennial Exposition of 1876. By then, Corliss's design was recognized as one of the most significant of all American contributions to the development of steam engines.

The Corliss engine's four rocking valves, controlled directly by a governor (the elevated device over the small wheel in the center of the photograph), resulted in a thermal efficiency of 18 to 20 percent, and its very constant speed of operation made it popular with owners of textile mills. Moreover, because it was assembled from interchangeable parts, replacement parts were easily obtained, and its initial cost was relatively low. It was affordable enough that for the first time in America, large numbers of mill owners had the choice of locating their mills away from sources of water power. They could now build them near large markets or near sources of raw materials or cheap labor, regardless of water flow in the area. The Corliss engine, coupled with a large population of immigrants willing to work for low wages, gave rise to such textile centers as Fall River, Massachusetts.

Like the flywheel on the Dickson steam engine, the flywheel on this venerable machine was made in multiple parts—and with remarkable precision, for the flywheel is still accurately round to within a few thousandths of an inch. Such precision would have required highly sophisticated, large-scale machine tools and skilled machinists.

The engine served for more than sixty years as the central source of power for some dozen commercial buildings in Providence. The firms located in these buildings made everything from wooden spools to jewelry. An anonymous friend of Dutee W. Flint, a Ford dealer in Providence and a close friend of Henry and Clara Ford, donated the Corliss engine to the Henry Ford Museum in 1929.

Acc. 29.403.1. Neg. B.105503.1.

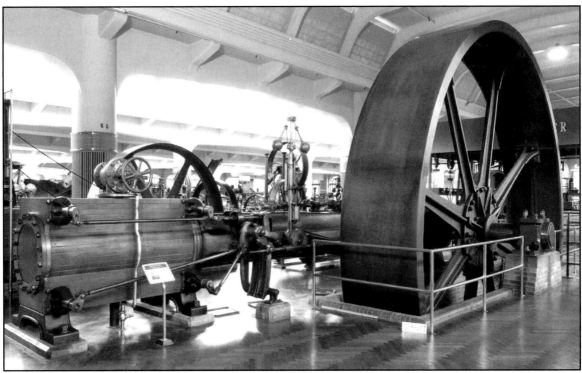

Brayton Internal Combustion Engine

The Dutch physicist and astronomer Christian Huygens experimented with an internal combustion engine in the 1600s. He used a small charge of gunpowder inside a cylinder to raise a piston; when the gases in the cylinder cooled, the pressure of the atmosphere forced the piston down again. Huygens was a founding member of the French Academy of Science, and Denis Papin became his assistant there. After experimenting with Huygens's device, Papin concluded that introducing steam into a cylinder would be a better means of creating a vacuum and getting a piston to work, and so Papin went on in 1690 to create what was probably the world's first steam engine—albeit a rather useless one.

The next person who seriously took up the study of the internal combustion engine was the French inventor Étienne Lenoir. In the late 1850s, Lenoir built an engine in which an electric spark inside a cylinder ignited an expoding mixture of coal gas and air, causing the piston to move. Lenoir's engine worked, but it was very inefficient, consuming large amounts of gas for small amounts of work. It was made more efficient in 1862 by Alphonse Beau de

Rochas's invention of the four-stroke cycle engine, and more efficient still by Nikolaus Otto's improvements on the four-stroke cycle in the late 1870s. On the first stroke in this type of engine, the piston moves down, drawing in a mixture of fuel and air to fill the cylinder. On the second stroke, the piston moves back up to compress the mixture. On the third stroke, expanding gases formed by the ignition of the compressed fuel and air drive the piston back down. On the fourth stroke, the piston moves back up to expel the products of combustion. The engine's crankshaft revolves twice during the four strokes.

In 1872, some years before Otto introduced his four-stroke cycle engine, George Bailey Brayton, an Englishman living in Boston, developed a two-stroke cycle engine, which requires only one up-stroke of the piston and one down-stroke to turn the crankshaft one revolution. Brayton's engine had two cylinders: a pumping cylinder in which the fuel and air were compressed, and a power cylinder in which the compressed mixture was burned. It was the first internal combustion engine used in industry in America. The New York & New Jersey Ready Motor Company of New York City built the Brayton engine shown here in 1878. The first Brayton engines burned gas; later models like this one burned kerosene or other light oils. A little less than five feet high with a flywheel diameter of about three feet, the 1878 Brayton developed four horsepower at 180 revolutions per minute.

Like the Otto engine and other early internal combustion engines, the Brayton engine was built to compete with industrial steam engines—over which it did indeed have certain advantages. The "Brayton Ready Motor," as it was called, could, in theory at least, be started right up with no need to fire a boiler and wait for the steam pressure to rise. That it had no boiler was in itself a great economic advantage. Because of the danger of explosions, most large cities required that licensed engineers operate the boilers of steam engines, and the cost of their labor was not cheap. Boilers also raised insurance costs and sometimes required separate structures to house them and their fuel supplies. In addition, steam engines were expensive to maintain, for they had to be cleaned regularly, and their boiler tubes needed frequent replacement.

Brayton engines, however, were far from trouble-free. Because the quality of the light oils they used as fuel was not always the best, the engines sometimes clogged and stopped running or refused

to start. The pumping cylinder, in which the fuel and air were compressed, used much of the engine's power, and as a result, the engine had an efficiency of only 7 percent. The Brayton was as efficient as steam engines of a comparable size, but when Nikolaus Otto introduced his more efficient single-cylinder, four-stroke engine in 1877, the Brayton engine was unable to compete. It was never built in large sizes, as later Otto engines were, and it never managed to displace steam engines in large installations. It did, however, achieve a moderate success in small plants and factories that could get along with less power and efficiency.

The College of Engineering at the University of Michigan in Ann Arbor used the Brayton engine shown here as a teaching device for many years before donating it to the Edison Institute in 1939. Henry Ford and the Ford Motor Company sponsored a number of engineering research projects at the university between 1934 and 1945.

Otto Internal Combustion Engine

In early Otto engines, a charge of coal gas and air entered a single horizontal cylinder through a slide valve, and there it was compressed and ignited by a flame. These single-cylinder, four-stroke engines developed only about three horsepower at 180 revolutions per minute, but they had an efficiency of 14 percent—twice that of the four-horsepower Brayton engine and two or three times better than that of a comparable steam engine. Schleicher, Schumm & Company of Philadelphia made this American version of the Otto engine about 1882.

Because early Otto engines ran on gas manufactured from coal, they were usually dependent for their fuel on a municipal facility that provided gas for lighting. This type of fuel was expensive, but for many plants whose low power requirements made fuel economy a minor consideration, the Otto engine became the power source of choice. It offered the same ease of start-up as the Brayton engine and the same economic advantages—no need to pay a licensed engineer to tend a boiler, no need for a separate structure, and lower maintenance and insurance costs—and it was twice as efficient.

The Otto engine also proved to be extremely adaptable. It could be made large or small, with single or multiple cylinders; it could burn gas or liquid fuel and use a flame, hot tube, or electric spark for ignition. It was very quickly a resounding success. Just a few years after Nikolaus Otto introduced his single-cylinder, four-stroke engine in Germany in 1877, thousands of Otto engines were being built all over Europe and in Britain and the United States as well. The first of these engines, like the one shown here, had at the most only a few horsepower. By 1885, however, over fifteen thousand Otto engines with as much as 25 horsepower were in service, and by 1900 a four-cylinder, 1,000-horsepower engine based on

Acc. 00.4.502. Neg. A9656.

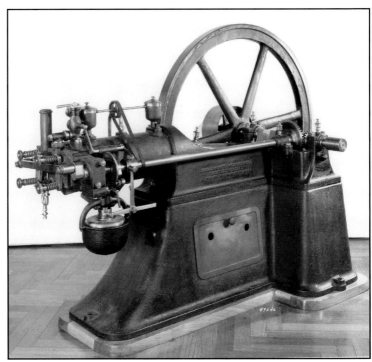

Otto's principles had been introduced.

In addition to being the first internal combustion engine to make any inroads on the supremacy of steam engines in industry, the Otto engine was the forerunner of the four-stroke gasoline engines found in modern cars and in many industrial tools. Henry Ford had his first encounter with an Otto engine when he was called upon to repair one in 1885. The experience evidently convinced him that four-stroke engines that ran on liquid fuel rather than steam or electric batteries were, as Thomas Edison later assured him, "the thing" as far as automobiles were concerned.

The Otto engine, one of several in the Henry Ford Museum, was an anonymous gift to the Edison Institute. The date of the gift was not recorded.

"Long-Legged Mary Ann": Edison's Bipolar Electric Generator

Thomas Edison gave the first public demonstration of his electric lighting system at Menlo Park on New Year's Eve, 1879. Just four months later, in April 1880, this generator and three others like it were installed on the *S.S. Columbia* to supply electricity for 115 lamps aboard the ship. The *Columbia's* electric plant was the first commercial application of Edison's lighting system.

Henry Villard, president of the Oregon Railway and Navigation Company which owned the *Columbia,* was among those who had witnessed Edison's lighting demonstration at Menlo Park. Much impressed, Villard had at once decided to have electric lighting installed aboard the fine steamship then being built for his company. The *Columbia* was to include all the latest fittings and be one of the premier ships afloat. When the builder of the ship was informed that an electric lighting system was to be included among those fittings, his comment was, "Let them try it out on land first—not on a ship." Others pointed out that the marine underwriters might object. But Villard was determined, and the work of installing the generators and lamps went ahead.

The bipolar, or two-field, generators—the same type Edison had used at Menlo Park—produced

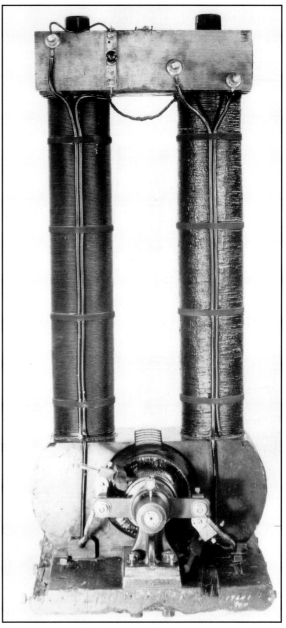

Acc. 30.1123.2. Neg. 188.19641.

five to six kilowatts at 100 volts DC. Because of their peculiar shape—two poles, each about five feet high—they were often called "long-legged Mary Anns." They were arranged in a line along one wall of the *Columbia 's* engine room. Two steam engines in an adjacent room supplied the power to drive them. The system for regulating resistance did not include a galvanometer to monitor the tension; a crew member had to judge it from the brightness of the lights in the engine room. Leads from the generators were connected to a common switchboard, from

which seven feeders ran off to supply power to different parts of the ship. Because the branch lines terminated in switch boxes that were controlled by a steward, passengers had to summon the steward when they wanted the lights in their staterooms turned on or off.

The *Columbia* left New York on May 2, 1880, and after sailing around Cape Horn, arrived in Portland, Oregon, almost three months later. The oil lamps that were kept in reserve during the voyage were never brought out; Edison's bipolar generators functioned perfectly. The publicity that attended the

success of this commercial venture sparked a good deal of interest in Edison's remarkable new lighting system.

When the *Columbia* was overhauled in 1895 and given a new electric plant, the Oregon Railway and Navigation Company returned two of the original bipolar generators to the General Electric Company of Schenectady, New York, successor of the Edison General Electric Company. In 1930 General Electric donated one generator to the Smithsonian Institution and the other, shown here, to the Henry Ford Museum.

Model of Edison's Pearl Street Station

On September 4, 1882, the Pearl Street Station, Thomas Edison's first large-scale commercial electric-generating system, went on line, lighting up one square mile of lower Manhattan. The event caused even the staid *New York Times* to wax eloquent:

> The light was more brilliant than gas and a hundred times steadier.
>
> To turn on the light nothing is required but to turn the thumbscrew; no matches are needed, no patent appliances. As soon as it is dark enough to need artificial light you turn the thumbscrew and the light is there, with no nauseous smell, no flicker and no glare. . . .
>
> There was a very slight amount of heat from each lamp, but not nearly as much as from a gas burner—one-fifteenth as much as from gas, the inventor says. The light was soft, mellow and grateful to the eye, and it seemed almost like writing by daylight to have a light without a particle of flicker and with scarcely any heat to make the head ache.

The six engines and six generators that made this marvel possible are illustrated in the working model of the Pearl Street Station shown here. Four Babcock & Wilcox coal-fired boilers on an upper floor not shown in the model supplied steam at 120 pounds of pressure to drive the six 125-horse-

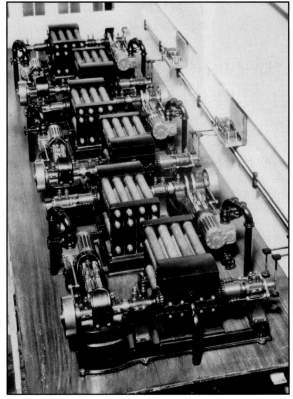

Acc. 29.1746.1. Neg. 188.62454.

power engines, three on each side of the installation. Each engine was connected to a "jumbo" generator that could easily light twelve hundred 110-volt, 50-watt lamps. The six generators look like a staggered line of firecrackers running down the center of the plant.

Although Thomas Edison predicted that his jumbo generators would "go on forever unless

stopped by an earthquake," they were stopped by a fire that destroyed the Pearl Street Station in January 1890. Before they quit, however, they demonstrated that Edison's system for generating direct current was effective for small, adjoining areas. His concept of a central station became the model for future alternating current systems.

Thirty-one men working under the direction of George K. Jessup, superintendent of the shops of the New York Edison Company, made this working model and two others like it in 1929 to commemorate the fiftieth anniversary of Edison's invention of the incandescent electric lamp. When Henry Ford saw one of the models in operation at a convention in Atlantic City, New Jersey, he turned to Matthew Scott Sloan, president of New York Edison, and said, "I'd like to have that in my museum in Dearborn." "All right, Mr. Ford, take it along," was the reply, and so the model came to rest in "Henry's attic."

Olds Portable Steam Engine

By 1890 small units combining a steam engine and a boiler fired by liquid fuel had become very popular, and a number of firms were manufacturing them. Because they produced small amounts of power, these units were generally exempt from laws that required licensed engineers to operate boilers. The internal combustion engines then coming into use were still at a noisy and unreliable stage, and since electricity was not available in rural areas, electric motors were of no use to farmers. The small combination steam engine and boiler therefore found a ready market among people who wanted power for small jobs.

The firm of Olds & Son of Lansing, Michigan, manufactured the compact and well-designed unit shown here sometime between 1885 and 1892. It consists of a very small, one-horsepower steam engine with an automatic cut-off and a gasoline-fired boiler, both mounted on a low, cast iron table. Just four feet long, four feet high, and two feet wide, the unit could be easily transported from place to place. The firm that built it belonged to Pliny Olds, who in 1885 sold a share in the business to his twenty-one-year-old son, Ransom E. Olds. By 1892, when Ransom Olds bought the rest of the shares in the business, the firm had built more than two thousand units similar to the one shown here. None had more than two horsepower, and all had gasoline-fired boilers.

After he renamed his father's firm the Olds Gasoline Engine Works, Ransom Olds began concentrating on building gasoline engines. In 1904 he sold the business and founded the Reo Motor Company, which became the manufacturer of the famed Reo and Oldsmobile automobiles. The rest of the story is, of course, automotive history. The Ingram Company of Lansing gave the Olds portable steam engine to the Henry Ford Museum in 1931.

Acc. 31.608.1. Neg. A8438.

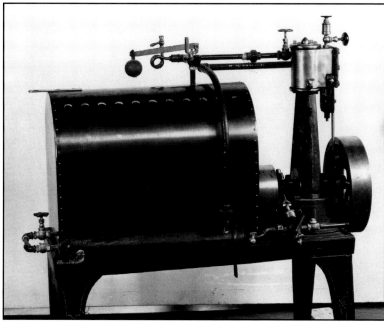

Steam-Driven Electric Generator

The installation of this unit at the New York Edison Company's Duane Street Station in 1891 coincided with the beginning of large-scale electrification in the United States. Based on the design of the generators used in ships, it was the mightiest but most compact generator yet built for a central power station.

Electric utilities companies like the New York Edison, which distributed power by direct current, faced a particular problem. Because considerable energy was lost in transmitting direct current, economy dictated that transmission be limited to a mile or less. To supply customers in cities, generators had to be installed in areas where land values were often very high. Thus, the generators had to be as small as possible, yet they had to produce unprecedented amounts of power. For this reason, in the 1890s, electric utilities began adopting engines like this one, which, based on marine design, were relatively compact but powerful.

Eighteen feet wide and twelve feet deep, the unit consists of a "triple-expansion" 625-horsepower steam engine directly connected on each end to an electric generator. Three cylinders of varying sizes—eighteen inches, twenty-seven inches, and forty inches in diameter—are mounted on top of the engine. The eighteen-inch cylinder on the right used high-pressure steam fed directly from the boiler to drive its piston. The same steam next went into the larger cylinder in the middle, and from there into the largest of the three cylinders on the left. Thus, the same steam expanded three times as it drove three pistons, all attached to the same crankshaft. At high pressure, the smallest cylinder probably produced the same amount of power as the largest one did at low pressure.

The Dickson Manufacturing Company of Scranton, Pennsylvania, built the triple-expansion steam engine; the Edison General Electric Company of Schenectady, New York, built the two generators. With about 20 percent thermal efficiency, the steam engine compared favorably with other similar engines of the period. The generators, which had an output of about 450,000 watts, converted 95 percent of the mechanical energy supplied by the steam engine into electrical energy, making the unit quite economical. Combination units such as this quickly came into use and were the standard in utilities in the United States until about 1905, by which time much more powerful turbine-driven generators had been introduced.

The Edison Electric Illuminating Company of New York City presented the steam-driven generator to Henry Ford in 1929. In 1980 the American Society of Mechanical Engineers designated it a historic landmark.

Acc. 29.111.1. Neg. B.83947.

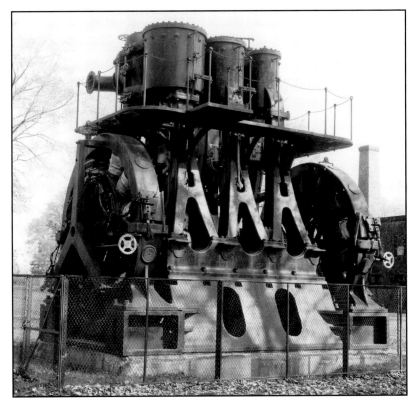

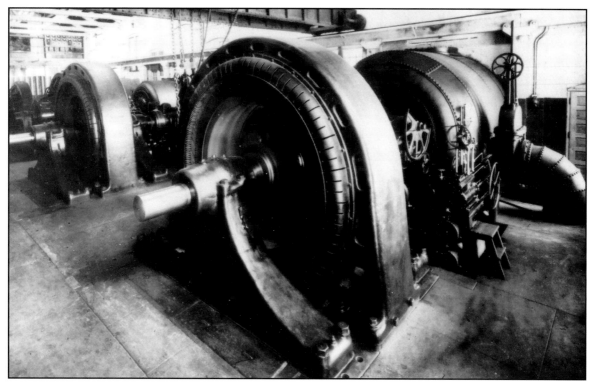

Hydroelectric Power Plant

As early as 1500, people had realized that a water wheel is more effective if encased in a chamber that directs the flow of water on its blades. It was not, however, until 1832 that advancements in hydrodynamic theory and improvements in machine tools enabled Benoit Fourneyron to build an effective water turbine in France. In 1849 James B. Francis, an English-born American, developed a type of turbine suited for use with medium or small waterfalls—that is, where the drop from the water to the turbine is moderate to small, although the flow of water may be very powerful. In 1870 Lester Allan Pelton, another American, developed a turbine for use with mountain reservoirs, where the waterfall is steep though the flow may not be great. These early turbines were used to power industrial machines. After electricity came into use, they were put to work powering electric generators. The first large-scale hydroelectric facility was built at Niagara Falls in the 1890s.

The photograph shown here, taken in 1913, is of two electric generators and a water turbine; the turbine appears behind the generator in the center of the photo. This equipment was installed in a hydroelectric power station in Spokane, Washington, in 1903 and remained in operation until 1990, when the Washington Power Company presented it to the Henry Ford Museum. It converted about 85 percent of the mechanical energy from the falling water available to it into electrical energy. The water turbine, rated at 1,676 horsepower, was built by the Stillwell-Bierce & Smith-Vaile Company of Dayton, Ohio. The General Electric Company of Schenectady, New York, built the 1,250-kilowatt generators.

The equipment shown here supplied cheap electricity to a mining district in western Idaho, over a hundred miles away from Spokane. Hydroelectric plants were also important in the establishment of a transcontinental grid of electrical supply, which led to the uniformity of electrical standards throughout the United States and Canada.

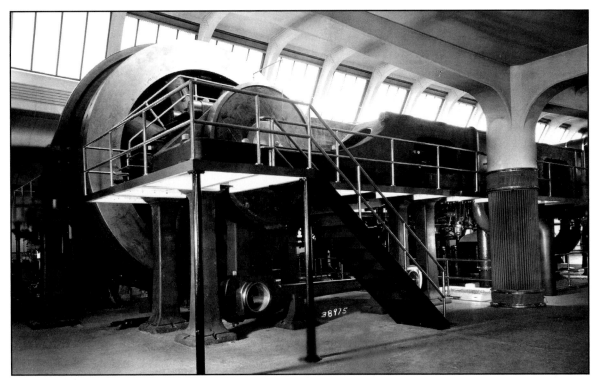

Acc. 30.1200.1. Neg. A.1879.

Gas-Steam Power Plant

This machine, eighty-two feet long, forty-six feet wide, and weighing 750 tons, is one of nine that powered the Ford Motor Company's Highland Park plant while Model Ts were being manufactured there. Together, the nine machines generated 53,000 horse-power. Each had a gas engine and a steam engine mounted on either side of a 4,000-kilowatt direct current generator. The gas engines, being more efficient than the steam-driven units but less regular in speed, provided economy and power; the steam engines provided regulation and reliability. At the time the units were installed at Highland Park around 1915, they created quite a stir in engineering circles. They were generally regarded as a highly innovative and economical means of supplying industrial power.

The Hoovens, Owens, Rentschler Company of Hamilton, Ohio, made the gas-steam engines about 1913; the Crooker-Wheeler Company of Ampere, New Jersey, made the electric generators. It took about six months to build the equipment and another six months to install it. William B. Mayo, who designed the gas-steam engines at the Hoovens, Owens, Rentschler Company, went to work for Henry Ford soon after the new power plant was installed. Mayo was for many years responsible for power installations throughout the Ford Motor Company.

Although the engines evidently operated with great efficiency, their design was never used anywhere outside the Ford Motor Company. For one thing, their size was enormous in comparison with their power output, and maintaining such large, complex machinery was costly. For another, by the 1920s, if not earlier, alternating current had replaced direct current in most installations. When the Ford Motor Company donated the engine shown here to the Henry Ford Museum in 1930, the power plant at Highland Park was obsolete. The engine remains a testament to Henry Ford's fascination with unusual machines and his passion for efficiency and abhorrence of waste.

Atomic Power Switch

When Admiral Lewis L. Strauss, chairman of the Atomic Energy Commission, threw this switch at West Milton, New York, on July 18, 1955, it set in motion the first commercial distribution of atomic electric power for use in American homes and industries. The General Electric Company installed and operated the generating equipment at West Milton, site of one of the government's prototype reactors for

Mohawk Power Corporation to homes and factories in upstate New York. The turbine-generator could produce electricity at the rate of about 10,000 kilowatts—enough to supply the needs of a city of 20,000 to 30,000 people.

The General Electric Company donated the atomic power switch to the Henry Ford Museum in August 1955. In making the presentation, GE's

Acc. 55.46.1. Neg. B.10460.

submarines. GE did so at no expense to the government in order to demonstrate the use of atomic power in peacetime. Using the by-product energy from the experimental operation of the reactor, a gigantic GE turbine-generator produced electricity that was transmitted on the lines of the Niagara-

spokesman, Samuel Littlejohn, noted that "General Electric feels it fitting to have the switch displayed with the museum's Pearl Street Station switch, which in 1882 started the first commercial electric power from a central station."

Maudslay Screw-Cutting Lathe

It is a long step backward from the atomic power switch to the machine tool shown here, but if accurate tools such as this had never come into existence, the atomic switch probably never would have either. The machine tools that Henry Maudslay produced in London in the late 1700s and early 1800s were a spur to the early growth of industry. Made mainly of metal, which did not wear or warp like wood, they were manufactured to very fine tolerances. When used properly, they produced uniformly accurate machine parts. Maudslay's screw-cutting lathes, for example, were made completely of metal and had a slide rest to keep the cutting tool in precisely the right place. The screws these lathes produced were standardized—uniform in both size and thread.

Maudslay built the screw-cutting lathe shown here about 1805. It may be the second oldest Maudslay lathe in existence. It was a special-purpose machine tool, for the screws that it produced were used in making other lathes. The lathe bed, formed by two triangular rails set at different heights, stands on short legs bolted to a cast iron table. Beautifully constructed, the tool is a tribute to the superb craftsmanship of Maudslay and his workers. Its cast iron bed rails, over seven feet long, are almost perfectly straight and parallel. One of them was found to have an accuracy of better than one-thousandth of an inch—a remarkable accomplishment, given that the rails were finished by hand without the aid of any power tools. The availability of lathes and other machine tools that could shape metal parts accurately and precisely made it possible in later years to produce things like sewing machines and automobiles.

The screw-cutting lathe was evidently repaired and rebuilt about 1828. Joseph Whitworth, who was then an apprentice in Maudslay's shop, may have had a hand in this work. Whitworth was to become as well known as his master. In addition to developing measurement standards for machine parts and machine tools, Whitworth developed a method for producing truly flat surfaced planes. In 1842, by which time he was in business for himself in Manchester, he devised an improved planer that could cut in both directions. He built not only fine machine tools but also a variety of machines, including a horse-drawn street-sweeping machine, which he introduced in 1847. In 1854, after Great Britain entered the Crimean War, Whitworth took up the manufacture of rifles, a product for which his company became famous.

When Whitworth's firm merged with W.G. Armstrong & Company in 1897, Maudslay's screw-cutting lathe from 1805 passed into the hands of the new firm. In 1929 the directors of that firm—Sir W.G. Armstrong, Whitworth & Company—presented the lathe to Henry Ford for his museum.

Acc. 29.702.1. Neg. B.14340.

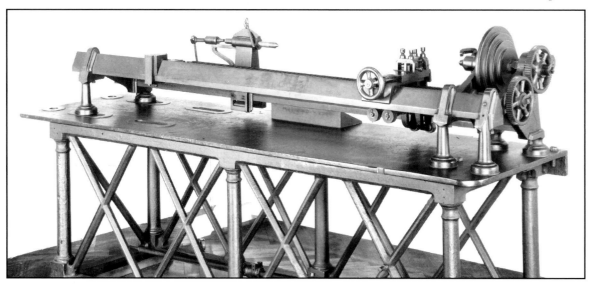

Drill Press

This large, single-spindle drill press was manufactured about 1875. Henry Ford used it five years later, when as a boy of seventeen, he worked in the machine shops of the Detroit Drydock Company, then one of the largest employers in the area. Between 1879 and 1884, the company built thirty-six ships—steamers, barges, and tugs—with engines that developed from 600 to 3,500 horsepower. Frank Kirby, a graduate of the Cooper Union Institute in New York and a builder of shipyards as well as ships, was the company's construction engineer. He was destined to become one of Henry's heroes.

One day as Henry was struggling up a steep ramp, pushing a heavily loaded wheelbarrow in front of him, Kirby saw him and called out, "Stick in your toenails, boy, and you'll make it." When Henry hired Kirby to help with the construction of the Eagle boats in 1918, he related this story to him, adding that "I've been sticking in my toenails ever since." As the Ford Engineering Laboratory Building was being erected in 1923, it was decided that the names of the world's greatest scientists and inventors—Newton, Galileo, Faraday, and Edison among them—should be inscribed in great, large letters above its portals. True to form, Henry saw to it that the name of Kirby went up there just as large as any other.

The drill press that Henry used at the

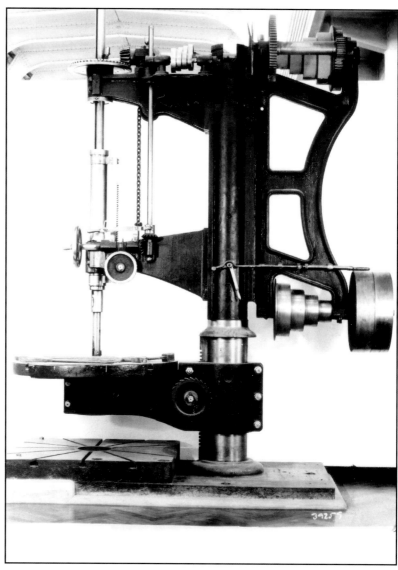

Acc. 28.371.1. Neg. B.65718.

Detroit Drydock Company to drive holes in metal plates has an overall height of eight feet and is four feet wide; it was powered by a belt from an overhead steam-driven shaft. The Detroit Shipbuilding Company, which was under the same management as Detroit Drydock, presented the drill press to Henry Ford in 1928.

Flaking Mill

Frank Lauhoff of Lauhoff Brothers in Detroit held the basic patent on this machine, whose water-cooled rollers made commercial cereal factories possible. Built sometime before 1900, it was one of four mills that the Lauhoff firm made for its own use. Seven feet wide and seven feet high, the machine flaked peas, corn, and rice until 1902, when Lauhoff Brothers began using it to produce brewer's flakes from corn. Two large, hollow steel rollers encased in the machine's heavy frame were kept water-cooled while the machine was in operation. The grain was fed in through the top of the machine and then pressed flat between the rollers. Lauhoff Brothers supplied all the early cereal manufacturers with flaking mills and until Prohibition also sold the machines to brewers.

In 1906 and 1907, Frank Lauhoff worked closely with W.K. Kellogg as the latter developed his ready-to-eat cereal business in Battle Creek, Michigan. Lauhoff used the machine shown here to test products for Kellogg, and after Kellogg's plant burned in 1907, he also used it to produce Kellogg's cereals. Charles Lauhoff of the Lauhoff Corporation donated the flaking mill to the Henry Ford Museum in 1988.

Norton Cylindrical Grinder

The grinder, an outgrowth of the basic lathe—which was itself an outgrowth of the primitive potter's wheel—uses abrasive materials to turn and shape hardened materials into desired forms. Charles H. Norton of the Norton Grinding Company in Worcester, Massachusetts, designed the grinder shown here in 1900. Capable of accurately finishing cylindrical parts sixteen times faster than any previous grinder, Norton's machine became essential to the fledgling automobile industry, which demanded precisely finished hardened-steel parts on an unprecedented scale. Before it appeared, grinding had been part of a finishing operation performed after the rough machining had been done. Norton's machine proved that if a grinding machine was massive enough, it could grind parts "in the rough" with great speed and precision. Over thirteen feet long, six feet wide, and weighing almost eight tons, the machine is mounted on a cast iron base. Among its innovative features were a very accurate micrometer wheel feed and a grinding wheel more than four times larger than any of its predecessors.

The Norton Company—with a bit of nudging from Henry Ford's purchasing director—donated its cylindrical grinder to the Henry Ford Museum in 1931. Norton was a major supplier of the Ford Motor Company, which operated dozens of grinding machines and wore out hundreds of grinding wheels every day. Henry Ford contributed to the mortality rate, for he was prone to test anything within his reach. Being a believer in self-sufficiency, he was particularly prone to testing an article when he had to buy it from a supplier. For a time, he owned a mining property in Garnet, California, and manufactured his own grinding wheels.

Acc. 31.368.1. Neg. A.9590.

Acc. 51.13.60. Neg. B.110622.

Johansson Gauge Blocks

Manufacturers throughout the world still use Johansson gauge blocks for calibration. Carl E. Johansson of Ekilstuna, Sweden, patented the first of these dimensionally accurate steel blocks in 1901, and they soon won international recognition. They were awarded the Medaille de Vermeil in Paris in 1903 and the Diplome d"Honneur at Liège in 1905. By 1911 "Jo-Blocks," as they became known, were widely recognized as the best commercially available means of ensuring the interchangeability of machine parts. Because of financial problems, Johannson sold most of the shares in his Swedish company in 1917. Two years later, he established himself in business in New York City.

Henry Ford was naturally interested in Jo-Blocks; indeed, his company's worldwide interchangeability of manufactured parts depended on their use. Thus, when Johansson's New York company was on the verge of bankruptcy in 1923, Henry offered Johansson facilities in Dearborn. As a result, the Johansson Division of the Ford Motor Company came into existence. Although Johansson would not give Ford the exclusive right to use his blocks, he did give the company the right to sell them. Johansson remained in Dearborn until 1936, when at the age of seventy-two he retired to Sweden.

The eighty-one steel Jo-Blocks in the set shown here are the oldest ones in the United States. They range from .1001 inch to 4 inches; each is accurate to within .000,002 inch. The Morse Twist Drill and Machine Company of New Bedford, Massachusetts, gave the old blocks to Henry Ford in 1930 in exchange for a new set. They were among the hundreds of items found at Fair Lane after Clara Ford's death and donated by her heirs to the Henry Ford Museum in 1951.

Tire-Building Machine

In the late 1800s, the rubber industry in the United States produced mainly footwear and tires for bicycles and carriages. By 1918 the industry had undergone a dramatic change; automobile tires were then accounting for about 50 percent of rubber sales. In 1901, when seven thousand new cars were sold, the rubber industry produced 96,000 automobile tires, including replacement tires. In 1918, with a million new cars on the market, total tire production reached 24.5 million.

Such a huge increase in production would not have been possible without improvements in technology. Before 1909, when W.C. State of the Goodyear Tire & Rubber Company patented the machine shown here, workers made tires by manually stretching, cementing and stitching each ply around an iron core. One worker could make six to eight tires in a day. With State's tire-building machine, a worker's productivity increased to twenty to forty tires in a day, depending on the type of tire. The principal innovative feature of the machine was a set of rollers on a central turret that carried plies, beads, and tread. As the worker pulled the materials over the core, the machine's electric motor held the proper tension so the worker could finish cementing and stitching. Although manual dexterity and skill remained important, the introduction of State's machine marked the beginning of mass production in the rubber industry.

State's tire-building machine was used as evidence in a patent lawsuit around 1928, and after the case was settled, Goodyear gave the Firestone Tire & Rubber Company of Akron, Ohio, permission to present it to Henry Ford for his museum. The machine, however, nearly fourteen feet long and eight feet high, seems to have gotten lost in the transaction. In 1938 a Goodyear employee happened to notice that it was not on display at the Henry Ford Museum. After some correspondence between Goodyear, Ford, and Firestone, the machine ultimately came to rest in "Henry's attic" in 1939.

Acc. 39.516.1. Neg. B.110822.

Milling Machine

Twenty-one feet long, ten feet wide, and weighing twenty tons, this behemoth is an example of the very specialized machinery the Ford Motor Company used in mass-producing its low-priced Models Ts. Ford bought the machine from its manufacturer, the Ingersoll Milling Machine Company of Rockford, Illinois, in 1912 and used it to mill the bottom and main bearings of Model T cylinder blocks. The large traveling bed of the machine carried fifteen cylinder blocks at a time. The bed passed beneath three cutters mounted on a belt-driven horizontal spindle; these cutters milled the main bearings. Three other cutters on vertically mounted spindles milled the bottoms of the blocks.

In the early 1890s, when Ingersoll began manufacturing milling machines, planers were customarily used to remove metal on a flat surface. Machines like the one shown here were in their infancy. They quickly advanced, however, and found a place in the milling operations of a number of industries. In 1903 Ingersoll built a milling machine that General Electric used in constructing the frame of an electric locomotive. When finished, the locomotive weighed 400,000 pounds, the biggest one in the world at that time. As early as 1905, Ingersoll was making specialized milling machines for the automobile industry. In 1909 the Ford Motor Company bought three such machines for Model T production. The company donated the 1912 milling machine shown here to the Henry Ford Museum in 1931.

Acc. 31.671.1. Neg. B.39901.

Paper-Ruling Machine

In the early years of the nineteenth century, lined paper was generally used only in business ledgers and account books. Workers in stationers' and bookbinders' offices produced it by hand, ruling the paper with pen nibs held in a board. As more businesses began adopting standardized accounting procedures in the 1830s, the demand for lined paper increased. Responding to this trend, the Hickok Manufacturing Company of Harrisburg, Pennsylvania, invented a paper-ruling machine in the 1840s.

The Hickok machine consisted of a moving belt running beneath a set of pen nibs held in place by a crossbar. Cotton threads dipped into a trough of ink containers kept the overhead pens continuously moist. Since the ink in the containers could be any color, the machine could line paper in different shades at the same time. A worker in the bindery, usually a woman or child, fed sheets of paper onto the belt, which carried them until they were picked up by strings and dropped on a delivery platform. Feeding the paper into the machine was a simple task, but the job of getting the pens in place and regulating the flow of ink required some skill. Bookbinders used Hickok's machines to prepare "blank books," especially business ledgers.

About nine feet long and five feet wide, the Hickok ruling machine pictured here was built in 1913. It is, however, very similar to the original Hickok model. Carl Dubac of Saginaw, Michigan, who bound books by hand for over sixty years, used it to line paper for ledger books until offset printing took away that part of his business. Dubac's son, Carl H. Dubac, also of Saginaw, donated the paper-ruling machine to the Henry Ford Museum in 1986.

Glass Ribbon Machine

William Woods and a colleague at the Corning Glass Works in Corning, New York, developed this machine for making glass casings for incandescent light bulbs in 1927. When the machine was put into operation at Corning's plant in Wellsboro, Pennsylvania, the following year, production underwent a dramatic increase. Before the machine was installed, two workers, blowing bulbs by hand, produced about 1,400 bulbs in an eight-hour shift. With the machine in place, two workers—one to operate the machine and one to lubricate it as needed—produced 30,000 to 36,000 bulbs in a single hour. In 1983 the American Society of Mechanical Engineers recognized this remarkable engineering feat by designating the machine a historic landmark. The machine remained in service until 1981; nine years later, Corning donated it the Henry Ford Museum.

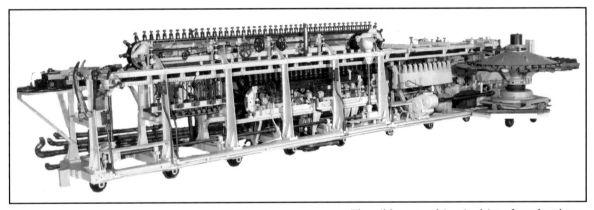

Acc. 90.349.1. Neg. B.110596.B.

The ribbon machine is thirty-four feet long, six feet wide, and six feet high. A furnace above the machine fed it a continuous "ribbon" of molten glass. The glass moved along a belt down to a blowing system, where air was applied as metal molds closed around the hot glass. The machine was mounted on wheels so that it could be rolled out from under the furnace for maintenance once a week. To change the molds and other equipment so that the machine could produce a different type of bulb usually took a team of seven experienced workers less than forty-five minutes. Because it took so long to get the glass to the right temperature and consistency, the glass furnace was kept fired continuously, except when it needed repair or when repairs to the ribbon machine took more than a couple of hours.

Pot Still

The L. Lawrence Company of Newark, New Jersey, manufactured this 300-gallon pot still and its attached condenser about 1930. Made mainly of heavy copper, the still is twelve feet high and five feet wide. It could be tipped over for cleaning by means of a crank and gear assembly. The equipment was used to produce extract flavorings, first by the Arrow Extract Company in Detroit and later by Heublein, Inc., at its plant in Allen Park, Michigan. Heublein donated it to the Henry Ford Museum in 1982.

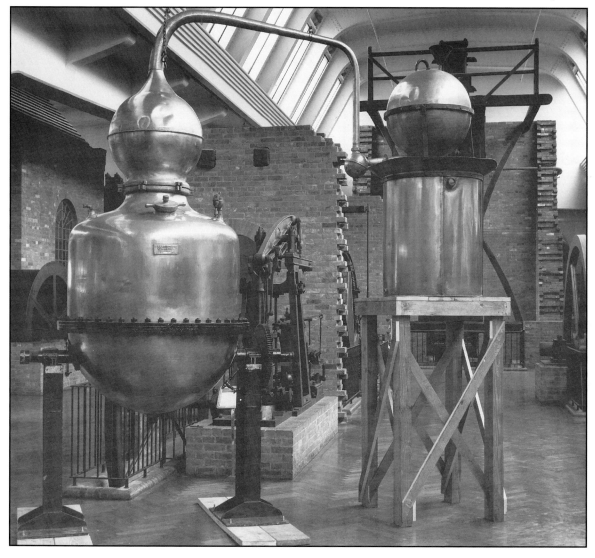

Printing Press

This roll-fed printing press, sixteen feet wide and over seven feet high, is typical of those used by small newspapers for many years. The machine has two flat beds, each four pages wide, one above the other. Two traveling cylinders printed one complete eight-page newspaper at each stroke. A cam-controlled roller system enabled the machine to produce up to five thousand folded copies of a four- to eight-page newspaper in an hour.

The Duplex Printing Press Company of Battle Creek, Michigan, manufactured the press in 1931. The company was founded by B.C. Stone, an industrialist, and two brothers named Cox, who had invented a press, sometime before 1893, when they exhibited their first printing press at the Columbian Exposition in Chicago. It was the first press designed for small newspapers, and it proved very popular. Duplex continued to make presses until 1947.

The first owner of the Duplex printing press shown here was a Hungarian-language newspaper in New York City. After Zolton Gombos became the owner of the Liberty Publishing Company in Cleveland in 1939, he acquired the press and used it to print several ethnic newspapers. In 1978 the rising costs of operating and maintaining his old equipment forced Gombos to invest in a computerized photo-typesetter and to contract with an offset printer to take care of the printing. Soon thereafter, he donated the Duplex press, together with a typecasting machine and a plate-caster, to the Henry Ford Museum.

Acc. 78.100.1. Neg. B.88391.

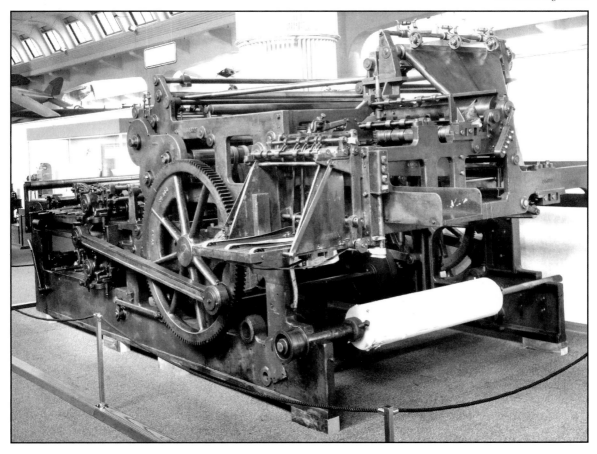

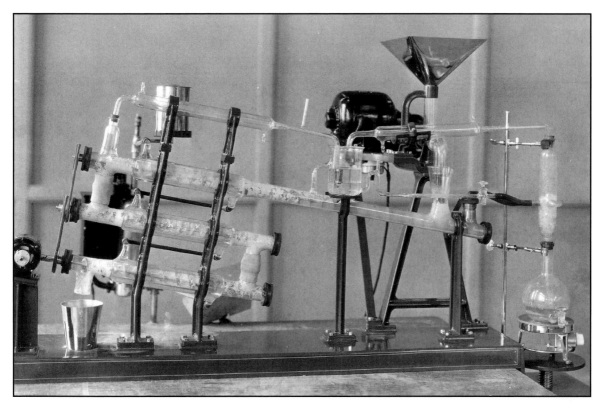

Acc. 84.56.1. Neg. 188.12927.

Model of a Soybean Oil Extractor

Henry Ford was, of course, a great believer in the virtues of the soybean. He not only occasionally wore suits and ties made of it but also for a while subjected guests and Ford executives eating in the company dining room to entire meals made from this one legume. In addition, he used it in the manufacture of automotive parts at his village industries in the 1930s. Today, the nutritional value of the soybean is widely recognized, and its oil is used in automotive paints as well as in coatings for glossy paper.

Robert Boyer was Henry Ford's chemist at the Edison Institute Schools from 1929 until 1943, and about 1935 he built this laboratory model to demonstrate how oil can be extracted from flaked soybeans. Boyer's patents from 1949 are still of use to agricultural chemists in industry. Boyer's model, a little over six feet long, has an electric grinder that flaked the beans and a set of glass tubes that dried them. The glass tubes had motor-driven stainless steel augurs that transported the dried flakes into a hot solvent bath, where the vapors were distilled and the soybean oil collected.

By about 1940, a plant that manufactured edible oils was using Boyer's model soybean oil extractor in its laboratory in Thunder Bay, Ontario. When K.A. Powell of Winnipeg, Manitoba, bought the plant and renovated it in 1974, he gave the model to Thunder Bay's Lakehead University. Having no use for it, the university stored it in a basement. In 1984, when university officials learned of its origins from former workers at the defunct edible-oil plant, Lakeland University returned Boyer's model to Greenfield Village.

Unimate: An Early Industrial Robot

By 1961 a team of nine men at Unimation, Inc., in Danbury, Connecticut, had perfected designs for a robot that could perform routine, repetitive jobs in factories. Among the jobs envisaged for Unimate, as the robot was called, were welding, spray painting, loading and transferring materials, inserting and tightening nuts and screws, and performing press and forging operations.

Unimate looked more like a gun turret than the human worker it was supposed to replace. The four-by-five-foot base of the machine contained the robot's "brain," a magnetic memory drum, as well as its "muscle," the hydraulic equipment that activated its "arm." The arm ended in a flexible, rotating "wrist" and a clawlike "hand." The arm could be extended from three to seven feet, and the grippers at the end of the hand had a clamping force of up to 180 pounds, though the clamping pressure could be varied.

To program the robot, the user simply pressed a recording button and guided Unimate by hand through the steps of the desired operation, while the memory drum recorded the key positions. That done, the robot would repeat the recorded pattern indefinitely and with no further need of human intervention. To shift the 2,700-pound robot to another operation required nothing more than loading it onto a forklift, moving it to the new location, and reprogramming it.

Unimation installed its first robot—the one shown here—at a General Motors factory in Trenton, New Jersey, in the fall of 1961. It was the first robot to be used in industry. The first job assigned to the robot was to remove the castings of small "ventipane" car windows from the dies, check them by holding them up to a feeler switch, and then drop them on a conveyor belt. Because the workers who had operated the diecast machines were constantly having to adjust water valves—a thing the robot could not do—the department foreman was skeptical. "It will never work," he said. But it did. Because of the consistency of the robot's operation, valve adjustments were not necessary. Unimate, which cost about $25,000, evidently paid for itself in about fifteen months. In 1976 Unimation reacquired its first industrial robot and donated it the Henry Ford Museum.

Acc. 76.115.1. Neg. B.93028.

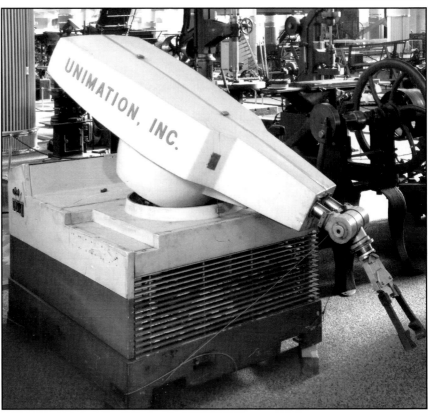

Acc.92.179.1. Neg. B.110403.

Automatic Assembly System

The Bodine Corporation of Bridgeport, Connecticut, built this machine at its facility in Cutlerville, Michigan, about 1990. Almost eighteen feet long, seven feet wide, and eight feet high, it weighs eleven thousand pounds. It was used until 1991 at a General Motors plant in Coopersville, Michigan, where it automatically assembled electrical solenoids used in automobile fuel injectors. It also automatically inspected the parts of the sole-noids as they were introduced to ensure that they were the correct size. The machine operated twenty-eight work stations at the rate of thirty to thirty-five strokes per minute and assembled fifteen hundred solenoids per hour. With modification, it could also assemble other kinds of small electrical devices. The Bodine Corporation donated the automatic assembly system to the Henry Ford Museum in 1992.

CHAPTER 8
Firearms

DURING BOTH WORLD WARS, the Ford Motor Company supplied the U.S. government with everything from gun caissons, steel helmets, submarine chasers, and ambulances to tanks, armored cars, and B-24 bombers. Nonetheless, the company's founder never relinquished his pacifist views or his low opinion of those he considered warmongers—nor did he ever let slip an opportunity to air these opinions. In 1915, blaming war on the machinations of munitions manufacturers and financiers, Henry Ford told the *New York Times,* "To my mind, the word 'murderer' should be embroidered in red letters across the breast of every soldier." Later the same year, while in New York organizing a peace expedition to Europe that he hoped would bring World War I to a close before the United States entered the fray, he happened to notice a billboard advertising a "hawkish" movie called *The Battle Cry of Peace.* Having discovered that munitions manufacturer Hudson Maxim had sponsored the movie, Henry told the press, which was avidly following his every move on the peace front, that in his opinion the film had been made to produce munitions contracts for Maxim. The movie company sued for $1 million in damages, only to drop the suit after the United States entered the war in 1917.

In 1919, while embroiled in yet another lawsuit—the one he initiated against the *Chicago Tribune* on the basis of libel—Henry testified that "war is murder." "I was a murderer," he told the defense attorney, "I was a helper of murder. When the crisis came we all took a hand. But it is all the same. War is murder." These words might have come straight from the pages of the McGuffey Readers on which Henry and many other children of the 1870s were raised. The author, William Holmes McGuffey, a teacher in small Ohio colleges, had a talent for dramatically invoking the consequences of wrong-

doing, and in a section entitled "Things by Their Right Name," he equated war with murder, defining soldiers—and, by implication, all others who participated in war—as murderers.

McGuffey also had a lesson called "Don't Kill the Birds!"—a theme that seems to have struck a particular chord with Henry Ford. An avid bird-watcher, Henry created acres of bird sanctuaries around Dearborn as soon as he had the money to do so and in 1912 struck up a friendship with the famous naturalist John Burroughs, who noted that Henry had an impressive knowledge of ornithology. Henry's first entry into the political arena occurred in December of that year, when he began mustering support for a bill to protect migratory birds from hunters. Henry's father and his foster grandfather, Patrick O'Hern, evidently also had a good deal to do with his awareness of wildlife and the desire to protect it. Taking stock of his life at around age fifty, Henry noted that his first memory was of being shown a bird's nest under a log near his home. Henry maintained that he could still remember the bird's song over forty-five years later.

Henry's mother, Mary Litogot O'Hern Ford, whose brother John died in the Civil War, probably also contributed to his abhorrence of bloodshed. But Henry himself attributed his pacifism to his birth-date. A believer in reincarnation, he was evidently convinced that having born in July 1863—the same month as the Battle of Gettysburg—he had previously been a soldier who lost his life in the Civil War. If so, the soldier was no doubt a good shot, for Henry himself was excellent at target practice and, despite his interest in protecting wildlife, occasionally enjoyed duck hunting. He also kept a revolver in his car for protection—somewhat paradoxical for a man who once said that "men and nations who carry guns get into trouble."

Regardless of what Henry Ford thought of them, gun manufacturers pioneered the American system of manufacturing—which Henry very successfully applied to the manufacture of automobiles many years later. This system depended on a number of workers, each making individual parts, which were then assembled into the finished product by one or more other workers. It was a radical departure from earlier days when one skilled craftsman made all the parts of a product and then assembled them into an object that was rarely, if ever, exactly like another. Because it not only speeded production but also increased capacity, the new system was also known as mass production. Not all the workers involved in mass production had to be skilled, which is why in the late 1700s and early 1800s the system was quickly adopted in America, then a land-rich but labor-poor nation. The individual parts the workers made, however, had to be interchangeable—that is, so alike and standardized that any one of them could be picked at random and used in assembling the finished product. This need for precision gave rise to the improvement and development of a number of machine tools, such as milling and screw machines, lathes, and jigs.

Eli Whitney was among the first to mass-produce arms, and in this venture, he also pioneered the assembly line, stationing workers for efficient transfer of parts. Having earned little from his invention of the cotton gin in 1792, Whitney six years later contracted with the U.S. government to produce 10,000 muskets in a two-year period. Because the young nation lacked skilled labor, Whitney would have been unable to fulfill the terms of his contract had he not implemented a mass-production system and devised a jig and milling machine that enabled unskilled workers to produce interchangeable parts. Even so, Whitney did not meet his deadline because he had underestimated the amount of skilled labor he would need. In the meantime, others had begun adopting his methods.

John Hall, Simeon North, and Samuel Colt were among the more successful of the early American mass-producers of firearms. Hall, who patented a breech-loading flintlock rifle in 1811, directed an assembly line at the U.S. government arsenal in Harper's Ferry, West Virginia, where gun parts were machined to much finer tolerances than Whitney's. North, who developed a breech-loading percussion-lock rifle in 1833, also developed a milling machine that made a significant contribution to the precision of interchangeable parts. In the mid-1800s, Colt manufactured an improved revolving pistol in such quantities that his very name came to denote a revolver. Other significant advances in the mass production of firearms occurred at the U.S Armory in Springfield, Massachusetts. That arsenal not only introduced a system of gauges for measuring parts at all stages of production; by the early 1820s, it was also using Thomas Blanchard's lathe in its production of gunstocks. Blanchard's lathe, which shaped irregular forms, was used in other asymmetrical manufacturing applications as well, such as the making of shoe lasts and axe handles.

Not surprisingly, given Henry Ford's views on the subject, his museum's collection of firearms pales by comparison with some other collections housed there. Nonetheless, as the items described on the following pages indicate, the collection provides a rich and realistic illustration of how firearms have developed over the centuries.

Powder Horn

Made of animal horn about 1650, probably in Germany, this flat powder flask, ten and a half inches long, has a wooden plug at each end; the plug at the small end is fitted into a brass ring. It was part of a collection of 104 gun-related items that George T. Trumbull of Birmingham, Michigan, donated to the Henry Ford Museum in 1972.

The steel wrench attached to the front of the powder horn indicates it was made for use with a wheel-lock musket, a type of gun that German artisans perfected about 1525 and that English settlers brought with them to New England a century later. The lock, a mechanically activated firing device that first appeared in the 1400s, was a giant step forward in the development of firearms. The type of lock known as a wheel lock had a rough wheel that spun against flint to create a spark. To set the wheel in motion, the user wound a spring in the mechanism with a wind-up wrench, a step that took a bit of time—especially if the user misplaced the wrench. The likelihood of that happening to the owner of this powder horn, with its attached wrench, must not have been very great.

The wheel lock, which produced its own spark, was an improvement over the matchlock, another firing mechanism of the same period. The matchlock consisted of an S-shaped piece of metal that held a burning wick or "match." When the user pulled the trigger, the match touched the powder in the priming pan, creating a spark that set off the main charge. The problem with matchlocks was that the match or wick had to be kept burning—not easy in wet weather. Although wheel locks did not require a burning wick, they, too, could be rather temperamental under humid conditions. They were also costly and somewhat fragile.

Acc. 72.146.95. Neg. B.69068.

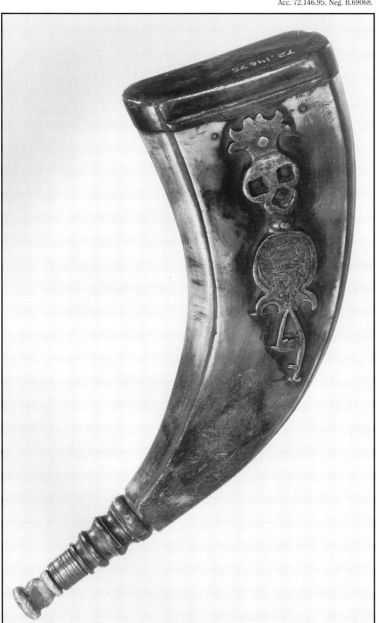

Flintlock Blunderbuss

Introduced between about 1610 and 1620, flintlocks were used until the advent of percussion caps in the early 1800s. They were a refinement of an earlier and more primitive firing mechanism known as a snaphance (deriving apparently from the Dutch word *snaphaans*, meaning "chicken thief"). It is said that thieves invented the snaphance so that the glow from matchlocks would not betray their presence in the dark of night. Like the snaphance, the flintlock created a spark in the priming pan when, at the release of the trigger, a hammer holding a piece of flint hit against a strike plate. The flintlock's strike plate was the underside of a metal cover on the priming pan. When the user pulled the trigger, the cover flipped up, and the hammer holding the flint struck against its underside, producing a spark that ignited the exposed powder. When the mechanism was not engaged, the cover on the priming pan protected the powder. English gunsmiths had perfected the flintlock by the end of the 1600s, but

muzzle that expedited loading. The blunderbuss itself, about three and a half feet long with a walnut stock and steel barrel, was made in Birmingham, England; the initials *SM* near the back of the lock indicate it was the product of a gunsmith named Samuel Mayo. The blunderbuss's ramrod is missing, but it was attached to the underside of the barrel by means of two thimbles. To load the blunderbuss, the user tore open a paper cartridge that contained a ball and gunpowder, placed a small amount of powder in the priming pan and closed the cover, and used the ramrod to stuff the ball and rest of the powder down the barrel. This loading procedure was standard with all firearms until breech-loading guns began appearing in the late 1700s; with these guns, the user could crack the weapon open at the breech and insert the charge.

Blunderbusses were commonly used aboard ships to repel an enemy attempting to board the vessel from rowboats pulled alongside. This one has

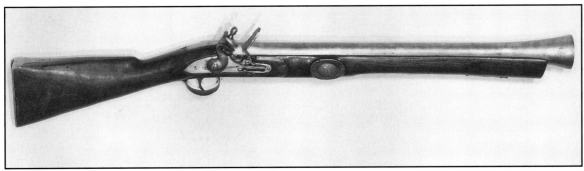

Acc. 00.3.1578. Neg. B.50905.

the mechanism was still often unreliable in wet weather.

The flintlock shown here, made in London about 1815, is the firing mechanism for a blunderbuss, a short firearm with a large bore and a flared

at its center provision for a swivel pin that would attach the weapon to a ship's gunwhales. It was given to the Henry Ford Museum by an anonymous donor at some unrecorded time.

Flintlock Punt Gun

For many years, commercial hunters, firing from punt boats, commonly used the type of shotgun shown here to bring down quantities of ducks, which they often sold to markets in large cities. Commercial hunting of migratory waterfowl was not outlawed in the United States until 1913, when Congress passed the Weekes-McClean Bill. Interestingly, although Henry Ford supported that bill, he also used to go duck hunting on Lake Erie at Pointe Mouillee near Rockwood, Michigan, where in the mid-1920s, he offered the owner of this punt gun, John Story, a new car if he would give the gun to the Henry Ford Museum. Story, who may have inherited the gun from his father and who used it to open the duck season at Pointe Mouillee for over half a century, thought about the offer for a while and then told Henry, "You know, I got to thinking, your car would rust out—and I'd have no car and you'd have the gun." Henry's interest in the gun was evidently never forgotten, however. When John Story died, the gun passed on to his son George, who lived in Carleton, Michigan. From his deathbed in 1968, George Story expressed the wish that the gun go to the Henry Ford Museum. His widow donated it to the museum the following year.

Over eight feet long, the punt gun was made between about 1820 and 1830, probably in England from whence it may have come to America with John Story's father. Its flintlock, however, was made in 1810 at the U.S. Armory in Springfield, Massachusetts. The gun has a walnut half-stock with a flat bottom and round butt and a round-to-octagonal barrel with a one-and-one-quarter-inch bore. In the days when waterfowl abounded, guns such as this are said to have brought down some sixty birds with one shot. John Story often sold the ducks he felled with this gun to the Cadillac Square Market in Detroit.

Acc. 69.46.1. Neg. B.52945.

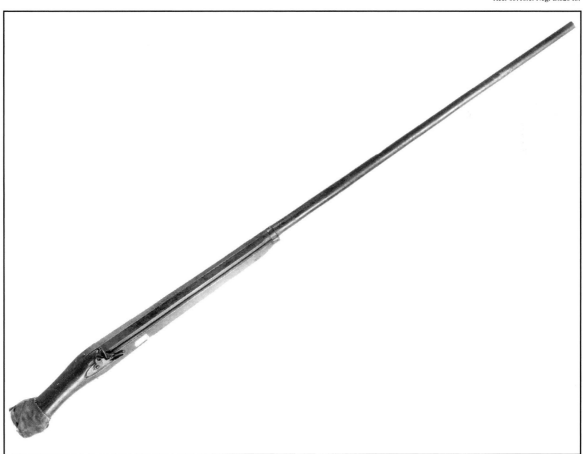

Percussion-Lock Dueling Pistols

Duels were for too many years the way in which gentlemen of honor settled their accounts. One particularly famous duel took place in Weehawken, New Jersey, soon after sunup on July 11, 1804, when the vice president of the United States, Aaron Burr, shot and killed Alexander Hamilton, former secretary of the treasury. The duel was the climax of fifteen years of bitter political wrangling. Of Burr, Hamilton had written, "Determined to climb to the highest honours of the State and as much higher as circumstances may permit, he cares nothing about the means of effecting his purpose. If we have an embryo Caesar in the United States 'tis Burr." The seconds who attended Hamilton and Burr described the duel as follows:

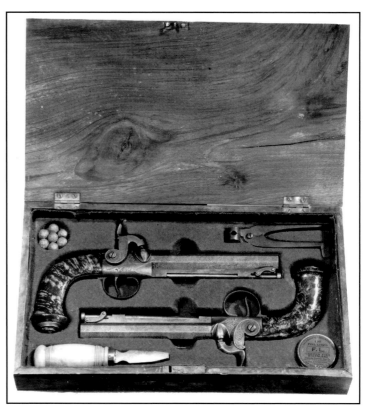

Acc. 71.101.139. Neg. B.63471.

. . . The parties exchanged salutations and the seconds proceeded to make arrangements. They measured the distance, ten full paces, and cast lots for the choice of position and also to determine by whom the word [to fire] should be given, both of which fell to the second of General Hamilton. They then proceeded to load the pistols in each other's presence, after which the parties took their stations. The gentleman who was to give the word then explained to the parties the rules which were to govern them in firing. . . .

He . . . then asked if they were prepared; being answered in the affirmative he gave the word "present!" as had been agreed on, and both parties presented and fired in succession. The fire of Colonel Burr took effect and General Hamilton almost instantly fell.

Colonel Burr then advanced towards General Hamilton with a manner and gesture that appeared . . . expressive of regret, but without speaking turned about and withdrew, being urged from the field by his friend . . . to

prevent his being recognized by the surgeon and bargemen then approaching. . . . We conceive it proper to add that the conduct of the parties in this interview was perfectly proper, as suited the occasion.

Alexander Hamilton's oldest son had been shot and killed in a duel only four and a half years earlier.

The cased set of .44 caliber dueling pistols with accessories shown here was made in Belgium about 1840. The pistols, each almost ten inches long, have percussion locks, engraved octagonal barrels with a hinged ramrod beneath each barrel, and handgrips made of olive wood. Set into each grip is a sterling silver cap box adorned with the head of a woman. The case, made of fruitwood, has a green cloth lining and contains, among other things, seven lead balls, a ball mold, and a five-inch-long steel screwdriver with a wooden handle. John L. Booth of the Booth Broadcasting Company of Detroit gave the case and its contents to the Henry Ford Museum in 1971.

Percussion-Lock Pepperbox Pistol

Benjamin and Barton Darling of Massachusetts patented the pepperbox pistol in 1836. The first popular multishot weapon, it gave Samuel Colt's revolvers stiff competition for some twenty years. Unlike a regular revolver, in which all shots pass through a single revolving cylinder, the pepperbox has a cluster of revolving barrels for each shot. Although considerably cheaper than Colt's revolvers, the pepperbox was not as accurate, and when the heat from a discharge set off the charges in the other barrels, it also "chain-fired." Nonetheless, it was very popular in California during the 1849 gold rush.

W.W. Marston & Knox of New York City manufactured the .30 caliber pepperbox pistol shown here about 1850. Just under eight inches long, it has

the flintlock in wet weather and is the basis of all conventional firearms in use today.

A. Harnick of Ypsilanti, Michigan, donated the pepperbox pistol to the Henry Ford Museum in 1930. Harnick, who for many years operated a bookstore adjacent to the campus of the Michigan State Normal College, the oldest teacher-training school west of the Alleghenies, collected antiques of all kinds as a hobby. He sold many of them to Henry Ford and made him gifts of others.

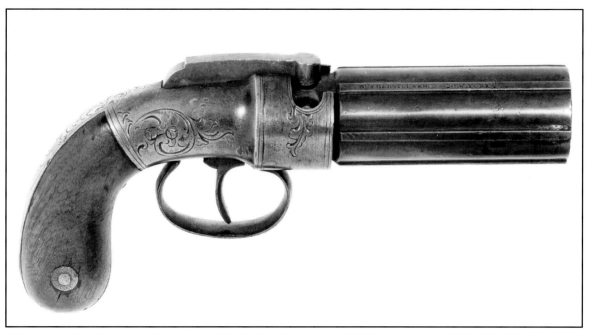

Acc. 71.101.139. Neg. B.63471.

a ribbed cluster of six barrels, an engraved steel frame, a walnut handgrip, and a percussion lock. Alexander Forsyth, a Scottish minister, devised what was probably the first percussion lock in 1807. It eliminated the need for flint by using a small cap filled with an explosive; when the hammer struck the cap, the resulting detonation ignited the main charge. The mechanism was far more reliable than

Needle-Firing Revolver

Although the invention of percussion caps and locks eliminated the need for flint and for pouring powder into a priming pan, the firearms user still had to tear open a cartridge and ramrod its contents—the ball and powder charge—down the barrel of the weapon. After breech-loading guns eliminated the need for the ramrod, the next step in simplifying the loading process was to improve the cartridge. Modern cartridges incorporate the bullet, powder charge, and primer in one unit. Johannnes Pauly, a Swiss gunsmith working in Paris, took the first step along this path in 1812, when he produced a brass cartridge with a primer at the rear. A "needle," or firing pin, was used to pierce the casing and set off the explosion.

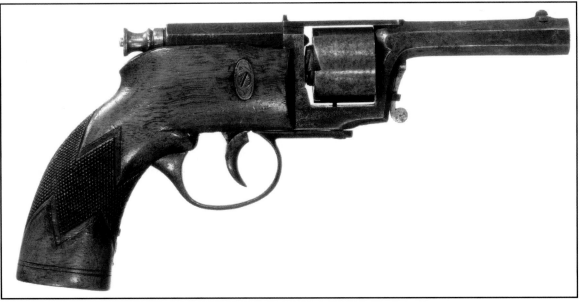

Acc. 72.146.40. Neg. B.72803.

Johann N. von Dreyse of Sommerda, Prussia, began working with Pauly in Paris in 1808. After returning to Prussia in 1824, he improved on Pauly's breech-loader and in 1841 patented a needle-firing revolver. He was apparently very successful; in I841 he signed a contract with the Prussian government and by 1871 had produced 300,000 firearms for the Prussian army.

Dreyse manufactured the needle-firing six-shooter shown here about 1850. Ten inches long, it has a walnut stock and checkered grip. It was part of the collection of 104 gun-related items that George T. Trumbull of Birmingham, Michigan, gave to the Henry Ford Museum in 1972.

Patrick O'Hern's Muzzle-Loader

Neg. 188.7937.

Patrick O'Hern, who with his wife, Margaret, raised Henry Ford's orphaned mother, was the only grandparent Henry ever really knew. Margaret O'Hern died at the Ford homestead when Henry was three, but Patrick lived on there until his death in 1882. Patrick and young Henry spent many happy hours together, with the old Irishman teaching the boy the names of trees and flowers and the calls of various birds. Henry showed his fondness for Patrick in many ways, carefully restoring the bedroom the old man had occupied in the homestead, attempting to trace Patrick's Irish ancestry, and naming Fair Lane after the street in County Cork where Patrick was born. Often when Henry entered Fair Lane, he would let his wife know of his arrival by whistling a bird call, no doubt one that Patrick had taught him. On the day that Henry died in April 1947, he paid a final visit to Patrick's grave at the Catholic cemetery at Schaefer and Warren roads in Dearborn.

This picture shows Patrick's muzzle-loading gun, which dates from about 1850, leaning against a chair in the restored homestead. It was taken before Henry had the house moved to Greenfield Village. According to Henry, Patrick always kept the gun near his bed so that he could at a moment's notice frighten prowlers—man or beast—away from the premises. Unfortunately, the current whereabouts of Patrick's gun are unknown.

Shotgun-Rifle

A shotgun is a smooth-bored, and often double-barreled, shoulder weapon used to fire at short range. A rifle, another type of shoulder firearm, has spiral grooves bored, or "rifled," into its barrel; these grooves give the ball or bullet a spin that enhances both accuracy and range. German immigrants who settled in eastern Pennsylvania in the 1700s introduced North Americans to rifled hunting weapons known as "jaegers." These firearms were far more accurate than the smooth-bored Brown Bess muskets the British troops used in the Revolutionary War, but they also tended to clog with powder residue when used under combat conditions.

Shown here is the double-barreled percussion-lock weapon, a rare combination of shotgun and rifle. Samuel Colt Browning, a descendant of the arms manufacturer Samuel Colt and owner of a hardware store in Detroit, ordered it from William Wingert, a Detroit gunsmith, about 1855. It has a separate trigger and hammer for each barrel. Although the gun has a percussion lock, it is not a breech-loading weapon, and a ramrod for driving the ball and powder down either of its two barrels is attached beneath the barrels. A hook and key were used to fix the barrels to the gunstock, which is made of walnut and has a steel butt plate. The gun's velvet-lined walnut case contains a number of accessories, among them a powder flask, a powder measurer, a bullet starter (a small white wooden rod that was used to enter the bullet in the barrel before the ramrod was applied), a bullet mold, and two boxes of caps. The gun case is about thirty-two inches long; with barrels attached, the gun is almost forty-six inches long. Frank S. Robinson of Detroit gave the shotgun-rifle with its case and accessories to the Henry Ford Museum in 1936.

Acc. 36.292.2. Neg. B.31571.

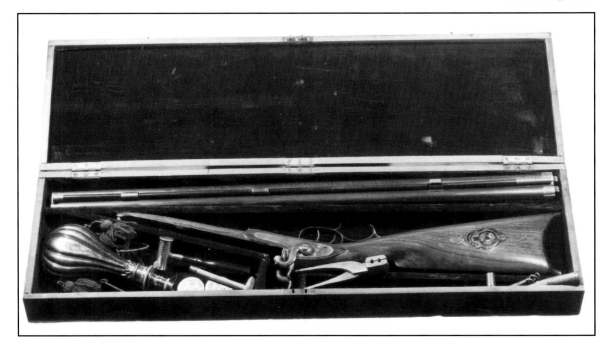

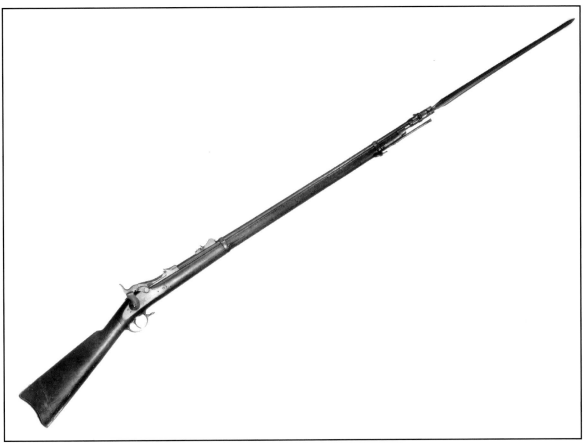

Breech-Loading Springfield Rifle

In 1778, in the midst of the Revolutionary War, Congress authorized the building of an iron foundry at Springfield, Massachusetts. George Washington was in the first year of his presidency when in 1789 U.S. ordnance officers decided to convert the iron foundry into a national armory. The Springfield Armory went into production in 1795, turning out flintlock muskets. By 1892 it had made at least fifteen different types of firearms, including the breech-loading rifle shown here. The armory reached a peak of production in 1864, employing 3,400 workers and turning out guns for the Union Army at the phenomenal rate of 1,000 per day. Springfield service rifles were the standard U.S. infantry weapon not only during the Civil War but in World War I as well. Because of its accuracy (effective at 2,000 yards) and extreme range (5,800 yards), the 1903 Springfield was still occasionally being used as a sniper rifle even as late as the Vietnam War.

The Springfield Armory made the .45 caliber, breech-loading rifle in the photograph in 1873. Shown with its eighteen-inch bayonet attached, it is seventy inches long. It has an elevated rear sight, a front-sight blade, a walnut stock, and a cleaning rod attached to the bottom of its round steel barrel. John L. Booth of the Booth Broadcasting Company of Detroit donated the rifle to the Henry Ford Museum in 1971.

Bench Rifle

Designed for shooting targets at a distance of several hundred yards (about the length of a city block), this sophisticated .52 caliber rifle has a telescopic sight and a twenty-two-inch-long steel rear mount that can be adjusted for wind direction and elevation. Weighing forty pounds—more than three times the weight of many sporting guns—it was called a "bench" rifle because when shooting, the user placed the heavy octagonal barrel on a bench or rest, securing it with the accessories shown in the photograph. The rifle has a walnut stock and light, delicate engraving on its breech as well as on its percussion-lock plate and trigger guard. A ramrod could be inserted into a milled channel on the bottom of its two-inch-wide barrel. H. Warner, whose name is stamped on the barrel, made the rifle about 1885 in Ridgeway, Pennsylvania. Also stamped on the barrel is the well-known name of Remington, manufacturer of arms and ammunition in Ilion, New York, which furnished parts for the rifle. Emerson B. Thatcher of Marine City, Michigan, donated the gun to the Henry Ford Museum in 1930.

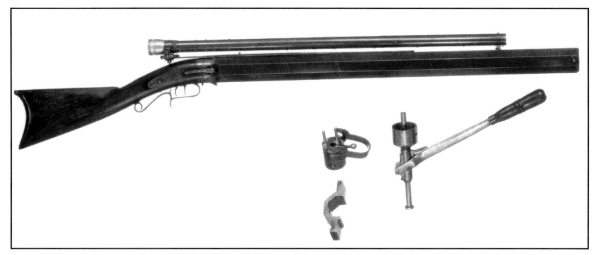

Acc. 30.449.2. Neg. B.69081.

Hotchkiss Machine Gun

Benjamin B. Hotchkiss, an American renowned for his invention and manufacture of various kinds of firearms and ammunition, designed this revolving, quick-firing gun while in France during the Franco-Prussian War of 1870–1871. Adaptable to use either on land or at sea, the gun was operated by a hand crank. Although it resembles the Gatling gun—an early crank-operated machine gun with a revolving cluster of barrels, each of which was automatically loaded and fired as the cluster revolved—the Hotchkiss's barrels remained stationary while firing. Rather than using a belt of cartridges, as other early machine guns did, the Hotchkiss fed them in from metal strips that held thirty cartridges each. Benjamin Hotchkiss died in 1885, but his munitions company went on. During World War I, U.S. divisions in France were equipped with a 1914 Hotchkiss machine gun. During World War II, the Japanese used a heavy Hotchkiss machine gun called the Model 92 (a reference to the Japanese year 2592, the equivalent of 1932).

The Hotchkiss machine gun shown here was part of the equipment on board the deck of the *Bear of Oakland*, Admiral Richard E. Byrd's supply ship during his second expedition to the South Pole in 1933–1934. A slow but sturdy wooden sailing vessel

with auxiliary steam power, the *Bear* had already had an interesting history before Byrd acquired it in 1932. Built out of oak in 1874 at Greenock, Scotland, and strongly braced to take the punishment of ice-laden waters, the *Bear* was first used as a whaler. Ten years later, the U.S. government bought the ship and immediately sent it off to Cape Sabine on the northern coast of Greenland to rescue the survivors of Adolphus Washington Greely's expedition to the Arctic. Greely had hoped to establish meteorological stations, but his attempt was ill-fated, and nineteen of his crew starved or froze to death. Greely was among the six survivors whom the *Bear* rescued. Having accomplished that mission, the *Bear* served the U.S. Coast Guard with distinction in the North Pacific, giving aid to whalers and policing waters during the gold rush to the Yukon.

After the Coast Guard retired the ship in 1928, the *Bear* became the property of the City of Oakland, California. When Byrd asked city officials in 1932 if he might buy the vessel, they amicably agreed to put it up at public auction, as required by law. The appearance at the auction of a junkman, who bid $1,000 for the vessel, was a surprise both to the officials and Byrd. But after one official had a brief, whispered exchange with the junkman, he refrained from further bids. Byrd thus acquired the *Bear* for $1,050 and, out of gratitude, renamed the ship the *Bear of Oakland*.

The *Bear of Oakland* was evidently scrapped in 1939. In that year, Byrd gave the Hotchkiss machine gun—as well as the steam whistle used aboard the *Bear* to locate the survivors of Greely's expedition—to the Henry Ford Museum. In 1987 the museum deeded and transferred the Hotchkiss gun to the Treasure Island Museum of Oakland.

Acc. 39.197.1. Neg. B.5193.

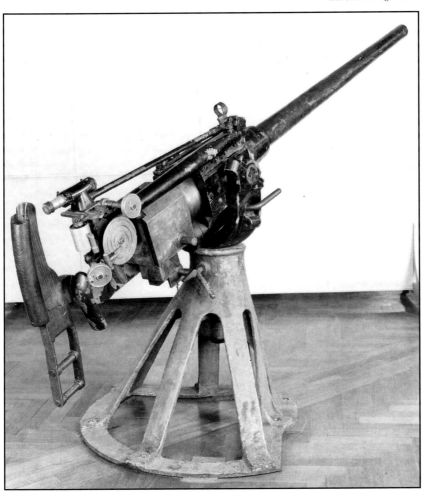

Derringer Pistol

Henry Deringer, Jr., a Philadelphia gunsmith, began manufacturing a heavy-calibered, short-barreled pocket pistol in the middle years of the nineteenth century. People seem to have had trouble spelling Deringer's name, for the small, deadly pistols that he made became known as "derringers"—as did many others that he did not make. Deringer never patented the design of his pocket pistol, and as the weapon proved quite popular, many other gunsmiths also made and sold "derringers."

One great advantage of the derringer over other percussion handguns of large caliber was its small size and light weight. Because of these characteristics, it could be used as a surprise weapon. A man could easily conceal a derringer in his pocket, waistband, sleeve, or boot, or even carry it around in his hat, and it was not unknown for ladies to tuck a derringer into their muffs, corsets, or garters. Originally a single-shot muzzle-loader, the derringer was often sold and carried in matched pairs. Two single-shot derringers, which were very effective at short range, gave a person face to face with an armed enemy a better chance than the less accurate multi-shot pepperbox.

Derringers evidently first achieved a following in the South, but after the gold rush of 1849, more were sold in San Francisco than anywhere else. They were popular among gamblers on Mississippi riverboats, among gold miners—most of whom considered themselves undressed if they did not have both a pistol and a Bowie knife stuck in their belts—and among denizens of the rough-and-tumble towns of the old West. Pony Express riders often carried pairs of them. John Wilkes Booth used a derringer when he assassinated Abraham Lincoln in 1865. With some modifications, including the introduction of double barrels, derringers were still being made by various companies during the 1920s and early 1930s. In that era, they were greatly favored by gangsters. Law officers also commonly carried them.

The Remington Arms Company of Ilion, New York, manufactured the .41 caliber derringer shown here about 1900. Less than five inches long, it is made of nickel-plated steel and has a hard rubber handgrip. When a small trigger on the right is released, the double barrels—one above the other—swing up for loading; a small button on the left ejects the shell casings. The derringer was part of a sizable collection of firearms that James W. Inches of Detroit, former commissioner of police, donated to the Henry Ford Museum in 1931.

Acc. 31.418.9. Neg. B23804.

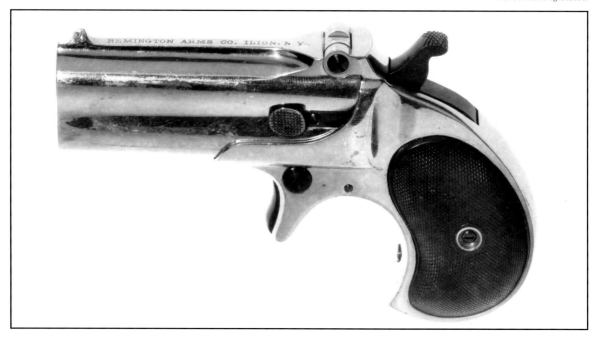

CHAPTER 9
Household Items

WILLIAM FORD was the son of an Irish tenant farmer. He was born in 1826 on an estate called "Madame" near the village of Ballinascarthy in County Cork. There he and his family lived in a stone cottage surrounded by twenty-three acres of leased land. By an early age, William, like his father before him and his son Henry after him, had established a reputation as a clever man with tools. In 1847, after Ireland's potato crop had failed for the second year in a row, William packed up his toolbox and together with a large contingent of his family embarked for America, where other members of the Ford family had already established a foothold in the frontier country of Michigan. Sailing with William were his two brothers and four sisters; his father, John; his mother, Thomasine; and his seventy-one-year-old grandmother, Rebecca. They were among the first waves of more than a million emigrants who fled the Great Famine of Ireland between 1845 and 1851.

The Ford family had apparently always had a venturesome streak. About 1600, after Queen Elizabeth had confiscated a large part of Ireland and offered inducements to English Protestants who would resettle the Catholic land, the Fords left Somerset—their home for more than three centuries—and set off across the Irish Sea for the wilds of County Cork. The Protestant Fords probably did not suffer the extremes of savage repression that Anglo-Irish landlords inflicted on the Catholic natives, who eked a precarious living from tiny plots of rocky, rented ground. Neither, however, do the Fords appear to have prospered very greatly. The stone cottages and gravestones they left behind indicate they had been a respectable family, remarkable neither for low deeds nor for great ones.

In 1832 Samuel and George Ford, William's uncles, left the stone cottage where they had been born and sailed for America, possibly drawn by the

knowledge that there a man could till his own land—rich and fertile land, at that—without paying homage to a landlord. They settled in Dearborn Township, Michigan, and, like all their pioneering neighbors, set about clearing the virgin forest, burning stumps, building rough wooden houses and rail fences, and planting crops. When William and his family joined this branch of the Fords in 1847, conditions were considerably less primitive than those that had greeted Samuel and George fifteen years before. Detroit, with a population of 20,000, had a thriving waterfront industry, and even at this early date, plumes of smoke from its factories could sometimes be seen from the little town of Dearbornville (later Dearborn), about ten miles to the west. The town itself, which had come into existence because it was a one-day journey by ox cart from Detroit, was also thriving. Home to some sixty families, it boasted a grain mill, a sawmill, a tavern, a church, two forges, seven stores, a railroad stop, and the Dearborn Arsenal, an impressive ordnance depot that the federal government had erected in 1833. Northeast of the town was a one-room schoolhouse that pioneers of the "Scotch Settlement" had built in 1839.

Soon after he arrived in Dearborn, William's father took out a mortgage and bought eighty acres of land in neighboring Redford Township. To pay off the debt, both William and his father put their carpentry skills to work and, as employees of the Michigan Central, helped extend the railroad along its western route to Chicago. Meanwhile, with the help of William's two brothers, they also cleared some of the eighty acres and established the family farm.

The product of an Irish tenancy, William's ambition was to become, like his uncles, cousins, and father, an independent landowning farmer, and he worked industriously to achieve that goal. By 1858, when barter was still a far more common form of

payment than hard cash, William had saved $600, and with it he bought the southern half of his father's eighty acres. In addition to working his own land, William also helped out on the prosperous farm of Patrick O'Hern, a fellow Irishman whose ninety-one acres straddled Dearborn and Springwells townships. O'Hern (whose name Henry Ford always pronounced and spelled *Ahern*) was born on March 17, 1804, in Fair Lane (now called Wolfe Tone Street) in the city of Cork. In 1842, some twelve years after O'Hern arrived in Dearborn, he and his wife had adopted a two-year-old orphan named Mary Litogot. William's interest in the dark-eyed young Mary no doubt accounted for at least some of the work he did around the O'Hern farm in the late 1850s.

William Ford and Mary Litogot O'Hern were married on April 25, 1861, when he was thirty-five and she, twenty-one. Soon thereafter, the newlyweds, together with the O'Herns, moved into a spanking new, white-painted frame house that William had helped build on the O'Herns' land. The house, imposing for that place and time, had seven rooms, to which four were later added. In 1867 Patrick O'Hern formally deeded the house and land to William, and there the two families lived together in harmony for many years.

Henry Ford was born in this homestead on July 30, 1863. He was the oldest of William and Mary's six children, and possibly the most mischievous of the lot. According to his sister Margaret, Henry from an early age was "always investigating things," and she and her other siblings had to hide their mechanical toys to keep Henry from dissecting them to see how they ran. At school, Henry's application of his mechanical skill to scientific experiments and practical jokes sometimes got him into trouble. On one occasion, he attempted to build a steam engine and ended by burning down the school fence. On another, when a male classmate was being punished in the worst possible way—by having to share a desk with a girl—Henry drilled two small holes through the designated "bad" seat during recess. He stuck an upright needle in one hole and ran a connecting thread down through the second hole to his own seat. What punishment befell Henry as a result of the shrieks elicited by his tugs on that thread is not recorded.

Young Henry also displayed a decided aversion to the hard manual labor that the farm required. His mother, however, saw to it that work came first.

Despite her busy routine of cooking, washing, gardening, preserving food, churning butter, and making clothes and soap, she found time to instill in Henry a stiff sense of duty and a clear idea of the distinction between right and wrong. Although she may have believed in sparing the rod, she certainly did not believe in spoiling the child. Once, when Henry was caught in a lie, she refused to speak to him for an entire day. Henry found that this punishment "cut more deeply than a whip." Mary Ford's death after a difficult childbirth in 1876 left the family in a state of shock and thirteen-year-old Henry heartbroken.

Three years later, Henry left the homestead for Detroit, intent on learning all he could about mechanical engineering. William Ford, although disappointed at his son's decision to forsake the life of an independent farmer, was also resigned to it, for, as his wife had noted years before, the boy was "a born mechanic." William himself, ever mindful of his origins on an Irish tenant farm, never ceased to wonder at his own good fortune in being an independent farmer with land to call his own.

The homestead was a comfortable place, in the Victorian mode, as befitted a man of William Ford's stature. In addition to running a profitable farm, William served as a church deacon, a justice of the peace, and a member of the school board. In 1902, when road construction necessitated moving the house two hundred feet east of its original location at Ford and Greenfield roads, William, at the age of seventy-six, sold the homestead to Henry. Henry soon embarked on a quest to furnish the house exactly as he remembered it in his mother's time—a quest that became more intense after 1919 when he decided to build his own museum. Henry not only sent his agents out in search of such amenities as an ornate cast iron parlor stove; he also had the soil around the house sifted in the best archaeological manner. The fragments of pottery thus unearthed were used as models in reproducing the original plates, cups, and saucers. Henry also had the old foot-pumped organ in the parlor electrified, and he spent many peaceful hours at it, pecking his way through the songs of his youth. The house remained at the site near Ford and Greenfield roads until 1944, when Henry, fearing vandalism, had it moved to Greenfield Village.

Henry's refurnishing of the homestead took many years, but he eventually found the exact items

he wanted. In the meantime, antiques that he could not use in the house were piling up in warehouses in Dearborn, and the pile became ever larger after he set about restoring the Wayside Inn in New England and the Botsford Inn outside Detroit in 1923. Most of the surplus was transferred to the Henry Ford Museum and the buildings of Greenfield Village when they opened in 1929. But Henry's collecting of household items did not stop there. He was now intent on providing furnishings of the appropriate date for everything from the 1638 Plympton House in the village to twentieth-century household displays in the museum. Added to the enormous number of things he bought were the thousands of gifts he received. Some individuals and manufacturers gave

him their entire private collections. The gifts included household furnishings of every conceivable kind: chairs, highboys, desks, bathtubs, stoves, heaters, quilts, rugs, washing machines, kettles, carpet sweepers, brooms, and ornamental ceramic, metal, and glass pieces, to name but a few.

The following pages offer just a small sampling of some of the more historic and unusual of these gifts. Also included are some gifts representative of an entire collection given by a single individual. One of these individuals was Edsel Ford, whose sizable donations over the years greatly enhanced the decorative arts collection of his father's museum.

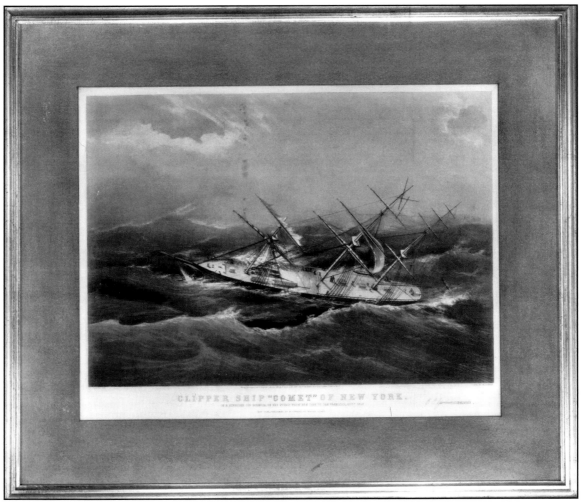

A hand colored lithograph by N. Currier: "Clipper Ship *Comet* of New York, in a hurricane off Bermuda on her voyage from New York to San Francisco, Oct. 1862." Donated by Edsel Ford to the Henry Ford Museum. Date of gift not recorded.

Neg. B.58699.

Earthenware Charger

Earthenware—opaque, slightly porous clay pottery fired at low heat—is one of the world's oldest inventions. The very first prehistoric potter no doubt discovered that when a bit of clay was left out in the sun or dropped into the embers of an open fire, the water in the clay evaporated, and it formed a hard but porous substance. The invention of the kiln, which took place in China around 4500 B.C., allowed potters to bake their wares at higher temperatures; the greater heat caused the pores in the clay to fill with molten paste and thus created a more watertight product. Later, to make their wares even less porous and more watertight, potters began glazing them with copper before firing them; a tablet dating from about 1600 B.C. found in Iraq contains a formula for such a glaze. Early potters also came to use lead, tin, and salt as earthenware glazes.

After the Arabs introduced the technique of making earthenware to North Africa, Spain, and Sicily in the early Middle Ages, it began spreading through Europe. By about 1400, the town of Faenza in Italy had become famous for its "faience," an earthenware decorated with colored glazes. Although American potters were at work very soon after settlers began arriving in the colonies, their wares were generally of a humble sort and were assigned to the kitchen; those who could afford it bought imported ceramics, most of them made in England.

The piece of tin-glazed earthenware shown here—a charger, or flat platter, about a foot in diameter—was made in the early 1690s, probably in London. Underglazed in blue, it depicts William III (Prince William of Orange) and Mary II, who reigned in England from 1689 until 1702. To the left and right of the standing figures of the king and queen are spiky green bushes; manganese purple-pink lines under a pink glaze decorate the rim.

In 1977, when Mary Dana Wells of Union, Connecticut, donated the Daggett saltbox to Greenfield Village, she also gave Greenfield Village nearly two hundred seventeenth- and eighteenth-century items to furnish the house. The entire collection was valued at $625,000 in 1977. The William and Mary charger, valued at $2,200, was part of this collection.

Acc. 77.11.82. Neg. B.78862.

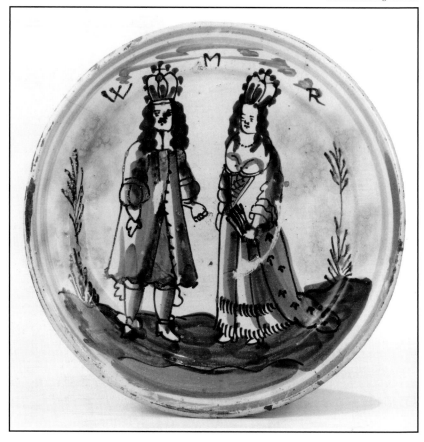

Porcelain Basket

Porcelain is a translucent, nonporous ceramic ware fired at high temperatures. It is made from kaolin, a fine white clay that when subjected to temperatures of 2,336° F or more changes its composition—that is, "vitrifies"—to produce a hard, glasslike substance. It also contains feldspar, a mineral that not only aids in vitrification but also provides extra silica, which makes the porcelain more translucent.

The first porcelain was produced, probably as early as A.D. 100, in China, where the kiln had been invented centuries before and where the first deposits of kaolin were discovered. By the year 1000, the Chinese were mass-producing porcelain for the royal court; a far-flung supply network brought quantities of kaolin and petuntse, a Chinese feldspathic rock, to the kiln city of Ching-te Chen. Visitors from the West, awed by the translucent material, took Chinese porcelain bowls and vases home with them to Europe, where they became highly prized objects. European attempts to duplicate porcelain were unsuccessful until after 1698, when the first kaolin deposit in Europe was discovered in Germany. About the same time, several Europeans almost simultaneously hit upon the secret of making porcelain. The first European porcelain works opened in 1708 in Meissen, Germany, and the craft soon spread to other cities on the Continent and Britain.

Made between 1770 and 1790, the openwork oval basket shown here was a product of the Worcester Porcelain Works of Worcester, England. When held to the light, the translucent basket has a greenish-brown cast. Its exterior is green and has applied blue and puce florettes. The sides of the interior are painted in the same colors, and the bottom is enameled with floral sprays. Ten inches long and almost nine inches wide, the basket has applied twisted gilt handles. It was part of a large collection of antique ceramic pieces that Mrs. Ernest R. Breech of Bloomfield Hills, Michigan, gave to the Henry Ford Museum in 1979 in memory of her late husband, who was president of the Ford Motor Company from 1946 until 1960. At the time of the donation, the collection was valued at over $95,000. The value of the basket alone was estimated at $1,500.

Chinese Porcelain Coffee Pot

When America resumed trading with Britain after the Revolutionary War, it was to the detriment of the new republic. Cheap imported goods flooded the market, domestic manufacturers were unable to compete, and commerce stagnated. Adding to the problem was that each of the thirteen states regulated its own commerce. After the states ratified the federal Constitution in the late 1780s, thereby creating a strong central government and giving Congress the power to regulate foreign and domestic trade, the young nation began to prosper. In the following decade, U.S. merchants engaged in profitable trade not only with Europe and the Caribbean but also with the Orient in what became known as the China trade.

The coffee pot shown here was made of porcelain about 1800 in the ancient Chinese kiln city of Ching-te Chen explicitly for the China trade. It has a double-entwined handle ending in two gilded floral sprigs. Both the lid and pot are decorated with orange bands and strips of brown and gold arrowheads. The finial on the lid is a gilded litchi nut. The eagle, painted sepia and gold and surmounted by gold initials, appears on both the front and back of the pot. Mrs. W.H. Marshall of Milwaukee, Wisconsin, who bought the coffee pot from an antique dealer in southeastern Pennsylvania for $750, presented it to the Henry Ford Museum in 1966. It is part of the museum's William Hughes Marshall and Louise Schneider Marshall Collection of China-Trade Porcelain.

Acc. 66.49.1. Neg. B.47178.

Silver Caudle Cup

Silver, copper, and gold, although never among the most abundant of the earth's substances, were the first metals worked by man. Just who discovered them and where is lost in the mists of prehistory. It was, however, probably not too long after earthenware pottery came into existence that people in various parts of the world, in the course of digging for clay, came across these metals—substances that differed not only from clay but also from the stone used to make tools and other objects. They found that metal, though hard, was unlike stone in that it was malleable and could be hammered into various shapes without splitting. Among the earliest examples of the metalsmith's craft are small hammered-copper objects made in the Middle East before 6000 B.C. By about 4000 B.C., people in western Asia had discovered that when rocks containing metallic deposits were subjected to fire, they produced a molten metal that could be shaped by pouring it into molds; they had also discovered that when copper was melted with tin, it produced a useful alloy known as bronze.

Silver, being a relatively rare element, has retained its appeal from ancient times to the present. From the sixth to the first centuries B.C., the Greeks worked a famous silver mine at Laurium. By the time the American colonies were settled many centuries later, metalsmiths adept at fashioning objects of silver—as well as of copper, gold, and a tin-copper alloy known as pewter—were community fixtures in the countries from which the colonists came. These craftsmen were among the first to set themselves up in business in America.

Jeremiah Dummer (1645-1718)—a talented metalsmith of Boston—made the hammered-silver drinking cup shown here about 1670. Just over three inches high and about four inches wide, it was meant for the sipping of "caudle," a warm beverage usually given to invalids and made of ale or wine mixed with eggs, sugar, spices, and bread or gruel. A heart-shaped indentation on the cup displays the letters *ID* above a small fleur-de-lis. The bottom of the vessel is engraved with the initials *MH*. Mary Hollingsworth, accused of witchcraft in Salem, Massachusetts, in the seventeenth century, is said to have been the cup's original owner.

The caudle cup is one of twenty-seven pieces of antique American silver that Edsel Ford gave to the Henry Ford Museum in 1936. At that time, the value of the collection was estimated at $83,500. The caudle cup was estimated to be worth $2,500.

Acc. 36.279.5. Neg. B. 13351.

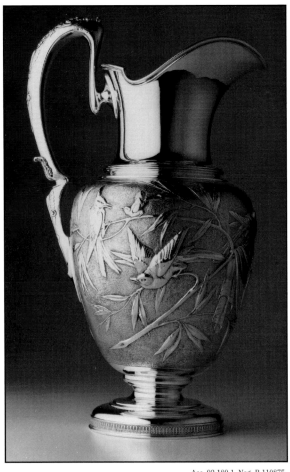

Acc. 92.189.1. Neg. B.110875.

Silver Caster

Sterling Silver Water Pitcher

Paul Revere (1735-1818), renowned both as an American patriot and as a skilled metalsmith, made this silver caster, one of an identical pair, in Boston about 1775. Its base and finial might have been cast; the rest was crafted by hammering, soldering, bending, cutting, and so on. Used as a salt shaker or as a muffineer for sprinkling sugar or spice, it is marked on the front with the block letters *AEM*. A rectangle on the side of the caster displays the name *Revere,* also in block letters. Donated to the Henry Ford Museum by Edsel Ford in 1936 and valued then at about $1,400, the caster was part of the collection that included Jeremiah Dummer's caudle cup.

Manufactured by Tiffany & Company of New York City about 1870, this water pitcher, fourteen inches high, has a neoclassical shape and is decorated with birds, leaves, and stems in bold relief on a stippled matte background. It is made of sterling silver, meaning that 92.5 percent of it is pure silver while the rest consists of copper. Its design is similar to the "Japanese" flatware pattern (now called "Audubon") patented by Edward C. Moore and introduced by Tiffany in 1871. When Tiffany opened a branch store in Troy, Michigan, in 1992, it donated the pitcher to the Henry Ford Museum. Had Tiffany been selling the pitcher, it would have priced it at $15,000.

Silver-Plated Tea Service

Simpson, Hall, Miller & Company of Wallingford, Connecticut, made this five-piece silver-plated service, probably about 1875. It has two large teapots with elongated spouts that end in animal-like heads. The pots are identical in every way except that one is relatively plain and the other is elaborately engraved, as are the other three pieces of the service. Tea services often had two pots for serving different kinds of tea, and although it is possible that one of the pots in this service was used for coffee and the other for tea, both have strainers at the base of their spouts and so were in all likelihood meant as teapots.

The tea service was part of a collection of thirteen items, which included other silver-plated pieces, a Steinway console piano, and a grandfather clock, that Gladys F. Sturm of St. Clair Shores, Michigan, gave to the Henry Ford Museum in 1980. The tea service was valued at $950; the entire collection, at $12,000.

Acc. 80.90.1. Neg. B.88561.

Pewter Goblet

Archaeological excavations have shown that the ancient civilizations of China, Egypt, Greece, and Rome used the metallic alloy known as pewter. Then, as now, pewter was made of about 90 percent tin; the rest consisted of copper, with traces of antimony and bismuth added to act as hardening agents. To reduce the cost of manufacture, lead was sometimes also added, but it made the product less durable—and durability was the characteristic for which pewter was usually prized.

The Romans introduced pewter to the British Isles in the pre-Christian era. Apparently used in parts of England before A.D. 1000 to make communion chalices, it became as common as ceramics in the manufacture of household plates, platters, and drinking vessels. It was used in all English homes and public establishments except the poorest, where crude wooden ware and pottery held sway, and the richest, where silver (and eventually porcelain) predominated. By 1348 London had an ordinance governing the quality of all pewter cast and sold in the city. By about 1475, charters issued by the king required that apprentices in all major cities train under a master pewterer for a set period of time before they could apply for membership in the pewterers' guild. The touchmark—the identifying mark that the master impressed on his pewter—came to be viewed as a royal guarantee of the quality of the material and the skill of the pewterer.

Although English settlers brought their taste for pewter with them to America, domestic manufacture of pewter was slow to develop because tin and copper had to be imported from the Old World. The British, recognizing the ready-made market for finished goods that the colonies represented, placed heavy taxes on raw materials exported to America. By 1700 only fourteen pewterers were working in America, nine of them in Massachusetts. As the colonies grew, however, the importation of pewter goods could not keep pace with the demand, and the number of American pewterers began

increasing. Still, it was not until after the Revolutionary War, when British restraints on trade were lifted, that domestic pewter started becoming as common as foreign-made.

In 1980 William Chambers Parke of Decatur, Illinois, gave the Henry Ford Museum a collection that illustrates the history of imported pewter in America from about 1625 to 1850. Gathered over a period of fifty-seven years, the Guy James and Gertrude Chambers Parke Collection, as it is known, consists of more than 375 pieces of British pewter, which were valued at nearly $150,000 in the early 1980s. The half-pint goblet shown here, made about 1840 in Sussex, England, is one of the pieces that make up the collection.

Acc. 80.108.86. Neg. B.90013.

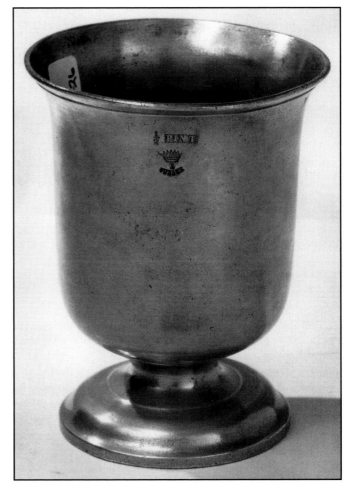

Acc. 78.73.14. Neg. B.82401.

Glass Sugar Bowl

Glass—a substance formed by heating a combination of ingredients, usually silica, sodium carbonate, and calcium carbonate (limestone)—was first made in Egypt and Mesopotamia, probably around 1530 B.C. Eygptian glassmakers built their products up into the desired shape by attaching a clay mold to the end of a metal rod and covering the mold with layer after layer of molten glass. Mesopotamian glassmakers sometimes used a different method, which consisted of carving a vessel out of a whole block of glass. These methods passed onto the Greeks and were later used by the Romans, who about 30 B.C. adopted the technique of glassblowing. Just how or where glassblowing came into existence is unknown, but no doubt some glassworker noticed that when he blew through the hollow metal rod that he was using to form the glass, he created an air bubble that could be shaped without using a mold. The Roman Empire soon had a thriving glass industry that produced a huge number of vessels, ranging from simple dishes to elaborate and expensive vases.

In the seventh and eighth centuries A.D., the Arabs were still using the ancient glassblowing technology of the Romans, and as a result, only relatively small glass pieces could be produced. Even in the late Middle Ages, glass windows were made of small panes joined by lead strips, and they were found only in wealthy homes and churches. Glassmaking technology does not seem to have changed appreciably until the nineteenth century. After about 1850, the availability of large sheets of glass that could be used to roof and wall metal-framed structures gave rise to enormous exhibition halls and train stations noteworthy for their visual lightness. The last half of the nineteenth century also witnessed improvements in making window glass, the invention of tempered glass and wired glass, and the introduction of semiautomatic machines for making glass bottles.

The aqua-colored, blown-glass sugar bowl shown here was made between 1835 and 1850, possibly in New York state. Including the "witch ball" that serves as a lid, it is about seven inches high and, from handle to handle, is about five inches wide. It has an applied crimped-glass base, lily-pad pattern, and solid ear-shaped handles. Preston R. Bassett of Ridgefield, Connecticut, former president of the Sperry Corporation and a long-time collector of glass, donated the sugar bowl to the Henry Ford Museum in 1978, along with about seventy other glass pieces. The entire collection was valued at $30,000; the sugar bowl, at $575.

Glass Fly Trap

Glass fly traps were used in America throughout the nineteenth century, probably most often in farmhouses in late August and early September—the time of year when houseflies still seem to be at their pestilential best, despite modern sanitation and the ubiquity of combination storm-screen windows with all their much-advertised virtues. When eighty-three-year-old Frederick F. Denzin of Salem Center, New York, donated the glass fly trap shown here to the Henry Ford Museum in 1967, he noted that in his childhood "flies were plentiful because of outdoor privies, open cesspools, unburied garbage, etc., and all we had on windows was mosquito netting." The fly trap had been in his family for as long as he could remember and was "used daily in season" when he was a boy.

Glass traps were a less messy nineteenth-century alternative to flypaper or to poisoned paper laid in a saucer and covered with water. Some glass traps were suspended from the ceiling by means of a cord. Others, like the one used by Denzin's family, were table versions with little feet that kept the bottom of the bulbous body raised. Attracted by honey or whatever other bait was poured into the bottom of the vessel, flies entered through the open cone at the bottom and became trapped by their natural instinct to fly up rather than down. The flies could be put out of their misery by removing the stopper and pouring water—carefully, if one did not wish to clean up a spill—into the bottom and drowning the pests. Frederick Denzin's mother used to fill the trap shown here "with soapy water and [set] it on the table after lunch with a small piece of raw meat as bait or perhaps a few drops of beer."

The Denzin family's fly trap, about six inches across at the base and made of clear blown glass, was patented in July 1872 by Friederic Stengal of New York City. It is distinguished by having a

stopper that could also serve as a flower vase. In the course of trying to having it appraised in the 1960s, Frederick Denzin could find no professional who even knew what it was. Since it baffled experts at an antique show in New York City, at a Brooklyn museum, and even at Corning Glass, Denzin concluded that his fly trap was "a scarce article [and needed] a real resting place before it [was] broken." Having no close relatives to leave it to, he entrusted its safekeeping to the Henry Ford Museum.

Acc. 67.35.1. Neg. B.47297.

Poland Springs Water Bottle

When Henry Ford started building Fair Lane, his fifty-six-room residence in Dearborn around 1914, he erected a filtering and pumping station on the Rouge River. The station provided water not only for Fair Lane but for all of Dearborn and several nearby communities as well. It continued to do so until 1932, when the City of Detroit began furnishing these towns with water pumped from lower Lake Huron.

Henry, however, did not care for the taste of the water from the Rouge, nor did he care for cow's milk or alcoholic beverages of any kind. The clear, aqua-colored glass bottle shown here, machine-molded in the shape of an ancient Chinese philosopher, once contained what was apparently his favorite beverage: Poland Springs mineral water bottled at Androscoggen, Maine. Henry kept a stock of it at Fair Lane and also carried it in his automobile—though not in bottles as fanciful as this. Almost a foot high, the bottle dates from about 1875, but just when it was given to the Henry Ford Museum is unknown, as is the donor.

Acc. 57.72.9. Neg. B.102603.

"Beetleware" Plastic Dishes

Plastic—a material deplored by some people and elevated to an art form by others—was known in its earliest form as Parkesine. Invented in the 1850s by Alexander Parkes, a British scientist, Parkesine could be produced as either a hard or flexible substance and molded or used as a coating. By 1870 John Wesley Hyatt, an American, was producing a plastic called Celluloid. Used to make everything from billiard balls and dental plates to combs and knife handles, Celluloid had one of its most successful applications in the manufacture of easily laundered shirt collars and cuffs. Neither Parkesine nor Celluloid was, however, completely synthetic. The distinction of producing the world's first truly synthetic material went to Leo Baekeland, an immigrant from Belgium, who in 1907 invented Bakelite, a substance formed by the chemical reaction of phenol and formaldehyde.

Bakelite was the first "thermosetting" plastic—that is, after it had been heated to a certain temperature, it became very hard and resistant to any further heat-related changes. Thus, the softened resin could be molded to the desired shape and heated to the point where it was permanently set. Bakelite was water-resistant, could be used as an electrical insulator, and lacked the flammable properties of Celluloid; in addition, it was stronger and easier to work than Celluloid. Because of its heat resistance, Bakelite was made into coffee cups and food bowls, and because of its insulating properties, it was used for plugs, sockets, and radio parts. It was also used in the manufacture of a wide variety of other items, ranging from clock cases to toilet seats.

Despite its many uses, however, Bakelite could not be produced in white or pastels, and the dark colors that could be obtained tended to fade when exposed to sunlight. In 1924 a British scientist altered the Bakelite formula by substituting urea (ammonia and carbon dioxide) for phenol. The result was a thermosetting, moldable resin as hard and heat-resistant as Bakelite but obtainable in a wider range of colors, including white. The British Cyanides Company was the first to manufacture products from the new substance. Consisting chiefly

of cups, tumblers, and bowls, "Beetleware," as it was called, created quite a sensation when it was exhibited for the first time in 1925. The manufacturer was so enthusiastic about its wares that in 1929 it opened a London retail outlet called the "Beatl Shop." The name was calculated to arouse public curiousity, and it served its purpose well. People who had no idea what "Beatl" was flocked to the shop to repair their ignorance.

The set of Beetleware dishes shown here was produced in the United States by the American Cyanamid Company of Perrysburg, Ohio, which in 1929 purchased the patent rights to the Beetle formula. The dishes were part of the furnishings of the "Stagecoach" trailer that Henry Ford bought in 1935 to demonstrate trends in modern travel in his museum. After he gave the trailer to Charles Lindbergh in 1942, it became known as "Stagecoach Darien." Lindbergh returned the trailer, together with its dishes and other furnishings, to the Henry Ford Museum in 1957.

Plaster Bust of Charles Lindbergh

Acc. 29.2194.1. Neg. B.19968.

William F. Engleman of Chicago created this life-sized plaster bust of twenty-six-year-old Charles Lindbergh in 1928, a year after the "Lone Eagle's" historic nonstop, solo flight across the Atlantic. The copyrighted sculpting process Engleman used was highly unusual. A special revolving camera took multiple exposures of his seated subject, and the film was developed and enlarged to life size. Engleman then took a stylus connected to a machine and traced the exact outline of the filmed images on a projection screen. As he did this, the machine chiseled the bust — with remarkably lifelike results. Engleman's original bust of Lindbergh, in bronze, is in the Smithsonian Institution.

In 1929, as the opening of the Henry Ford Museum was looming, Jack Talbot of Miami, Florida, one of Engleman's associates, gave this plaster bust to the museum. He evidently hoped it would lead to other important commissions for Engleman—such as busts of Thomas Edison and President Herbert Hoover, who were scheduled to be on hand for the museum's opening ceremonies.

Acc. 27.312.1.

Wooden Portrait of Henry Ford

Here is Henry Ford—looking a little wooden perhaps, but like a cheerful and most benevolent industrialist. A Pole from Warsaw named John Ciborski carved this life-sized wooden image of Henry and sent it to him about 1926. It is adorned with many wheels and a good deal of foliage. All the wheels are inscribed with the names of Polish cities, except for the center wheel at the top, which is inscribed "Amerika Detroit 1893." What the 1893 might signify is a bit obscure; Henry was working in Detroit as chief engineer for the Edison Illuminating Company in 1893, and he did not complete his first Quadricycle until 1896. The inscription below Henry's image, literally translated from the Polish, reads: "To the great American industrialist in recognition and proof of manufacturing wherein workers do not strike."

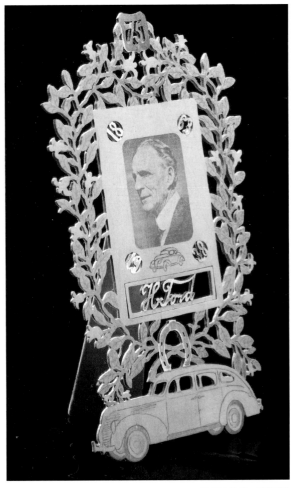

Acc. 00.1510.17. Neg. B.110633.

Portrait of Henry Ford in Cutout Frame

This was a present to Henry on the occasion of his seventy-fifth birthday. It was made for him by Edward Swinkels of The Hague, Holland. The photograph of Henry is set into a frame elaborately carved and cut out of thin plywood. Twenty inches high, it features Ford V-8 automobiles, a horseshoe, and the dates "1863" and "1938." Henry kept the portrait at Fair Lane. It was among the many items that Clara Ford's heirs donated to the Henry Ford Museum in 1951.

Acc. 44.41 1. Neg.189.1718.

Acc. 00.240.39. Neg. B.15899.

Portrait of Alice Ford

Portrait of Henry Dearborn

This gentleman is someone Henry Ford never knew, but whom he might have held in high regard: Henry Dearborn (1751–1829), after whom the town of Dearborn, Michigan, was named. Dearborn fought in the Revolutionary War, was secretary of war during Jefferson's two terms of office (1801–1809), and commanded the U.S. Army during the War of 1812. The eminent American artist Gilbert Stuart painted this portrait sometime between 1810 and 1815. Edsel Ford donated it to his father's museum during the 1930s.

Here is someone Henry Ford knew very well and of whom he was very fond, as were other members of the Ford family. Indeed, "Aunt Alice" Ford (1810–1893) was so well loved that she had four grandchildren named after her; at one point three generations of her namesakes were all living under the same roof. Born Alice Good, she married George Ford, Henry's great-uncle, in Detroit in 1832, when Michigan was still a wilderness. George Ford died in 1863, the year Henry was born, but Aunt Alice lived on to tell Henry tales of Indians, bears, and wolves in those pioneer days. She was Henry's favorite aunt.

In 1944 Alice's granddaughter, Mrs. H.M. Plock of Lakewood, Ohio, offered Henry this thirty-six-by-forty-inch airbrushed portrait of Alice, made about 1880. Henry already had a smaller version of it hanging over the mantel in the parlor of his restored homestead in Greenfield Village. Henry was in failing health at the time, and it fell to Clara Ford to accept the gift, which she did, acknowledging Henry's love of his Aunt Alice and promising that the portrait would be carefully preserved in his museum.

Shaker Cook Stove

The concept of interchangeable parts, which was one of the factors that made mass production possible, was first used in America in the manufacture of guns in the late 1700s. By the early 1800s, the concept was being applied to the manufacture of cast iron stoves. These new stoves were far from labor-free, for the wood to feed them still had to be cut and fetched, and ashes had to be emptied. Nonetheless, they were an improvement over the fireplace, in use since the Middle Ages both as a source of heat and a place for cooking. Iron stoves provided a more efficient, radiant heat than the fireplace, which allowed much warm air to escape up the chimney. As cooking devices, they provided a convenient flat surface for pots and pans—a convenience so much taken for granted today that is hard to grasp the inconvenience of cooking over an open fire.

The spate of cookbooks published in the nineteenth century attests to the cast iron stove's having led to a new way of cookery, as one-pot meals like stews, originated out of necessity by the fireplace cook, became less of a staple. An early alternative to spit-roasting meat was to place the roast on a trivet between a metal reflector and the coals of the fireplace, but by the 1830s, up-to-date cooks were putting their roasts in ovens contained in iron stoves. The results of oven baking were largely hit or miss, for although the ovens had dampers to control the flow of air, the heat provided by their wood or coal fires tended to be very uneven.

The wood-burning cast iron stove shown here was designed for serious communal cooking. It came from a house built in 1814 in a Shaker settlement on Mt. Lebanon in the Berkshires. About eight feet long, it had three fire boxes that heated a center cooktop and a large kettle at each end of the stove. It also had an eye-level oven, resembling some of those built into the brickwork of fireplaces. When Avery Robinson of New Lebanon, New York, bought the house from the Shakers in 1941 with the intention of "removing it," he offered the stove to the Henry Ford Museum in the hope that "this unique relic of a disappearing period in our national life" would be preserved. After the museum accepted the gift, Robinson wrote a letter expressing his pleasure and noting that Sister Emma Neal, the ninety-four-year-old leader of the eleven elderly Shakers who remained on Mt. Lebanon, "will also be very pleased indeed to hear this news."

Acc. 41.167.1. Neg. B.110756.

Nott Base Burner

Anthracite coal—also known as hard coal—was a key factor in the development of the Industrial Revolution in America. Abundant in northeastern Pennsylvania, where blacksmiths began using it as early as 1768, it can produce enormous heat at low cost. For many years, however, most people regarded anthracite as more trouble than it was worth, since they found it difficult to ignite. Unlike soft coal, which reacts to poking, anthracite ignites best when left undisturbed. Josiah White, co-owner of a factory outside Philadelphia, discovered this secret one day in 1815 when he and his companions, frustrated after repeated attempts to get the hard "black stones" to burn, slammed the door on the furnace and left the factory. Fortuitously, one of them had forgotten his coat, and when he went back to get it, he found the furnace glowing from the intensity of the fire inside it.

White was quick to grasp both the industrial and domestic usefulness of hard coal. In 1815 he formed the Schuylkill Navigation Company to bring anthracite down from the wilds of northeastern Pennsylvania to Philadelphia, and in 1818 he went on to form the Lehigh Coal and Navigation Company. Two years later, White's new company asked Dr. Eliphabet Nott, president of Union College in Schenectady, New York, to find a way to use hard coal for heating homes.

The result of Dr. Nott's effort, shown here, is considered to be the first stove ever designed for burning anthracite. A cast iron base burner of gothic design, it has an ash drawer with a beaded "flower" pull at the bottom and, on the lower right-hand side, provision for a crank to move the interior grate. Behind the finials adorning the upper corners of the base is a cupola-shaped section with a grooved cover that lifts off to accept the coal. Rising from behind the cupola is a tall chimney with a grooved flaring top.

Dr. Nott, whose patents date from 1823 to 1832, used this particular stove for experiments in his rooms at Union College. In 1865 it was given to William J. Keep, a Union engineering graduate. Almost thirty years later, in 1893, it was exhibited at the Columbian Exposition in Chicago—together with the remarkable new wonders of electricity. In 1919 Keep's daughter, Helen E. Keep of Detroit, presented the stove to Henry Ford.

Stanley Cook Stove

Patented by M.N. Stanley of New York City in 1832, this unusual three-legged cast iron stove has a crank-operated revolving top. Thirty-one inches wide, the top has four openings of varying sizes covered with bail-handled lids. At the rear of the stove is an elevated oven with doors at either end decorated in a pineapple-and-leaf motif. Designed for use with coal or wood, the stove has double hinged front doors and an ashpan below. The Stanley stove was manufactured about 1833 by the Peninsular Stove Company, an old Detroit firm that failed during the Great Depression. The Detroit Trust Company, receiver for the stove manufacturer, donated the stove to the Henry Ford Museum in 1931.

Acc. 31.691.2. Neg. B.49148.

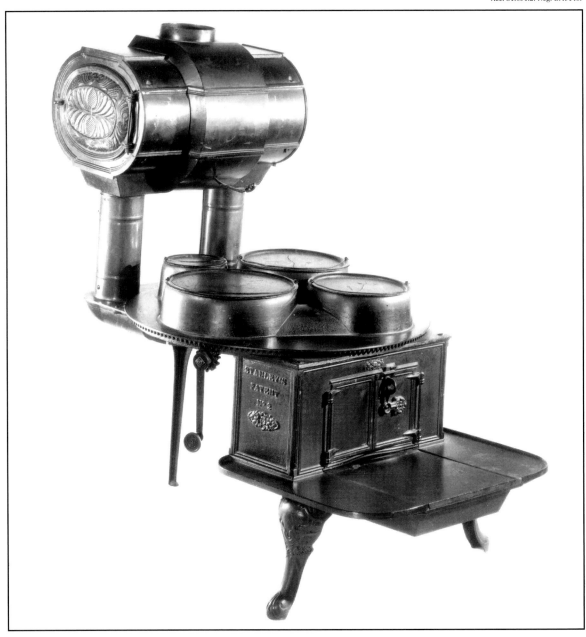

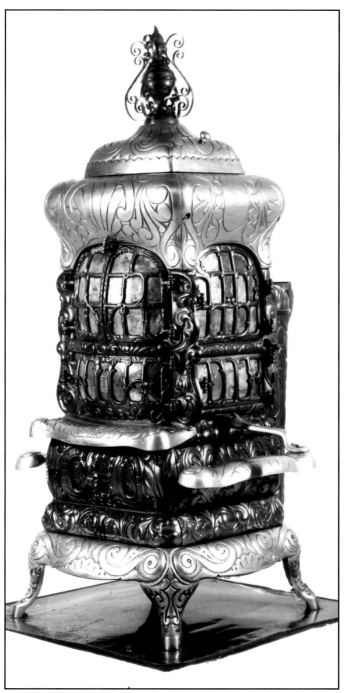

Cribben & Sexton Base Burner

Manufactured by the Cribben & Sexton Company of Chicago about 1880, this "Sparkling Universal" stove is typical of the elegant upright base burners proudly displayed and used in Victorian parlors until the advent of the basement furnace. Sixty-three inches high and heavily decorated, it has ornate cast iron doors with isinglass panels, nickel footrests on two sides, a nickel base, and a nickel cupola with a copper finial. The cupola swings to one side to reveal a removable lid marked "Use Chestnut Coal." ("Chestnut" coal was medium-sized; "egg" coal was large; "pea" coal was small.) Beneath the projecting nickel plate at the front is a cast iron door that opens onto an ash pan. The stove has a set of double doors over a single horizontal door at the front and two single doors on each of two sides. Banked with hard coal in the evening, stoves like this kept houses warm all night.

In 1955 Daisy Harrison of Saline, Michigan, wrote to the Henry Ford Museum, offering the Cribben & Sexton stove as a gift. She noted she had used it a long time and giving it up seemed "like parting with one of the family." "But," she wrote, "because I am nearly seventy-seven years old all my friends think I should have an oil burner and not carry coal any more. I live all alone so have decided to take their advice. Now if you could take my stove I would be more than glad to give it to you. . . . I can't . . . think of sending it to the junk[yard]."

Kerosene Lamp-Stove

Made by the Pittsburgh Lamp, Brass & Glass Company around 1890, this kerosene-burning device, known as "Success No. 2," provided both heat and light. It has two standard kerosene lamps backed by a curved, reflecting sheet of metal, which directed the heat forward and out the pierced sides of the steel cabinet. On the base of the cabinet are two knobs to adjust the lamps' wicks. Only sixteen inches wide and twenty-four inches high, this unusual device probably served as a seasonal space heater, in much the same way portable electric heaters do today. It saved the user the labor of chopping and fetching wood for the fireplace or shoveling coal into a furnace; a few quarts of kerosene provided hours of warmth and comfort on chilly mornings and evenings in early spring and late autumn. The kerosene lamp-stove was one of sixty-six items that Edward Durell, chairman of the board of the Union Fork and Hoe Company of Columbus, Ohio, donated to the Henry Ford Museum in 1983.

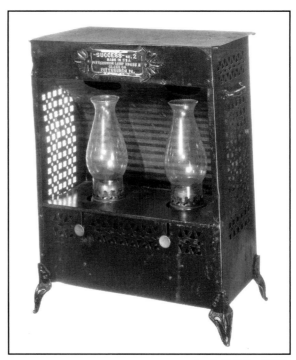

Acc. 83.178.61. Neg. B.70255.

Acc. 44.16.5. Neg. B.44566.

Laundry Stove

Manufactured by J. Van of Cincinnati about 1900, this stove was designed for the home laundry. It supported six flatirons at a time, and since one of them was always bound to be hot enough for immediate use, it robbed the laundress of any excuse to stand around waiting for an iron to heat. Commercial laundries used similar but larger stoves that heated a dozen or more irons at a time.

Mrs. George H. Lewis of Marlette, Michigan, donated the laundry stove to the Henry Ford Museum in 1944, together with several other items, including a "fluting iron" that was then over a hundred years old. A recent widow, Mrs. Lewis was breaking up housekeeping and had first attempted to sell these items to the museum. After the museum refused to buy them, she shipped them off as a gift.

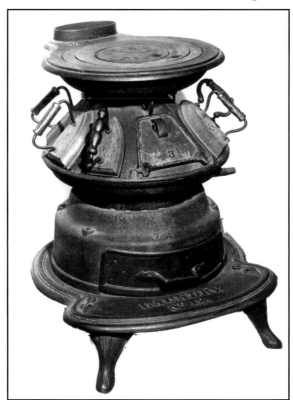

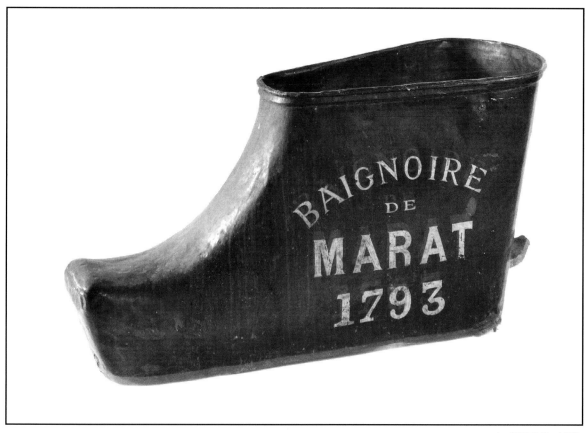

Copper Bathtub

Europeans of the Middle Ages, not known for their attention to cleanliness, bathed—if they bathed at all—in simple wooden tubs. During the 1600s, bathtubs of solid brass made their first appearance, but only the wealthy could afford them. Some of the very wealthy of this period, such as Louis XIV of France, bathed in marble tubs lined with lace and cloth to conserve the heat of the water. Toward the end of the 1700s, a special varnish for coating sheetmetal resulted in the production of reasonably priced bathtubs. Because they had the added attraction of retaining heat, these tubs soon became rather popular items.

The bathtub shown here, made of heavy copper sheetmetal, was constructed in France, probably after 1800. It seems to have been made for a traveling show, where it was no doubt touted as the very tub in which Jean Paul Marat, a notorious leader of the French Revolution, was bathing when the French heroine Charlotte Corday stabbed and killed him in 1793. Fifty inches long and twenty-eight inches high, it is shaped like a slipper or boot and has a seat about halfway down the back. Below the seat is an opening for a drainage spout, and just to the left of that is a space for a heater of some kind, perhaps an oil-burning lamp. The tub is portable in that it can be moved by means of a rear wheel and handle. Roy Ormstead of Ann Arbor, Michigan, gave the tub to the Henry Ford Museum in 1930.

Canvas Bathtub

After patenting this portable canvas bathtub in 1870, E.J. Knowlton of Ann Arbor, Michigan, proceeded to market it vigorously, offering prospective buyers illustrated circulars as well as testimonials from satisfied users. Described as "efficient for almost every conceivable form, size, and kind of bath—vapor and water, infant, adult, full, sitz, sponge, electric, mineral spring, artificial sea baths, etc.," it was aptly called the "Universal bath." In addition to its astounding versatility, the Universal bath did not corrode in the manner of metal tubs, cost only about $16 as opposed to $160 for a metal tub, weighed but fifteen pounds, and could be "attached to the common house chair" in any room in the house, including the "sick-room." When the bath was over, the user had only to "set the foot on a common bucket, raise the head, and pour out the water." The tub—seventy-five inches long and twenty-three inches wide—could then be "collapsed and hung up like a common garment."

In all, this "valuable appliance" was thought to render a bathroom quite unnecessary. Moreover, "the many conveniences and important advantages which it presents have attracted the attention of eminent physicians, who recommend it for conve-nient use in practice." The inventor himself particularly recommended it for hip baths, noting that no other tub "yet known presents so many advantages as this, especially in the treatment of spinal and rheumatic complaints. For ease and comfort it cannot be surpassed. By the employment of pillows and other pliable fixtures under the sack any desirable modification . . . of the cavity may be obtained, and the pain occasioned by the pressure of feeble and diseased parts against an unyielding substance avoided."

This remarkable device consists of a "bent rim . . . of timber, to which is secured a [pliable canvas] sack . . . of the proper shape, said rim being provided with proper cleats at head and foot, and cords and belaying-pins, for the purpose of securing the bath to chairs, or any other proper article." Water-stained from years of use—but certainly uncorroded and still bearing a ragged paper label reading "send for circulars/E.J. Knowlton, Ann Arbor, Mich."—this sample of household life in America in the late 1800s was donated to the Henry Ford Musuem in 1961 by James H. Hopkins of Ypsilanti, Michigan.

Acc. 61.195.1. Neg. B.84962.

Violet Ray Machine

Renulife Electric Company of Detroit patented this remarkable little home health-care gadget in 1919. Equipped with three knobs to control current, voltage, and the violet ray tube (on the far right in the photograph), it came complete with a set of operating instructions written by "Noble M. Eberhart, M.D., Ph.D., D.C.L." Fitted out with twenty-six special accessories—all available at slight additional cost, of course—it could be used for "scalp treatment, Falling hair, Dandruff . . . Goitre, Tonsilitis . . . rectal and prostatic treatment . . . cauterizing and removing blemishes, scars, warts . . . spinal treatments . . . internal ear treatment for deafness; also for internal nose treatment," and a variety of vaginal treatments. A "Urethral Plain Electrode"

and a "Cataphoric Electrode" were "for professional use only," but for $1.25, the home health-care giver could buy a "Single Eye Electrode, Made to fit over eye, with lid closed." For just an extra 75¢, a "Double Eye Electrode, For treating both eyes at the same time" was available.

From the unused appearance of this violet ray machine, it would seem that the only beneficial effect it ever had was on the financial health of the Renulife Electric Company. Gladys Dodge of Plymouth, Michigan, donated the machine to the Henry Ford Museum in 1962. Her gift also included an "electric belt," a sort of leather-covered inner tube complete with electric cord and plug made by the Theronoid Corporation of Cleveland about 1920.

Grand Rapids Icebox

Before electric refrigerators first became available for household use about 1913—and for quite a few years thereafter—the icebox was a common kitchen fixture. The city dweller was treated to home delivery; an iceman with powerful arms would drive a horse and cart to the kitchen door, lift a block of ice with tongs onto his rubber-caped shoulder, and tote it inside to the icebox. Country dwellers, however, generally had to fetch their own blocks of ice from the local icehouse, where, after being cut from ponds and lakes in the winter, the ice was stored all year round in insulating piles of sawdust. Once the country folk got the block of ice home, they had to hoist it up and lower it into a galvanized metal compartment at the top of the icebox —no easy feat, since the block might weigh 150 pounds. As the block melted, water ran down a pipe through a metal-lined food compartment into a drainage pan, which needed to be emptied regularly and often entailed cleaning up messy spills.

Not surprisingly, most people eagerly replaced their iceboxes with electric refrigerators just as soon as they could afford to do so. One of the rare individuals who did not was Mary V. Peyton of Stockton, California, who owned the icebox shown here from 1881 until 1932. Her reason for parting with it after fifty-one years of continuous use was that the Leonard Refrigerator Company of Detroit, successor of the Grand Rapids Refrigerator Company which had made the icebox, had launched a sales promotion campaign, offering $500 for the oldest of its prod-

ucts. Mrs. Peyton was the hands-down winner. About forty inches high and twenty-seven inches wide, the wooden cabinet of her icebox is decorated with floral motifs and has ornately cast brass hardware. Noting that there is something about "this sturdy, time-worn cabinet that typifies American manufacturing ingenuity and integrity—something that we feel qualifies this grizzled veteran for a place among . . . historical exhibits," the Leonard Refrigerator Company presented Mrs. Peyton's old icebox to the Henry Ford Museum in 1933.

Acc. 33.50.1. Neg. B.49188.

"Home Economizer"

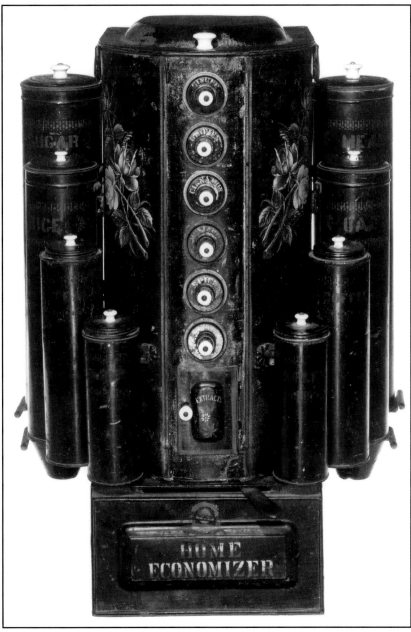

Acc. 63.101.1. Neg. B.50281.

Built about 1900, this device for storing food staples is about thirty-one inches high and made of black-japanned tin. It was the predecessor of the free-standing wooden kitchen cabinet, which, in turn, preceded today's built-in models. Said to be "what every well-organized home should have," the "Home Economizer" has a center canister large enough to hold the contents of a twenty-five-pound sack of flour. The owner poured the flour into the canister by lifting the lid at the top and released it by moving the handle at the base, which caused the flour to drop into the bottom drawer. Down the front of the flour canister are a series of small containers for ginger, cloves, cinnamon, mustard, "spice," and pepper, and below them is a small storage space with a little door labeled "extracts." The graduated canisters along the sides are marked for sugar, rice, tea, tapioca, meal, oats, coffee, and barley. The four smaller side canisters could be lifted off; the others have knobs for releasing their contents. In 1963 Edward Durell, then of Berryville, Virginia, donated the Home Economizer to the Henry Ford Museum.

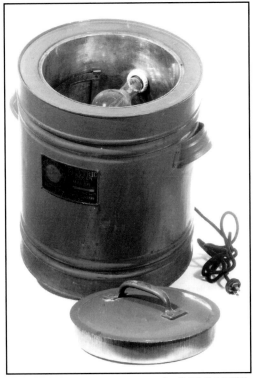

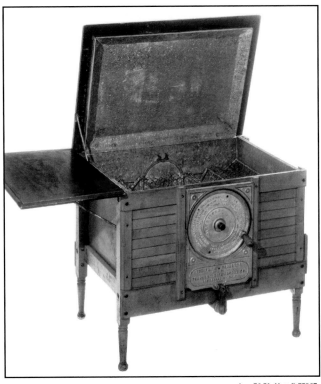

Electric Cooker

Fearless Dishwasher

The Marvel Electric Cooker Company of New York City made this little steel oven—sixteen inches high and fourteen inches across—about 1900. Equipped with a tight-fitting lid, it stewed, baked, or roasted, using two electric light bulbs as heating elements. A label on the front of the cooker reads: "To cook or stew—use 100 watt bulb/to bake or roast—use 100 watt at bottom [and] 100 watt at top." The little electric Marvel came to light in January 1976 when Cornell University's Department of Design and Environmental Analysis was cleaning out one of its storage areas. The department donated the cooker, along with with several other old household appliances, to the Henry Ford Museum later the same year.

Americans led the way with dishwashers, developing hand-cranked models between 1850 and 1865, producing the first motorized dishwashers in limited numbers during the 1920s, and introducing the first fully automatic dishwasher in 1940. The hand-cranked affair shown here was made about 1900 by the Fearless Washer Company of Rochester, New York. Known as the "Family Fearless," it has a galvanized steel interior encased in a wooden cabinet. The interior contains tin dish racks and long washer arms that revolve when the exterior crank is turned.

Thirty-six inches wide and twenty-eight inches deep, the Family Fearless is considerably larger than modern dishwashers, but it held fewer dishes. Directions are to soak the dishes in cold water, wash them in hot water, rinse them twice, and then open the lid to allow them to steam dry. The Family Fearless was another item that the Department of Design and Environmental Analysis at Cornell University donated to the Henry Ford Museum in 1976.

"Locomotive" Washing Machine

Between 1790 and 1850, the U.S. Patent Office granted more than 250 patents for washing machines—testimony to the historic labor-saving impulse of Americans. Some of these devices were intended not only to wash clothes but to do other chores as well, such as churning butter, shelling corn, and grinding grain. None were electric, and all were variations on the manual motions of pounding, rubbing, rotating, and wringing. An American named Alva Fisher built the first washing machine with an electric motor in 1901. The device shown here, also powered by an electric motor, was built about 1910, long before washing mechanisms became safely and stylishly hidden. The American Wringer Company of New York City produced the machine-driven wringer. The Remmer Manufacturing Company of Belleville, Illinois, manufactured the copper tub, which agitated its contents by moving from side to side on an iron frame. The "locomotive" washing machine was a gift to the Henry Ford Museum from Margaret Robertson of Detroit in 1955.

Acc. 55.71.1. Neg. B.11207.

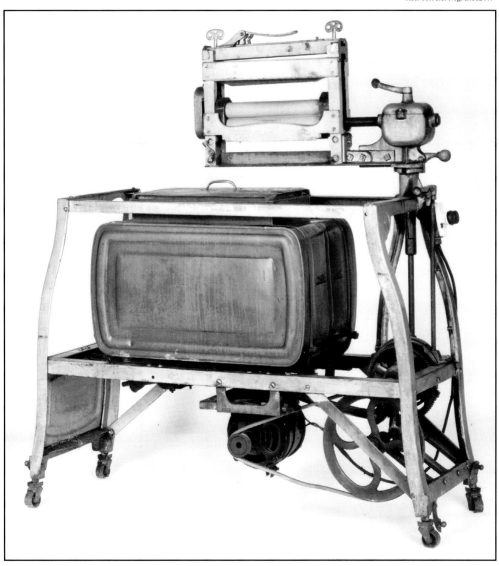

Dry Cleaner-Washer

Credit for founding the dry cleaning industry must go to the French. It is said that a Parisian named J.B. Jolly accidentally discovered the principle of dry cleaning when he spilled turpentine on a piece of clothing and found that rather than its having been ruined, the garment was cleaned. Jolly went on to establish a dry cleaning firm in Paris in 1855. Another breakthrough for commercial dry cleaning occurred in 1897, when a German named Ludwig Anthelin discovered the cleaning properties of carbon tetrachloride.

As the dry cleaning industry grew, ordinary householders who could afford it came to rely less on home remedies for cleaning nonwashable fabrics (such as using the liquid and ground pulp from grated potatoes) and more on their local dry cleaning establishments. Thus, when the Rusko Products Company of Chicago introduced the household dry cleaner shown here about 1930, it was taking something of a gamble. The company, however, hedged its bets by calling the machine a "Duette" and describing it as a device that could be used not only for dry cleaning but also for washing. A label on the door cautions the user to apply "only Duette Cleaning Fluid," adding that "it is dangerous to use highly inflammable fluids in this machine." Hand-cranked and quite a rarity, the machine is eminently portable, being only about eighteen inches wide and thirteen inches high.

J. Jordan Humberstone of Detroit donated the dry cleaner-washer to the Henry Ford Museum in 1986. Humberstone, an antique dealer and appraiser who directs the annual antique show at the museum, was born in the Sarah Jordan Boarding House in Greenfield Village soon after it was moved there from Menlo Park. His father was working in the village as the first buildings were being assembled in 1929. The only person ever born in Greenfield Village, J. "Jordan" Humberstone was one of Henry Ford's protégés, and he learned about antiques at Ford's museum.

Acc. 86.102.1. Neg. B.99279.

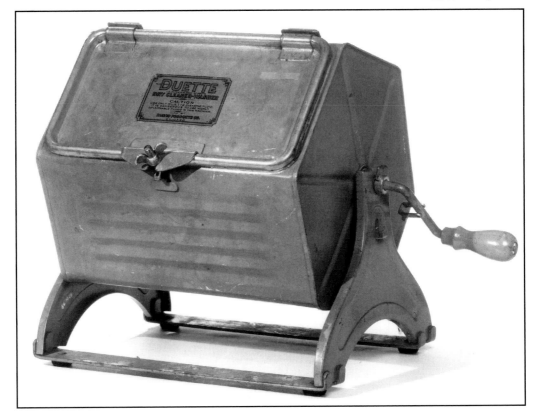

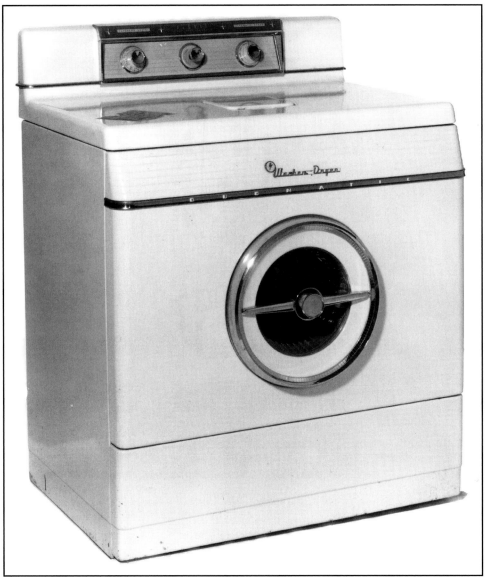

Washer-Dryer

The first recognizable forerunners of today's electric washing machines did not appear until the late 1930s. By the late 1940s, the combination washer and dryer shown here was what appliance dealers today would call "state-of-the-art." Manufactured by Bendix Home Appliances of Cincinnnati and marketed as the "Duomatic," it was encased in gleaming white-enameled porcelain. It had lights to indicate which operation was in progress and a small covered opening in the top for adding detergent. The user had only to load the clothes and detergent, turn a knob to start the washing cycle, and retire to another room until the washing was finished and another knob had to be turned to start the dryer. Some models even signaled the end of the drying operation by chiming a tune called "How Dry I Am." Paul Holoweski of Pleasant Ridge, Michigan, donated the Bendix Duomatic to the Henry Ford Museum in 1984.

"American Pride" Quilt

This quilt, ninety-six by ninety inches, has eagles on each of its four corners and clusters of red, white, and blue stars around its central motif: a somewhat misshapen, black-embroidered Statue of Liberty. Entered in a contest that Sears, Roebuck sponsored at the Century of Progress Exposition in Chicago in 1933, it won no prizes. Its maker, Mrs. J.G. Taylor, the busy wife of a country doctor in Farmersville, Louisiana, was nonetheless determined that her efforts should not have gone in vain. She mailed it off to Henry Ford, along with a letter in which she wrote:

> I prize the sentiment embedded in [the quilt] and am determined to send it where it can be of service. I am sending it to you because I think you have done more for the American people than any one man living. Your untiring efforts to make peace during the world war, your money sharing device for your employees, your reverence for Mr. Edison and the pleasure you gave him, and now your splendid scheme of assisting the veterans and others in the time of depression make me feel that you could make use in some manner of this "American Pride" quilt.

She closed by saying, "Your Ford car has done more for a country doctor than any one can imagine, for we travel over many rough roads with a territory of ten miles and more. . . . My husband has practiced forty years, so you can understand what a Ford means now."

Litogot Quilt

Henry Ford's mother, Mary Litogot O'Hern Ford, had three brothers, and though she was not raised with them, she appears to have been fond of them. Her brother Sapharia married a woman named Lethara Brown, who left him in 1867 and married one Andrew Threadgould. Threadgould had already played a dark role in the Litogot family history; in 1862, after the draft was instituted in the Civil War, he had paid Mary's brother John $1,000 to serve in his place. John Litogot was killed a few months later at the battle of Fredericksburg, where in December 1862 the Union Army lost over 12,000 men. Mary's third brother, Barney, fought in the Civil War, survived the loss of two fingers at the Battle of Gettysburg when a bullet ricocheted off his gun, and went on to become a lighthouse keeper.

Sapharia Litogot had two sons, John and Charles, who lived in New Boston, Michigan. In 1934 their wives made this patchwork quilt for Henry Ford in the hope that it might be used in the "Litogot Home"—Henry's birthplace.

Although the quilt itself is quite ordinary, made in a "Star of Bethlehem" pattern common in the 1930s and perhaps even sold in kit form, Henry Ford was no doubt touched by this gift from his mother's side of the family.

Acc. 34.390.1. Neg. B.57906.

Hooked Rug of 1890

The designer of this rug was Eleanor Blackstone; Blanche Blackstone Grieves of Lacon, Illinois, made the rug in 1890. Both women were descendants of the family that deeded the Boston Commons to the City of Boston. About nine feet wide and eight feet long and coarsely hooked on a burlap backing, the multicolored rug is made of wool, cotton, silk, and human hair from members of the Blackstone-Grieves family. Biblical verses adorn two sides: on the left, "In my Father's house are many mansions"; on the right, "They that seek me early shll *[sic]* find me." The rug, also dated "Feb. 23, 1890," depicts a family in front of a gabled house in winter. The older woman in the center is Eleanor Blackstone. The boy with the sled is her grandson, J. Paul Grieves of Canon City, Colorado, whose wife donated the rug to the Henry Ford Museum in 1970.

Hooked Rug of 1934

This photograph shows Victoria and Loraine Boudreau, enterprising thirteen-year-old French-speaking twin sisters from Upper Bertrand, New Brunswick, holding a hooked rug that they sent to Henry Ford in 1934. Along with the cotton rug, they mailed the photograph and a lengthy letter, which read in part:

Sir, Henry Ford,
. . . We have had many time the occasion to heard some body speaking of you of your great spirit, and invention, that give so many work to both American and Canadian peoples. . . . You may find enclose our picture we look like two squaws on it. We are holding a mat, with a Ford stamp on it, and [are] sending you this mat, if it can be of some used to you. We wish it can serve of a display card to show to American people that Canadian people like the Ford, and that they find it the best car ever made.

If you will be good enough to send us the last model picture, we would be happy to do another one for you, in good wool, the one we are sending you are the first, . . . and we have stamp it by the guest, we have not the picture to look on.

Although the girls asked only for pictures and not money, they went on to say they were a family of thirteen children, their father had not worked in four years, two of their sisters were working in Montreal and sending money home, and two other sisters were also making nice mats displaying the Ford car.

The rug was evidently not an altogether welcome addition to "Henry's attic." Ford officials offered to send it back if the girls would pay the $3.95 customs fee. At length, however, the Henry Ford Museum accepted the rug , the girls received a catalogue with pictures of all the 1935 Ford models, and Henry Ford's secretary came up with the $3.95 for the customs fee.

Acc. 34.264.1. Photo courtesy of Victoria and Loraine Boudreau.

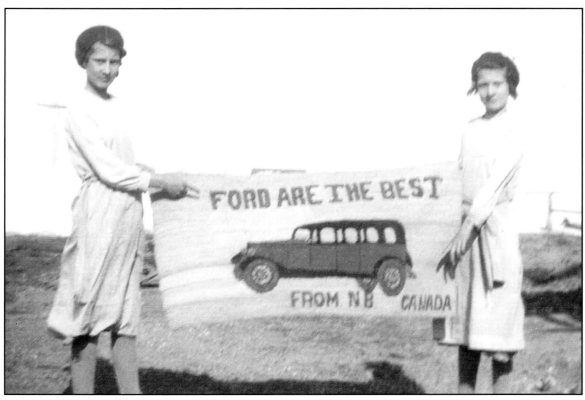

Flax Spinning Wheel

Before the textile industry began producing ready-made cloth in great quantities, spinning wheels were common household fixtures. They were used to turning flax, wool, and cotton into yarn or thread, which was then woven into cloth. This little flax spinning wheel, only thirty-one inches high with a wheel diameter of eleven inches, was made before 1850. It arrived at the Henry Ford Museum from Fair Lane sometime soon after the museum opened; neither the date nor the donor was recorded. Of European design, it has a small round table supported by four legs with elaborate rope turnings. Two uprights with the same rope turnings are notched to support the wheel high enough so that the rim clears the table.

It is thought that Thomasine Ford, Henry Ford's grandmother, may have taken this flax spinning wheel with her when she left her home in County Cork in 1847; flax, used in making linen, was—and still is—a common crop in southwestern Ireland. Thomasine did not survive the voyage to the New World. According to some accounts, she was buried at sea or at Belle Isle off the coast of Maine, but according to others, she died in quarantine in Quebec. If the spinning wheel did indeed once belong to her, then the likelihood is that one of her four daughters or their offspring gave it to Henry for his museum.

Acc. 00.2.59. Neg. B.83335.

Colonial Highboy

Made in Maryland between 1750 and 1760, this stately chest of drawers, still fitted with its original brasses, stands over eight feet tall. It is crafted from select mahogany and has a poplar and pine interior, claw and ball feet, three "flame in urn" finials, and a molded bonnet top terminating in two large rosettes. The shell motif and carving that adorn the top are repeated in a drawer at the base. Eleanor Clay Ford, Edsel Ford's wife, bought the highboy for $35,000 in 1966, specifically as a gift for the Henry Ford Museum.

Acc. 66.60.1. Neg. B.45422.

Firestone Family's Corner Cupboard and Ironstone China

This walnut corner cupboard is from the farmhouse in Columbiana, Ohio, where the tiremaker Harvey Firestone grew up. It was among the more than three hundred household items that the Firestone Foundation donated, together with the house, to Greenfield Village in 1983. A fine, simple piece about seven feet tall, it may have been built into the Firestones' dining room when the house was modernized in 1882. It is now used in that same dining room to display the Firestone family's ironstone china. A hard, heavy, durable white pottery, ironstone was first produced in England in the early 1800s. The ironstone pieces shown here, made in England with a tealeaf design, were a wedding gift to Mrs. Benjamin Firestone.

Acc. 83.1.1. Neg. B.92862.

Acc. 83.1.2. Neg. B.96848.

Étagère

America had a large and affluent middle class by the late 1850s, and tastes in furniture had changed. The rococo revival style championed by John Henry Belter was now much in vogue, and the simpler, lighter pieces of earlier days had been banished to the back room. Belter, probably the best-known and most-imitated American furniture maker of the Victorian era, used sections of laminated wood bent to shape and glued together in overlapping fashion to achieve elaborately curved pieces, which were also heavily carved and ornamented. The trappings of the respectable middle-class Victorian household included not only Belterlike settees, chairs, and tables; yards of red plush, seas of starched antimacassars, and a forest of ferns and aspidistra were also de rigueur—as was the étagère.

Commonly called a whatnot, the étagère generally had numerous shelves that were crammed full of bric-a-brac. The example shown here, built between 1860 and 1870, has nine wooden shelves, as well as a drawer at the base covered with a serpentine marble shelf, mirrors all over the back (the better to display the objets d'art), heavily turned spindles and ball and ring feet, and an arched top with pierced carvings and an urnlike finial. Mr. and Mrs. Patrick Dinnan of Pontiac, Michigan, donated the étagère to the Henry Ford Museum in 1956.

Acc. 56.65.1. Neg. B.25493.

Wright Family's Desk

In 1937, several years after Henry Ford himself had retired from the aviation industry, he bought not only the bicycle shop in which the Wright brothers had constructed their first, flimsy airplane; he also bought the house in which Wilbur Wright was born in 1867 and Orville, in 1871. After having the buildings moved from Dayton, Ohio, to Greenfield Village, Henry—never a man for halfway measures—proceeded to furnish them with authentic items representative of the period when Wilbur and Orville lived and worked in them. In this endeavor, he had a good deal of help from Orville Wright. The oak rolltop desk shown here, dating from the 1890s, was one of fourteen items from his family's house that Orville donated to the home-furnishing project in 1938. It now sits in the upstairs front bedroom of the Wright house in Greenfield Village. Among the other household items that Orville donated at this time were three parlor rockers, two washstands, two bookcases, a chest of drawers, a Victorian office chair, and a mantel clock.

Acc. 38.792.2. Neg. B.48307.

Acc. 80.80.1. Neg. B.88221.

Horn Armchair

In 1904, when Texas was still largely cowboy country, Mr. and Mrs. John Vine of Fayette, Ohio, visited the Louisiana Purchase Exposition in St. Louis and became smitten with the Texas longhorn furniture on exhibit there. Upon returning home, they ordered a large number of steer horns from a packinghouse in Texas and proceeded to fabricate the armchair shown here, as well as seven other longhorn items: a library table, a rocking chair, a clock shelf, a hall tree, two wall plaques, and a set of ornamental horns.

The horn armchair is indeed "Texas-size," being almost three feet wide. It has a saddle-shaped seat made of oak, feet made of brass claws and glass balls, and arms, legs, and back made of fourteen pairs of Texas longhorns. In 1980 Leona Bates, the Vines' granddaughter, and her husband Don Bates, both of Fayette, donated the armchair and the rest of the Vines' handcrafted longhorn furniture to the Henry Ford Museum. When making the donation, Leona Bates noted that she had grown up with the longhorn furniture, having gone to live with her grandparents in 1908.

Ornamental Wicker Stand

S.J. Ferris of Bay City, Michigan, donated this wicker stand to Henry Ford around the time the latter was preparing to open his museum. The stand was made in the 1920s, when sunrooms, ferneries, and wicker were at their peak of popularity. This particular example of 1920s wickerwork has a few unusual features: a birdcage, two electric light fixtures with bell-shaped glass shades, and two glass fishbowls.

Modern Chair and Sofa

Herman Miller, Inc., of Zeeland, Michigan, has long been known for its design and manufacture of contemporary home and office furniture. It holds the rights to manufacture the now-classic furniture designed by Charles Eames in the 1940s, and several of its products are displayed in art museums around the world. The bright red lounge chair and royal blue "Marshmallow" sofa shown here, designed by George Nelson Associates in 1956, are part of a large collection of furniture and over 1,000 catalogues and other documents

Acc. 00.4.230. Neg. B.50269.

Acc. 89.177.59. Neg. B.103957.

that Herman Miller donated to the Edsel B. Ford Design History Program in 1989. The collection demonstrates not only the innovativeness of Herman Miller's products but also some of the most significant developments in furniture design in the twentieth century. In making the donation, Herman Miller's chief executive officer noted that the "Henry Ford Museum was selected to receive the materials because the Edsel B. Ford Design History Program is focused on the entire design process that moves a product from an idea through its realization and ultimate use."

CHAPTER 10
Lighting Devices

FOR ARTIFICIAL LIGHT, colonial America depended largely on candles. Most households used them sparingly, for making them required considerable time and effort. Tallow, the solid rendered fat of cattle or sheep, had to be prepared, the candles had to be molded or dipped in the tallow, their wicks set by hand, and finally they had to be hung to dry. Factories with automatic candlemaking machinery did not appear until the first half of the nineteenth century, and until then rooms alight with candelabra and candle-burning chandeliers were the province of people who could afford to have servants or slaves make their candles for them.

Colonial Americans also used lamps with wicks soaked in vegetable oil or rendered animal fat. Most of these devices looked more like the small dishes containing oil and a floating wick used by ancient civilizations than the lamp as we know it today. The modern lamp took on its characteristic shape with the invention of devices that had a metal, wick-bearing cylinder set on top of a container of fuel and a glass chimney around the wick assembly to conduct the smoke upward. Such lamps, made from metal, glass, and ceramics, became common after the War of 1812, when the burgeoning whaling industry began supplying oil in great quantities. An oil lamp invented by Aimé Argand, a Swiss scientist, was widely used at this time. It had a small, braided wick shaped to fit a hollow tube that allowed the air to reach the center of the flame. The Argand lamp produced a brighter and whiter light than any yet seen, and it had the added virtue of being relatively smoke-free. Its tubular wick required a round glass chimney, a design that was still evident in the globe-shaped, glass-shaded oil lamps in common use at mid-century. By the 1870s, kerosene was being used as fuel not only for lighting devices but for stoves as well.

Americans who visited England in the 1820s found streets, houses, and factories there illuminated by gas. The gas, obtained by burning soft coal in metal retorts at a municipal gasworks, was piped underground to its destinations. Much impressed by England's new technology, many Americans returned home enthusiastic promoters of gas lighting. Their efforts to persuade their city councils to establish gasworks met, however, with varying degrees of success. In Philadelphia, for instance, such arguments initially fell on deaf ears. Worried about lethal odors, explosions, and a litany of other perils, the Philadelphia councilmen long held out against authorizing the burning of soft coal to produce gas for public use. When Philadelphia finally did turn on its first gas street lamps in 1836, the citizenry was awed—in much the same way the sight of a night-time blackout of a major city would awe us today. One Philadelphian wrote that it was the "most clear, bright, and dazzling" light he had ever seen.

Dazzled though that gentleman may have been, the first gas lamps emitted a good deal of smoke and a yellowish light. The atmospheric burner, invented in the 1840s, produced a whiter light and cleaner combustion by injecting air into the gas stream just below the flame. This invention came into general use in the 1850s, by which time the gasworks of Philadelphia and other large American cities had laid miles of underground pipes that were supplying homes with gas for lighting devices. Gas-fired stoves and furnaces, although few and far between, were not unknown; in London in 1802, a Moravian by the name of Z.A.Winsler had entertained guests in a gas-heated room in which he had served food cooked on a gas stove. But such uses of gas were rare and would remain so for many years, despite the fervor of gas technology's advocates. Even as electricity was coming into its own in the late 1800s, gas continued to monopolize scientific and public attention. In 1861 John C. Cresson, the generally far-sighted chief engineer of Philadelphia's gasworks, wrote that proposed improvements in gas technology "do not bear upon their face the evidence of absurdity, or impracticability, such as one attached to the famous

project of electric lite, so much agitated a year or two back."

Cresson would, of course, be proved dead wrong. As early as 1811, the English chemist Sir Humphrey Davy had observed that after he touched two carbon electrodes together and then drew them slowly apart, the electric current continued to flow between them in a luminous arc. By the 1870s, arc lamps based on Davy's observation and powered by electric generators were being used in factories and lighthouses, and by 1878 many streets in Paris were being illuminated this way. New York City began switching to arc lamps for street lighting after a successful demonstration along Broadway in 1881. Arc lamps, however, were too bright to be used for home or office lighting.

The factor that truly revolutionized lighting was the invention of the incandescent filament lamp—a device that uses electricity to heat a thin strip of material known as a filament to the point that it glows. Such a device required not only an appropriate source of electricity; it also required that a vacuum be created within the bulb so the filament would not oxidize and burn when the current was applied. Sir William Crookes, an English physicist and chemist, provided a solution to this problem in 1875, when he devised an improved way of evacuating air from glass globes. Another problem in developing an incandescent lamp was finding a filament material that would withstand high temperatures; this problem was not completely solved until 1910, when William David Coolidge of the General Electric Company invented the tungsten filament. But years before that, two inventors on opposite sides of the Atlantic had come up with the basic elements of a practical incandescent filament lamp. In England in 1878, Sir Joseph Swan produced an incandescent lamp with a carbon filament, and a year later, in Menlo Park, New Jersey, Thomas Edison created similar lamps that used filaments of carbonized cotton. After suing each other for patent infringements, the two men joined forces and in 1883 formed the Edison and Swan United Electric Company to market their electrical products in Britain.

Meanwhile, Edison had recognized that what was needed, if electricity was going to overtake gas as the most common form of lighting, was a system of electric-generating stations that could supply power to large numbers of individual subscribers. In 1882 Edison's Pearl Street Station began operating in New York City, and by 1888 it was powering about 65,000 electric lights. The concept of an integrated network of electric-generating stations was, however, rather slow to take hold. One

reason for the delay was a battle over the relative merits of alternating current (AC) and direct current (DC) systems.

A good deal of energy is lost in transmitting direct current, and power stations therefore generally distributed it over distances of only a mile or less. The cost of distributing it over a far-flung network, which required numerous generators, was reflected in the utility rates; in Chicago in 1887, customers were paying about twenty cents per kilowatt hour. While DC systems held sway—as they initially did—even fairly affluent middle-class families commonly used electric lights in the parlor only when company was present; when alone, the family turned on the old gas lamps. Nonetheless, many people were leery of the high voltages associated with alternating current—especially after the Westinghouse Corporation created an AC system for the electric chair. The fact that some direct current systems operated on voltages as high as those of AC systems seems to have escaped public attention. Edison, whose company distributed power by direct current, did little to disabuse the public of its notions about AC circuitry.

But it was not long before the advantages of alternating current became clear. Around 1885 Nikola Tesla, a Croatian-born American, invented an AC motor far superior to earlier motors designed for direct current, and by 1893 the Westinghouse Corporation, for which Tesla worked, had developed a generating system that could supply both alternating and direct current at different voltages. The system was later used at Niagara Falls, where it provided power for lights, factory machines, and railroads, including those operating in industrial Buffalo, twenty miles away.

The work of Charles Proteus Steinmetz in the 1890s and early 1900s was another factor that led to the predominance of alternating current. Steinmetz, the German-born electrical wizard who served as a consulting engineer for the General Electric Company in Schenectady, New York, analyzed the behavior of AC circuits and patented inventions that made use of both AC and DC circuitry. Steinmetz's electrical inventions were more sophisticated than Thomas Edison's, for Edison continued to rely on direct current long after alternating current was found to be more practical. It was because of Steinmetz that General Electric was able to overtake Edison in the business of making electric motors and appliances.

By 1896 electric-generating stations had begun to proliferate in America, and homes in many cities had been wired—some for direct current, other for alter-

nating current. In that year, with 1,200 Detroit residences electrified, the Edison Illuminating Company, where Henry Ford was chief engineer, supplied direct current power for 65,000 lamps. Although an electric range had been demonstrated at the World's Columbian Exposition in Chicago in 1893, it would be quite a while before electricity would be commonly used in homes for anything besides lighting. General Electric marketed its first kitchen range in 1906, and while it was a remarkable device—consisting of a wooden table with plugs and switches for thirteen appliances, including an oven, frying pan, toaster, coffee pot, and waffle iron—people nonetheless tended to cling to their iron stoves. In rural areas, they had no choice. It was not until the New Deal of the 1930s that electricity came to most of rural America.

Although Henry Ford learned enough about electricity while he was working at the Edison Illuminating Company to apply it to automobiles, he seems to have had one blind spot as far as electricity was concerned: like his hero Thomas Edison, he never fully recognized the benefits of alternating current. Henry used Edison's incandescent lamps to illuminate the buildings of Greenfield Village and his museum, and power there remained a combination of alternating and direct current until after his death. Despite his narrowness in this regard, Henry's taste in lighting devices was catholic. In the course of searching for household furnishings for his mother's house and for the old inns he acquired in the 1920s, he started amassing a collection that illustrates centuries of progress in lighting not only homes and hostelries but also streets, shops, and other public places. The Henry Ford Museum today houses a collection of 615 lamps and 237 lanterns dating from colonial times to the present. The following pages provide just a small sampling of the items that have been donated to this collection.

Betty Lamp

The household lighting device known as a betty lamp was essentially a small wrought iron dish for burning vegetable oil or rendered animal fat. It probably derived its name from the old English word *bete,* meaning "to make or kindle a fire." The betty lamp was an advance over earlier lamps in that it had an open spout through which the tip of a horizontal wick protruded and burned; this arrangement ensured that the drippings from the flame drained into the container rather than onto a table or floor. Betty lamps were in use from the 1500s until around 1810, a rather remarkable length of time. Some of these lamps sat on small pedestals; others were suspended from hangers.

The betty lamp shown here is an unusual and very finely made example. Four inches across, it is decorated with a sculpted figure, to which are chained implements for trimming and adjusting the wick. The lamp itself is attached to a hanger adorned with a brass serpent and bird; the hanger can be extended from two and a half feet to five feet. The betty lamp and its hanger were among sixty-six items related to lighting that Edward Durell, chairman of the board of the Union Fork and Hoe Company of Columbus, Ohio, donated to the Henry Ford Museum in 1983. Durell's hope was that these devices would be "properly displayed for the education and enjoyment" of museum visitors.

Acc. 83.178.3. Neg. B.70244.

Rope-Burning Lamp

Simple wrought iron devices like this were commonly used in the 1700s to illuminate windowless workshops. Because iron conducts heat, the adjustable horizontal strip of iron that grips the rope prevented the flame from traveling beneath it. As the rope burned, the worker pushed more rope up into the holder. Impregnated with animal fat or tar, the rope burned so smokily that today the device would be outlawed as an environmental hazard. To hang the lamp on a wall or wooden beam in the workshop, the worker drove in its two sharply pointed ends. The device was part of the collection that Edward Durell gave to the Henry Ford Museum in 1983.

Acc. 83.178.5. Neg. B.70246.

Crystal Chandelier

Crystal, still a highly valued type of glassware, was invented in England early in the 1600s. The invention came about when English glassmakers substituted coal for wood and thus added a flux of lead oxide to the other ingredients they were melting to make their product. The result was a glass that differed from others in that it was unusually clear and colorless.

Glassmakers in England or Ireland produced the elaborate crystal chandelier shown here around 1770. About forty-six inches high and twenty-nine inches wide, it has four candleholders supported by scrolled arms fastened to a silver plate. The plate is concealed inside a cut-glass bowl. Four similar arms support hollow urns, which are surmounted by two-tiered cut-glass pendants and triangular silver spires. The metal shaft of the chandelier is covered with cut-glass pieces of various shapes. At both the top and bottom of the shaft are scalloped glass canopies hung with prisms; a hollow ball hangs from the lower canopy. Henry Ford II donated this exceptionally fine crystal chandelier to his grandfather's museum in 1972. At that time, it was valued at $7,500.

Acc. 72.193.1. Neg. B.54995.

Butcher's Chandelier

Made in America for use in a butcher's shop, probably in the early 1800s, this sturdy wrought iron fixture served two functions. The butcher could use its four candleholders to light his shop, and he could also hang heavy slabs of meat on the hooks of the hoop below the candleholders; the hoop is about two feet in diameter. The butcher's chandelier was one of the more highly valued items in the sizable collection of lighting-related devices that Edward Durell donated to the Henry Ford Museum. At the time of the donation in 1983, this device was estimated to be worth $1,250; by contrast, the betty lamp was valued at $525, and the rope-burning lamp, at $225.

Oil Wall Lamp

The R.E. Dietz Company of New York City, a firm later known for its automobile lamps, manufactured this gilded-tin wall lamp for home lighting about 1840. It was no doubt quite sophisticated for its time. The three lobes of the fuel container simultaneously fed turpentine-based oil to the six-wick unit threaded into the center lobe; when not in use, the wicks were covered with metal caps. Soldered to the bottom of the center lobe is a cylinder with a shallow saucer. Because the saucer could serve as a base, the wall lamp could also be used as a table lamp. The fuel container is six inches wide; the sconce to which it is attached is a little more than nine inches high.

Preston R. Bassett of Ridgefield, Connecticut, donated the lamp to the Henry Ford Museum in 1974, along with two Dietz lanterns. Four years later, Bassett, former president of the Sperry Corporation, also gave the museum his valuable collection of glassware.

Kerosene Skating Lantern

As colonists embarked for the New World in the 1600s, lanterns—or "lanthorns" as they were then known—were among the items they were advised to take with them. By the late 1800s, American farmers, railroad workers, policemen, sailors, miners, and various other workers were using kerosene lanterns much like the one shown here. Bearing the picture of a skater on its hinged door, this particular lantern was obviously intended for outdoor recreational use. Made of tin and called a "pocket" lantern, it is three inches wide and less than two inches deep. It has a ruby glass window behind its hinged door, a wire bail handle, and a ventilated hood. A small container for kerosene and a flat wick burner slide out the bottom; a knob on the side of the lantern was used to adjust the wick. The R.E. Dietz Company of New York City patented the device in 1875. It was one of the items that Preston R. Bassett of Ridgefield, Connecticut, donated to the Henry Ford Museum in 1974.

Acc. 74.51.2. Neg. B.68791.

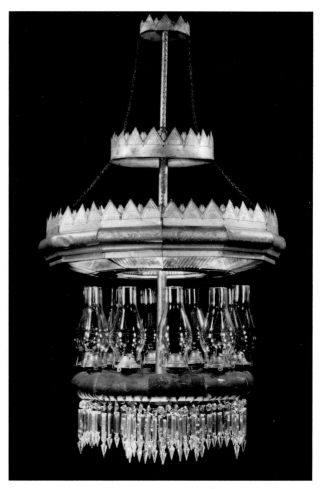

Kerosene Chandelier

Kerosene Police Lantern

Made by the R.E. Dietz Company of New York City about 1886, this policeman's lantern has a hooded top for ventilation and a bull's-eye lens mounted on a hinged door. The lens focused the light cast by a kerosene-burning wick inside the lantern. The policeman used an outside knob (not visible in the photograph) to adjust the wick. About nine inches high and made of tin-coated steel, the lantern has a bail handle at the top and a folding wire handle at the back. The policeman could also use a spring clip at the back to attach the lantern to his belt or another support. The police lantern was one of Preston R. Bassett's gifts to the Henry Ford Museum in 1974.

Patented in 1876, this elaborate ten-burner kerosene chandelier was made for use in public buildings in places where gas pipes had not been installed. It may have adorned a hotel lobby, a church, or a rather fancy tavern in a rural or semirural area. Known as "Frink's Patent Reflector Kerolier," it is fifty-six inches high and twenty-eight inches wide and made mainly of painted and gilded tin. A decorative tin piece covers its main supporting shaft. At the bottom is a round, prism-hung container for kerosene made up of ten separate compartments; the compartments are alternately painted red and gilt and are decorated with a leaf design. The chandelier has three "crown" canopies connected by decorative metal chains. The large canopy on the bottom is lined with corregated mirrors that reflect the light. Carleton and Hazel Brown of Dearborn Heights, Michigan, gave the "Reflector Kerolier" to the Henry Ford Museum in 1969.

Oil Time Lamp

This tiny oil lamp, less than seven inches high, was manufactured in the United States in the late 1870s. Embossing on its stepped base reads: "Pride of America Time & Light/ Grand-Vals Perfect Time Indicating Lamp." Intended as a "night lamp," it has a clear pressed-glass fuel container, fluted and shaped like a column, and an unfluted panel in the front marked with numbers representing the hours from eight o'clock in the evening to five o'clock in the morning. As the fuel level dropped during those hours, it indicated the time. The time lamp had to be filled with oil each day; a mechanical clock would have been less nuisance, but it would not have been visible in the dark. A brass wick burner is screwed into a filler collar on top of the fuel container. Four spring clips on the burner support a beehive chimney made of milk glass.

The time lamp was one of an enormous number of antiques that Susan Stebbins Stark of Lansing, Michigan, collected during her lifetime. In 1938, after her death, the executor of her estate wrote to the Henry Ford Museum, explaining that in her will Mrs. Stark had bequeathed her collection to "such museum or museums in the State of Michigan as can and will properly exhibit them." He added that it had been Mrs. Stark's particular wish that some of her antiques become part of Henry Ford's exhibits. When a representative of the Henry Ford Museum went to look at the collection, he was astonished to find a twenty-five-room house and two barns chock-full of antiques of every kind. The collection so interested Henry Ford that he and Clara Ford made a personal visit to Lansing to examine it. Some five thousand of Susan Stark's treasures, including the time lamp, soon made their way into the Henry Ford Museum.

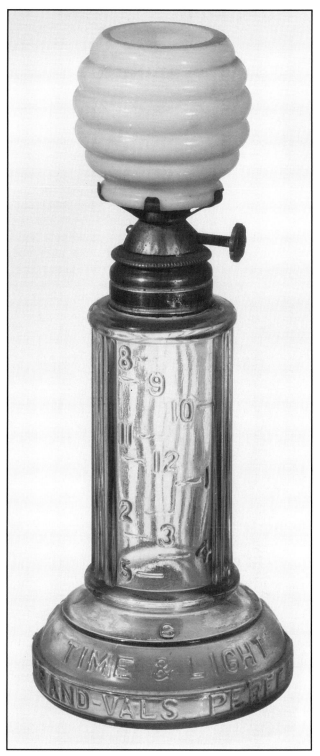

Acc. 38.309.166. Neg. B.43950.

Edison's Incandescent Lamp

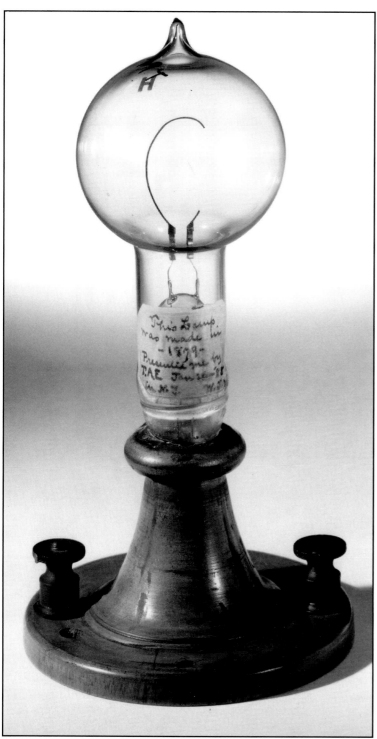

Acc. 29.1980. Neg. B.53288.

On October 19, 1879, after months of experimenting with a multitude of filament materials ranging from gold to silver to platinum, Thomas Edison finally produced a successful incandescent lamp, which ran on direct current. For the filament in this lamp, he had carbonized a piece of cotton sewing thread; he soon found to his delight that it had a suitably high melting point. But the filament was not the only ingredient in the success of Edison's lamp. He also had to evacuate enough air from the glass bulb to keep the filament from igniting when the current was applied. In October 1879 that procedure took ten hours. To evacuate the air, Edison used what was known as a Sprengel pump. It was difficult to operate but produced a better vacuum than most other pumps. After the vacuum was created, Ludwig Boehm, Edison's glassblower, sealed off the bulb, and the lamp was connected to the electric current.

Edison's first successful lamp with its carbonized cotton filament produced sixteen candlepower. It burned continuously for over forty hours and would probably have been burned longer had Edison not yielded to the temptation to force the lamp with increasingly higher voltages. After the lamp expired in a dazzle of brightness, Edison and his workers broke it apart and subjected it to minute scrutiny.

The Edison lamp shown here, also made in 1879 and similar to the original, became part of a remarkable lamp collection that William J. Hammer, a member of the Edison Pioneers, started amassing in the late 1800s. In 1912, soon after buying Hammer's collection, the General Electric Company presented it to the Association of Edison Illuminating Companies. In 1929 the association, with the agreement of Edison, Hammer, the Edison Pioneers, and the Electrical Testing Laboratories, gave the entire collection to Henry Ford for his museum.

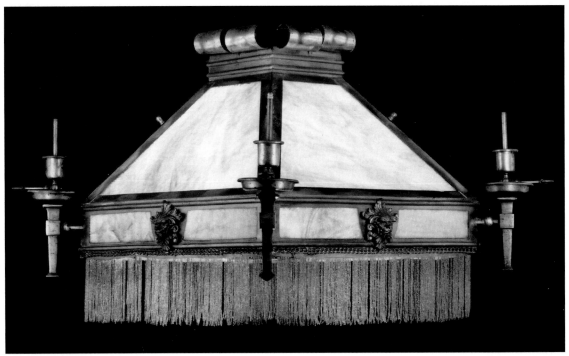

Gas Chandelier

Made about 1890, this elaborate lighting fixture was no doubt one of the most highly prized objects in the dining room of an affluent middle-class family. Its square brass frame, seventeen inches high, has textured glass panels of a light rose-amber hue. It is adorned with rolled scrolls at the top, beaded fringe at the bottom, and grotesque animal faces of cast bronze on all four sides. At each corner of the frame is a tubular gas burner mounted in a candlelike socket with a purely cosmetic drip pan below. The shades that originally covered the burners are missing. The chandelier originally also had four gas burners inside its brass frame; their removal suggests that someone was intending to convert the chandelier to electricity, a common occurrence as more and more urban homes were wired around the turn of the century. R.F. Leonard of Pittsburgh donated the chandelier to the Henry Ford Museum in 1936.

Tiffany-Type Electric Chandelier

Dating from between 1895 and 1910, this electric chandelier bears a close resemblance to those made in the famed studios of Louis Comfort Tiffany in New York City. The Tiffany Studios made many items on special order for use in libraries, private clubs, churches, and opulent residences throughout America. These special-order items were often unsigned, making it difficult to attribute them with certainty to Tiffany. The umbrella-shaped dome on this unsigned chandelier, two feet in diameter, is made of leaded stained glass and has a wide, stylized fleur-de-lis border. At the top of the fixture, four inverted leaded glass lilies, each with an electric socket, are suspended from brass crossbars affixed to a brass ball. Another four sockets are contained inside the dome.

The chandelier was used in the residence of Dr. Otto Scherer at East Kirby Street and Woodward Avenue in Detroit. Dr. Scherer, a physician, also maintained an office there for a considerable length of time, from at least 1920 to 1940. By 1955 the Detroit Board of Education was converting Dr. Scherer's former residence to a children's

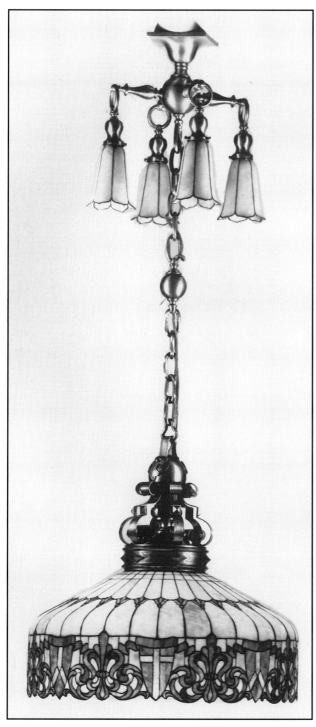

Acc. 55.15.1. Neg. B.54927.

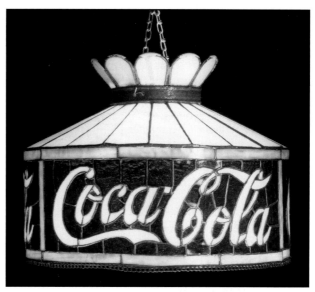

Acc. 68.155.1. Neg. B.54992.

Electric "Coca-Cola" Chandelier

Thomas H. Eurich was a well-known clockmaker and merchant in Dearborn. He was as interested in antiques as Henry Ford and, on at least one occasion, was able to purchase what Henry could not: the furnishings, dating from about 1900, of an ice cream parlor in Natick, Massachusetts. For some reason, the owner of the ice cream parlor did not cotton to Henry Ford and refused to sell to him. He did, however, agree to sell to Eurich, who had the equipment shipped to Dearborn, where he set up an ice cream parlor on the main street.

About the same time, Eurich bought this electric chandelier in Detroit and installed it in his new establishment. Made around 1900, the leaded glass chandelier has a diameter of sixteen inches. The top consists of opaque white glass, as do the insets that display "Coca-Cola" in script on each of the three lower panels, which are made of clear red glass. Marbleized green glass borders the panels, and the lower edge of the chandelier is trimmed with a small band of openwork bronze.

Eurich's ice cream parlor did a booming business until 1968, when Eurich sold the property and donated the Coca-Cola chandelier to the Henry Ford Musuem. The museum bought the rest of the ice cream parlor's furnishings, including a mahogany and marble bar and its fittings, mirrors, tables, chairs, glassware, and tableware.

museum. At that time, the board donated this chandelier and another similar one from the Scherer home to the Henry Ford Museum.

Giant Electric Lamp

In 1929, to celebrate the fiftieth anniverary of Edison's incandescent lamp, the General Electric Company, then the country's largest producer of light bulbs, made a limited number of 50,000-watt bulbs, including the one shown here. At the time, they were the largest electric lamps ever made. Each weighed thirty-six pounds and was thirty-five inches high and twenty inches across. The tungsten filament alone weighed three pounds and produced as much light as 6,000 bulbs of 25 watts each. When drawn to the proper size, the filament would have been sufficient to make 125,695 bulbs of 25 watts each. The bulbs were called "Mazda" lamps, evidently a reference to Ahura Mazda, supreme creative deity and "god of light" of the ancient Iranian religion of Zoroastrianism.

On the seventy-fifth anniversary of Edison's incandescent lamp in 1954, General Electric made another small number of giant electric lamps; these consumed 75,000 watts. GE donated the 50,000-watt bulb in the photograph to the Henry Ford Museum in 1936, and in 1958 it gave the museum a 75,000-watt bulb.

Acc. 36.79.1. Neg. A.9494.

CHAPTER 11
Clocks and Watches

B
Y THE TIME Europeans began settling in America in the 1600s, the art of making clocks and watches was well advanced. Sundials and waterclocks, also called clepsydras (age-old devices that measured time by the constant speed of water flowing through a small aperture), had given way during the Middle Ages to mechanical weight-driven clocks. Large and bulky, these weight-driven clocks were suitable for use only on public buildings. They were in turn supplemented by portable clocks with mainsprings and pendulums that could be used in homes; the first of these is said to have been introduced in Florence in 1410 by Filippo Brunelleschi, a noted architect. The mainspring used in portable clocks also led to the development of watches. The first watches evidently appeared around 1500, but late in the 1500s, they were still regarded more as luxurious ornaments than as functional timepieces. People wore them chiefly for display; for telling time, they continued to rely on pocket sundials.

The first thorough investigation of the pendulum was the work of Christian Huygens, the great Dutch physicist and astronomer. In 1657 Huygens gave drawings and instructions for constructing a clock based on his pendulum studies to a clockmaker in The Hague. The result was a timepiece with greatly improved accuracy. In 1675 Huygens made a similarly valuable contribution to watchmaking by creating the balance wheel and spiral spring oscillator. The spiral shape of Huygens' oscillator is still used in watch design today.

Immigrant clockmakers and watchmakers brought their skills with them to the New World and by the early 1700s were practicing their craft in almost every settled corner of the land. Most of these artisans concentrated on creating timepieces with high-quality brass movements, handsome dials, and elegant cases. The work was time-consuming, and the products were expensive. Only the wealthiest colonists could afford them. The rest either relied on the clocks installed on churches and civic buildings or bought clocks with wooden movements. Introduced by American clockmakers sometime before 1750, wooden-movement clocks were cheap imitations of the costly brass timepieces.

In the 1790s, as the economy of the new republic boomed, American clockmakers started casting about for new ways of manufacturing their products. One notable clockmaker of this period was Simon Willard of Massachusetts. In 1801 Willard invented a timepiece popularly known as a "banjo" clock. Designed to be hung on a wall, it was smaller and easier to set up and handle than the traditional "grandfather" clock, which was well over five feet tall. Willard's clock was not unique in this feature, for other "hang-up" clocks were also then available. Willard's clock was, however, not only relatively inexpensive; it was also simply but beautifully constructed, had a brass movement, and was an excellent timekeeper.

Another notable clockmaker of the Federal period was Eli Terry of Connecticut. Terry is credited with bringing about the mass production of clocks in America. As early as 1801, his water-powered factory on a Connecticut river was turning out 500 grandfather clocks a year. It was a remarkable figure at the time, but just a few years later, using machine tools and interchangeable parts, Terry stunned the clockmaking industry by producing 3,000 wooden-movement clocks in a single year. In 1816, when Terry patented a small wooden-movement clock that could sit on a shelf, mantel, or table, he was able to sell it for just fifteen dollars, a sizable sum of money in that era but at least five times less than any other clock then on the market. In addition to its low price, the "shelf" clock was far easier to move about the house than the wall clocks and grandfather clocks that preceded it, and its small size was also better-suited to small homes. Terry and a whole slew of new manufacturers, many of them in Connecticut, were soon producing inexpensive shelf clocks that found a ready

market all over America. Itinerant peddlers had great success with them in the backwoods, where isolated housewives were much taken by the comforting sound of their ticking.

In 1837 Chauncy Jerome, who had learned clockmaking from Eli Terry, devised a method of making clock parts from thin rolled brass. Jerome's rolled brass was so much less expensive than the thicker cast brass traditionally used in high-quality clocks that it soon put the makers of wooden-movement clocks out of business; clocks could now be sold for as little as two dollars. Yet another ingenious early clockmaker was Joseph Ives, a native of Connecticut, who in 1838 patented a spring that could be inserted in a clock without taking the movement apart; the spring transformed the clock's old twenty-four- or thirty-hour movement to one that had to be wound only every eight days. In 1845 Ives went on to invent a mechanism that would run a fully spring-driven clock; this invention ultimately gave rise to the construction of clocks without pendulums and weights.

The manufacture of watches also underwent some interesting changes in the nineteenth century. James Bogardus, an American who around 1850 pioneered the use of cast iron in building construction and also invented the I-beam still in use, produced an improved gear movement for a clock with a second hand dial; the gear movement he designed was applicable to watches as well. The keys originally used to wind watches disappeared after 1842, when a Swiss by the name of A. Philippe made a lug that could not only wind a watch but also set its hands. Philippe's lug had a screw with a serrated head, the forerunner of the winding stem.

The Parisian jewelry firm of Louis Cartier evidently made the world's first wristwatch in 1907 for Alberto Santos-Dumont, a Brazilian aeronaut who set early speed records in France. Until then, watches had customarily been carried in pockets or pinned to lapels. Wristwatches gained in popularity during World War I, for soldiers found them handier than pocketwatches. Some soldiers made their own by strapping their pocketwatches to their arms with watch chains. After the war, wristwatches remained popular among men and were soon the height of fashion for women as well.

By the time Henry Ford was born, more than a few Americans had made their fortunes in the manufacture of clocks and watches. While in his teens, Henry seriously considered emulating them. Later in life, he had a scheme for making a reliable timepiece that would sell for thirty cents, drastically undercutting the popular Ingersoll watch, which sold for a dollar. The problem, as Henry saw it, was not that he would have to make 2,000 watches a day but that he would have to sell 500,000 of them a year, and he decided to abandon the idea.

Henry had his first careful look at a watch when he was seven years old. The timepiece belonged to one of the hired hands on his father's farm, who gave him a lesson on its intricate mechanisms. Thereafter, whenever Henry was in Detroit, he spent as much time as he could with his nose pressed against the window of Englebert Grimm's Jewelry Shop, observing the watchmakers at work. He tinkered with watches at school, sometimes with the teacher's permission, and sometimes no doubt without. He traded marbles for clock wheels and made tiny tweezers and other tools from his mother's knitting needles and corset stays. The great moment came when he made his first watch repair at the age of thirteen. As he later recalled it in one of his "jotbooks":

> The first watch I fixed was after Sunday School. Albert Hutchings came out of the Gardner house with a big watch chain on his vest. I wanted to see it—it was stopped. I looked in it and saw what was wrong. . . . I ground a shingle nail into a screw driver. Took the cap off. And what a sliver I took out! . . .
>
> I then got reputation. Then the neighbors brought many watches and clocks to repair.

Of Henry's obsession with his hobby, one of the neighbors was later moved to note, "Every clock in the Ford home shuddered when it saw him coming."

According to Henry's recollection of his boyhood, he kept a work shelf in his bedroom, which he shoved under his bed by day and where he secretly repaired watches and clocks at night. According to his sister Margaret, no such shelf ever existed. Whatever the case, Henry's interest in watches and clocks stayed with him. When he went to work in Detroit at age sixteen, he took a night job at Robert Magill's Jewelry Shop to supplement his income. Although pleased with Henry's work, Magill was concerned that his boyish appearance would alarm patrons accustomed to entrusting their valuables to more mature-looking watchmakers. So Henry had to use a side door and confine himself to the back room.

Watches also played a part in Henry's courtship of Clara Bryant. They met for the first time at a New Year's Eve dance in 1885 and did not see each other again for nearly a year—by which time Clara had little or no recollection of Henry. Vivacious and popular with the boys, Clara might well have forgotten Henry again, had he not impressed her with his practicality. As she remembered it,

"He showed me a watch that he'd fixed himself to tell sun time and standard time—standard time was just coming in then, and he explained how he'd done it. I remember going home and telling how sensible he was, how serious minded. That was the beginning. . . . "

Not surprisingly, Henry saw to it that jewelry shops were very well represented in Greenfield Village. There were originally no fewer than three. One of them has been converted to a millinery shop; another—the Sir John Bennett Jewelry Shop, an elaborate import from London whose mythical "Gog" and "Magog" strike the bells on each quarter hour—has been converted to an outlet for baked goods; but the third—Magill's from Detroit—remains in its original guise. Henry stocked all three jewelry shops, as well as his museum, with many fine antique clocks and watches. Although some of these items have been deaccessioned, the village and museum today have a collection of over twelve hundred clocks and more than nineteen hundred watches. The following pages describe just a few of the gifts that have been made to the collection over the years.

Early American Grandfather Clock

This grandfather clock is supposed to have originally belonged to Daniel Boone. In 1930 Dr. George C. McVoy, a staff member of the Henry Ford Hospital in Detroit, gave it to Henry Ford. McEvoy had bought the clock in 1903 from a Mr. Leonard of Kalamazoo, Michigan. Leonard had told McVoy that as Daniel Boone was leaving Kentucky for the wilds of Louisiana in 1793, he had given the clock to Leonard's father. Beyond that, unfortunately, the story is obscure. But whether the famous frontiersman ever owned the piece or not, it is nonetheless a fine example of the early American clockmaker's craft. Probably made about 1790, it has a brass weight-powered pendulum movement that strikes the hour, a "calendar date" (a small dial indicating the day of the month), and a painted metal dial with hour, minute, and second hands surmounted by a pastoral scene. Almost seven and a half feet high, the case is made of cherry wood and has a scrolled pediment, inlaid striping and stars, and reeded quarter-round pilasters. The Henry Ford Museum sold the clock at auction in 1970.

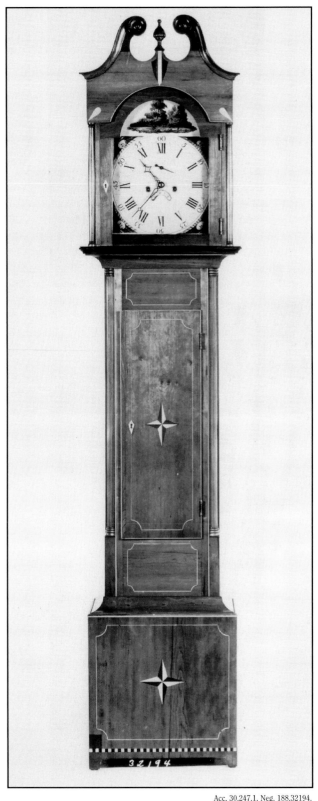

Acc. 30.247.1. Neg. 188.32194.

"Banjo" Wall Clock

A little less than three feet tall, this wall clock was made sometime between 1810 and 1840. Although it does not bear the maker's name, it very closely resembles the famous wall clocks that Simon Willard began producing in Roxbury, Massachusetts, in 1801. Willard's name customarily does not appear on his wall clocks, although it does appear on some other types of clocks that he made. The wall clock has a banjo-shaped case of mahogany veneer with brass sidearms and an urn finial, and a brass, eight-day, weight-powered pendulum movement. The door over the painted metal dial is made of convex glass and has a molded-wood frame.

The "banjo" clock was a gift to Henry Ford in 1937 from Altia and Neva Austin, two rather unusual sisters from Hancock, Maine. The women, both then in their sixties, lived in a forty-room mansion known locally as "old man Austin's dream castle." Their father, who had made a fortune as a jeweler in New York City, had started building the mansion fifty years earlier, but shortly thereafter both he and his wife had died. Half a century later, only one room of the mansion had been finished—but not for lack of funds; Miss Altia and Miss Neva had a small fortune in jewelry, stocks, and bonds, all safely tucked away in a bank. It was the sisters' schedule that precluded their getting around to finishing the mansion—or doing any housekeeping.

In addition to tending an army of cats—at one time as many as fifty-six of them—Miss Altia and Miss Neva took turns patrolling the mansion to discourage marauders and sightseers. Altia had the nightshift; from six o'clock in the evening until five in the morning she roamed the forty rooms with a flashlight or stood watch in the mansion's castlelike turret, during which time she also fed three shifts of cats. She slept all day, while Neva took over the rounds. With this routine, there was no time for housekeeping—let alone house construction. A reporter from the *Detroit News* who visited the sisters in 1937 described the scene that greeted him:

> Scattered through the forty rooms, gathering dust, are boxes and piles of materials ordered for the completion of the mansion and a dozen carloads of furniture, bric-a-brac, art objects, hundreds of framed pictures and thousands of expensively bound books, still in the crates in which they were delivered half a century ago. . . . Miss Neva received me on the magnificent porch, littered with fallen plaster, bricks, broken glass,

rotting boards, a battered parrot cage that . . . had fallen there fifteen years before, and a rusty coal scuttle.

According to one of Henry Ford's emissaries who read the newspaper article after visiting the mansion, "The only thing the writer neglected to tell about were the piles of filth the castle . . . contains."

What prompted the sisters to give the banjo clock to Henry Ford is not clear, though they may have known Edsel Ford, whose summer home at Seal Harbor was not far from Hancock. In addition to presenting Henry with the banjo clock, they also gave him two grandfather clocks, a Hepplewhite sideboard, a set of dueling pistols, a pair of boots that had "belonged to the Duchess of Marlborough," and a few other items.

Acc. 41.10.1. Neg. B.46216.

English Pocketwatch

Made about 1830 by T.F. Cooper & Company of London, this pocketwatch has a brass movement, a silver case just over two inches in diameter, an enameled face with gilt hour and minute hands, and a second hand dial. Attached to the watch is a silver chain with a key for winding the mechanism. In 1941, after visiting the Sir John Bennett Jewelry Shop in Greenfield Village, Cyrenius R. Wilson of Syracuse, New York, was inspired to make a gift of this watch to the village's "old jewelry shop."

Acc. 81.165.1. Neb. B.90982.

"Patti" Shelf Clock

Welch, Spring & Company of Forestville, Connecticut, produced a line of elaborate shelf clocks about 1880. The company, which apparently had high hopes for these clocks, named them after Adelina Patti (1843–1919), a noted Spanish-Italian operatic soprano. The "Patti," nineteen inches high, has a rosewood case with ornately turned columns and finials, a stepped base, glass sides, and a glass door decorated in gold leaf. The elaborate brass pendulum of its eight-day, spring-powered movement is visible through the glass door and has a center insert of Sandwich glass and a bell to strike the hour. The dial is made of heavy paper, the rim is brass, and the hands are blued steel.

Unfortunately for Welch, Spring & Company, the

Patti's production costs were higher than anticipated, and the clock was not a commercial success. Today, it is a collector's item. When the Great Lakes Chapter of the National Association of Watch & Clock Collectors gave the Patti shown here to the Henry Ford Museum in 1981, it was valued at $1,200.

Acc. 73.88.2. Neg. B.73712.

French Mantel Clock

M.S. Smith & Company, jewelers and diamond merchants of Detroit, ordered this clock from Japy Freres & Company, a Parisian clockmaker, in 1887. It is typical of a style that became popular in the United States in the early 1900s. A little more than fifteen inches high, it has a polished black slate case with mother-of-pearl inlays, a round white porcelain dial with a beveled glass door, and a round brass spring that powers the eight-day pendulum movement. It also has a bell that chimes the hour and half-hour. Mr. and Mrs. Keith B. Hackett of Dearborn Heights, Michigan, donated the clock, as well as a gold watch and a large number of antique silver pieces, to the Henry Ford Museum in 1973. The gifts were made in memory of Keith Hackett's parents and grandparents, who were the original owners of these items.

Acc. 38.792.19. Neg. B.105021.

Wright Family's Shelf Clock

The William L. Gilbert Clock Company of Winsted, Connecticut, made this simple "cottage clock" about 1881. Just over thirteen inches high, it has a brass, eight-day, spring-driven pendulum movement with an hour chime; a case of rosewood and mahogany veneer; a metal dial painted white with black roman numerals and gold decorations; and a glass door with a panel of colored flowers on a black background. The clock was used in Wilbur and Orville Wright's family home in Dayton, Ohio, until 1938, when Orville gave it to Henry Ford to furnish the house, which had been moved to Greenfield Village a year earlier.

Street Clock

Street clocks are the direct descendants of the weight-driven clocks that were installed on public buildings during the Middle Ages, long before people carried watches. The Brown Street Clock Company of Monessen, Pennsylvania, made this one sometime after 1880, presumably for the small Ohio town of Gates Mills, whose name appears—together with a painted horse's head—on glass panels over the double-sided dial. The clock is almost fifteen feet high. Its glass dials have a cast iron housing and are supported by a fluted cast iron post and square base.

The dials are inscribed with the name of the well-known American clock designer and manufacturer Seth Thomas, but the inscriptions were put there by a former owner of the clock, and it seems unlikely that Thomas's firm made the clock's original brass pendulum and weight movement. The Great Lakes Chapter of the National Association of Watch & Clock Collectors bought the street clock for the Henry Ford Museum for $5,000 in 1979. Since then, it has been on the museum's "Street of Shops," where it is now powered by two electric motors.

Acc. 79.70.1. Neg. B.110859.

Stationmaster's Wall Clock

Acc. 00.4.3604. Neg. B.84085.

The Ansonia Clock Company made this wall clock, probably in the 1890s, in Brooklyn, New York. The Detroit, Toledo & Ironton (D.T. & I.) Railroad used it in its depot in Ironton, Ohio, until about 1926. It has an eight-day movement with brass weights and pendulum and a natural oak case adorned with a carved pediment and turned spools and columns. The metal face is painted white and has blued-steel minute and hour hands and a second hand dial. The records of the Henry Ford Museum do not list the donor of the clock, but Henry Ford owned the D.T. & I. from 1920 until 1929, and it seems likely that he found it a suitable candidate for his museum. Now about a hundred years old, the clock is still marking time in the library of the Henry Ford Museum & Greenfield Village Research Center.

Floral Clock

Upon his death, one Chauncey Hurlbut left a sizable sum of money to the City of Detroit to beautify the grounds around a municipal waterworks on East Jefferson Avenue. With this bequest, Elbridge A. Scribner, first superintendent of grounds at that waterworks, established quite a reputation by creating unique floral designs for the "Water Works Park," among them a floral cow in a field of corn and a floral wigwam with smoke—supplied by the pumping station—coming out its top. Scribner designed and built this floral clock for the park in 1893. It was originally water-powered, operating by means of a stream that flowed down over a paddlewheel. The floral clock was a popular attraction in summer, the subject of a great many photographs.

By the early 1930s, after it had seen almost forty years of service, the floral clock—never a completely accurate timepiece—was becoming less accurate, and it was also the victim of occasional vandalism. When officials decided to relegate it to the city dump, citizens protested, but nothing was actually done until Henry Ford offered to move it to Greenfield Village. There, in 1934–1935, it received a brass weight-driven pendulum movement and was put back into operation—running more accurately than ever before—on July 4, 1935. Maintenance of the clock, which was over seven feet high and ten feet wide, required winding it twice daily and the cultivation of some seven thousand plants during the summer months; a wooden face was used in winter. Because of the cost of the upkeep, Greenfield Village eventually removed the floral clock from exhibit and put it into storage. In 1989 the clock was returned to its original home at Detroit's Water Works Park.

Henry Ford's Office Clock

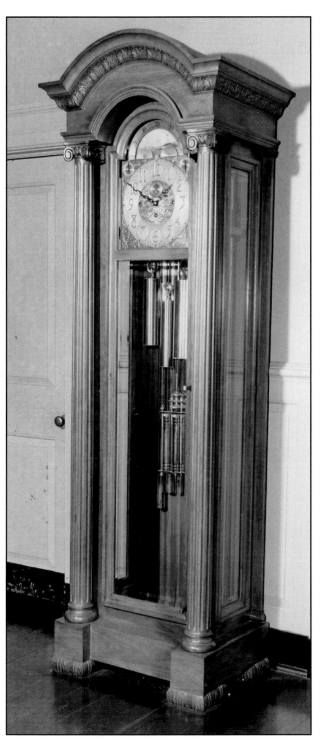

Acc. 00.136.399.2. Neg. B.42959.

Founded in 1849 in Waltham, Massachusetts, the Waltham Watch Company had achieved complete automation in watch manufacture by 1910. Henry Ford is reported to have visited the factory and received some inspiration for his automotive assembly line from it. By 1915 the Waltham Watch Company was also manufacturing car clocks, or "automobile timepieces," as the company advertised them. "While these Waltham Timepieces are strictly innovations," the ad read, "they permit you to enjoy the same accuracy in timekeeping in your Limousine or 'Electric' as you have been accustomed to expect from the most expensive Bracelet, Lorgnette, Boudoir or Pocket Watch. . . . You will now find them attached to the leading makes of cars, and they will be fitted to yours if you so specify when ordering, or you may purchase a model for your car from your jeweler or auto-accessory dealer."

The Waltham Watch Company began supplying clocks for Ford cars in 1933 and for Lincolns much earlier than that. About 1924 Waltham made this grandfather clock expressly for Henry Ford, who used it in his office at the Ford Engineering Laboratory until his death in 1947. It was no doubt as fine a timepiece as the Waltham Watch Company could produce. Almost eight feet tall, the clock has a brass, eight-day, weight-powered pendulum movement and nine chrome-plated brass tubes that chime the hour and quarter-hour. Its solid walnut case has a broken-arch top, fluted side columns surmounted by carved capitals, and beveled glass doors on the front and both sides; the front door opens at both the top and the bottom. The face, made of brass, is engraved with decorations and has applied arabic numerals, pierced black hands, and two small dials for turning the striking mechanism on or off and selecting the chimed tune that preceded the striking. Above the face is a "lunette" that shows the phases of the moon. The Ford Motor Company donated the clock to the Henry Ford Museum sometime after Henry's death in 1947.

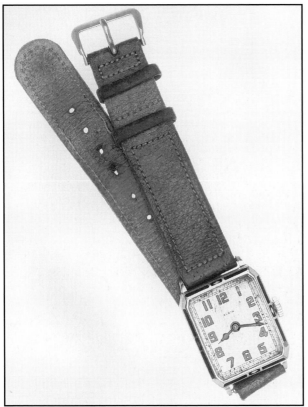

Acc. 43.9.1. Neg. B.49301.

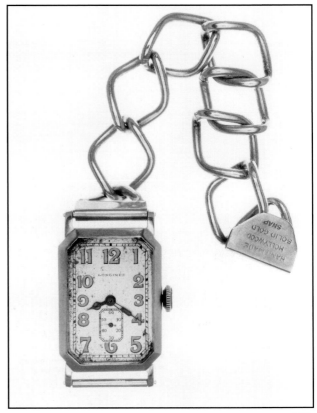

Acc. 43.9.2. Neg. B.49302.

"Amos" and "Andy" Wristwatches

Henry and Clara Ford were great fans of the weekly "Amos 'n' Andy" radio program, a comedy enormously popular almost from the moment of its first broadcast in 1927. Like other popular radio programs, it went on televison in the late 1940s, but it did not last long in the new medium; CBS canceled the show in 1953. It was one of the longest-running programs—if not the longest-running—in broadcasting history: more than twenty years on radio and over three years on television.

The stars of the program were Freeman F. Gosden ("Amos") and Charles J. Correll ("Andy"), who also wrote the scripts. On December 8, 1942, Henry Ford wrote them a personal letter, congratulating them on "sustaining so high a level of quality for so long a time." A few weeks later, after attending a Christmas performance that they gave in Detroit, he wrote to ask them for a copy of the script. "Amos" and "Andy" not only sent him the script but also the two watches shown here, along with the following letter:

Dear Mr Ford:

We are sending you . . . two wristwatches. The one with a leather strap [an Elgin] belongs to Charles Correll. The one with the chain [a Longines] belongs to Freeman Gosden. These watches were worn by us the night we . . . wrote our first Amos 'n' Andy program. We watched the hour hand on these watches make a complete revolution. It was a long night. We thought you would like to have these watches for your collection.

Acc. 51.13.235. Neg. B.7445.

Henry Ford's Cartier Pocketwatch

Edsel Ford probably ordered this expensive novelty watch as a gift for his father in 1928—the year that Henry Ford and Son stopped making Fordson tractors in the United States. Cartier of Paris created the thin platinum case and a platinum chain and locket that were once attached to it; the nineteen-jewel watch movement was made in Switzerland by the European Watch and Clock Company. In place of numerals, the dial displays the twelve letters of "Henry Fordson." The dial also has an inner track with a twenty-four-hour dial. Around the rim of the case, which is one-eighth of an inch thick and less than two inches across, are seventy-one sapphires. The platinum locket that was attached to the case was about two-inches square; it contained photographs of Henry and Clara Ford, Edsel and Eleanor Ford, and the Ford grandchildren—Henry, Benson, Josephine, and William Clay. The watch was one of the many items that Clara Ford's heirs gave to the Henry Ford Museum in 1951. At that time, it was valued at $950.

Twentieth-Century Alarm Clock

Alarm bells inside clocks preceded even the pendulum, but getting them inside the smaller clocks of the 1800s presented some difficulties. In 1838 an American named Benjamin Knight invented an alarm for a small mechanical clock, in 1847 a Frenchman named Antoine Redier invented another, and after about 1890, inventors on both sides of the Atlantic came forth with a variety of schemes for electric-powered alarm clocks. No doubt all these were a far cry from the object shown here. The point of this vinyl-covered, baseball-sized digital alarm clock is that one can relieve the stress of being disturbed from sleep by hurling the sphere at a convenient wall. This effectively silences the alarm, while presumably also contributing to the hurler's sense of well-being.

While not in motion, the electronic clock rests on a black plastic ring that bears the name of its maker: "Off-The-Wall" Products, Inc., of Hong Kong. It has SET, MODE, and SNZ buttons, a plastic-covered aperture for the digital LCD (liquid crystal display) readout, and three slots above the aperture that emit beeping sounds at the preset alarm time. The device, made in 1986 and still in excellent condition, was donated to the Henry Ford Museum in 1991 by Steven K. Hamp of Ann Arbor, Michigan, a director of the Henry Ford Museum & Greenfield Village.

Acc. 91.321.1. Neg. B.110623.

CHAPTER 12
Musical Instruments and Phonographs

MUSICAL INSTRUMENTS were not as common in homes when Henry Ford was growing up as televisions, radios, and stereos are today, but they served much the same function. Unable to have instant amusement at the flip of a switch, people in those days had to make their own diversions. Social evenings at home often consisted of friends and family members singing to the accompaniment of a piano, organ, or fiddle. Band concerts and country dances were also popular, and Henry and Clara Ford were fond of both. They attended many dances during their courting days, energetically performing polkas, Virginia reels, waltzes, and various kinds of quadrilles. By 1923, however, the Fords had evidently fallen out of practice. One early autumn evening that year, after they had been talking with guests at Fair Lane about the old days, Clara remarked, "Do you realize, Henry Ford, that we have danced very little since we were married?" After thirty-five years of marriage, most husbands would probably have responded with a shrug— but not Henry; with his customary zeal, he set about rectifying the situation.

A few weeks later, when the Fords were visiting the Wayside Inn in Massachusetts, they arranged an old-fashioned country dance and engaged Benjamin Lovett, a dancing master well known in the vicinity, to help guests brush up on their square-dancing steps. So proficient was Lovett that he soon found himself a full-time resident of Dearborn, in charge of Henry Ford's private orchestra— an odd combination of cymbalum, violin, string bass, dulcimer, sousaphone, and, for special occasions, an extra fiddle. Ensconced in a temporary ballroom in the new Ford Engineering Laboratory Building, Lovett instructed local schoolchildren in the intricacies of "old-fashioned dancing." With Henry's backing, he was soon out spreading the word among college students as well. Lovett ultimately went through his paces with students at thirty-four colleges and universities, among them Radcliffe, Temple, North Carolina, Georgia, and Michigan.

Nor did Ford executives escape the passion of Henry's latest interest. Indeed, they were among the first to experience it. Whether burdened with two left feet or not, the executives were obliged to attend the dances that the Fords began giving regularly each Friday evening; it is reported that many fortified themselves for the occasions beforehand with strong spirits, beverages that Henry Ford deplored. If the executives were sure-footed and lucky enough, they might avoid Lovett's lunchtime instruction, which Henry invited the more awkward of his lieutenants to attend. But Charles Sorenson, Ford's production chief who was a large and handsome man, found himself mortified on more than one occasion, as with agile Henry as his partner and Lovett looking on, he was guided through the mincing steps of a quadrille.

In 1937 the Fords' Friday night dances moved to "Lovett Hall," a newly constructed colonial-style building in Greenfield Village, where an elegant ballroom with a springed floor of teak parquet had been installed on the second floor. In those regal surroundings, guests clad in formal attire square-danced as Benjamin Lovett yodeled the "ho-dee-ho's." After attending one of the functions at Lovett Hall, Prince Louis Ferdinand, grandson of Kaiser Wilhelm II, reported that "the Ford invitees were as well drilled as the dancers at one of my grandfather's court balls in Berlin. After an hour's continuous dancing, there was an intermission of fifteen minutes. . . . No one smoked. The dancers could get a glass of water at an ordinary water tap." After the dance, guests were served coffee, fruit juice, and other nonalcoholic beverages, together with cookies and doughnuts.

Henry could hardly have undertaken his crusade to revive old-fashioned square-dancing at a less auspicious time. In 1923 the Roaring Twenties were heading toward their zenith; it was the age of jazz and flappers, speakeasies and bathtub gin, the Charleston and the Black Bottom. Of the sound of jazz, Henry was known to say, "It's like a cat fight in a boiler yard." He took an

equally dim view of "modern" ball-room dancing; a booklet that his presses published to provide instruction on the old-fashioned dancing implied that the contemporary sort, in which couples embraced, bordered on promiscuity. As part of his crusade, Henry sponsored radio programs that broadcast old-fashioned dance music nationwide. Somewhat surprisingly, given the times—but perhaps not so surprisingly, given the publicity attending it—Henry's crusade was successful. The old-time values of rural America that he was trying to express and preserve found a warm audience, perhaps not in all those who had to attend his dances, but in the populace at large. By 1926 old-fashioned dancing was a national craze.

When in 1923 Henry also mounted a campaign to rekindle public interest in fiddling, he met with equal, if not greater, success. Although he was almost never without a Jew's harp in his coat pocket, the fiddle was Henry's favorite instrument. He played it himself—though never very well—sometimes rendering such tunes as "Turkey in the Straw" on a $75,000 Stradivarius violin. Unable to master the trick of fiddling and doing a jig at the same time, Henry was exuberant when in 1923 he met Jep Bisbee, an eighty-year-old fiddler from northern Michigan, who could perform this feat. Jep, the recipient of a Ford sedan and the "Henry Ford Gold Cup"—which he won in a well-publicized Detroit contest by outfiddling fifteen other grey-bearded contestants—was Henry's favorite fiddler for two years.

But then along came Mellie Dunham, a seventy-two-year-old snowshoe maker from Norway, Maine, who attracted Henry's attention by winning a Maine fiddling contest. When Henry invited Mellie to play at a dance in Dearborn, the publicity was enormous. The upshot of it was that Mellie abandoned his snowshoes and went off on a well-paid tour of the vaudeville circuit, inspiring many other fiddlers—including President Calvin Coolidge's eighty-year-old uncle—to do the same. Fiddling contests became the rage, and Henry sponsored many of them, providing trophies for the winners. Neither the fad for fiddling nor the taste for country dancing lasted very

Acc. 91.0.1693.
Neg. B.110632.

These two steel Jew's harps, each two and a half inches long and having a different pitch, were found in their wooden case in Henry Ford's desk at Fair Lane after Clara Ford's death. Her heirs gave them to the Henry Ford Museum in 1951.

long, however. By the end of 1926, both had begun to fade. Nonetheless, Henry and Clara continued to hold their Friday night dances until their son Edsel died in 1943.

Although Henry cherished the fiddle above all other instruments and had a collection of dozens of them, his tastes extended to just about any kind of music-making device—harmoniums, calliopes, pianos, spinets, harpsichords, harps, woodwinds and brass horns, drums, and even music boxes and phonographs. He apparently had a particular weakness for music boxes—the larger, the better—and often visited antique shops to seek them out. Clara Ford tended to view these expeditions with a somewhat jaundiced eye. As she once explained to someone who had accompanied Henry on one of his music-box buying sprees, "He sometimes takes them to pieces and, besides, he's already got about forty of them."

Today, the Henry Ford Museum has no fewer than ninety-eight music boxes, as well as numerous phonographs and a large and valuable collection of violins, pianos, drums, harps, and many other kinds of musical instruments. The items described on the following pages include a few of the more historic and unusual pieces donated to this collection.

English Violin

The violin, an outcome of improvements made to stringed instruments used in the Middle Ages, first appeared in France in 1529. It was brought to the height of perfection in the late 1600s and early 1700s by Italian instrument makers, foremost among them Nicolò Amati and Antonio Stradivarius. Stradivarius made over a thousand violins before his death in 1737, and many of them are still in existence. Between 1924 and 1930, Henry Ford bought at least two Stradivarius violins dating from the first decade of the 1700s and one Amati made in 1647. Today, some of the violins in the collection that Henry amassed are valued at over $2 million. Henry apparently thought nothing of lending these and other rare instruments to students at the Edison Institute—providing they were doing well in their music lessons.

Jacob Ford of Grosvenor Square, London, made the violin shown here in 1742. In 1937 Rudolph Wurlitzer of Cincinnati, a well-known manufacturer of coin-operated automatic musical devices, sent the violin to his friend Henry Ford, along with a letter in which he wrote, "Now, I know why you are musical. This violin was evidently made by one of your ancestors. One can see he had a finer feeling for the art of violin making than the usual maker." Although the genealogical records of the Fords of Dearborn make no mention of a violin maker named Jacob Ford, Henry seems never to have denied the relationship. The violin, valued at $1,000 in 1937, has a fine-grained spruce top, a one-piece bird's-eye maple back, exceptionally fine edges, deep and vigorous scrolls, and wide arching.

Acc. 37.293.1. Neg. B.77068.

Pedal Harp

Very popular at least as early as the Middle Ages, the harp is one of the world's oldest musical instruments. The earliest harps had no provision for changing the pitch of a string except by retuning. In the 1700s a German instrument maker named Hochbrucker devised what is known as a pedal harp. Using the pedals on Hochbrucker's harp, which controlled a series of hooks that tightened the strings, the harpist could change the pitch of any string without retuning the instrument.

The pedal harp shown here was made about 1800, probably by H. Naderman of Paris. Its thirty-eight strings are controlled by hook action, and its frame is beautifully decorated with painted carvings. Fay Leone Faurote of Garden City, New York, gave the harp to the Henry Ford Museum in 1936, along with a collection of books pertaining to U.S. industry from about 1850 to 1930. Faurote, a close friend of Henry Ford, was himself the author of a voluminous work called *Ford Methods and the Ford Shop;* published in 1915, it offers a complete and authoritative description of the automotive manufacturing methods of that period. In 1929 Faurote also wrote *My Philosophy of Industry, by Henry Ford: An Authorized Interview.*

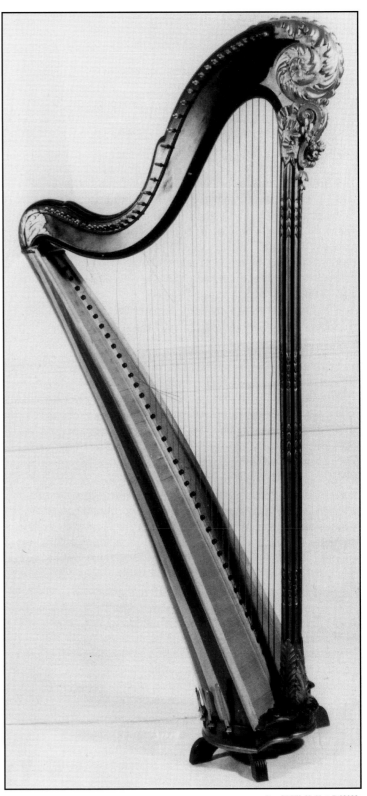

Acc. 36.759.40. Neg. B.83999.

Chickering Square Piano

Around 1710, an Italian named Bartolomeo Cristofori built the first piano, or pianoforte, which in Italian means "softloud." The piano could produce many variations of tone, a capability lacking in its immediate ancestors—the clavichord and harpsichord. By 1790 American craftsmen, who had been making harpsichords since before the Revolution, were also making the new "square" pianos and selling them throughout the country. Like the harpsichord, these first pianos were flat wooden boxes on legs. The square piano remained the most popular model in America until about 1900.

In the first half of the nineteenth century, as numerous inventors on both sides of the Atlantic contributed to the piano's development, it underwent many changes. Among these inventors were S. Erard, who in 1822 invented the double escapement that allows a note to be repeated; G. Silbermann, who perfected the piano's hammers; John Hawkins, who in 1833 patented the first upright piano, which others later perfected; and Thomas Loud, who, among other things, received an 1837 patent for an improvement to the mechanism that strikes and releases the keys and hammers.

Another inventive talent who made significant contributions to the piano's development was Jonah Chickering, whose many patents enabled him to establish a piano empire. His firm, Chickering & Sons of Boston, made the square piano shown here around 1835. In 1930 Chickering & Sons donated it, together with four other historic pianos, to Henry Ford "to be displayed and perpetuated in his museum." Included were Chickering's first piano, a "square"; its first grand piano and its first upright; Abraham Lincoln's Chickering, which he used in the White House; and the Chickering that Jenny Lind, the "Swedish nightingale," used during her first American tour.

This square piano, bearing a metal plate inscribed "Jenny Lind, St. Louis, March 1837," was the one that the famed soprano used. It has a rosewood case with carved walnut cabriole legs, a pine soundboard, an oak frame, two pedals—piano and forte—and a range of seven octaves. In 1939 Chickering & Sons borrowed it and its companion pianos from the museum to display them at the New York World's Fair and later returned them to the museum fully restored.

Acc. 30.1953.4. Neg. A.8811.

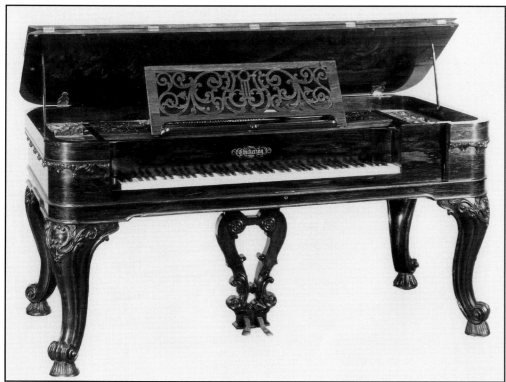

The Eagle Tavern's Square Piano

In 1927 Ella Smith sold the Clinton Inn in Clinton, Michigan, to Henry Ford, who had the building, then nearly a hundred years old, moved to Greenfield Village, fifty miles away. The inn was subsequently renamed the Eagle Tavern. While running her inn during the 1920s, Ella Smith gave piano lessons to local children, using a piano in the inn's parlor. Among her pupils was Lilah Myers, who did chores for Miss Smith in exchange for her lessons. Miss Smith became very fond of Lilah and promised her that the piano, shown here, would eventually become hers.

When Henry Ford bought the inn, he had assumed the piano would come with it and was evidently quite dismayed to learn it had been given to thirteen-year-old Lilah. He is reputed to have taken the girl on his knee and pointed out to her that more people would enjoy the piano if she would allow him to take it to Greenfield Village; he also promised her that any time she wanted to visit the village, he would send his chauffeur for her. In the face of such cajoling, Lilah gave in and agreed to let Henry have the piano.

Allen & Jewett of Boston made the square piano about 1861. Like the Chickering square piano, it has a rosewood case, oak frame, piano and forte pedals, and a range of seven octaves. Although Lilah (now Lilah Myers Patchett) has occasionally visited the piano in the ladies' parlor of the Eagle Tavern, she says that she never did get a ride from Henry's chauffeur and that Henry "sweet-talked" her into giving up her piano.

Acc. 27.276.1. Neg. B.48449.

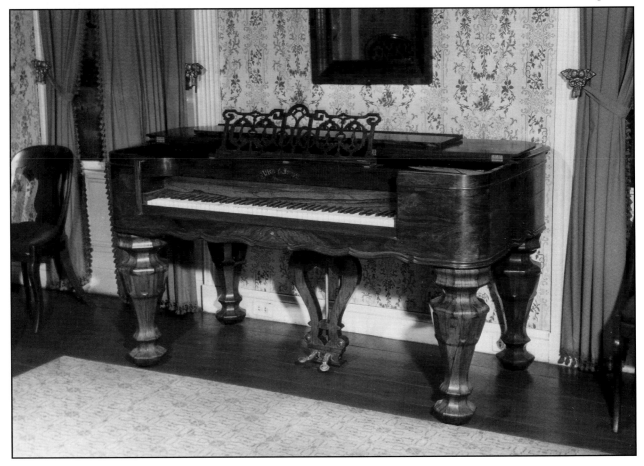

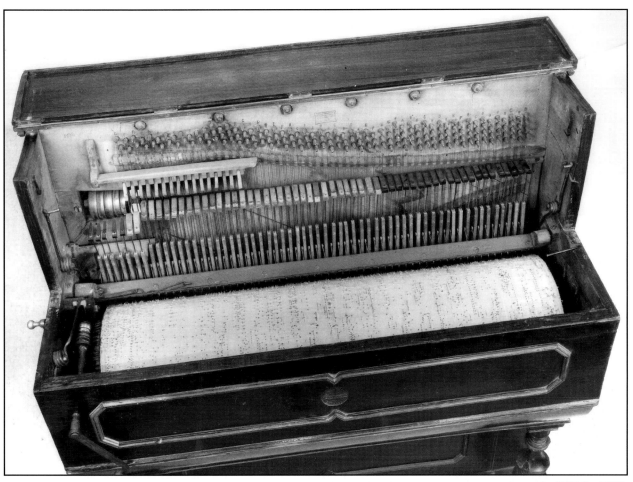

Barrel Piano

Built by Luis Gasali in Barcelona about 1875, this barrel piano once no doubt added to the vibrancy of the streets of that ancient Spanish city. Since the instrument lacks a keyboard, the street musician who used it needed no talent other than the ability to operate the crank that turned its wooden cylinder and the ability to tote around its four-foot-long solid oak case. As the wooden cylinder turned, its pins hit the hammers, which in turn hit the strings, and the barrel piano went into its rendition of ten Spanish songs. William John Upjohn of Kalamazoo, Michigan, donated the instrument to the Henry Ford Museum in 1976.

Edison's Demonstration Phonograph

In 1877, while recording Morse code messages on waxed paper tape, Thomas Edison noticed that the tape made sounds of different pitches when he pulled it rapidly past a spring. It occurred to him that he could record sound by connecting a speaking tube, like the one used in the newly invented telephone, to a needle that would cut a groove into a tinfoil-covered rotating cylinder. Responding to the variations in the sound waves, the needle would record them as a series of light and deep impressions on the tinfoil; when the needle was moved back across the cylinder, it would play back the recording. In December 1877, after months of experimentation, Edison successfully recorded and reproduced "Mary Had a Little Lamb" on his tinfoil-covered device, which he called a phonograph. It was the world's first sound-recording machine, and although Edison was very deaf, it was his favorite invention. He envisioned many uses for it, among them recording music, dictating letters, and recording the sound of the human voice to teach diction and to make "talking" books for the blind.

S. Bergmann & Company of New York City made the phonograph shown here for Edison in 1880. It is considerably larger than the original. Edison, who used it to demonstrate to the public how his invention worked, gave the device, together with hundreds of other items, to Henry Ford for his museum in 1929. These photographs, taken in the 1930s, show Charles Natzel, an interpreter at the Menlo Park Laboratory in Greenfield Village, recording his voice on the tinfoil as he rotates the cylinder and then listening to the recording as the needle moves back across the cylinder.

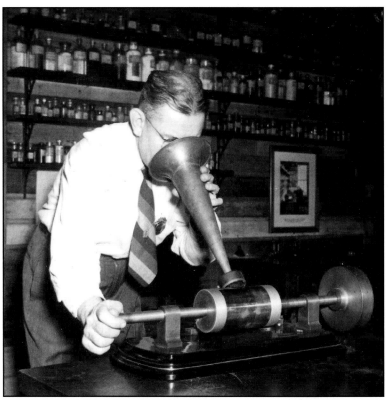

Acc. 00.1832.441. Neg. B.426.

Acc. 00.1832.441. Neg. B.428.

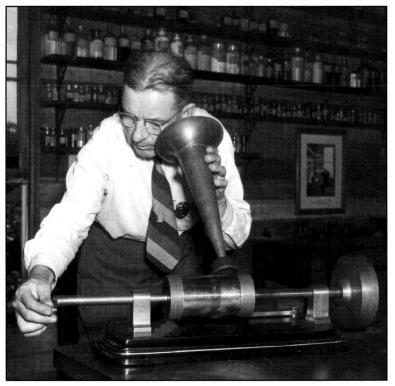

Edison's Water-Motor Phonograph

It was not until after 1900 that electric motors were used to turn the mechanisms of sound-recording devices at a constant speed. The device shown here was evidently an early experimental attempt by Thomas Edison to avoid the sound distortion produced as the cylinder of his phonograph was cranked by hand at uneven speeds. Manufactured by the North American Phonograph Company of New York City about 1890, this unusual and probably not very practical contraption operates by means of a stream of water under pressure. The water motor, which drives a main shaft to which the recording and reproducing mechanisms are connected by leather belts, consists of a paddlewheel with intake and outflow fittings and a valve to control the flow of water. A three-ball governor controls the speed at which the shaft rotates. The body of the phonograph, fourteen inches wide and mounted on a wooden base, is made of cast iron; the motor has steel parts.

The water-motor phonograph was given to the Henry Ford Museum soon after it opened. The donor is unknown, but the Cummins Engine Company of Columbus, Ohio, donated two similar devices to the museum in 1930.

Acc. 00.4.2244. Neg. B.111106.

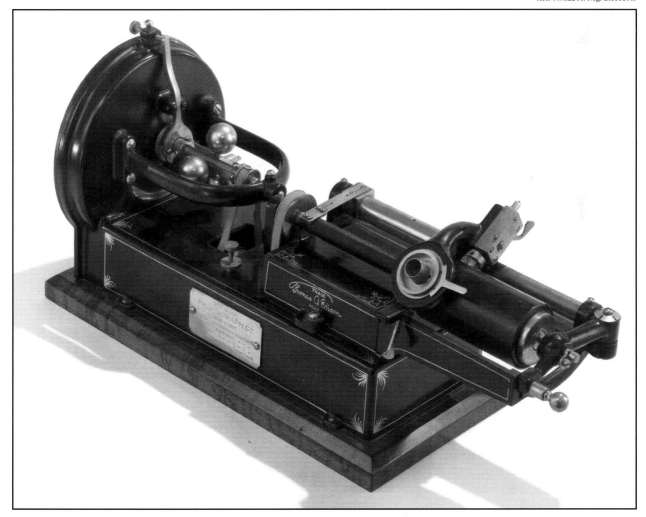

Edison's Excelsior Phonograph

Thomas A. Edison, Inc., of Orange, New Jersey, manufactured Excelsior phonographs from 1901 to 1908. Designed for use in public places, such as neighborhood taverns, the Excelsior was an early type of jukebox. When a patron inserted a nickel in the slot at the top of the case and wound the mechanism, the cylinder inside rotated and played a tune. It played the same tune until the proprietor unlocked the case, opened the hinged glass door, and changed the cylinder. Small enough to sit on a bar, the Excelsior no doubt competed with the proprietor's five-cent beers for the patrons' nickels. Jukeboxes began taking on a new dimension in 1926, when J.P. Seeburg, a Swedish-born American, invented an electric phonograph that offered a choice of eight records. The Excelsior shown here was part of the large collection that Thomas Edison gave to Henry Ford for his museum in 1929.

Acc. 29.460.100. Neg. B.99857.

Acc. 79.22.1. Neg. B.91832.

Edison's Triumph Phonograph

Thomas Edison's company in Orange, New Jersey, manufactured the Triumph, a hand-wound cylinder phonograph, about 1908. With its ornamental flourish and superb cylindrical mechanism, the Triumph is considered a benchmark in the history of recorded sound. The one shown here is a well-preserved example. Supported by an adjustable metal arm, its large "morning glory" horn is painted with colorful flowers, and its cylinder rests on an oak case fourteen inches wide. The Triumph accommodated a choice of either a two-minute or a four-minute cylinder recording. Arden W. Tiley of Detroit donated the phonograph to the Henry Ford Museum in 1979, together with some thirty cylinders.

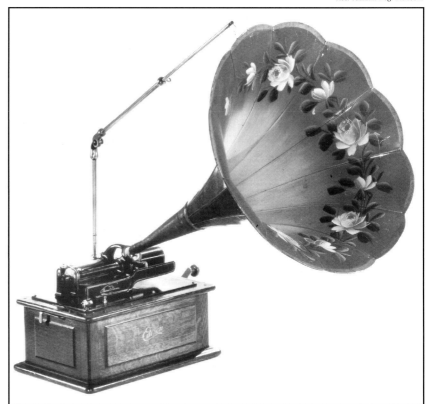

Mandolin Harp

Known as the "American Mandolin Harp, Special Niagara Model," this instrument—a type of zither—was made around 1900. Its sounding board is adorned with a romantic view of Niagara Falls enclosed in a small oval. Resting on its strings is a numbered and lettered push-button keyboard decorated with gold scrolls; the numbers and letters of the keys are printed below the strings at the front of the case. The case, about twenty inches long, has a border of gilt rope and red flowers painted on a black background. The opening in the center is surrounded by a decorative motif of scrolls, harps, mandolins, and ribbons. The Reverend Everett Bunck, pastor of the Immanuel Lutheran Church in Jackson, Michigan, donated the mandolin harp to the Henry Ford Museum in 1955.

Violano Virtuoso

The violano virtuoso is an automatic piano and violin that plays music encoded as a series of holes on a paper roll. Henry K. Sandell invented the violin-playing mechanism at the Mills Novelty Company in Chicago about 1905. The company, which owned the patent, added a player piano to the machine in time to have it displayed at the Alaska Yukon Pacific Exposition in Seattle in 1909. Introduced to the public in 1911, the violano virtuoso could be purchased as either a push-button or coin-operated model, and it soon became very popular. It was a familiar sight in American hotels, restaurants, ice cream parlors, and drug stores until about 1930, when Mills stopped producing it. Between 1926 and 1928, Mills also made a "double-violin" machine for large halls and other areas where more volume was needed.

Mills manufactured the "single-violin" model shown here in 1926. Sixty-five inches high, it is coin-operated and has a mahogany-veneered case. Patricia and Lyle Sexton of Almont, Michigan, donated the violano virtuoso to the Henry Ford Museum in 1972, together with eleven rolls of music.

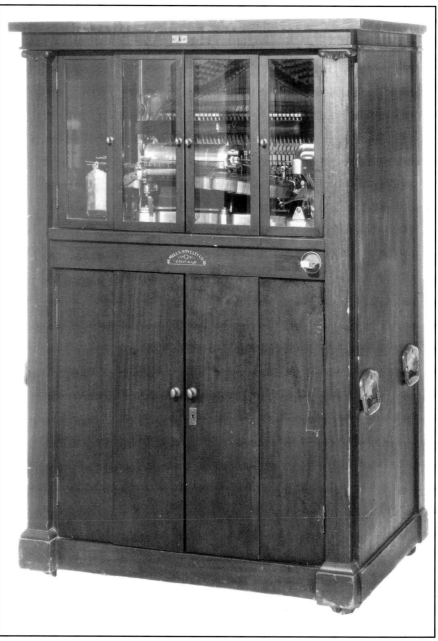

Acc. 72.2.7. Neg. B.77009.B.

Regina Music Box

The ancestor of the music b[?]
wooden barrel studded with wooden [?]
rotated, the pins set a chiming me[?]
Such devices—the first automatic m[?]
were used in the bell towers of Eu[?]
teenth century. Music boxes un[?]
development in the centuries that [?]
until the early years of the tw[?]

phonograph was starting to capture [?]
that they hit full stride. In the 1890s,
working to get the rasping sounds out
greatly improved mechanisms in music
oducing clear, bell-like tones. They were
tems. Music was specially written for them,
ple could not imagine that Edison's "talking
ith its inferior sound would ever supersede
them. As Edison struggled to perfect the phonograph, others made important improvements to music boxes. By about 1903, however, it was apparent that Edison would win the battle.

Among the best-known manufacturers of music boxes was the Regina Company of Rahway, New Jersey. By 1900 Regina was selling a music box that had superb sound as well as the novel feature of an automatic disk-changing mechanism. The Regina Company made the music box shown here about 1910. It is fifteen inches wide and played eleven-inch disks. The Regina Company also made much larger music boxes equipped with a penny slot for commercial use, but Edison's Excelsior phonographs soon proved a more popular type of "jukebox." After Regina stopped making music boxes, it then started manufacturing household items, including a well-known vacuum cleaner. Hadley Banta of Flint, Michigan, donated the Regina music box and thirteen disks to the Henry Ford Museum in 1976.

Calliope

The calliope, named after the Greek Muse of heroic poetry, is a distant cousin of the music box. It was invented in 1845 by a God-fearing man of Massachusetts, one J.D. Stoddard. Stoddard hoped that the instrument's piercing tones would summon people from the countryside into church on Sunday mornings. Though it failed in that role, the calliope became enormously popular—in a way that no doubt appalled Stoddard. Its steam-powered whistles sounded aboard Mississippi riverboats, in carnivals, and in circus parades. During the Civil War, calliopes aboard troop trains wheezed and shrilled out patriotic tunes as soldiers rode off to battle.

The Bode Wagon Works of Cincinnati made the horse-drawn calliope shown here for the John Robinson Circus of Peru, Indiana, in 1917. The John Robinson Circus used it for five years and then retired it because of its extraordinary weight. In 1925 Floyd King, manager of a number of circuses, bought it and four years later sold it to the Donaldson Lithographing Company. That company in turn sold it to the Thomas J. Nichol Company of Cincinnati, which donated it to the Henry Ford Museum in 1930.

Eighteen feet long and eight feet wide, the calliope has a red wooden body gaily decorated on both sides with gilded scrolls, swags of roses, and figures of cherubic children, a seal balancing a ball, and a woman playing a stringed instrument. Its wheels are painted red, white, and blue. The driver sat high in the front, and behind him sat the calliope player with his keyboard and whistles. At the rear is the vertical steam boiler that powered the whistles.

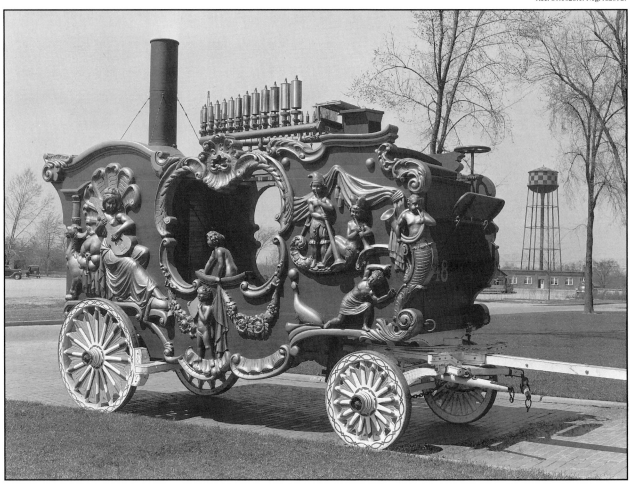

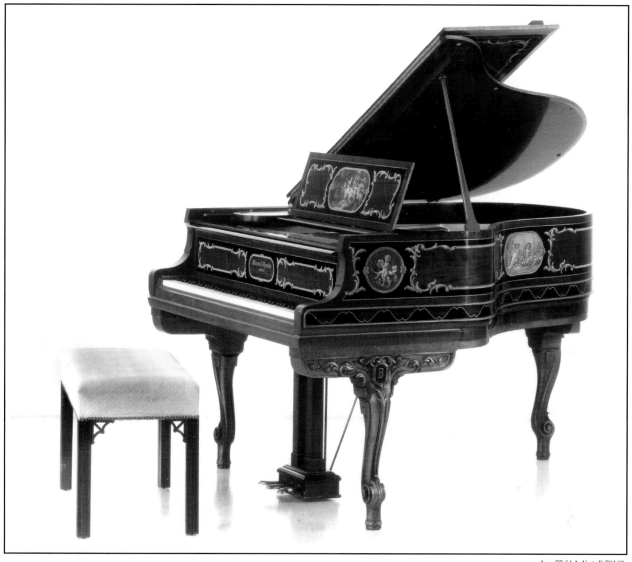

Mason & Hamlin Grand Piano

The Mason & Hamlin Company of Boston made this grand piano in 1927. The eighteenth-century, French-style paintings adorning it were added by its first owners, a wealthy Detroit family. The piano was originally equipped with an "Ampico," a device embedded in the piano that moved the keys and faithfully reproduced the music of the distinguished pianists who made recordings for it. According to Mason & Hamlin, the sound reproduction was so accurate that "with a player seated at the piano a listener cannot tell whether the instrument is being played by the player's hands or by means of the artist's Ampico recording." Among the advantages of the Ampico that the company stressed were that it brought "to its possessor a wealth of piano music as played by great artists, always available at a moment's notice for enjoyment and education," and that it could be used in schools and colleges "as an aid to teaching and for the cultivation of musical appreciation."

By 1977, when Simon D. Den Uyl of Grosse Pointe Farms, Michigan, donated the piano to the Henry Ford Musem, the Ampico mechanism had been removed. The piano is now often used in musical programs at the museum.

Theremin

The 1920s witnessed the invention of a number of electronic musical instruments based on "superheterodyning," a principle of sound reproduction used in radio transmission. The most successful of these instruments was the Theremin. Invented in the early 1920s by Leon Theremin, a Russian physicist, this device had two radio-frequency oscillators that generated clearly audible signals. One oscillator had a fixed frequency, and the other, a variable. The difference between these two frequencies resulted in a sound somewhat akin to the voice and the violin. It was a fixed tone, produced one note at a time, and could not be altered except by varying its pitch. By continuously changing the frequency of the variable oscillator, the Theremin player could not only vary the pitch but also create a melody. To do this, the player stood in front of the instrument and waved his or her right hand in the electromagnetic field of the vertical antenna. Movements of the left hand over the horizontal antenna jutting from the side of the Theremin served to alter the volume.

The art of Theremin playing required not only precision of movement but also physical stamina. When the instrument was well-played, however, the eerie sounds it produced—a fixed tone continuously altered by vibrato—seem to have had great appeal, at least for some people. When Leon Theremin gave a concert in Paris in 1927, the police had to be called to control the enthusiastic crowds, but when he introduced his invention at the Metropolitan Opera House in New York City later the same year, it met with a mixed reception. Conventional musicians were not enthralled with the inventor's idea of "controlling sound . . . by means other than mechanical, by the free movement of the hands in the air." Theremin later accommodated them by producing an instrument with a keyboard.

Despite its initial reception in the United States, the Theremin ultimately achieved a certain following. Avant-garde composers wrote music for it, and Hollywood directors used it to make soundtracks for such movies as *King Kong.* In 1929, as the Great Depression was about to lower the boom on the economy, Leon Theremin sold RCA Victor of New York City the right to manufacture his invention. But the times being what they were and the price tag being what it was—$500—RCA sold few

Acc. 68.62.4. Neg. B.50536.

Theremins, and most of these went to radio stations, which used them for special effects. Many years later, Robert Moog, who pioneered music synthesizers in the 1960s, introduced a transistorized version of the Theremin, which made a strange, whining music caused not by a waving of hands, but by the movement of a slider along a track. The Beach Boys used Moog's version of the Theremin to record their 1966 hit tune "Good Vibrations."

RCA manufactured the Theremin shown here about 1929. It was donated to the Henry Ford Museum in 1968 by Russell E. Cushing of Gibraltar, Michigan.

Hitter Violin

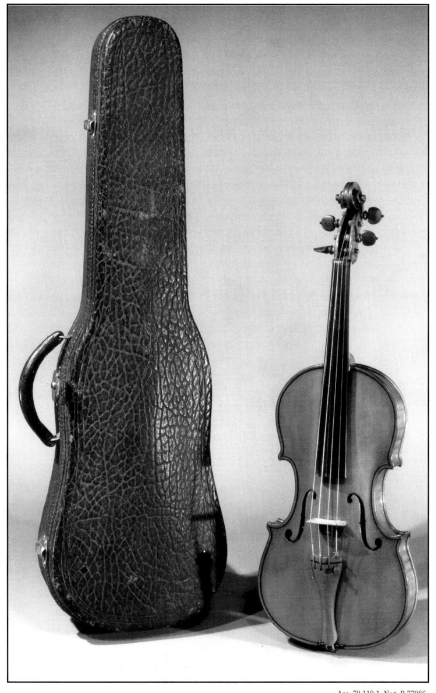

Acc. 79.119.1. Neg. B.77986.

In the early 1930s, Henry Ford engaged John Hitter to make and repair violins at his museum. Hitter, an immigrant from Europe who had taught himself the art of violin making after he arrived in the United States, remained on the job until 1948. He made the violin pictured here in 1935. It was one of a number of medium-quality violins that he made for students and some professional violinists.

Hitter's son William was an excellent violinist and often played for Henry Ford. While a student at the Edison Institute, Bruce Simpson, who donated this Hitter violin to the Henry Ford Museum in 1979, also frequently played the violin for Henry Ford. Years later, Simpson described one of those occasions: "One day as I finished playing for the Village School's chapel service, Mr. Ford asked me to get my violin. He gave me a lesson on how to change the bow's direction without making an unpleasant sound. I may be the only person in the world to get a violin lesson from Mr. Ford." Simpson later became a violinist with the Dearborn Symphony Orchestra.

CHAPTER 13
Photographic Equipment

A S A YOUNG MAN, Henry Ford took a great interest in the relatively new field of photography. He bought his first camera in 1893 when he was thirty years old—the same year he bought his first bicycle and three years before he built his first car, the Quadricyle. The Ford Archives are filled with pictures taken of and by the enthusiastic neophyte photographer. They show, among many other things, a proud, mustachioed, dark-haired Henry with his new bicycle; the Ford homestead as it was in 1896, years before Henry restored it; Clara Ford in all guises from a scarf covering her probably pinned-up hair to formal poses in her Sunday best; little Edsel from infancy into boyhood in shots that suggest a playful relationship between father and son; Clara's home and her mother, sisters, and brothers; hayrides with Dearborn friends and relatives; the exteriors of the many houses Henry and Clara occupied during the early years of their marriage; the extended Ford family on holidays and vacations; and the Brooklyn Bridge in 1896, thirteen years after it was built and the year a Brooklyn meeting of the Association of Edison Illuminating Companies brought Henry into contact with the Brooklyn Bridge and Thomas Edison for the first time. Henry took copious pictures on that momentous trip, including many of Edison and a rare one showing Charles Proteus Steinmetz in an environment other than his laboratory.

Henry was fifty when he bought his first motion picture camera. He had become intrigued with the notion that moving pictures might be of both educational and advertising value after a movie company had filmed production at his Highland Park plant during the summer of 1913. Henry bought the camera in September and used it for several months to record assembly operations at his plants, including Highland Park, which was then turning out about a thousand Model Ts a day. In April 1914, after receiving strong encouragement from Thomas Edison, Henry ordered his advertising department to create a motion picture department to produce films and distribute them. The venture was something of a gamble, since no other American company to that date had such a department. Yet no expense was spared.

By the autumn of 1914, the new department had facilities at least as good as those of any movie studio in the country. Its staff of twenty-four included six cameramen who traversed the globe in pursuit of their assignments. The department began by producing a ten- to fifteen-minute newsreel called the "Ford Animated Weekly." These newsreels were ultimately distributed, free of charge, to about two thousand cinemas on a regular basis. Viewed by some three million people each week, they showed current events, as well as topics relating to sports, nature, and travel. Although they betrayed their commercial origin only by subtitles imposed on the image of a Model T radiator, the newsreels were considered an advertising success.

The problem with news, of course, is that yesterday's news is no news; it fast becomes obsolete. In late 1916, Henry Ford asked his motion picture department to create a series of films of more enduring interest. The new series, called the "Ford Educational Weekly," covered history, travel, and geography, and, like the newsreels, had only the subtlest advertising content; reference to the Ford Motor Company was limited to the title frame. The educational series was tremendously successful. Films such as *Historical Boston, A Visit with Luther Burbank,* and *Petrified Forests of Arizona* proved as popular as the main features in the more than four thousand American cinemas where they were shown weekly and viewed by about five million people. They were also given foreign-language subtitles and distributed abroad. By 1918, when it was spending over $600,000 a year on film making and distribution, the Ford Motor Company had become the world's largest distributor of motion pictures.

The "Ford Educational Weekly" began losing its following in 1920, after the company started charging

theaters a dollar a week to show it, and by the end of 1921, the series had been scrubbed. Also contributing to its demise was the enmity aroused by Henry Ford's newspaper, the *Dearborn Independent,* which in May 1920 began publishing a series of anti-Semitic articles. Meanwhile, Ford's motion picture department had started producing the "Ford Educational Library," instructional films for students in grade school through college that were to be sold or rented to educational institutions. Although the department ultimately produced more than fifty of these films pertaining to such subjects as medicine, industry, physics, transportation, and agriculture, it was clear by 1923 that the series was not going to be a viable commercial venture. Far more successful from the point of view of Ford's executives and car dealers were the department's sales promotion films, which showed everything from Fordson tractors in use on the farm to the company's car-purchase plan and its mining, lumbering, railroading, and manufacturing operations. In rural areas especially, people flocked to wherever the films were being shown—the local dealer's showroom, a church, school, fraternal lodge, recreational hall, and sometimes even a prospective buyer's home.

In 1932, the same year he decided to retire from the aviation business, Henry Ford—with sales down and the country in the throes of the Great Depression—shut down his trend-setting motion picture department. Far from abandoning this venture, however, he continued to pursue it vigorously, hiring an outside firm the following year to take over film making and distribution. Until World War II, the only American company more active in this area was General Motors. In 1963 the Ford Motor Company gave the National Archives in Washington, D.C., the historic films its motion picture department had begun producing in 1914.

Reflecting Henry Ford's interest in photography, his museum and village house well over a hundred cameras and a dozen or more projectors. Not unexpectedly, many of the cameras were gifts of George Eastman, founder of the Eastman Kodak Company of Rochester, New York, who undoubtedly sold the Ford Motor Company miles of Kodak film. As the following pages indicate, Thomas Edison was another significant benefactor of this historic collection.

Daguerreotype Camera

The Frenchman Louis Jacques Daguerre was one of the great pioneers of still photography. In 1839 he perfected a process whereby an image was fixed on a copper plate. The plate was covered with silver, burnished to a mirrorlike appearance, and sensitized to light with iodine vapor. The photographer placed the plate in the camera at the focal point of the lens, and the lens then projected the image onto the plate. One problem with the so-called daguerreotype process was that it required a long exposure time, from fifteen to thirty minutes; hence, it was not suitable for photographing portraits. To develop the picture after removing the plate from the camera, the photographer exposed it to vapors from heated mercury. The image was set by immersing the plate in a bath of common salt.

Daguerre did not invent photography. Others, such as Nicéphore Niépce, Thomas Wedgwood, and Henry Fox Talbot, also contributed significantly to its development. Wedgwood, an Englishman, was the first to conceive of combining a camera and chemicals to make permanently fixed images, but he was unsuccessful in practice. In 1826 Niépce, who became Daguerre's partner, created a permanent photograph—the first person to do so. In England in the 1830s, Talbot developed the principle of the negative/positive process still in use today. And in 1841, two years after Daguerre perfected his process, Joseph Petzal of Vienna designed a lens that produced a sharp, well-defined image.

But Daguerre's process was the first practical method of photography, and it aroused enormous interest and enthusiasm. People were spellbound by his photographs. Painters and engravers, wondering how they could possibly compete with a process that produced images much faster than they could ever hope to, were in despair. Parisians, gripped by "daguerreotypomania," rushed out to buy Daguerre's instruction manual and equipment, and it was not long before even small villages had their own daguerreotype studios.

The daguerreotype camera shown here was made in Paris by J.C. Schiertz in the nineteenth century. It came to the Henry Ford Museum in 1936 after its owner, Philip O. Gravelle of Orange, New Jersey, wrote to Henry Ford, explaining that a friend had recently visited Greenfield Village and been intrigued by the Victorian-style studio in which C.H. Tremear took pictures of visitors with an antique camera. Recalling that Gravelle owned a very old daguerreotype camera, the friend had suggested it might be a good specimen for the Greenfield Village studio. Gravelle ultimately sent Ford not only the camera and tripod but also a number of silvered metal plates, holders to fix the plates while polishing them, a fuming box, and seven bottles of chemicals for processing the photographs. In his letter to Ford,

Acc. 36.392.1. Neg. C.876.

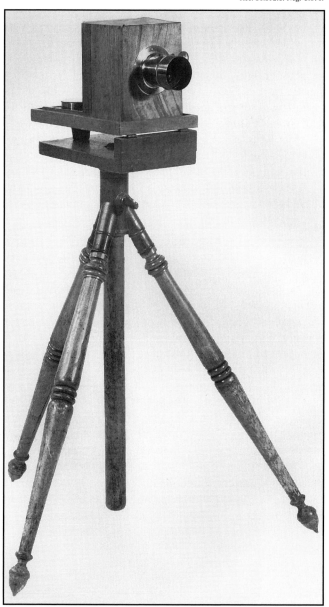

Gravelle noted that the camera "would attract more interest in your grand scheme of historical record than on exhibition in my little laboratory." A noted photomicrographer himself, Gravelle was the first to use a microscope to trace bullets to the guns that fired them. His pictures of magnified objects found favor not just with criminologists but also with a number of manufacturers, who used them both for improving their products and advertising them.

Tintype Camera

Hamilton Smith patented the tintype in the United States in 1856. Also called a ferrotype, the tintype is a positive photograph on a thin iron sheet coated with black enamel. It was made by a wet-plate process, a variation on the collodion process that Scott Archer, an English architect, had introduced in 1851. Best results were obtained if the photographer moistened the plate just before exposure and developed it immediately afterward. The tintype had a much shorter exposure time than the daguerreotype and therefore was suitable for portrait photography; the photographer could hand the subject the finished portrait within three minutes. Tintypes were very popular for many years, especially during the Civil War. Itinerant photographers—lugging with them their large tintype cameras, tripods, darkroom equipment, and tents that served as darkrooms—followed the armies around, taking portraits of soldiers, who sent the pictures home to their families. The soldiers also carried small tintypes of loved ones with them. Tintypes remained popular among street photographers until well into the twentieth century.

An American firm, B.F. & Company, made the tintype camera shown here about 1860. Its four lenses with brass casings were intended to provide sharper focus. Fourteen inches high, fifteen inches wide, and twenty-four inches deep, the camera has a wooden frame, a black cloth diaphragm, and a plate holder with a ground-glass screen. Eugene M. Lewis of Elmhurst, Illinois, a self-described "Box Brownie" photographer, donated the camera to the Henry Ford Museum in 1959. Lewis had inherited it from his father-in-law, a photographer who had apparently visited C.H. Tremear's studio in Greenfield Village with some regularity. Lewis's father-in-law had noted that the old tintype camera he had in the basement was in better shape than the one Tremear used to photograph village visitors. Remembering that, it occurred to Lewis, who was about to dispose of the camera, that it might be of interest to the museum and its visitors.

Acc. 59.57.13. Neg. B.23204.

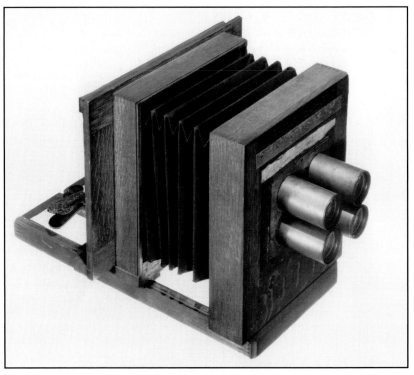

Giant Portrait Camera

Although the ranks of amateur photographers continued to grow after the Civil War, portrait photography remained largely the province of professionals—possibly because they, like the portrait artists they were displacing, had the means to improve on nature. Photographers of the Victorian era made liberal use of these means, brushing out wrinkles, obliterating warts, shortening or lengthening noses, and generally remaking the image to the subject's liking, if not in the subject's likeness. One instruction for nineteenth-century portrait photographers noted that the "retoucher may slice off, or curve the lady's waist after his own idea of shape and form and size." Another suggested that the photographer "correct with his brush defects which, if allowed to remain, spoil any picture. For instance, where a head is so irregular in form as to become unsightly, soften those features which are the most strikingly deformed, and reduce the head to a greater semblance of beauty. Try to discover what good points there are . . . and give these their full value."

Manufactured by an unknown firm, probably around 1875, this enormous portrait camera with its adjustable iron base is fully six feet tall. Its size is a testament to the days when enlarging paper was not available, and to get large prints, photographers had to make equally large negatives. The camera, which could produce eighteen-by-twenty-two-inch negatives, had been out of use for many years when Lorenzo P. Baker, owner of the Baker Art Gallery in Columbus, Ohio, offered it the Henry Ford Museum in 1945. Mindful that the camera "tells a story in the progress of photography," Baker did not want to destroy it, but neither did he have the room to store it.

In making the donation, Baker noted that his firm, founded by his grandfather in 1861, had used the camera to photograph several U.S. presidents and, in the late 1890s and early 1900s, many stage stars as well. The presidential figures so immortalized included Rutherford B. Hayes, Grover Cleveland, William McKinley, Theodore Roosevelt, William Howard Taft, and Warren G. Harding. Their terms of office spanned the years from 1877 to 1923.

Acc. 45.51.1. Neg. B.12617.

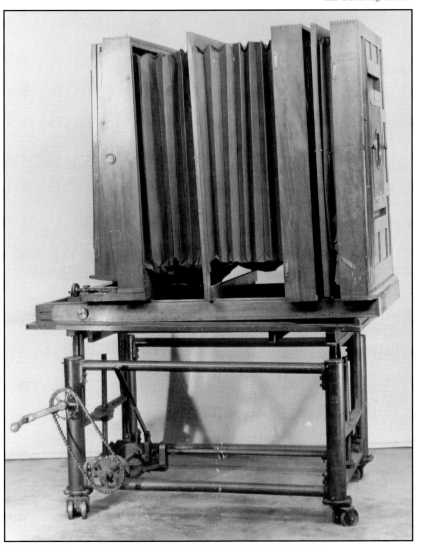

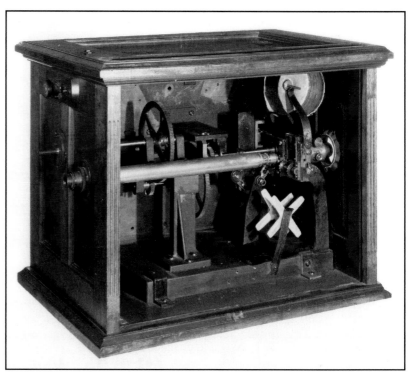

Acc. 29.460.89. Neg. B.19945.

Prototype of Edison's
Motion Picture Camera

About ten years after his invention of the phonograph in 1879, Thomas Edison became interested in the notion of supplementing recorded sounds with moving pictures. Linking sound with moving pictures was at the time a new idea, although moving pictures themselves were not. People had been experimenting with them in one guise or another ever since the invention of the magic lantern in 1654. With the development of still photography in the 1800s, the idea came closer to reality.

During the 1870s and early 1880s, two photographers, in particular, contributed to the development of moving pictures. In the United States, Eadweard Muybridge made hundreds of sequential photographs of men, women, and animals in motion and projected them with the zoopraxiscope, a machine newly invented by a Frenchman named Charles Reynaud. (Muybridge's sequential pictures of people, which included many in various states of undress, achieved quite a following among wealthy men of the day.) In 1874, using multiple cameras strung along a racetrack, Muybridge was able to demonstrate that a horse at full gallop lifts all four hooves off the ground—much to the delight of Leland Stanford,

governor of California, who had $25,000 riding on a bet that that would be the case and who had commissioned Muybridge to prove it. Around the same time in France, Étienne Jules Marey developed a "photographic gun" that could take twelve pictures per second of moving objects, such as birds in flight. Because Marey's use of fixed plates often resulted in overlapping of images, he began using flexible film instead, an innovation that facilitated the projection of sequences.

George Eastman of Rochester, New York, also made a very significant contribution to the development of motion pictures when he began marketing celluloid film in rolls in 1889. The roll of film, long enough to take a hundred pictures, initially came as part of a small Eastman camera. Fully loaded, the camera sold for twenty-five dollars. When all the film was used, the photographer sent the camera back to Eastman's factory, where workers reloaded it and developed and printed the film.

Flexible roll-film was a vital factor in enabling Thomas Edison to produce the world's first commercially successful motion picture camera and viewer. In 1888,

after acquiring some of Muybridge's plates, Edison set his research team to work on producing a camera that would use roll-film to take sequential pictures at high speed. The bulky device shown here is a prototype of the camera that Edison ultimately patented under the name *Kinetograph* (*kinesis* being the Greek word for "motion"). About two feet high and two feet deep, it is pictured with its interior exposed and its electric motor removed. Like Marey's camera, which Edison had seen while in Paris in 1889, it used flexible film. The film had perforated edges that passed over a sprocket inside the camera, thus allowing the film to move steadily through the camera and overcoming a problem that Marey had experienced. An electric motor drove the sprocket, as well as the shutter and take-up reel. The viewing eyepiece is at the left of the long tube, and the lens is to the right of the shutter mechanism. Because the focusing mechanism is inside the camera, the camera and subjects to be photographed had to be at relatively fixed distances from one another. The prototype motion picture camera was one of several hundred Edison artifacts that Thomas Edison and the Edison Pioneers gave to Henry Ford in 1929.

Prototype of Edison's Motion Picture Projector

Acc. 29.460.172. Neg. B.101681.

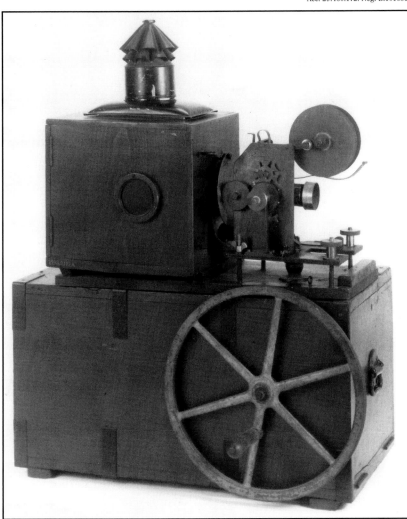

At the same time Edison's workers were developing a motion picture camera, they were also developing a means of viewing the film. Shown here is one of their early efforts. Dating from 1890, the prototype motion picture projector has a hand crank, an electric lamp on the interior, a magnifying lens, and a heavy iron wheel with a sprocket mechanism to accept the perforated edges of the celluloid film. As the operator turned the hand crank, the film wound past the lamp and magnifying lens at a more or less constant speed. Although later models had battery-powered motors that moved the film at up to forty-six frames per second—approximately three times the number needed to create the illusion of motion—the pictures still flickered so much that it is no wonder early movies became known as the "flickers." The prototype motion picture projector was another of the many items Thomas Edison and the Edison Pioneers gave to Henry Ford in 1929.

Edison's "Peephole" *Kinetoscope*

As it turned out, Edison's first commercially successful motion picture viewer, which he called the *Kinetoscope* (meaning "moving view"), did not project images on a screen. Rather, the top of the Kinetoscope had a peephole about the size of a silver dollar. In May 1891, Edison demonstrated his "latest novelty" for a group of women attending a luncheon party given by his wife. Peering through the peephole, the women were treated to a spectacle of animated, if flickering, images of a man bowing, smiling, and doffing his hat, while a phonograph played a recording of the man's voice—though not exactly in synchronization with his movements. Because other projects were demanding much of his time, Edison did not get around to marketing the first of his *Kinetoscopes* until 1894. By then, they were equipped with slots for coin-operation. The problem of accurately synchronizing sound with motion had proved insurmountable, so these machines were introduced to the public without sound—and the silent movie was born.

To produce films for the Kinetoscope, Edison created the world's first movie studio. Built in early 1893 at a cost of $638, the lightweight structure, completely covered with tar paper, contained little more than a stage and Edison's motion picture camera. It had a steeply pitched roof that could be raised like a skylight and was mounted on wheels so that it could be turned to catch the rays of the sun. Looking something like a police paddy wagon, it was called the "Black Maria."

Although the films produced in the "Black Maria" were very short and could be viewed by only one person at a time, they attracted a great following after first being shown to the public at a "peepshow parlor" in New York City in April 1894. By November, peepshow parlors had sprung up all over America and in European capitals as well. Edison ultimately sold nine hundred of his Kinetoscopes at prices ranging from $250 to $500, depending on what the market would bear. The peepshow parlors' clientele paid twenty-five cents a head for the thrill of watching ten to fifteen seconds of motion pictures; twenty-five cents was at the time a skilled worker's hourly wage. The films soon became as long as sixty seconds and featured exotic dancing, lion taming, tightrope walking, such celebrities as Buffalo Bill Cody and Annie Oakley, and a variety of other subjects. One

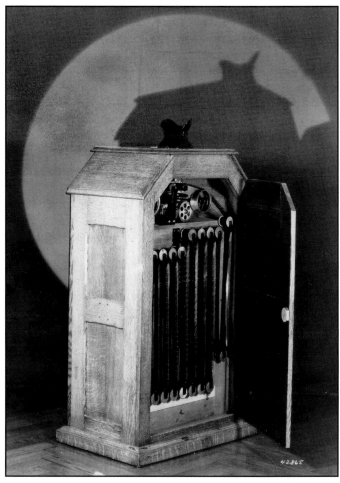

Acc. 36.753.1. Neg. A.5233.

film, entitled *The Blacksmith Shop,* evidently focused largely on beer drinking. Prizefighting, then conducted in bare-fisted fashion and outlawed in most of the United States, proved a particularly popular subject.

Edison must have been delighted as peepshow parlors quickly came into vogue in 1894, but the vogue did not last very long. By the spring of 1895, the initial curiosity and enthusiasm had started to dissipate. At the same time, other inventors—notably the Lumière brothers of France—were working to develop a projector that would throw images on a large screen so that many people could watch the film at the same time. With his Kinetoscope business booming, Edison dismissed this approach, believing he could sell more of his peephole viewers than he could large-scale projectors. In December 1895, the enthusiastic reception that a paying audience of Parisians accorded a film projected by the Lumière brothers' "Cinématographe" made it clear that Edison

would lose his bet on the Kinetoscope, and he soon turned his attention back to a motion picture projector.

The Kinetoscope shown here, which came to the Henry Ford Museum from William P. Curis of Port Hueneme, California, in 1936, was made about 1894. Forty-five inches high, its oak case is surmounted by a coin slot, a brass push button, and a raised, binocular viewing aperture of black metal. Inside the cabinet are the film-driving sprockets, illuminating optics, and long loops of film. Approximately fifty feet long, the film shows dancers clad in Middle Eastern garb.

Edison's Motion Picture Projector

Acc. 29.460.4. Neg. A.5396.

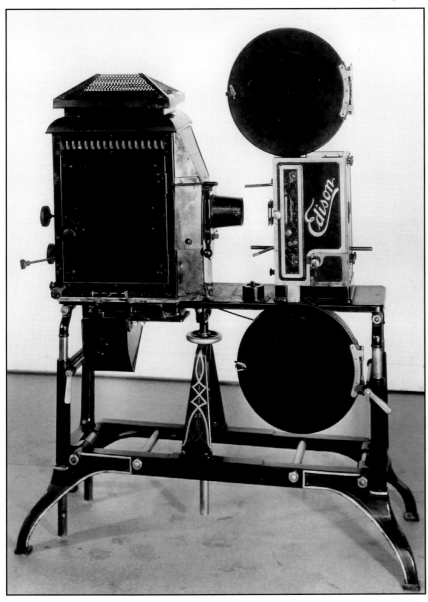

Edison manufactured this screen projector for motion pictures about 1905. As the name emblazoned in silver on the film-transfer box indicates, Edison was obviously no slouch at advertising. He constantly arranged demonstrations of his new devices, ran ads in newspapers and magazines, and also made certain that his name was conspicuously displayed on every one of his products, as it most certainly is here. Made of black metal and supported by an adjustable black iron stand decorated in red and gold, the "Super-Kinetoscope," as Edison called it, stands sixty-seven inches high. It was another of the gifts that Edison and the Edison Pioneers made to Henry Ford in 1929.

Aerial Camera

Hand-held cameras such as this were used in the open cockpits of early aircraft for surveillance. This one has a focal plane shutter made by the Folmer & Schwing Division of Eastman Kodak, probably around 1923. Its wooden case tapers toward the Zeiss Tessar lens, which has a haze-cutting filter, and extends beyond it to provide a sunscreen. A collapsible range finder sits on top of the case, and on each side is a handle large enough to be gripped by a person wearing heavy gloves. The handle on the right side of the camera has a metal lever that controls the shutter. The camera, thirteen inches wide at its broadest point, belonged to an aviation pioneer, John W. Pattison of Cincinnati.

Born in 1884, John Pattison was a member of the Early Birds, an organization of pilots who flew before 1916. Rejected for military duty in World War I because of illness, he went overseas as a volunteer ambulance driver. In 1920, just as the civil war between Red and White Russians was ending with the victorious Red Army reclaiming western territories, Pattison joined the Polish Army's flying corps and was commissioned a captain in the Kosciuszko Squadron. While in Poland, he served as a correspondent for the *Cincinnati Enquirer,* and in 1923, after returning to Cincinnati, he became that paper's aerial photographer. In 1959, after Pattison's death, his widow, Marie S. Pattison, donated his aerial camera to the Henry Ford Museum, together with his flying goggles, and helmet.

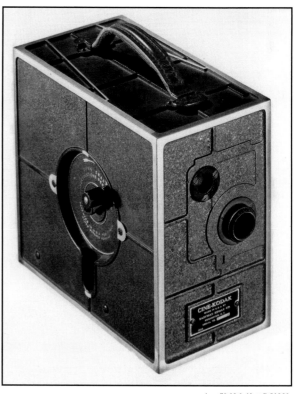

Portable Motion Picture Camera

Eastman Kodak announced its development of the portable motion picture camera shown here in the *Rochester Times Union* of January 9, 1923. Known as the Ciné-Kodak, Model A, it introduced Americans to home movies. These productions soon became the rage, enthralling the family members who participated in them and providing hours of boredom for many of the guests who had to watch them. Eastman Kodak produced the Model A from 1924 through 1929 and sold it originally at $125. A mere eight inches long and eight inches high, the hand-operated camera could be loaded in daylight with hundred-foot spools of sixteen-millimeter film. Helen H. Dunn of Birmingham, Michigan, donated the Ciné-Kodak to the Henry Ford Museum in 1959.

Spectrograph

Spectrographs are instruments that disperse radiation into a spectrum and that photograph or map the spectrum. The Bausch & Lomb Optical Company of Rochester, New York, built this spectrograph about 1930. It was specially designed to resolve the closely spaced lines in the ultraviolet spectrum of iron. Working under contract with the Ford Motor Company and Bethlehem Steel, the Department of Engineering Research at the University of Michigan used the spectrograph to develop a method of metal analysis based on optical emission spectra rather than traditional, wet chemical methods. The new method created a revolution in the analysis of iron and steel.

The method entailed using not only the spectrograph; the Department of Engineering Research also developed an electric spark generator and a microphotometer that measured spectral line densities on a photo-graphic plate. The electric spark vaporized and excited the metal or alloy, and a quartz prism dispersed the resulting emission of light so that it formed an atomic spectrum on an eleven-by-four-inch photographic plate. (The plate is visible in the photograph in front of the camera end of the six-foot-long spectrograph.) By measuring the blackness of individual element lines on the plate, it was possible to determine the quantity of each element in the metal or alloy. Although modern spectrometric devices use photomultiplier tubes rather than a photographic plate and a grating rather than a prism, these same optical principles still serve the entire metal industry.

The Ford Motor Company, which used this landmark instrument to analyze iron and steel at its Rouge plant for over forty years, presented it to the Henry Ford Museum in 1983.

Neg. 833.71240.H.

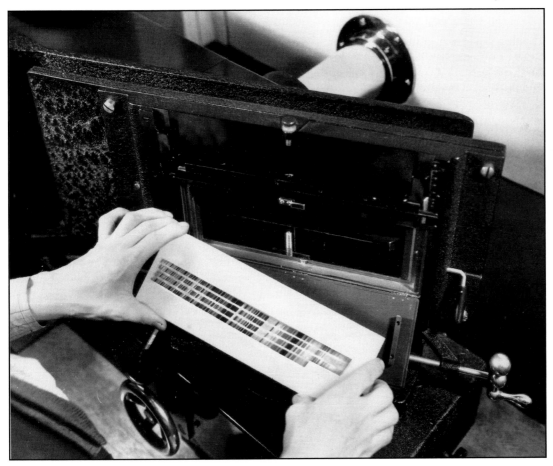

Photosensitive Glass Picture

In the early 1940s, S.D. Stookey of the Corning Glass Works of Corning, New York, developed a new photographic medium: photosensitive glass. When an ordinary photographic negative was laid over this glass and exposed first to ultraviolet light and later to heat, the result was a glass article that had a three-dimensional colored image embedded in it. The colored image was as long-lasting as the glass article itself.

The images in photosensitive glass could be produced in a variety of colors. The one shown here—a portrait of Dr. Otto Schott of the Schott Glass Works in Jena, Germany—appears in shades of blue throughout the one-quarter-inch thickness of the glass. It was produced with a photosensitive glass that contained gold. The gold was initially submicroscopic—that is, utterly invisible to the human eye—but after being subjected to ultraviolet light and heat, it turned a visible blue; the intensity of the blue varied with the intensity of the ultraviolet light.

Glass pictures containing gold were too expensive to compete with ordinary commercial photographs, and they are no longer made. A photosensitive glass containing silver, however, continues to be used, especially in architectural applications. A noteworthy but by now historic example is the United Nations Building in New York. Completed in 1952, the building is faced with hundreds of square feet of photosensitive glass whose silver content displays a marbled pattern.

Ford R. Bryan of Dearborn, Michigan, donated the glass picture of Dr. Schott, together with several other examples of colored images embedded in photosensitive glass, to the Henry Ford Museum in 1974.

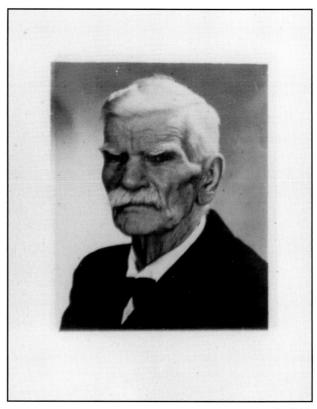

Acc. 74.1.1.

CHAPTER 14
Communications Equipment

FAX MACHINES, cellular phones, videophones, communication satellites, fiber-optic networks, and other manifestations of today's "telecommunications" are just the latest chapter in the very long history of people's efforts to convey messages over long distances. Even before the Great Wall of China was finished in the third century B.C., the Chinese were lighting bonfires along it to warn compatriots of impending attacks from barbarian tribes to the north. In similar fashion, the ancient Greeks and Romans used torches and mirrors to flash signals from hill to hill, and Amerindians used smoke signals.

In the early 1790s, a Frenchman named Claude Chappe introduced a new signaling system, which, like earlier ones, depended on the use of a code. Called a semaphore, it consisted of a series of towers, each with a pair of arms that could be placed in particular positions to spell out and relay messages from one tower to the next. Napoleon found Chappe's semaphore system an effective way of communicating with his far-flung generals during his conquest of Europe. One line of fourteen semaphore towers extended about 150 miles from Paris to the Rhine River; a message could be transmitted along it in just six minutes. In an additional fifteen minutes, the message could be conveyed along a line of towers between the Rhine and Berlin. The problem with Chappe's semaphore, as with earlier methods of long-distance communication, was that the signal was an optical one. Thus, when weather or other factors interfered with visibility, the system broke down.

Although Chappe coined the term *telegraph* to describe methods of long-distance communication, the electric telegraph, which overcame the visibility problem inherent in earlier communication systems, did not come into existence until the 1830s. Its invention had to await scientific proof of the long-suspected relationship between magnetism and electricity. The first scientist to recognize evidence of this relationship was the Danish physicist Hans Christian Oersted, who while giving a lecture in 1819 observed that an electric current in a wire caused a nearby compass needle to deflect. Some twelve years later, Michael Faraday in England and Joseph Henry in America almost simultaneously showed that when a wire is moved near a magnet or, conversely, when a magnet is moved near a wire, it produces an electric current. These discoveries led to the development of magnetic generators that produced powerful electric currents for use not only in communication but in lighting and transportation as well.

The first people to apply for a patent on an electric telegraph were two Englishmen, W.F. Cooke and Charles Wheatstone. Cooke had become interested in telegraphy while serving as a medical officer in the Indian army. After returning to civilian life in England, he had attempted to develop an electric telegraph system, but lacking the technical expertise needed, he had approached Wheatstone, a noted professor of physics in London, with the suggestion that they form a partnership to perfect and market such a system. After patenting their telegraph in 1837, they offered it to the British railway system, and by 1839 it was linking Liverpool with Manchester. Three years later, the telegraph enabled the police to arrest a murderer as, fresh from the scene of the crime in the suburbs, he alighted at London's Paddington Station—a sensational event that brought home to the British newspaper-reading public the utility of a telegraph system.

Meanwhile, Samuel Finley Breese Morse, a well-known American painter, had taken an interest in the new science of telegraphy. In 1832 he had visited France, where he had been impressed with the semaphore system. On the voyage home, a young scientist had explained to Morse that in an electromagnet, the magnet appears when the electric current is on and disappears when it is off. Reasoning that this phenomenon could be used in the transmission of long-distance messages, Morse enlisted the help of Joseph Henry, then America's leading scientist

and later the first secretary of the Smithsonian Institution, in developing an electromagnetic relay that could regenerate a signal every few miles, thus creating a long-distance link. Morse's system was inaugurated in May 1844, when the message "What hath God wrought" was sent by wire from Baltimore to Washington, D.C. Morse used a telegraph key—a switch that rapidly turns an electric current on and off—to transmit the message; the rhythmic interruptions of the current corresponded to the short dots and long dashes of Morse code. Although the code bears Morse's name, it was, in fact, invented by another of his collaborators, Alfred Vail, a mechanic with whom Morse went into partnership in 1838.

By 1848 a telegraph line was connecting New York with New Orleans, and by 1860 New York and San Francisco were linked by wire. Even before the transcontinental link was made, two abortive attempts had been made to lay an underwater telegraph cable between Ireland and Newfoundland. A third attempt succeeded in August 1858, an astounding accomplishment, given the technology then available—but a short-lived one. The cable broke after only three weeks of operation when a telegrapher, attempting to speed up transmission, subjected it to too high a voltage. With the support of the American financier Cyrus Field, who had backed the venture from the beginning (and who almost lost his fortune doing so), two further attempts were made using more sophisticated equipment, resulting in a successful transatlantic connection in 1866.

Just ten years later, Alexander Graham Bell patented his telephone, and it soon became evident that this more direct method of communication would eventually overtake coded telegraphy as the preferred means of long-distance communication. Bell's claim to having invented the telephone did not go unchallenged, for after the success of the telegraph, a number of other inventors had also produced telephone prototypes—some workable, some not. The term *telephone* itself was a word that Philip Reis, a German musician, coined for a device that he invented about 1861: a simple microphone that transmitted musical sound through electrical wires. Among the leading challengers to Bell's claim was the American inventor Elisha Gray. Gray, whose telephone closely resembled Bell's and was in some ways better, filed a patent for his device on February 14, 1876, just two hours after Bell filed his.

Born in Scotland in 1847, Bell was teaching phonetics at a school for the deaf in Boston when he began the experiments that led to his invention of the telephone. His inspiration for a device that could transmit speech through electrical wires had occurred years earlier, when a friend in London had demonstrated for him some of the experiments the German physicist Hermann Helmholtz had conducted on the nature of sound. Among these experiments was one that showed how electromagnets could be used to set up vibrations in metal tuning forks in such a way that they sounded like human voices. In Boston, Bell constructed a "musical telegraph" out of metal reeds and electromagnets; using different frequencies, it transmitted several messages simultaneously. After patenting his multiple-musical telegraph in 1875, Bell replaced its metal reeds with a diaphragm of metal. This device, he soon discovered, could reproduce any sound, including that of the human voice. One day, after he and his assistant Thomas A. Watson had strung wires down two flights of stairs to the ground floor of their building, Bell, working alone on the third floor, spilled some acid on his workbench and trousers. As he dabbed at the mess, he uttered into the experimental device the famous words, "Come here, Mr. Watson, I want you." An excited Watson instantly raced up the stairs with the news that he had heard every word distinctly.

In Bell's first telephones, transmitter and receiver were combined in one. To conduct a conversation, the user had to repeatedly shift the instrument from mouth to ear, an operation that required some agility, especially in a lively conversation; customers often bought the instruments in pairs. Another drawback of Bell's early telephone was that the transmitter's weak currents restricted transmission to only a few miles. In 1877, a year after Bell patented his telephone, Thomas Edison patented a carbon telephone transmitter that increased the volume of sound and extended transmission for hundreds of miles. Edison sold the rights to his invention to the Western Union Telegraph Company of New York City, which in 1878 formed a separate telephone company and, using Edison's transmitter and Elisha Gray's telephone, to which it had also acquired rights, began competing with the newly formed Bell Telephone Company of Boston. Meanwhile, Bell had armed for the impending contest by buying the rights to a transmitter that Emile Berliner, a German immigrant, had patented two weeks before Edison patented his.

The battle was brief but heated. Bell sued users of Edison's transmitter for infringing on Berliner's patent. Western Union sued Bell for infringing on Gray's patent, claiming that Gray was the rightful inventor of the telephone. In 1879, on the advise of its own lawyers, who could find no grounds for declaring Bell's patent invalid,

Western Union settled the case out of court and retired from the telephone business.

Meanwhile, Bell had begun leasing telephones to subscribers and linking up their lines through an exchange, a central switchboard to which all subscribers in a particular area were connected. The first telephone exchange, established in New Haven, Connecticut, in 1878, had just 21 subscribers. Very soon, however, other exchanges were creating a telephone network. By 1885 Boston and New York City had a telephone link, and Bell had 800 exchanges and 140,000 subscribers. In that year, the American Telephone and Telegraph Company (AT&T) was formed as a subsidiary of Bell to build and operate long-distance lines. The new company grew very rapidly and by 1899 had become the parent company of the Bell System.

AT&T established the first transcontinental telephone link in 1915. This feat required an improved means of amplification, which was supplied by the newly perfected vacuum tube; it also required the digging of countless postholes for the telephone poles. More insurmountable problems—including the need to install small repeating and amplifying stations every forty miles—delayed the laying of the first transatlantic telephone cable until 1956. Meanwhile, calls across the ocean were made by means of another remarkable invention of the late nineteenth century: the radio. AT&T inaugurated radiophone service between New York and London in 1927, but transmission left something to be desired. Even AT&T had to acknowledge in advertising the service that "static will at times cause breaks in the ether circuit."

The radio, first known as the "wireless" or "wireless telegraph," was invented in the 1890s. Like the telegraph, it could not have come into existence unless scientists had first identified particular physical phenomena. The radio operates by means of electromagnetic waves of various lengths that travel at the speed of light. The existence of such waves was postulated in 1862 by the Scotsman James Clerk Maxwell, probably the greatest theoretical physicist of the nineteenth century. Some twenty years later, Heinrich Hertz, a German physicist, not only proved the existence of radio waves but also measured them. Hertz built a spark generator to produce radio waves and a rudimentary detecting apparatus, or receiver, for picking them up again. He was able to determine that radio waves have properties quite different from those of light waves; for example, the longer radio waves—a foot to a yard long—could penetrate many materials that are opaque to light. Around 1890, the coherer, a more sensitive device for picking up radio

waves than Hertz's receiver, came into existence through the independent efforts of the English physicist Oliver Lodge and the French scientist Édouard Branley.

A number of inventors were soon experimenting with wireless telegraphs. Among those who built operable ones was Alexander Popov, the Russian inventor of the antenna. Although these efforts preceded Guglielmo Marconi's, Marconi is usually credited with—if not inventing the radio—at least ushering in the radio age. Lacking theoretical knowledge himself, the wealthy young Italian sought the advice of the physicist Augusto Righi as he put together his first wireless set in 1894. It included a spark transmitter powered by a generator, a coherer that indicated the presence of a signal by emitting clicks in a telephone earpiece, and—thanks to Popov's invention—an antenna.

Unlike Hertz and other scientists who could see no practical use for radio waves, Marconi was intent from the start on using them for communication. With his simple transmitter, he produced high-voltage electric sparks (the source of the radio waves) in short and long bursts corresponding to the dots and dashes of Morse code. In 1895, at the age of twenty-one, he succeeded in transmitting a signal a mile and a half—the length of his family's estate. Convinced he had a useful device, he tried to interest the Italian government in it, but receiving no support there, he moved to England, where in 1896 he patented his radio transmission system. The following year, with the help of one of his Irish mother's relatives, he founded the Wireless Telegraph and Signal Company. In 1899, after a freighter sinking off the coast of England used Marconi's wireless to send out a successful Morse signal for help—the first such distress call from the high seas—the new company received a flood of orders. It was in circumstances like these, where a telegraph could not relay a message, that the "wireless telegraph" proved its worth. The drama of such rescues also made great newspaper copy. For quite a while, many people believed that ship-to-shore communication was the ideal—if not the only—use for radio waves, but that was in the days before vacuum tubes enabled the radio to "talk."

Marconi continued to increase the power of his transmitter and to improve his antennas, gradually extending the range of his transmission, so that by 1901 he was able to triumphantly announce that his apparatus had sent a signal across the Atlantic Ocean from Cornwall, England, to Newfoundland. Even scientists were incredulous; in those days, little was known about the structure of the atmosphere—particularly the ionosphere off which Marconi's transatlantic signals

bounced—and the consensus was that the curvature of the earth would limit radio wave transmission to about 185 miles. When Thomas Edison was told about Marconi's feat, his blunt comment was, "I don't believe it." Marconi was awarded the Nobel Prize in physics in 1909.

The vacuum tube that provided the amplification needed for a transcontinental telephone link in 1915 was also an essential element in the development of the radio. It was, in fact, the element that allowed sound to be transmitted, and without it the wireless might have remained just another type of telegraph. In 1904 John Ambrose Fleming, an Englishman who had been a consultant to both Edison and Marconi, invented the first vacuum tube, a two-element affair designed to detect radio waves. In New York in 1906, Lee de Forest added a third element to Fleming's tube to produce a triode vacuum tube, a super-sensitive valve that generated, detected, and amplified radio waves. Although it took de Forest and other researchers several more years of work to develop it, when perfected, the triode vacuum tube provided the technology needed for clear transmission of the human voice, music, and other sounds.

By 1906 two Americans, Henry N.C. Dunwoody and G.W. Pickard, had independently discovered that a sharp needle point resting against certain types of crystals could act as a detector of radio waves—a discovery that soon permitted thousands of amateurs to build their own crystal radio sets. Lacking vacuum tubes, these early sets were not powerful enough to drive a loudspeaker, and the amateur operators therefore had to wear headphones. World War I provided the impetus for many improvements to transmitters and receivers, and with the introduction of these improvements and the vacuum tube, commercial broadcasting became possible. Broadcasts for the general public began in 1920, at which time some 60,000 homes had radios. Just two years later, that figure had risen to 2,750,000.

The enormous popularity of radio broadcasts inspired inventors to devise ways of transmitting pictures by wire, and thus began the age of television. Two of the pioneers in this field were C. Francis Jenkins of Washington, D.C., and John Logie Baird, a Scottish engineer. During the 1920s, both these men devised mechanical methods of scanning pictures, which they converted into electrical signals by means of photoelectric cells. The slowness of the mechanical scanning and the red glow of the neon tubes used in the receivers produced flickering, low-resolution images in shades of black and pink. The mechanical method was soon replaced by electronic scanning based on the cathode ray tube—a vacuum tube that converts electrical impulses into visible form by projecting an electron beam on a screen.

Vladimir Zworykin, a Russian emigré who persuaded RCA to allow him to work on transmitting pictures electronically, was a key figure in the development of electronic televison. In 1923 Zworykin applied for a patent on the Iconoscope, a fully electronic television camera tube, but he did not actually perfect the device until some ten years later. He was also the inventor of the Kinescope, an electronic television picture tube. Thanks in no small part to Zworykin, commercial televison had become a reality in the United States by 1939. It was not until after World War II, however, that television began replacing radio as a popular form of entertainment.

When the Ford Motor Company, under the direction of Henry Ford II, began sponsoring television shows in 1946, it was one of the first companies to do so. There is no evidence, however, that the founder of the Ford Motor Company ever took any interest in the new medium. Henry remained a devoted radio fan, tuning in every Sunday night he could to the "Amos 'n' Andy" program, until his death in 1947. He seems to have first become interested in radio in 1919. One September day that year, he buttonholed Fred L. Black, the business manager of Ford's newspaper, the *Dearborn Independent*. The conversation went like this:

"Say, Fred, what do you know about wireless?"

"I don't know anything, Mr. Ford. Just the stories published in the newspapers."

"Well, I think it would be a damned good time to learn. You make me one of these wireless receiving outfits."

Black later recalled that "Ford might as well have told me to make a rocket to go to the moon, for all I knew about wireless at that time." Nonetheless, make a wireless set Black did, and Henry soon had not only a chain of transmitting and receiving stations for intracompany communications but a small public broadcasting station as well. The latter, Station WWI in Dearborn, opened in 1922 and was on the air for an hour each Wednesday evening, broadcasting such fare as a talk on health or industrial materials, a story reading, and some music. In 1926, after Fred Black informed Henry that it would require the expenditure of $250,000 to make the station competitive with other local stations, Henry decided to close it down. He went on, however, to sponsor many programs on national radio and in 1934 launched the popular "Ford Sunday Evening Hour." The Ford hour, a musical program with a six-minute intermission talk by William J. Cameron, did not go off the air until January

1942, a month after the Japanese bombed Pearl Harbor.

Henry also made use of telegraphy. As early as 1917, the Ford Motor Company had a separate telegraph department that handled 800 to 900 wires a day. Henry did not, however, encourage the use of telephones. In an economy measure in 1920, noting that "only a comparatively few men in any organization need telephones," he had 60 percent of the telephone extensions in the company's offices removed and sold. Only executives, plant supervisors, and some foremen had them at their disposal. In noisy production areas, the telephone was equipped with an automobile horn rather than a bell so that it could be heard above the din. From this arrangement came the expression "you're on the horn," meaning "you are wanted on the phone."

Despite Henry's apparent disdain for telephones, the Henry Ford Museum has no fewer than 247 of them, as well as numerous pieces of telegraphic equipment, radios, and televisions. Together, these devices illustrate the remarkable progress in communication the world has witnessed from the 1830s to the present. The items described on the following pages are just a small sampling of this collection.

Edison's Printing Telegraph Transmitter

Not too long after the telegraph came into use, a number of inventors tried to devise an instrument that would automatically print the messages in letters. Such a machine would not only eliminate the need for an operator with a knowledge of Morse code but also speed transmission. David Hughes, an English-born Kentucky schoolteacher, invented such a telegraphic printer in 1856. He sold the American rights to his device to Cyrus Field's group of investors, who in 1857 began attempts to lay a transatlantic telegraph cable. Hughes's printer was used on overland telegraph lines between Newfoundland and New York during the three weeks in 1858 that the first transatlantic cable was in operation. Thereafter, however, it was relegated to use mainly on busy lines between large cities. Hughes eventually took his device to Europe, where it became quite popular.

Thomas Edison patented the printing telegraph transmitter shown here in 1872 and sold the rights to it to the Gold & Stock Telegraph Company of New York City. Murray & Company of Newark, New Jersey, manufactured the device. Edison was quite familiar with Gold & Stock, for it was while working there in 1870 that he developed the "Universal" stock ticker, the first invention that ever brought him any substantial amount of money. Later the same year, he used these earnings to build a factory in Newark, where he developed 106 of the 1,093 inventions that he ultimately patented, including the one shown here. It was the income from his invention of such telegraphic devices that enabled him to build his Menlo Park complex in 1876. The printing transmitter was among the many hundreds of items that Edison, together with the Edison Pioneers, the Association of Edison Illuminating Companies, and the Electrical Testing Laboratories, donated to Henry Ford in 1929.

Acc. 29.1980.1330. Neg. B.99256.

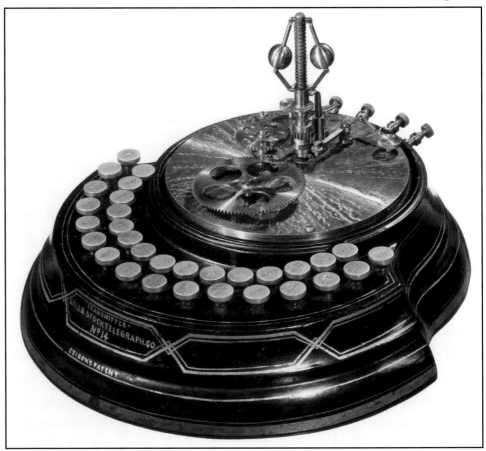

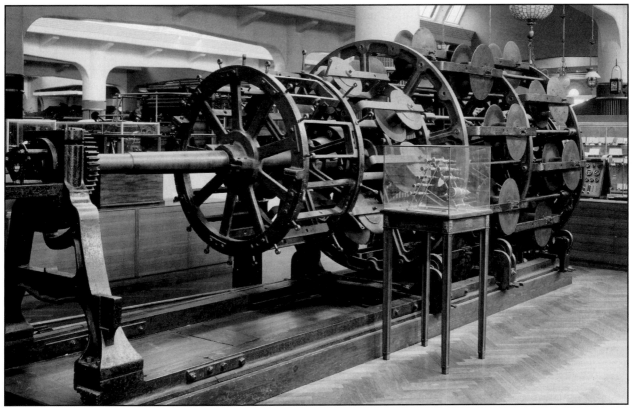

Cable Sheathing Machine

This cable sheathing machine was used aboard the *Great Eastern* in July 1866 in the fifth—and finally successful—attempt to lay a transatlantic telegraph cable. Built by Glass & Elliot of Greenwich, England, the machine was first used on land to fabricate the core of the cable out of iron wire and to twist around it copper conducting wire. On board the ship, as the cable was being paid out into the ocean, the machine coated it with galvanized steel for armor, gutta-percha for insulation, and jute for abrasion resistance.

On its two-week voyage in July 1866, the *Great Eastern* laid down a total of 1,866 miles of telegraph cable between Valentia, Ireland, and Heart's Content, Newfoundland. After completing the assignment on July 27, the ship returned to the place in the Atlantic where it had lost a piece of cable the previous year, retrieved it from beneath 3,000 meters of water, and connected it to the rest of the cable it had laid in 1865. Cyrus Field was thus able to announce to his fellow investors in the Atlantic Telegraph Company, which had backed the venture, that there were now not one but two transatlantic telegraph cables in working order.

Cable work seems to be one of the few things at which the *Great Eastern* ever succeeded. Driven by steam paddle engines, steam screw engines, and auxiliary sail, the ship—692 feet long, with a gross displacement of 22,500 tons and room for 4,000 passengers—was the largest afloat during the nineteenth century. Designed by the English naval architect Isambard K. Brunel, it was launched on the Thames in 1858—an undertaking that required special hydraulic machinery so expensive that it bankrupted the company that had financed the shipbuilding. After the *Great Eastern's* maiden voyage to New York in 1860, it soon became clear that the ship was not going to be profitable in the cargo and passenger service for which it was originally intended. After being successfully used to lay cable from 1865 until 1873, it met an inglorious end, serving in the early 1880s as a sort of floating exhibition and tawdry fair in various English harbors. While workers were dismantling the ship for

scrap in 1888, they found the skeleton of a man in the sealed double bottom of the vessel—the remains of a riveter who had gone missing while the ship was being built. Old salts pointed to this discovery as the explanation for the *Great Eastern*'s bad luck, for according to seafaring tradition, it is always unlucky to carry a corpse aboard ship.

After its service aboard the *Great Eastern,* the cable sheathing machine was put ashore in the United States and used by various factories in New Jersey and New York, finally ending up in the hands of the Anaconda Wire and Cable Company of Hastings-on-Hudson, New York. In 1930, after Anaconda had offered the historic machine to Henry Ford, an intermediary had to inform Ford's office that the delivery would be delayed because, owing to changes at Anaconda's plant, the machine—then about sixty-five years old—was temporarily in use. It arrived at the Henry Ford Museum in 1931, twenty-three feet long and six feet in diameter, with many fittings that were not original. The main structure, however, is the same that sheathed the first successful transatlantic telegraph cable on the deck of the *Great Eastern.*

Acc. 29.1980.1306. Neg. B.97463.

Edison's Printing Telegraph Receiver

In 1872, Thomas Edison patented this printer for receiving telegraphed messages, and the Gold & Stock Telegraph Company subsequently bought the rights to it. Edison & Unger of Newark, New Jersey—one of several companies Edison formed to manufacture his own inventions—produced it about 1873. Almost nine inches across, it has a cast iron base painted black with gold lettering and stripes, a spool of paper tape mounted on a bracket, and two type wheels—one with letters and one with numbers. It was another of the items that Edison, the Edison Pioneers, the Association of Edison Illuminating Companies, and the Electrical Testing Laboratories gave to Henry Ford in 1929.

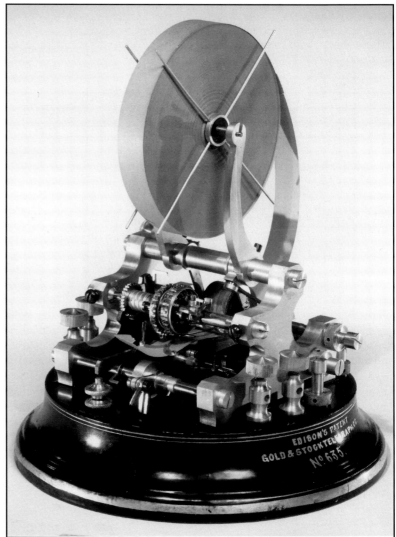

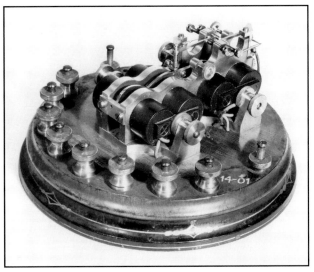

Edison's Quadruplex Telegraph: Compound Polarized Relay

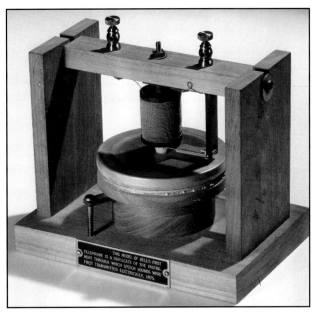

Replica of Bell's First Telephone

In 1874, at the age of twenty-seven, Thomas Edison developed the quadruplex telegraph, a complicated system of neutral and polarized relays, keys, sounders, condensers, and batteries. With this system, Edison solved a problem other inventors had long wrestled with: how to send multiple messages over the same wire at the same time. The quadruplex, which sent four messages simultaneously, two in each direction, was hailed as the most important advancement in telegraph communication since Morse's work and secured Edison's early reputation as a brilliant inventor. It is said to have saved some 50,000 miles of telegraph wire and millions of dollars in telegraph construction costs.

After Edison gave a successful demonstration of the quadruplex system between New York City and Albany, Jay Gould, one of America's notorious "robber barons," bought the rights to it for $30,000. At the time, Gould was seeking to gain control of the Western Union Telegraph Company, which was Edison's best customer for his telegraphic inventions. Gould's takeover succeeded in 1881. Western Union donated parts of Edison's quadruplex telegraph, including the compound polarized relay shown here, to the Henry Ford Museum about 1934.

This device, seven and a half inches wide, is an exact copy of the one into which, in 1875, Alexander Graham Bell summoned his assistant with the immortal words "Come here, Mr. Watson, I want you"—the first speech ever transmitted electrically. As Thomas A. Watson later remarked, "Perhaps if Mr. Bell had realized that he was about to make a bit of history, he would have been prepared with a more . . . interesting sentence." As it was, in the jubilation that followed Watson's announcement that he had distinctly heard the words over the "telephone" from two floors below, the reason for the summons—the acid Bell had dripped on workbench and trousers—was forgotten.

Called a "gallows" telephone because of the shape of its wooden frame, the replica was made by the Bell Telephone Laboratories in New York City and presented to the Henry Ford Museum by the Michigan Bell Telephone Company in 1936. Bell Labs, established in 1924 as a research facility for the companies of the Bell Telephone System, has been the site of some remarkable technological progress over the years, including work that contributed immeasurably to the development of the computer and other modern electronic devices.

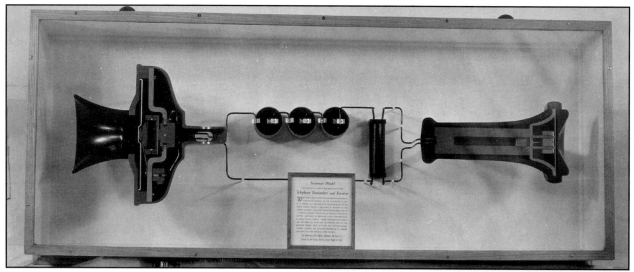

Sectional Model of a Telephone

Bell Telephone Laboratories built this sectional model in 1936 to illustrate how a telephone transmitter and receiver work. Michigan Bell donated it to the Henry Ford Museum the same year. The model is about three times the size of an actual phone, and its electrical system can be activated by moving a small lever beneath the glass case. On the case is a caption that reads:

> When the voice enters the transmitter mouthpiece, voice waves impinge on the diaphragm causing it to vibrate. Any movement of the diaphragm creates vibrations in pressure in the carbon chamber. Since the carbon offers resistance to a current flowing continuously through the transmitter, variations in pressure cause corresponding changes in the current. These variations of current are transmitted over the telephone line to the receiver where they activate the electromagnet causing the receiver diaphragm to vibrate and give out the original voice sound.

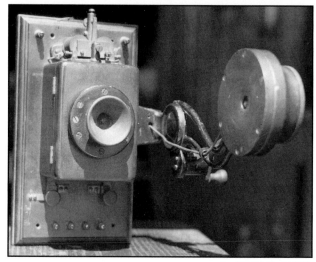

Edison's Carbon-Transmitter and Chalk-Receiver Telephone

In 1879, three years after Bell patented his telephone, Thomas Edison patented the device shown here. Its carbon transmitter (left)—basically, the same type still used in telephones—was far superior to the one Bell was using, but its chalk receiver (right) was not. The telephone user had to keep turning the crank beneath the receiver to get any sound from its rotating chalk disk. As a young man of twenty-three, George Bernard Shaw worked for the Edison Company in England promoting this device—an occupation that no doubt inspired him to take up other pursuits. The device was among the many relics of his Menlo Park complex that Thomas Edison gave to his old friend Henry Ford in 1929.

Telephone Switchboard

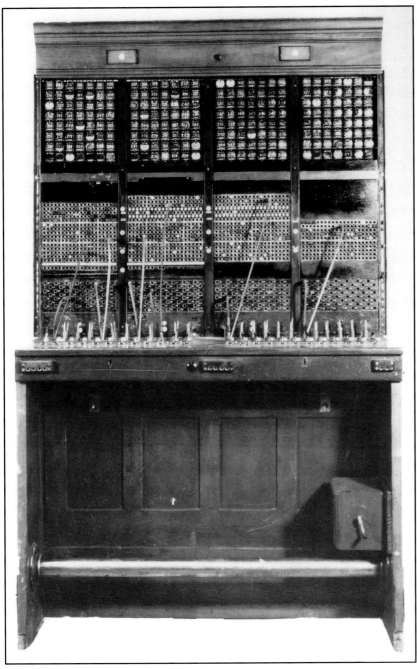

Acc. 41.140.5. Neg. B.66363.

In the early telephone exchanges, all connections were made manually by operators who plugged the calls in and out at switchboards much like this one. After 1892 manual switchboards began giving way to the automatic exchange, in which pulses from push buttons installed on the telephones were received by magnets that automated the switches; dial telephones soon replaced the push buttons. The automatic exchange was the creation of Almon B. Strowger, an undertaker in Kansas City. Strowger was inspired to devise this system because the wife of one of his competitors was a switchboard operator, and he suspected her of rerouting calls for his establishment to her husband's funeral parlor. The automatic exchange solved not only Strowger's problem but many others as well. The new and much faster system was eventually adopted by telephone companies around the world.

This particular manual switchboard was part of Detroit's main telephone exchange from 1892 until 1907, when it was replaced by an automatic exchange. It was then used until 1939 in Calumet in northern Michigan, where it was powered by electric batteries rather than a magneto. Six and a half feet wide, it accommodated two operators. Beneath the projecting desk top, which holds keys, plugs, and signal lights, is a metal rail on which the operators could rest their feet. The Michigan Bell Telephone Company donated the switchboard to the Henry Ford Museum in 1941.

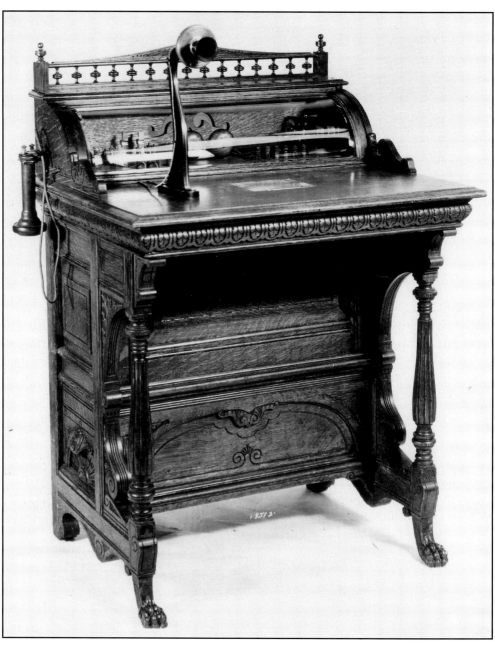

Acc. 36.147.32. Neg. A.4316

Telephone Desk Set

At AT&T's formal opening of the Boston-to-Chicago telephone line in 1893, William E. Russell, then governor of Massachusetts, used this ornate little desk set at AT&T's Boston office to place the first call. Not quite three feet wide, the desk has a gooseneck mouthpiece, a curved piece of glass covering the machinery at the rear, and a receiver hanging from one side. On the side of the desk not visible in the photograph is the hand crank for ringing the exchange. A silver plate on top of the desk commemorates the occasion on which the set was first used. The desk set was part of a collection of fifty historic telephonic items that the Michigan Bell Telephone Company donated to the Henry Ford Museum in 1936.

Acc. 68.2.3. Neg. B.48583.

Wireless Telegraph Key

The original Morse code for a distress signal was "CQD," standing for "Come Quick Danger." It was changed in 1909 to "SOS"—not as an abbreviation for "Save Our Souls," as it was sometimes interpreted—but because the three short dashes of the Morse *S* and the three long dashes of the *O* were so easy to recognize. On August 11, 1909, soon after the code was changed, the S.S. *Arapahoe*, southbound with passengers and freight, broke its main propeller shaft when twenty-one miles southeast of Cape Hatteras. With the ship drifting helplessly ahead of a gale toward the Hatteras shoals, T.D. Haubner, the *Arapahoe*'s wireless operator, used the telegraph key shown here to transmit the first SOS signal ever sent from a vessel in distress. Realizing that other operators might not be familiar with the new code, he alternated it with the CDQ call—a judgment that saved the ship. R.J. Vosburgh, wireless operator at Cape Hatteras, picked the signals out of a blanket of interference from Navy ships on manoeuvers in Hampton Roads, and the *Arapahoe* was rescued thirty-six hours after Haubner sent the first distress signal.

The telegraph key that Haubner used to send his historic signal was manufactured by J.H. Bunnell & Company of New York City. Five inches long overall, the instrument is made mainly of brass. The operator positioned the sending key by adjusting two screws on the oval base. The screws tightened against two pinions from opposite sides, allowing the key to move up and down freely within that setting. Haubner's widow, Dorothy S. Haubner of Upper Montclair, New Jersey, donated the telegraph key to the Henry Ford Museum in 1968, noting as she did so that she would like to have her late husband's "memory preserved in the only way I believe he would wish."

Acc. 36.157.106. Neg. 188.32910.

Wireless Spark Transmitter

The Wireless Specialty Apparatus Company made this device for ship-to-shore communication in 1917. About four feet high, it operated with two kilowatts of power at approximately 500 cycles. It is typical of the crude radio wave transmitters used before vacuum tubes were perfected. Such transmitters were generally noisy, and the high-voltage electric sparks they put into the air generated considerable ozone—a factor that today would make them illegal. The spark transmitter was one of more than a hundred items related to the history of radio that the RCA National Radio Museum of New York City donated to the Henry Ford Museum in 1936.

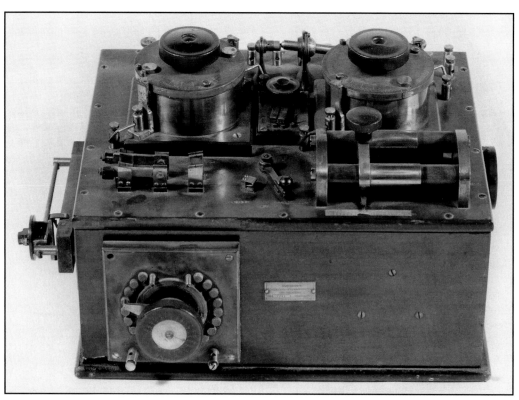

Marconi Wireless Receiver

This wireless telegraph receiver, eighteen inches long and about ten inches high, has dual crystal detectors of carbondum or cerusite and a Billi condenser—a type of low-capacity condenser with two brass tubes that varied the capacity. (The Billi condenser is at the right front of the receiver.) Marconi's U.S. affiliate, the Marconi Wireless Telegraph Company of America, manufactured the receiver in New York City about 1912. Very few such devices were ever produced, probably because they lagged behind the technology of the times, which was advancing at a frenetic pace.

Hampered by having much of its stock held abroad and by patent agreements with its British parent company, American Marconi was not a successful venture. In 1919 it agreed to sell its patents and stations to the newly formed Radio Corporation of America—RCA—which in the same year also took over General Electric's radio rights. In 1936 RCA National Radio Museum in New York presented the Marconi receiver to the Henry Ford Museum as a "permanent loan."

Replica of Home Wireless Set

In New York City in 1905, Hugo Gernsback, a native of Luxembourg, developed a small wireless set for home use and began marketing it under the name "Telimco Wireless Telegraph Outfit." It was the first time such a set had ever been offered to the public for sale, and the mail order house Gernsback set up to handle the sales was also a first in the wireless telegraph field. Gernsback initially sold the set, both transmitter and receiver, for $7.50, a very low figure even at that time. An advertisement that Gernsback ran in the *Scientific American* of January 13, 1906, stressed "unprecedented introduction prices." It also proclaimed that "the set will work up to 1 mile."

The photograph below shows an exact replica of the 1905 Telimco set as constructed by Gernsback himself for Henry Ford Museum in 1956. The transmitter on the right includes a box housing a spark coil which produces a spark between the two balls above the box. Each time the telegraph key beside the box is depressed, a spark passes between the balls radiating energy from the projecting aerial. Power is supplied by the three dry cells. The receiver (left) has an aerial to pick up the radio signal which activates a sensitive coherer which in turn triggers the door bell. The battery powered bell rings briefly on a "dot" signal and longer on a "dash."

In addition to marketing the first home wireless set, Hugo Gernsback also founded the first radio store in the United States. His interest in radio also led him into publishing when in 1908 he founded *Modern Electrics,* the first magazine devoted to radio; in 1913, *Electrical Experimenter;* in 1919, *Radio News;* and in 1929, *Radio Electronics.*

At age 72, Hugo Gernsback was invited to Dearborn on April 5, 1957, to present his replica to Henry Ford Museum, and to speak at a joint meeting of the Institute of Radio Engineers and the American Radio Relay League; his topic: "Fifty Years of Home Radio and the Electronic Future."

Acc. 57.8.1. Neg. B.20008.

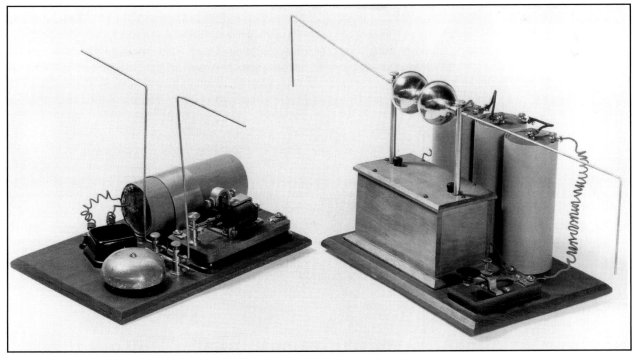
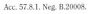

De Forest's "Singing Arc" Radio Transmitter

Missing the microphone that once hung from its front, this transmitter was one of the first that ever conveyed the sound of the human voice by "radiophone." Lee de Forest invented it in 1907, a year after he applied for a patent on the triode vacuum tube—the device that was to ensure his fame. De Forest did not immediately recognize the vacuum tube's full potential for sound transmission; his patent application for it described only a "device for amplifying weak currents." It was not until after 1912 that the vacuum tube saw any widespread use, and it was owing not only to de Forest's efforts that it did. Both H.D. Arnold at Bell Labs and Irving Langmuir at General Electric evacuated the vacuum tube to a degree that provided excellent sound-transmission properties.

The device shown here was a continuous wave voice transmitter that used an arc, known as the "singing arc," to generate the radio signal. The can on the back (in foreground of photo) contained alcohol that dripped into the arc chamber and ionized it. In late 1907, de Forest sold twenty-six "singing arc" radiophones to the U.S. Navy for use on a round-the-world cruise. They were apparently not very satisfactory, for neither the Navy nor Army ever bought any more. Lack of sales to the military helped bankrupt de Forest's company—just one of the lows in a career peppered with highs and lows and patent infringement lawsuits. During his lifetime, de Forest received more than 300 patents, the last for an automatic telephone dialing device that he invented at the age of eighty-four.

De Forest was a believer in the educational opportunity that radio broadcasting presented and deplored its commercialization. He once demanded of radio executives, "What have you gentlemen done with my child? The radio was conceived as a potent instrumentality for culture, fine music, the uplifting of America's mass intelligence. You have debased this child, sent him out in the streets in rags of ragtime, tatters of jive and boogie-woogie, to collect money from all and sundry." De Forest died in 1961. It would be interesting to hear what he might have had to say about the course taken by that other electronic marvel, television.

In 1940 the U.S. Navy gave the Henry Ford Museum about forty items related to the development of radio. De Forest's singing arc transmitter was among them.

Acc. 40.581.6. Neg. 188.48608.

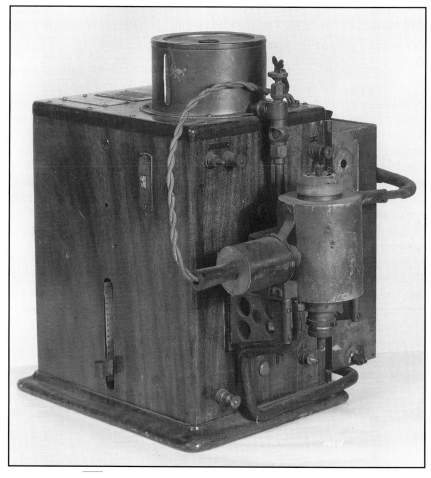

Acc. 36.557.1. Neg. A.4650.

Low Frequency Radio Receiver

This receiver, built in 1918, is representative of the kind of radio equipment that evolved during World War I. Twenty-three inches long and fifteen inches high, it has two built-in detectors—one, a vacuum tube, and the other, a crystal detector. Its frequency range was 30 to 300 kilocycles, as compared with today's range of 500 to 200,000 kilocycles, but it was the best that was then available. In December 1918, when President Woodrow Wilson sailed on the *U.S.S. George Washington* to the Peace Conference in France, the receiver was installed aboard the ship and used for his communications. Fred H. Schnell of Chicago, who donated the receiver to the Henry Ford Museum in 1936, was the radio operator. Schnell also reported that he used this receiver in Washington, D.C., to "copy the peace acceptance from Germany" in June 1919.

Acc. 30.1379.1. Neg. 188.32698.

Atwater Kent Radio Receiver

In 1921 Arthur Atwater Kent of Philadelphia, like thousands of other Americans, became "hooked" on radio. Unlike others, however, he was a well-known manufacturer of automotive products whose business was in something of a slump. Realizing he had all the equipment and technology needed to manufacture radio parts, including expertise in molding Bakelite—then a relatively new process—Kent in 1922 began making parts that amateurs could assemble into radio sets at home. It was quickly apparent, however, that people preferred buying complete sets, and in late 1922 Kent turned to this endeavor, with such success that by 1930 the Atwater Kent Manufacturing Company had the capacity to turn out 12,000 radio receivers a day.

The battery-operated radio receiver shown here was one of Atwater Kent's first models. Known as a "breadboard" set, it has two detector-amplifier vacuum tubes mounted on a wooden board eighteen inches long and eight inches wide. Lacking a loudspeaker, it required the listener to use headphones. The Atwater Kent Manufacturing Company of Philadelphia gave the receiver to the Henry Ford Museum in 1930.

Acc. 35.434.263. Neg. B.107875.

RCA Radio Receiver

Made in 1922 by the Westinghouse Electric Company of Camden, New Jersey, for RCA—under whose name it was distributed and sold—this "Radiola" receiver is an example of radio in its adolescence. Battery-operated, with vacuum tubes that emitted a visible glow, it came equipped with an antenna switch and headphones—all for the price of $49.50. For an extra $18.00, the buyer could have "volume from distant stations" by investing in a loudspeaker called a "Radiola Balanced Amplifier." McMurdo Silver of the Fada Radio and Electric Company of Long Island City, New York, donated the Radiola to the Henry Ford Museum in 1935, together with nearly three hundred other sets and parts dating from radio's earliest days.

Steinmetz's Portable Radio Receiver

Shortly before his death in 1923, Charles Proteus Steinmetz, the great electrical wizard of the early twentieth century, built this device in his laboratory at General Electric for one of the company's executives. It may well be the first "suitcase" radio ever made. The leather-covered case, containing a loadspeaker and batteries, is just twenty-one inches long, seven inches wide, and fifteen inches high. H.R. Wickes of Saginaw, Michigan, whose father had been a close friend of the GE executive for whom the portable receiver was made, donated it to the Henry Ford Museum in 1936. The gift was prompted by a visit Wickes had made to Greenfield Village, site of Charles Steinmetz's little cabin since 1930. Wickes's tour guide had been none other than Henry Ford himself.

Acc. 36.172.1. Neg. 188.32965.

"Majestic" Radio Console

By 1932, when the Grigsby-Grunow Company of Chicago built this console model, radio had come into its own—and into most American homes, occupying a niche as an entertainment center that was not challenged until television arrived after World War II. Grigsby-Grunow first began manufacturing "Majestics" in 1928. With their impressive console cabinets and powerful "dynamic" speakers—far more powerful than those of most competitors—they were expensive. Nonetheless, Grigsby-Grunow thrived. In 1929 the Majestic was the best-selling radio in America; the 1932 model shown here was the millionth one the company produced. In 1933, however, the Great Depression caught up with Grigsby-Grunow, and the company went into receivership. At about that time, Grigsby-Grunow gave its one-millionth Majestic to the Ford Motor Company, which in 1946 donated it to the Henry Ford Museum.

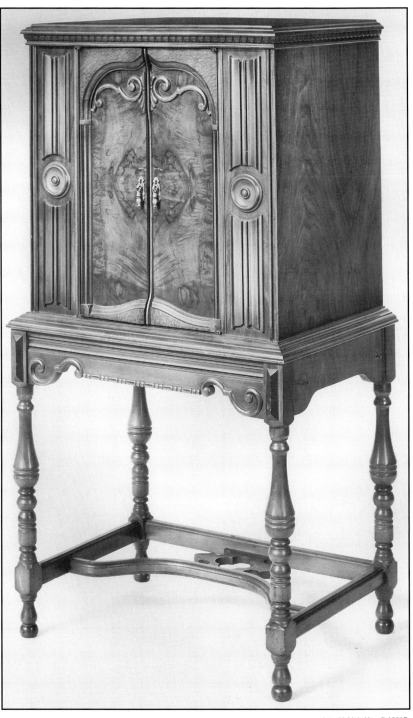

Acc. 46.84.1. Neg. B.13807.

High Altitude Shortwave Radio

The equipment shown here was used to communicate with a hydrogen-filled balloon, 175 feet tall, that took off from Ford Airport in Dearborn on October 23, 1934, and ascended almost eleven miles into the atmosphere. The ascent was part of a worldwide program initiated by Arthur Holly Compton, noted American scientist and winner of the 1927 Nobel Prize in physics, to measure the intensity of cosmic rays, which, it was thought, might offer a new source of energy. In the gondola of the balloon were Jean Piccard, who conducted the measurements, and his wife, Jeanette, who piloted the craft; in doing so, she became the first woman to take a balloon into the stratosphere. (Jean Piccard was the twin brother of Auguste Piccard, the Swiss physicist who became well-known for his record-breaking balloon ascensions in

Europe, as well as for his deep-sea explorations in the pressurized bathyscaphe he invented in 1948.)

The balloon reached its peak height somewhere over Lake Erie about two hours after takeoff. During the flight, the Piccards used a two-way shortwave radio to communicate with William K. Duckwitz, who built the shortwave equipment shown here. It was the first time radio communication had taken place at such heights. Duckwitz, who constructed the apparatus in collaboration with William O. Gassett, radio engineer and instructor at the Edison Institute Schools, donated it to the Henry Ford Museum in 1962.

Acc. 62.48.1. Neg. B.30715.

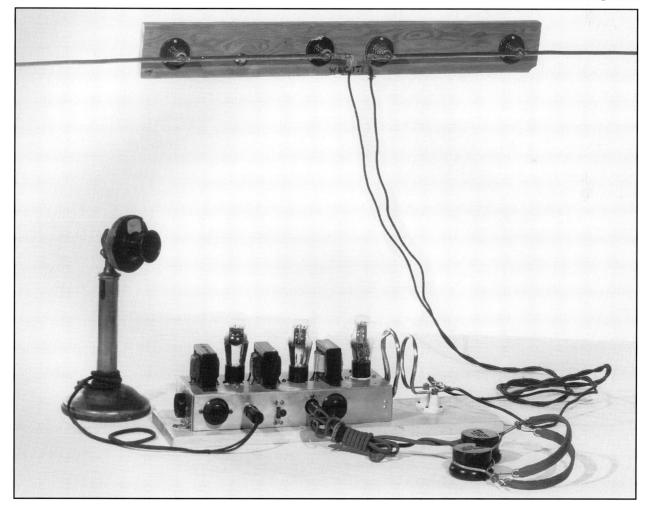

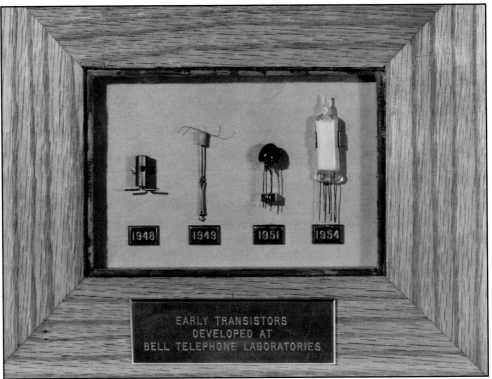

Early Transistors

The transistor was the harbinger of a revolution in electronics. Developed at the Bell Telephone Laboratories in Murray Hill, New Jersey, between 1942 and 1947, it soon replaced vacuum tubes not only in radios and televisions but in computers as well. John Bardeen, Walter H. Brattain, and William Shockley, the men responsible for creating the transistor, shared the 1956 Nobel Prize in physics for their work.

The vacuum tube, invented by J. Ambrose Fleming in 1904 and later perfected by Lee de Forest and others, was the outcome of a phenomenon Thomas Edison had observed in 1888: when he placed a wire between the legs of a filament in one of his evacuated electric bulbs, it acted as a valve to control the flow of current. In contrast to the vacuum tube, which relies on the flow of electrons through a vacuum to amplify, rectify, and switch electrical signals, the transistor relies on semiconducting elements, such as silicon or germanium, which allow electricity to pass through them only when the voltage exceeds a certain level.

The transistor's great advantages over the vacuum tube were that it was much smaller, far more energy-efficient, and produced much less heat. Because many transistors for different functions could be assembled on the same circuit board, radios and other electronic devices became much more compact. This was a particular advantage for computers, for as they became smaller, the electronic signals had a shorter distance to travel, and the machines therefore operated at faster speeds. Vastly reduced energy requirements and generation of less heat meant that transistors had a much longer life than vacuum tubes. In the gargantuan early computers, which often had as many as 20,000 vacuum tubes, this was a very real consideration, for the time spent in tracing the burned-out elements and replacing them meant that the computers were "down" more often than they were "up." During the 1960s, when the U.S. space program created the need for even smaller and more compact means of relaying electronic signals, transistors on printed circuit boards began giving way to integrated circuits etched on small silicon chips.

Bell Labs donated the transistors shown here to the Henry Ford Museum in 1959. They illustrate the transistor in various stages of development from 1948 to 1954.

Time-Recording Clock

An American named W.L. Bundy invented a time-recording clock in 1885. Companies that used Bundy's devices gave their employees numbered keys, which they inserted in the clock as they arrived for work. The clock then printed the time and key number on a paper tape. IBM's International Time Recording Division manufactured the device shown here in Endicott, New York, about 1915. The clock was in operation at the Shelby Division of Copperweld in Shelby, Ohio, until 1991.

Instead of using a key to punch in their employee numbers, Shelby employees used a rotating rod attached to the clock's twenty-seven-inch cast iron wheel. Mounted on an oak case, the wheel has holes numbered from 101 to 200. When the probe at the end of the rod entered the hole, it activated a recording mechanism inside the case, which then printed the time and employee number on a paper tape. Side doors on the cabinet provided access to the recording mechanism and the drum that held the paper tape. In 1992 the employees of the Shelby Division donated the time clock to the Henry Ford Museum.

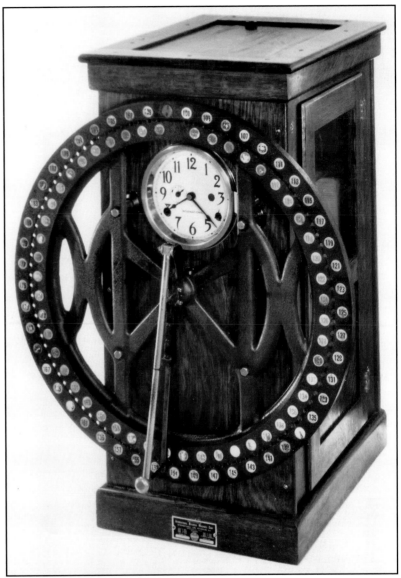

Acc. 92.45.1. Neg. B.109415.

National Cash Register

The National Cash Register Company of Dayton, Ohio, had it origins in 1878, when James J. Ritty, a Dayton saloonkeeper, took a vacation cruise aboard a steamship. A sometime mechanic, Ritty became intrigued by a piece of equipment in the ship's engine room that counted the revolutions of the vessel's propellers. Plagued in his present occupation by bartenders who could not keep their hands out of the till, Ritty decided he could make a similar device to register cash sales. This, he figured, would be a more accurate way of keeping track of bar sales than writing them down in pencil, and it might also discourage his pilfering bartenders.

In a room over his saloon in Dayton, Ritty and his brother John set to work building such a machine. The one that emerged, called "Ritty's Incorruptible Cashier," had pop-up indicator tabs, push-down keys, and a bell to signal the completion of a transaction, but it had neither a cash drawer nor a recording mechanism. In 1881, after selling a number of the machines, Ritty decided to go back to saloonkeeping full-time, and he sold his cash-register business to a local man who renamed it the National Manufacturing Company. Two years later, another Ohioan, John Patterson, acquired a controlling interest in the business for $6,500, and he renamed it the National Cash Register Company.

Patterson, an excellent merchandiser, proceeded to add many refinements to the "thief catcher," including an internal printing mechanism that kept a running tally of sales and also produced sales slips. One of the employees responsible for a number of improvements to the company's products was Charles Franklin Kettering—better known in later years as "Boss Ket" of General Motors. Kettering joined National Cash Register a few years after graduating from college in 1904. While there, he developed, among other things, the electrically operated cash register and one of the first accounting machines designed for use in banks. Kettering left to form his own company in 1909.

By 1910 the National Cash Register Company controlled 90 percent of the nation's market for cash registers—a situation that resulted in the Justice Department's filing an antitrust suit against Patterson. His sentence—a $5,000 fine and a year in jail—was dropped because of his actions during a flood that devastated Dayton in 1913. Patterson not only fed and housed the flood victims on his company's premises but also put his assembly line to work turning out rowboats at the rate of one every seven minutes.

The National Cash Register Company manufactured the machine shown here about 1914. Made of nickel-plated, ornately cast bronze, it has a heavy oak base containing a cash drawer and two pairs of windows on both the back and the front to show the type and amount of the sale. The highest amount it could register was $9.99. Patrick C. Springstead of Nemo's Restaurant in Dearborn, Michigan, donated the cash register to the Henry Ford Museum in 1980.

Acc. 80.129.1. Neg. B.88216.

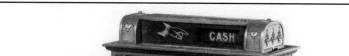

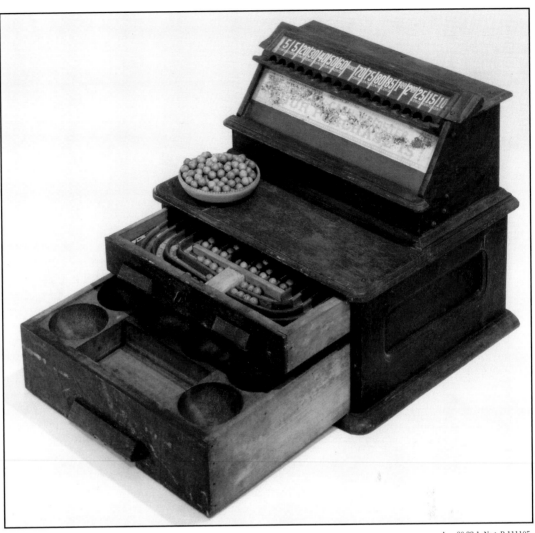

Simplex Cash Register

R.N. Shoemaker applied for a patent on the Simplex cash register in 1892, but it was not granted until 1895. The John M. Waddel Manufacturing Company of Greenfield, Ohio, made the model shown here about the time Shoemaker applied for the patent. The machine could register sales in different amounts, ranging from five cents to two dollars. These amounts were marked at the top of the machine, and beneath each amount was a hole. When making a sale, the clerk put a ceramic ball into the hole representing the particular amount, and a flag for that amount popped up in the glass window beneath the holes. When the clerk depressed a hidden lever, the cash drawer at the bottom opened, the flag disappeared, and the ball rolled down a chute into a drawer where the daily totals accumulated. By unlocking the drawer where the ceramic balls accumulated, the proprietor could see at a glance what sales amounted to.

The Simplex cash register is somewhat reminiscent of the ancient Chinese abacus used in counting and computing, in that the abacus has rows of balls representing different denominations. Lee Howard of Bay Harbor Islands, Florida, donated the Simplex machine to the Henry Ford Museum in 1980.

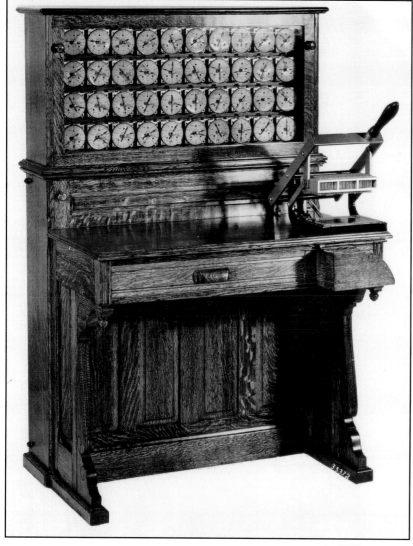

Hollerith Tabulator

In 1887 the U.S. Census Bureau realized it was facing a monumental problem. It had taken the bureau seven long years to finish tabulating the results of the 1880 census, and with immigration increasing and the nation's population skyrocketing, it seemed likely that the data from the 1890 census would not be tabulated before the 1900 census was due to begin. The bureau's solution was to sponsor a competition in which contestants submitted methods of accelerating the counting procedure. The winner was Herman Hollerith, who submitted the kind of machine pictured here. Resembling a small upright piano, the Hollerith Electric Tabulating System,

patented in 1889, was designed to count data that were recorded on cards as punched holes. The machine consists primarily of a press that closes contact points when the punched card is inserted and rows of dials that register the data from the card.

Using systems of punched cards to process data was not a new idea even in Hollerith's day. The British mathematician Charles Babbage had used such a system in the 1830s when he invented the prototype of today's computer, and he, in turn, had borrowed the idea from an automated weaving loom programmed by punched cards, which Joseph Jacquard had invented in France in 1801. Hollerith's invention nonetheless marks a milestone in the history of data processing (or, as it is more commonly called today, information processing), for Hollerith was the first to use electricity in this conjunction—and with astounding results. The Census Bureau was able to announce an unofficial count of the population just six weeks after the close of the 1890 census.

Recognizing the commercial potential of his invention, Hollerith left the Census Bureau and in 1896 founded the Tabulating Machine Company, which made equipment for computing and monitoring the schedules of freight trains. In 1911 Hollerith's company merged with three other small companies to become the Computing-Tabulating-Recording Company. Thomas J. Watson took over the management of that company in 1914 and ten years later reorganized it as the International Business Machines Corporation (IBM). In 1936 IBM donated the fully reconditioned Hollerith tabulator in the photograph to the Henry Ford Museum.

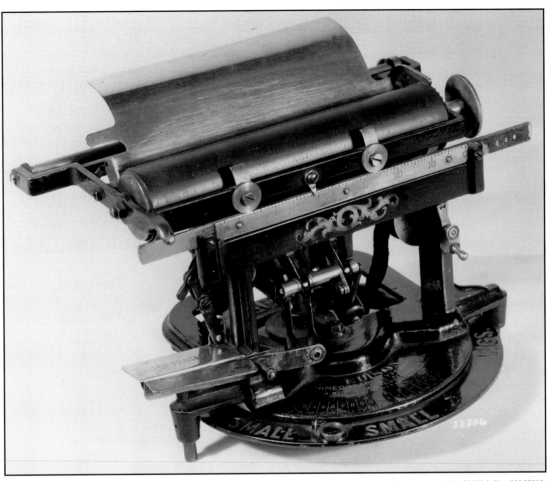

"Edison Mimeograph" Typewriter

Thomas Edison, who sometimes acted as a consultant to typewriter manufacturers, designed a number of typewriters, including the one shown here. A.B. Dick Company of Chicago, owner of the Mimeograph trademark, manufactured "Edison Mimeograph" typewriters from 1894 to 1900. Typing on them must have been a little tedious, for it took two hands to print one character. The ring around the base of the machine is marked with divisions of small letters, capital letters, numbers, and "characters" (i.e., punctuation marks, dollar signs, and the like). As the typist rotated the ring around the base with one hand, a small wheel under the platen rotated and put the type in position for printing.

Using the other hand, the typist pushed down on the handle at the bottom left, which caused the printing mechanism to push up against the platen. The handle was also used for spacing.

Max Sprague of Hannah, North Dakota, who had read that Henry Ford was "collecting American antiques," wrote to him on March 14, 1928, offering him the "Edison Type Writer No. 1" pictured here. Sprague added, "I have had a good many chances to dispose of it to typewriter Co's for adv. purposes but never did. Let me know if you would like to have it." It was recorded as a gift to Henry's museum on May 1, 1928.

World Typewriter

Inexpensive typewriters soon began giving the Remington a run for its money. In 1890 the World typewriter shown here was the cheapest on the market. It sold for $10, as compared with the Remington's price tag of $125. A more deluxe World model with seventy-seven characters was available for $15. For an extra $2, the buyer could have a walnut case. The World Type Indicator Company of Portland, Maine, patented the basic machine in 1886. Mounted on an oak base, it has a "keyboard" consisting of a semicircular index and one metal key.

In September 1935 Thomas H. James of Dexter, Michigan, where Henry Ford had one of his village industries, wrote to Henry saying, "If you would care to drive out some time in the next three or four days I will be pleased to give you for your museum either a circular tin bath tub about 100 years old together with some other relics and antiques from old Dexter House or a very old styled typewriter on a wooden base & metal keys. I don't believe you have any such relics and antiques now in your museum at Dearborn." Evidently, either Henry or someone from the museum did soon drive out to Dexter, for the typewriter, shown here, was recorded as a gift to the museum in November 1935. James also sold the museum two metal coffins for $25 on this occasion.

Acc. 35.633.1. Neg. C.4038.

Remington Typewriter

After patenting a page-numbering machine in 1866, Christopher Latham Sholes, a printer and newspaper editor in Milwaukee, Wisconsin, began developing the world's first practical typewriter. With the help of two friends, Samuel W. Soulé and Carlos Glidden, Sholes patented a workable model in 1868 and an improved one in 1871. But it still had a long way to go before it would be commercially practical, and Soulé and Glidden lost interest in the project. Sholes did not. He journeyed to Newark to enlist Thomas Edison's help, who was interested in it because of its applicability to printing telegraph transmitters. After tinkering with the device, Edison wrote, "This typewriter proved a difficult thing. The alignment of the letters was awful. One letter would be a sixteenth of an inch above the others; and all the letters wanted to wander out of line."

Acc. 00.711.10. Neg. B.53307.

After Edison finished his work on the typewriter, several were built by hand and used in the office of the Automatic Telegraph Company. But Edison took the project no further, which he may have lived to regret. After many improvements, Sholes's typewriter was put on the market in 1874 by E. Remington & Sons of Ilion, New York, a well-known gun manufacturer which after the Civil War also began producing, among other things, sewing machines and agricultural implements. One of the improvements made before the typewriter went on the market was a repositioning of the letters on the keyboard. Sholes originally had them in alphabetical order, but with that arrangement, the most frequently tapped keys were not always the most accessible, and they also often jammed. The order that was finally decided on was a scattering of the most-often used vowels and consonants *(a, e, i, o, n, t)* around the keyboard to slow typing speed and thereby reduce the possibility of the keys colliding. It is still in use today.

Typewriters initially met with a good deal of resistance. They were, for one thing, expensive; the Remington, for example, cost $125, whereas a pen nib cost a penny. It was not until the 1890s that the typewriter actually caught on as a machine for use in business offices. As early as 1878, however, a few large firms were using typewriters, and three years later, the Young Women's Christian Association in New York announced its plan to offer a six-month course in typing. Businessmen were appalled at this proposed female incursion into their domain, calling it "an obvious error in judgement" on the part of "well-meaning, but misguided ladies." Nonetheless, six months later, six trained female typists graduated from the YWCA's Ballard School and started their assault on the masculine bastion of business. Christopher Sholes was quite proud of the social effects of his invention, telling his daughter, "I do feel that I have done something for the women who have always had to work so hard. This will enable them to more easily earn a living."

The Remington desk typewriter shown here, manufactured sometime between 1874 and 1876, has an enclosed case, wooden key levers, a large wooden platen, and a ribbon wound on wooden spools as wide as the platen. The keyboard is similar to those in use today, but the machine, like all early typewriters, printed only capital letters. The Remington Rand Laboratories of Ilion gave the typewriter to Henry Ford. The date of the gift was not recorded.

corresponding to the formation of the letters. As you write, the needle is projected into the paper at the rate of about 8,000 punctures a minute, forming a perfect autographic paper stencil.

The stencil is then secured in a frame or press, a felt roller saturated with printer's ink is passed over the face of the stencil, and the perforations become filled with ink, which is deposited upon the paper underneath. From 1,000 to 15,000 copies can be taken from one stencil prepared with this pen.

In 1887 the A.B. Dick Company of Chicago, manufacturers of duplicating equipment under the trade mark *Mimeograph*, acquired Edison's two principal patents on the electric pen and began manufacturing and distributing the "Edison Mimeograph." Selling for about $25, it was a forerunner of twentieth-century stencil duplicating machines.

The Ford Motor Company gave the electric pen in the photograph to the Henry Ford Museum in 1930. It is a copy of an original one that was owned by C. Goodwin of Bristol, England. The museum also has an original, which Thomas Edison and the Edison Pioneers gave to Henry Ford in 1929.

Hall Typographic Machine

In England in 1714, Queen Anne granted a patent for an "artificial machine or method for the impressing or transcribing of letters, singly or progressively, one after another as in writing, whereby all writings whatsoever may be embossed on paper or parchment so neat and exact as not to be distinguished from print." Although the inventor evidently had great expectations that such a device would discourage forgers of political documents—the chief reason the idea appealed to the queen—nothing much seems to have come of it.

It was not until the 1800s that Americans took the idea of a "writing machine" a few steps further. William Burt of Detroit received a patent signed by President Andrew Jackson in 1829 for a "typographer," a table-sized machine that never got into production. In 1843 Charles Thurber of Worcester, Massachusetts, patented a typewriter with the kind of roller-platen that was later universally adopted, but it, too, never got into production. The "Hall typographic machine" shown here is another American effort at a typewriter—one of approximately fifty such efforts before 1865.

Thomas Hall patented the device in 1861, and the National Typewriter Company of Boston manufactured it. The solidly built machine in its strong wooden case was intended as a portable model. It has a square keyboard at the right with a cardboard chart just above it to indicate the position of each character. Though the machine might have printed clearly, it could not have been too speedy. To print each character, the "typist" had to depress a hand lever. L.J. Egelston of the Rutland Business College of Rutland, Vermont, sent this historic machine to Henry Ford in 1928.

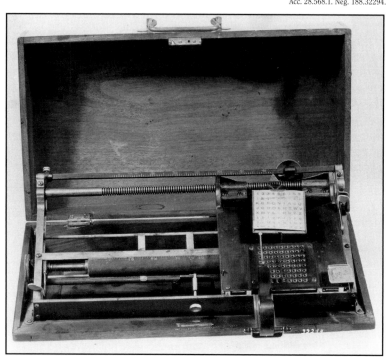

Acc. 28.568.1. Neg. 188.32294.

Edison's Electric Pen:
An Early Duplicating Machine

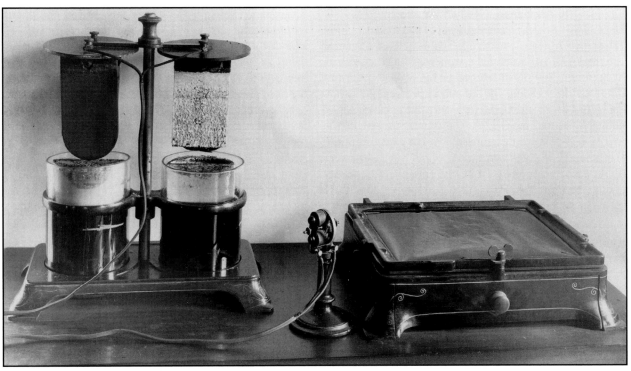

Thomas Edison invented the electric pen in the fall of 1875, shortly before moving to Menlo Park, where he patented the device and manufactured it. Electric pens were evidently a great success, especially in business offices; at one time, over 60,000 of them were in use worldwide. Before they came on the market, businesses had to have material copied by printers and lithographers, usually at considerable expense. The electric pen was powered by a small electric motor that drew its current from a wet battery of two cells; the electric motor is reputed to be the first one that ever sold in large numbers. Edison demonstrated his electric pen for the press in 1878, and a *New York Sun* reporter who attended gave the following description:

A wire is attached to the pen [in the wooden holder shown in the photograph] or stencil, and while a person is writing, a steady stream of electricity perforates the paper, making almost invisible little holes

Stock Ticker

Thomas Edison patented his first invention in 1869 while working as a telegrapher at the Western Union Telegraph Company in Boston. The device, an electrical vote recorder, was a decided commercial flop. Legislators in Washington, Edison learned to his dismay, were not interested in speeding up the voting process; filibusters and other delays in voting were time-honored means of killing unwanted legislation. The experience taught the twenty-two-year-old Edison a lesson. His next invention, also patented in 1869, was one for which there was a sure market: a stock ticker used in brokers' offices to deliver quotations from stock exchanges. Functioning much like

Acc. 86.25.11. Neg. B.101250.

a printing telegraph, the device printed the quotations automatically on a roll of paper tape. Although an inventor named E.A. Callahan had introduced a stock ticker in New York two years earlier, Edison's was a vast improvement, simplifying the circuitry and eliminating the need for an operator at the receiving end. A telegraph company quickly bought the patent rights to Edison's first stock ticker, but he had to share the proceeds with the people who had backed him in the venture, and he realized little from it.

After resigning from his job in Boston, Edison arrived in New York later in 1869, poor and in debt. He took a job with the Laws Gold Reporting Telegraph Company, very soon to become the Gold & Stock Telegraph Company. The firm used telegraphic apparatus to supply brokers with up-to-the-minute quotations on the price of gold—a commodity of more interest than paper money in the post–Civil War Years. While working there and, later, in partnership with Franklin L. Pope, former electrical engineer at the Laws firm, Edison patented two improved tickers, one for gold and stock and the other for gold and sterling.

Edison's partnership with Pope was amicable but short-lived, and after it ended, he accepted an invitation to join the technical staff of the Gold & Stock Telegraph Company, now an affiliate of the Western Union Telegraph Company. Within a few weeks, he had developed the "Universal" stock ticker, a more compact and dependable machine than his earlier models. Company officials were so impressed they paid an incredulous Edison $40,000 for the rights to it; Edison had quietly been hoping for $5,000. With the money, he opened a small laboratory and factory in Newark, New Jersey, in 1870. As his business prospered, Edison was forced time and again to move to larger quarters in Newark, and finally, in 1876, he built his laboratory complex at Menlo Park.

The stock ticker shown here, based on Edison's "Universal" patent, was manufactured about 1880 by J.H. Bunnell & Company of New York City for Western Union. It has one print wheel with numbers and another with letters; a ratchet and escapement mechanism moved the roll of paper tape forward. With its glass cover, the device is about thirteen inches high. It could print up to forty words per minute. The American Telephone and Telegraph Corporation of Skokie, Illinois, donated the stock ticker to the Edison Institute in 1986, together with twenty-two similar items.

within the Ford company, and Liebold was for a long while certainly one of them. Controlling access to Henry, he achieved a certain omnipotence.

In his 1922 autobiography, Henry proudly declared that his company had "no organization, no specific duties attaching to any position, no line of succession or authority, very few titles, and no conferences"—a policy that understandably left some of his employees feeling somewhat at sea. As his company grew larger and he grew older, Henry rebuffed all attempts on the part of his executives, Edsel Ford among them, to create a more systematic management structure. He appeared to make business decisions intuitively and was not given to explaining them. He would go off somewhere to mull over a problem and then come up with a solution, saying "Well, I can't prove it, but I can smell it." And, of course, he was usually right. He generally confined himself to dealing with production matters, leaving administrative decisions to Edsel, who was in any case a far better manager. Unfortunately for Edsel, however, Henry in his later years often pulled rank and reversed Edsel's orders.

Henry, who liked to keep office space and office staff to a minumum, was particularly averse to hiring accountants, whom he disliked almost as much as paperwork. His idea of accounting was to compare bank balances at the beginning and end of the month; if the figures were up at the end of the month, then there was nothing wrong with business. On one occasion, when Henry was away, Edsel ordered the construction of a new office building to provide badly needed space for accounting and sales staff. Upon his return, Henry not only reversed the orders and had the partially constructed building torn down; he also fired all the accountants, cleared out their old offices, and told Edsel that if he still needed more space for the sales staff, there was now some available. In the weeks that followed, Edsel quietly managed to find jobs in other departments for all the accountants his father had sacked—an action in which Henry, by his silence on the matter, colluded.

In 1920, with the economy in recession and the Ford Motor Company in serious financial trouble, Henry turned his attention to what he regarded with distaste as the bureaucracy within his company. He merged the tax and controller's departments with auditing, cut his office staff from 1,074 to 528, and sold all the equipment these employees had used. Out went their desks, typewriters, filing cabinets, even their telephones and pencil sharpeners. In the future, any office employee who wanted to sharpen a pencil at work was to bring a knife from home for that purpose. These rather drastic economy measures actually resulted in the offer of some gifts. Mrs. M.D. Brown, a Detroit housewife of modest means, wrote to tell Henry she would lend him one hundred dollars from her life savings, and similar offers poured in from people around the country.

Despite Henry's general lack of interest in offices and all that they entail, his museum has an interesting collection of equipment used in business offices, retail establishments, and the offices of doctors and dentists over the years. The following pages describe some of the items that have been donated to this collection, including some given by people like Mrs. Brown.

Business and Office Equipment

IT IS A WELL-DOCUMENTED FACT that Henry Ford spent very little time in his office at the Ford Motor Company. Visitors with appointments were ushered in and asked to sit, but almost before they could draw a breath, Henry would be up and off at a brisk pace, inviting them to follow as he headed for the assembly plant. There he would give them a quick tour, explain what was going on, and occasionally pause for a minute to talk with workers. Meetings with his executives and office staff were also usually "on the run." Henry would seek them out when he wanted, buttonholing them in a hallway or dropping in at their offices unannounced; he would also simply walk away whenever he pleased. As Ernest Liebold, Henry's secretary and administrative assistant, described it:

> You couldn't sit down with a stack of letters and go through and ask Mr. Ford about each one. When you got to the second one, he'd get up and walk out. He just didn't want to be bothered about that. If he saw I had any number of letters in the drawer or anything I was going to talk to him about, he'd get up and walk out. He'd say, "I'll be back in a few minutes," or "I'll be back later on." That's the last I'd see of him. He didn't have a set routine. I never knew when he was coming.

Henry disliked paperwork. He seldom wrote letters, once admitting that he had written but ten in one year, all of them to children, no doubt his own grandchildren. Nor was he fond of reading letters. One day in the early years of the Ford Motor Company, a clerk who was looking for a lost invoice asked Henry, who was, as usual, not in his office but in the plant, if he knew where it was. Henry replied vaguely that it might be in his office. Going there, the clerk found enough unanswered correspondence to fill two wastebaskets. Some of it was unopened and contained not only invoices but also checks for sizable sums. Shortly thereafter, the clerk, Frank Klingensmith, found himself serving as Henry's personal secretary. Like Liebold who succeeded him in the job, Klingensmith found it impossible to get Henry to concentrate on more than one letter at a time.

Forms were another kind of paperwork for which Henry had little use. One day when he wanted to demonstrate an engine part for a visiting Englishman, he sent a clerk to collect the part and was quite perturbed when the clerk returned with a form and the information that Mr. Ford would have to sign it before the part could be released. Henry signed, got his part, and went to the office where the forms were kept. "Are these all you've got?" he asked. Assured that it was, Henry ordered up a can of gasoline, had the pile of forms taken out in the yard, and built a bonfire with them.

Henry also had an aversion to signing legal documents. Whenever possible, he made verbal argeements rather than written ones. This practice sometimes led to his making promises that he failed to keep. In 1948, a year after his death, his "gentlemen's agreement" with Harry Ferguson regarding tractors resulted in a $251,000,000 lawsuit. The Ford Motor Company settled out of court for $9,250,000.

Ernest Liebold took over Klingensmith's job of running Henry's private office in 1912, answering his correspondence, dealing with all business and legal matters, and generally shielding Henry from things and people he did not care to deal with. Liebold's manner of handling these matters, which could be stiff and unpleasant, alienated many people who came in contact with him, but he did the job so competently he soon became one of Henry's most trusted lieutenants. In Liebold's defense, Henry once said, "Well, when you hire a watchdog, you don't hire him to like everybody that comes to the gate." Henry's willingness to turn certain matters completely over to trusted employees like Liebold permitted a few of them to establish their own empires

Early Television Camera and Monitor

Detroit's first television station, WWJ-TV, which opened in 1947, used this equipment for several years before donating it to the Henry Ford Museum in 1953. The camera with its rolling metal stand is fifty-five inches high. It was manufactured about 1945 by Akeley Camera, Inc. Alan B. DuMont Laboratories made the monitoring console shown on the left. Below the console's television screen are two monitoring devices. The one on the left is an oscilloscope used to display electrical waveforms. (Before becoming a television manufacturer, DuMont was well-known in scientific circles for its high quality "scopes.") The console also held the three units of electrical components shown in the foreground. The coil of cable on the right connected the camera to the control console.

Acc. 53.15.1. Neg.B.3517.

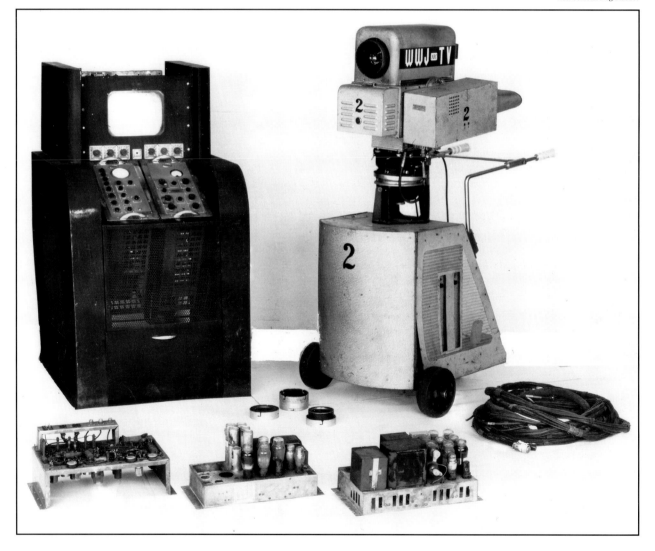

Facsimile Transmission Equipment

In 1902 the German physicist Arthur Korn began developing a facsimile machine that could transmit photographs over telegraph wires. Like the television systems that came later, Korn's device used both scanning mechanisms and photoelectric cells. Soon after he used it in 1907 to send a photograph from Munich to Berlin, it became a popular means of transmitting photographs of news events. In 1913 Éduoard Belin invented an even more popular facsimile machine, which journalists of the day called the "Belino." A portable device, the Belino sent photographs over telephone wires. AT&T introduced a commercial wirephoto service in 1925, and a year later, RCA inaugurated the first commercial transatlantic service for radio transmission of photographs.

From 1938 until 1940, the *Detroit News* used the apparatus shown here to transmit newspaper facsimiles by radio into customers' offices and homes, thus assuring them of up-to-the-minute news. The transmitting station was on the forty-fifth floor of an office building in downtown Detroit; an antenna on top of the building rose 400 feet above the street. The equipment included twenty-four transmitters built by the Finch Telecommunications Laboratory in New York City and an equal number of Finch recorders.

In the transmitters, an electric lamp threw a concentrated beam of light back and forth across the copy, in much the same way the human eye sweeps from left to right across a printed page. The light from the scanned copy, varying in intensity as it moved from black to halftone to white areas, was then reflected back to a photoelectric cell. The cell converted the light reflections into electrical impulses of varying amplitude, and these signals were sent out by a radio broadcasting transmitter with 150 watts of power. Because of difficulties in synchronizing the equipment, the reliable signal range was limited to just a few miles. In 1940, after unsuccessful efforts to solve this problem, the *Detroit News* abandoned its effort at facsimile transmission and in 1944 donated several pieces of its old equipment to the Henry Ford Museum.

Early Televison Apparatus: Jenkins's Scanner and Baird's Receiver

Acc. 40.567.19. Neg. B.107829.

Acc. 39.554.1. Neg. A.4712.

In 1923 the American inventor C. Francis Jenkins used the optical scanner shown here to treat government officials in Washington to a spectacle of "radio vision." As reported in a Washington newspaper, the officials "actually saw by radio an object set in motion several miles distant in front of a 'radio eye.'" About the same time, John Logie Baird began experimenting with television in Britain. The mechanical systems these two men developed for scanning pictures and breaking them up into individual elements were similar. Both used their own version of the Nipkow disk, which the German physicist Paul Nipkow had invented in 1884. When rotating rapidly in front of an illuminated object, the disk, pierced with small holes, scanned and dissected the entire image into a succession of horizontal strips in varying shades of light and dark.

To convert the strips into electrical signals, both Jenkins and Baird placed a photoelectric cell behind their scanners. The current in the photoelectric cell varied according to the intensity of the light from the scanned object, and the electrical signals thus produced were transmitted by radio waves to a neon tube in the receiver. In the receivers, the picture was reconstructed by looking at the tube through a matching disk. Baird gave the first public demonstration of his apparatus in 1925 at Selfridge's Department Store in London, at which time it produced a recognizable human face, though one that appeared to be covered with gray scales. By 1936 Baird had improved his equipment to the point that the BBC allowed him to start a regular public television service. At the same time, however, the BBC also allowed the Marconi EMI Company to use its electronic-scanning system on the air. The difference in quality was so evident that the BBC dropped Baird from the airways after only three months.

Meanwhile, Baird—whose persistence in developing a television system had at times reduced him to utter poverty—had formed a company for manufacturing television receivers, of which a thousand were sold. The one shown here is marked "Shortwave and Television Corporation/Baird/Boston, Mass." Louis F. Dienst of Cleveland, who said he used it to receive pictures from experimental transmitting stations along the Atlantic coast in 1929, donated it to the Henry Ford Museum in 1939. The optical scanner was given to the museum in 1940 by C. Francis Jenkins's widow, Grace L. Jenkins of Washington, D.C.

Vending Wagon

Street vendors with hand-drawn wagons full of popcorn, peanuts, pretzels, doughnuts, coffee, and the like were common sights on city streets even in the horse-and-buggy era. With the advent of the automobile, some builders of vending wagons mounted them on the chassis of cars or trucks. A builder that spanned both these eras was the C. Cretors Company of Chicago. Founded in 1885, C. Cretors made the old-fashioned, hand-drawn vending wagon shown here in 1921 and shipped it to Ed Sinanian of Highland Park, Michigan; the total cost was $400. Sinanian's wagon soon became a familiar fixture in front of the old Michigan Central Railroad Station in Detroit. The wagon, less than six feet high and three feet wide, is equipped with a steam-operated engine for popping corn and has a steam cylinder on its roof. The black drum in the front was for roasting nuts. Raymond C. Dahlinger, who worked for Henry Ford for many years, donated the wagon to the Henry Ford Museum in 1929.

Acc. 29.284.6. Neg. A.2847.

Dental Chair

The S.S. White Dental Manufacturing Company of Philadelphia made this chair in 1899. Known as the "New Model Wilkerson Chair," it was the first dental chair that could be lowered to a horizontal position. Upholstered in black leather, it has a folding footrest, an amethyst-colored glass spittoon, and a small clear-glass sink with a curved metal spout above it. A foot pedal behind the chair was used to raise and lower it. John E. Roche, Jr., who began practicing dentistry in Detroit around 1900, donated the "New Model Wilkerson Chair," together with a large array of other dental equipment, to the Henry Ford Museum in 1956.

Acc. 56.37.1. Neg. B.11252.

Surgical Instruments

In the early 1920s, Francis K.B. Lim came to the United States from China to study at the University of Michigan. After completing his studies, he worked for a while as a laborer at Ford's Highland Park plant. Around 1936, at the Central Health Field Station in Nanking, China, Lim began making surgical instruments out of used or broken Ford car parts. The cost was one-sixth of importing new instruments from foreign countries. After an undeclared war between China and Japan began in 1937, Lim was transferred to military duty, but the work he had begun—more needed now than ever—was continued at another health field station in Chungking,

Szechuen Province. The Chinese eventually produced thousands of these instruments.

When Ford officials in China informed Henry Ford of Lim's work, he expressed an interest in obtaining some examples of the surgical instruments for his museum. In March 1937, on behalf of the Chinese National Government, General Chiang Kai-shek sent Henry 127 surgical instruments made from old Ford parts, including the ones shown here.

H.J. Heinz's Office Desk

This Victorian office desk is part of the furnishings of H.J. Heinz's house in Greenfield Village, ensconced there ever since 1953, when the H.J. Heinz Company donated the house and its furnishings to the village. The desk was not, however, in the house while H.J. Heinz occupied it. He moved his burgeoning bottled-condiment business from the house to a factory building in Pittsburgh in 1875—three years before his mother bought the desk and gave it to him as a present. H.J. apparently used it in his office at the factory until 1890. These were critical years in the development of Heinz's Company, and it is easy to imagine, as a brass plate on the desk announces, that H.J. labored at this desk on an average of four nights a week for twelve years "laying the foundation of the business."

Patented in 1877 by H.H. Wiggers and built by Kearney & Wiggers Manufacturers of Cincinnati soon thereafter, the walnut desk with a bookcase above it is over seven feet tall and just under three feet wide. The double-doored cupboard that forms the base of the desk has compartments for storing records. The photograph shows the desk's green-felt writing surface in its extended position, with pigeon-holed side panels open. When the panels are shut, the writing surface slides back in and disappears from view.

Acc. 53.41.203. Neg. B.6862.

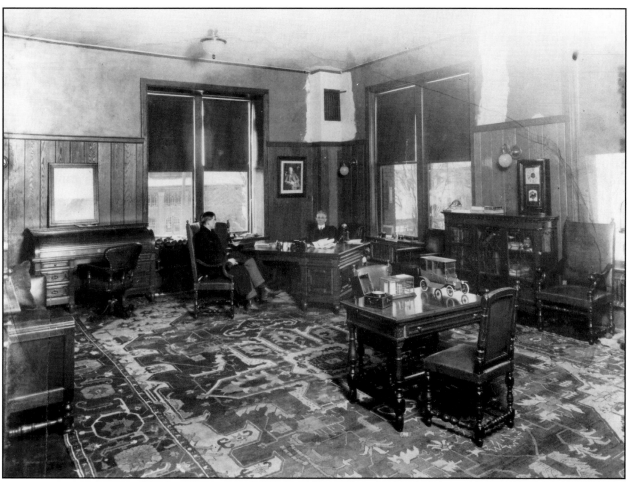

Henry Ford's Office at Highland Park

This photograph, taken in 1914, captured Henry Ford in one of the rare moments when he was seated behind his pedestal desk in his office at the Highland Park plant. The Persian rug seems to be the most colorful thing in the room, which—judging by the white patches above the wall paneling—was undergoing some repairs. Thanks to his secretary, Henry's desk was, as always, unlittered, though it does contain a few papers (perhaps put there for the photographer's benefit) and an upright telephone. On the wall behind Henry is a photograph of Thomas Edison, and to the left of Henry's young visitor, who appears to be holding his hat in his lap, are a rolltop desk and swivel chair.

Among the other furnishings of Henry's office—some visible in the photograph and some not—were a bird-watching telescope, a bird cage, a barograph and

chronometer, an umbrella stand and clothes tree, a world globe, an old-fashioned pendulum clock, a six-foot sofa, and two oak bookcases. Adjacent to his office, Henry had a small room where he stored—temporarily at least—the gifts he received from people the world over. Near the door to the office was a small vault for storing ledgers and minute books.

In 1923, by which time Henry had moved his office to Dearborn, Edsel Ford converted his father's Highland Park office into a conference room for the executive organization he was then attempting to build. After Edsel abandoned the office, the Ford Motor Company preserved the original furnishings, some of the wall paneling with lighting fixtures, and donated them to the Henry Ford Museum. The date of donation is unrecorded.

Herman Miller
Open-Plan Office Furniture

Herman Miller, Inc., of Zeeland, Michigan, was a leader in designing and manufacturing furniture for open-plan office systems in the 1960s. Such systems offered expanding businesses much greater flexibility than the old, permanent, square-cornered office cubicles. The open plan's easily movable, free-standing wall panels and work stations could be reconfigured to meet new needs in minimum time and at minimum moving cost. The technique was dubbed "space management" or "office landscaping."

Robert Propst and George Nelson of the Herman Miller Research Corporation designed the open-plan office furniture shown here about 1964. The "action office desk" at the left, forty-eight inches wide and thirty-two inches deep, has a work surface of beige plastic laminate with vinyl edging, three pencil drawers, wooden side panels painted blue, and, at its back, a recessed hanging file bin. A teakwood tambour can be closed over the writing area. The I-shaped legs and footrest between them are aluminum, as are the legs and crossbar on the wood and metal shelves at the right. The desk and shelves are among 365 pieces of furniture that Herman Miller donated to the Edsel B. Ford Design Program in 1989.

Acc. 89.177.98. Neg. B.103956.

CHAPTER 16
Documents

THE RESEARCHERS assigned to exploring Fair Lane after Clara Ford's death in 1950 not only encountered an awe-inspiring number of three-dimensional objects; they also found enough papers and photographs to create a two-story document file in the mansion's indoor swimming pool. Sticking their hands at random into cartons stuffed with documents, they pulled out such items as a 1941 letter from Robert R. McCormick, publisher of the *Chicago Tribune*. In it, McCormick apologized for the editorial his paper had long ago printed about Henry—the one that set off the *Chicago Tribune* trial of 1919. In addition to many hundreds of other historic letters and telegrams, the researchers found dozens of Henry's "jotbooks"; an astounding collection of "Edisonia"; box after box full of old, faded photographs; seemingly every Christmas card the Fords had ever received; countless bills and receipts for groceries, clothes, rent, hardware, tools, gasoline, rosebushes, and newspapers—even a bill Henry had paid for a $35 toupee that a balding, and evidently impecunious, relative had ordered; and newspaper clippings, ticket stubs, calling cards, and other items too numerous to mention.

With this vast amount of Americana to be sorted, the Ford Motor Company, which had bought Fair Lane after Clara Ford's death, quite logically decided to estab-lish its corporate archives at Fair Lane. A team of archivists set to work in May 1953, cataloguing both the Ford family's personal papers and photographs and the records of Henry's company from the time it was established in 1903 until 1950. The company documents included copies of correspondence, accounts, and audits; blueprints of racing cars, trucks, tractors, and aircraft; 350,000 photographs; and millions of feet of the films that Henry's motion picture department began producing in 1914. The archives also came to include over three hundred transcripts of oral interviews conducted in the 1950s with people who had known Henry Ford—relatives, friends, business associates, and company and personal employees, among them gardeners, security guards, and mechanics.

In 1957, when the Ford Motor Company donated Fair Lane to the University of Michigan to establish a Dearborn campus, the Ford Archives were transferred to a nearby Ford building in Dearborn. Seven years later, the company donated these documents, then valued at $4,375,000, to the Edison Institute. The Ford Archives are now part of the Henry Ford Museum & Greenfield Village Research Center. A few items of general interest selected from this mountain of material are reproduced on the following pages.

"The Song of Mr. Phonograph"

Written by H.H.H. "von Ograph" and published by G. Schirmer, "The Song of Mr. Phonograph" was a great success when Edison exhibited his phonograph in New York City in 1878. It was just long enough to be recorded on one sheet of tinfoil, and it reproduced admirably. The lyrics of the first verse are

My name is Mr. Phonograph and I'm not so very old;
My father he's called Edison and I'm worth my weight
 in gold.

The folks they just yell into my mouth and now I'm
 saying what's true:
For just speak to me I'll speak it back and you'll see I
 can talk like you.

"The Song of Mr. Phonograph" is just one out of more than eleven thousand pieces of sheet music in the collections of the Henry Ford Museum & Greenfield Village Research Center.

Neg. B.65357.

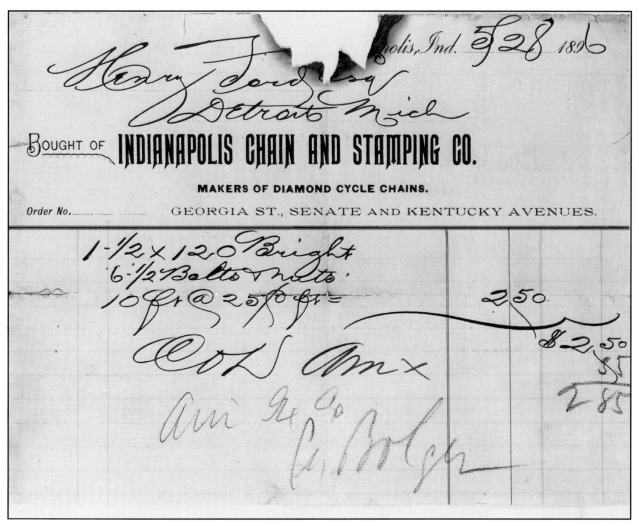

Neg. D.357.

Bill for a Bicycle Chain

Henry Ford used the ten-foot bicycle chain that he bought from the Indianapolis Chain and Stamping Company for $2.85, including postage, in his first automobile, the Quadricycle. The Quadricycle made its debut on the streets of Detroit not long after the chain company issued this invoice on May 28, 1896.

Grocery Bill

Dated September 1, 1898, this grocery bill is one of dozens that Clara and Henry Ford saved while Henry was working at the Edison Illuminating Company in Detroit—and spending every hour he could building his first and second Quadricycles.

Neg. D.78.

One Jillion Shares of the Ford Motor Company

On June 13, 1903, the twelve stockholders of the Ford Motor Company elected John S. Gray as the company's first president, and three days later, the company was incorporated. Dated June 16, 1903, this unassigned stock certificate for "one jillion" shares suggests that some levity accompanied the incorporation.

Neg. D.414.

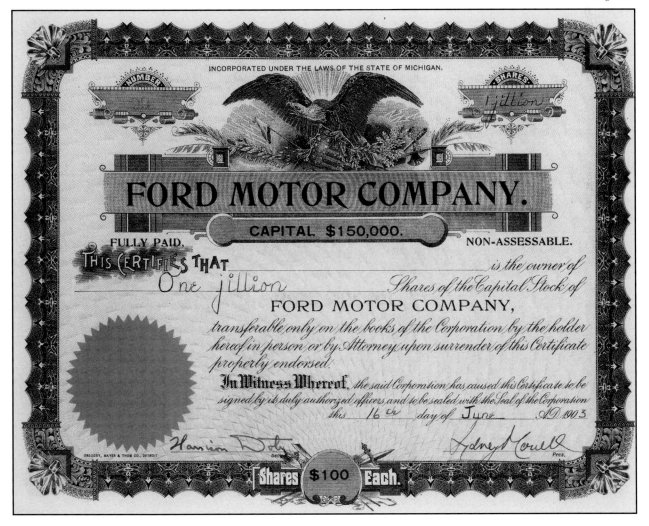

Drawing by Edsel Ford

Edsel Ford was sixteen years old and a student at the Detroit University School when he drew this picture in 1909. His artistic sense was later to stand the Ford Motor Company in good stead. In the early 1920s, as it was becoming evident that the more stylish cars of other automobile companies would soon begin outselling the outmoded Model T, Edsel continuously attempted to persuade his father that it was time their company produced a new car. Henry by then was becoming known for his bullheadedness—especially where Edsel was concerned—but in 1926 he finally agreed. Edsel's taste became evident in the styling of the Model A, the Ford V-8s, and the Lincoln Zephyr and Continental.

Neg. D.594.

```
          MINUTES OF MEETING OF THE BOARD OF DIRECTORS OF THE

                        FORD MOTOR COMPANY

          HELD AT THE OFFICE OF THE COMPANY, HIGHLAND PARK,

          MICHIGAN, AT NINE A. M.,   JANUARY 5TH, 1914:

               Present:

                        .Henry Ford,
                        H. H. Rackham,
                        James Couzens.

               The Treasurer, James Couzens, acted as Secretary of the
          Meeting due to the absence of Secretary Klingensmith.

               Minutes of the Meeting of the Board of Directors held
          December 31st, 1913, were read and approved.

               It was suggested by the Officers that a plan of better
          equalizing the Company's earnings between the Stockholders and
          labor  employed by the Company be inaugurated.

               The plan was gone over at considerable length,  but
          briefly it carried with it, in addition to wages, sums to make the
          minimum income of all men over twenty-two years of age $5.00 for
          eight hours work, and that other increases were to be made to men
          getting above the minimum wage to maintain the same  rate between the
          minimum, intermediate and maximum wages.

               After considerable discussion it was moved by Director
          Rackham, and supported by Director Couzens, that such a plan be put
          into force as of January 12th, 1914, which plan it was distinctly
          understood would approximate an additional expenditure for the same
          volume of business of Ten Million ($10,000,000.00) Dollars, for the
          year 1914.    Carried unanimously.

               There being no further business, the meeting then adjourned.

                              James Couzens
                            ─────────────────────
                            S e c r e t a r y   Pro Tem
```

Minutes of the Meeting That Inaugurated the Five-Dollar Day

Only three stockholders of the Ford Motor Company—Henry Ford, H. H. Rackham, and James R. Couzens—were present on January 5, 1914, when the company voted to pay its workers five dollars for an eight-hour day. The estimated increase in labor costs was ten million dollars. Owners of other automobile companies were flabbergasted; the going rate for an auto worker was then two dollars for a ten-hour day.

Diploma of the Ford English School

The Ford English School, located at the Ford Motor Company's Highland Park plant, taught English and civic studies to the immigrant workers who flocked to the plant because of Ford's five-dollar day. The school opened in 1914, and by 1916 it had enrolled more than 2,500 foreign-born employees. In 1917–1918, that figure increased to 14,000, but after World War I ended, enrollment declined, and the school eventually closed. Graduates who satisfactorily completed the nine-month course were presented with a diploma like this, signed on the bottom line by Henry Ford.

Neg. D.783.

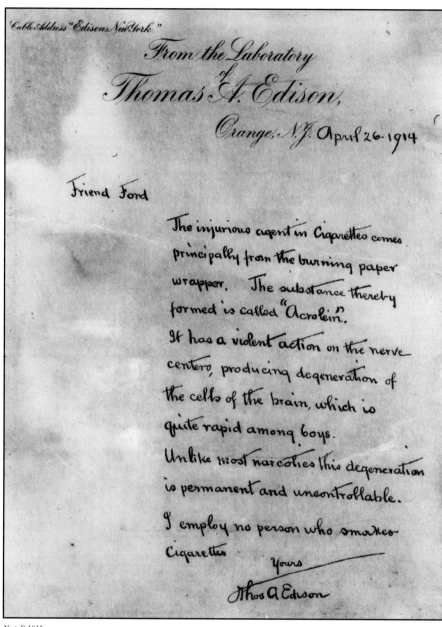

Cable Address "Edison New York."

From the Laboratory

of

Thomas A. Edison,

Orange, N.J. April 26-1914

Friend Ford

The injurious agent in Cigarettes comes principally from the burning paper wrapper. The substance thereby formed is called "Acrolein."

It has a violent action on the nerve centers, producing degeneration of the cells of the brain, which is quite rapid among boys.

Unlike most narcotics this degeneration is permanent and uncontrollable.

I employ no person who smokes Cigarettes

Yours

Thos A Edison

Neg. D.1041.

Edison on the Evils of Cigarettes

Henry Ford waged a continuous campaign against the cow and its milk. He advocated chemically manufactured food in their stead and was obviously not the only one with some peculiar but decided notions about health-related matters. In an age given to shades of grey rather than black and white, one must marvel at Thomas Edison's absolute assuredness when he wrote this missive to "Friend Ford" in 1914. Henry used Edison's letter to launch a campaign against cigarette smoking, advising journalists to "study the history of almost any criminal and you will find an inveterate cigarette smoker."

In this crusade, Henry once even went so far as to have his chauffeur confiscate all the cigarettes and cigars in the clubhouse of the Dearborn Country Club, which he had built in 1925 for the enjoyment of his fellow townspeople. The swag was delivered for safekeeping to Ernest Liebold, Henry's secretary, who subsequently found an outlet for the high-quality cigars in Henry's executives. When Henry got wind of what was going on, he staged—for the benefit of his offending executives—a tobacco bonfire in front of the Edison Institute.

Neg. B.110824.

Menu from the "Telegraph Operators Dinner"

The pages of the menu speak for themselves, after help in translation from Morse code by Varley Sperbeck, a volunteer at the Henry Ford Museum.

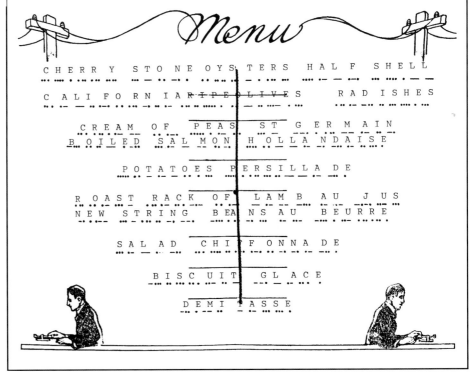

Neg. B.110825.

Neg. D.132.

Neg. D.127.

Henry Ford's Driver's License

When this Michigan driver's license was issued to Henry Ford in 1919, he was fifty-six years old, grayhaired, weighed 138 pounds, and was one of the main reasons such licenses had to be issued.

Henry Ford's License to Carry a Revolver

Here is evidence of one of the many paradoxes that have continually confounded Henry Ford's biographers: a license "to go armed with a concealed or dangerous weapon," issued in 1922 to the man who despised munitions makers.

A $1,100,000,000 Offer for the Ford Motor Company

This telegram, dated February 11, 1927, and offering Henry Ford "one billion and one hundred million" for his "automobile industry in its entirety" is one of at least three such offers Henry received at about the same time. The Model T had been out of production since the preceding August, and the Model A had not yet been introduced. Thus, the men behind these offers were hopeful that this might be the time Henry would sell out.

FORM 717
DATED 4-15-26

Ford Motor Company

Automobile Manufacturers

TELEGRAM

CLASS OF SERVICE	SYMBOL
Day Message	
Day Letter	Blue
Night Message	Nite
Night Letter	N L

If one of these three symbols appears after the check (number of words) this is a day message. Otherwise its character is indicated by the symbol appearing after the check.

1090

RECEIVED

FEB 11 1927

FR 10 ZA 52 6 EXTRA

FI NEW YORK NY 328PM FEB 11TH 1927

HENRY FORD
DEARBORN MICH

WILL YOU CONSIDER ONE BILLION AND ONE HUNDRED MILLION
FOR YOUR AUTOMOBILE INDUSTRY IN ITS ENTIRETY INCLUDING ALL ITS
CO-RELATED SUBSIDIARIES WOULD LIKE NINETY DAYS IN WHICH TO
CLOSE DEAL AND PAY YOU ENTIRE SUM IN CASH OR NEGOTIABLE
SECURITIES OR TERMS TO SUIT YOUR REQUIRMENTS

SWOBODA
TWENTY ONE WEST FORTY FOURTH ST

40 4PM

Neg. D.518.

Letter from Clyde Barrow

The quick acceleration of the Ford V-8 was popular with people on both sides of the law who liked to make fast getaways. On April 10, 1934, in between racing from one bank holdup to another, Clyde Barrow, of the notorious Bonnie and Clyde team, wrote this letter to Henry Ford.

Neg. D.790.

Tulsa Okla
10th April

Mr. Henry Ford
Detroit Mich.

Henry Ford
RECEIVED
APR 13 1934
Secretary's Office

Dear Sir:—

While I still have got breath in my lungs I will tell you what a dandy car you make. I have drove Fords exclusivly when I could get away with one, For sustained speed and freedom from trouble the Ford has got ever other car skinned and even if my business hasent been strickly legal it don't hurt eny thing to tell you what a fine car you got in the V8 —

Yours truly
Clyde Champion Barrow

Hello Old Pal;-

Arrived here at 10 A.M. Today.

Would like to drop in and see you.

You have a wonderful Car, Been driving it for three weeks. Its a treat to drive one.

Your Slogan should be,

Drive a Ford and watch the other cars fall behind you. I can make any other car take a Ford's dust.

Bye — Bye.

John Dillinger

Neg. D.909.

Letter from John Dillinger

John Dillinger, public enemy No.1, also wrote to Henry in 1934 to congratulate him on his car. A bit more flippant than Clyde Barrow, Dillinger neglected to give his "old pal" any return address. Soon after writing this letter, Dillinger, betrayed by a girlfriend, met his end in a shootout with police.

Invitation to an Old-Fashioned Dance

This is one of the invitations that many people received with groans, fortifying themselves for the dry occasion beforehand with invigorating spirits.

You are cordially invited to attend

a class in

Old Fashioned Dancing

sponsored by

Mr. and Mrs. Henry Ford

Friday, January the Nineteenth, 1934

at nine o'clock

The Administration Building at Dearborn

Dividend for Henry Ford II

When the Ford Motor Company went public in 1956, the first share of common stock was issued to the company's president, Henry Ford II. The first quarterly dividend on that share amounted to sixty cents. The dividend check, uncashed and dated March 12, 1956, is now in the archives of the Henry Ford Museum & Greenfield Village Research Center.

Neg. D.517.

CHAPTER 17
Gifts from Fair Lane and Other Oddities

PART OF THE INSPIRATION for this book was the odd and often unique nature of many of the items that have come as gifts to the Henry Ford Museum over the years. Among these items, none are stranger than some of the objects found at Fair Lane after Clara Ford's death and donated to the museum by her heirs in 1951. Many of these "gifts from Fair Lane" were originally gifts to Henry Ford or Clara Ford, things they apparently could not bear to part with—though the evidence, which is in a very real sense overwhelming, suggests they never could bear to part with anything.

Henry's announcement after the *Chicago Tribune* trial of 1919 that he was going to build his own museum—and the publicity surrounding that undertaking in the 1920s—evidently triggered an emotional response in people from all walks of life all over the world who regarded Henry as an authentic American hero. Gifts of every kind poured into Dearborn from little hamlets in Michigan and from as far away as Foochow, China. Unlike some donors in recent years, these early donors surely had no tax deductions in mind. In the 1920s, thousands of these gifts were stored in Henry's warehouses in Dearborn. Some found their way to Fair Lane; a few made their way into the Henry Ford Museum around 1930; but the fate of many others is unknown.

The people charged with categorizing Henry's gifts in the 1920s were understandably puzzled about how to proceed. Some gifts were so bizarre they defied categorization as anything other than oddities. Others were more remarkable for their duplication than anything else; for example, in one lot there were ninety-one wooden canes, eighteen miniature automobiles, twenty-two glass bottles containing various small objects, twelve wooden chains, and twenty-eight paper flowers. At one point, however, a worker, looking at seventy-two crates of diverse gifts in a hangar at the Ford Airport apparently despaired and categorized the whole lot of them under the label "Freaks." A list describing the approximately 1,750 items contained in these crates and identifying the donors survives, though many of the gifts do not. It contains such notations as

Handbag from inner tube, Goldie Allen, Kane, Illinois

Tablemat made from 1920 Ford coil wire, Mrs. Grace Nee (no address)

Branches of tree shaped like Henry Ford, H.L. Brown, Dexter, Michigan

Cushion top, Gaston Black, State Prison Camp, Troy, New York

An old piece of wood, E.G. Grimsley, Freeman, North Carolina

Bale of wool, Valmin Pagin, Biene, County Cork, Ireland

Ox cart with load of bananas, banana tree, and wax figure of Henry Ford, Carlos Guetinag Koyas, San Jose, Costa Rica

Fancy work made of tin cans, Catherine Watts, Moultrie, Georgia

Sled loaded with wood, Louis Flinn, Munising, Michigan

Box of dress patterns, M. Harnick, Ypsilanti, Michigan

Miniature Model T, Evon Gelden, Dorm, Germany

Wooden block puzzle, J.A. Bushman, Algonac, Michigan

Flag pole, Charles T. Raven, New York City

H. Ford photo in 1-gallon bottle, J. Porter, Poorhouse, Parkersburg, West Virginia

Carved pipe, Harry Anderson, Detroit Police Department

Box of butterflies, Franklin Helm, Bogota, Colombia

Black necktie, J.P.D. Bordus, Catlettsburg, Kentucky

Shark's tooth, W.H. Blackburne, San Francisco

Medicinal remedy, John Linden, Cleveland

Box with three dolls, Kansuke Takeda, Japan

Airplane made of wood (32"), N.M. Hakett, Marietta, Oklahoma

Miniature wood cars, John D.V.A. Berg, Leiuwdoonsstod, South Africa

Silver coffin plate (3" x 5"), "Mr. Jonathan Wheeler, Died July 2, 1849, Aged 29 Years" (no donor tag)

Ash tray made from piston, T.W. Ferguson and A.H. Olson, Twin Falls, Idaho

Covered wagon made from coconut shell, R. Payne, Honolulu, Hawaii

Log schoolhouse, J.D. Noah, Cedar Springs, Michigan

American flag made from bits of paper, J.E. Martin, Niagara Falls, New York

Picture made from postage stamps, G.E. Thompson, New Haven, Connecticut

Mr. and Mrs. Henry Ford in jigsaw, A.F. Michalewski (no address)

Ox yoke, John Lenox, Flint, Michigan

Piece of Plymouth Rock, Mrs. Margaret Dill, Plymouth, Massachusetts

Old Meat grinder, Judd Lytle, Clyde, Ohio

Car made from pith of corn, W.N. Watson, Faxton, Virginia

Chicken carved from wood, Charles Cypress, Seminole, Florida

Shell with engraved Indian, Preston White, New Bedford, Massachusetts

Leather boat, A.B. Gillis, Detroit House of Correction

Root of tree grown through a small plate of iron, Jose I Velez, Sarmiento, Pira de Cardabo, Argentina

Cigar cutter, Leo Carney, Detroit

Branch of tree grown around Ford crankshaft, J.L. Vacature, East Palestine, Ohio

Engine and tender made of wood, W.W. Taylor, Boston

"Ford" cut from bar of soap, Mrs. Andrew Heckling, Muskoda, Ontario

Iron band used on legs of prisoners (no donor tag)

Old bolt, Hannibal S. Towle, South Sudbury, Massachusetts

Stuffed alligator (no donor tag)

Birdhouse and stuffed birds, Manuel Suarer, Laugeportte, Pennsylvania

Pliers made of wood, R.W. Watson, Oasis, Georgia

Straw Hat, R.I. Gellian, Ninety Six, South Carolina

Wooden pop gun, L.D. Felton, Moorhead, Indiana

Fancywork from inner tube, J. Wilson Tarbell, Lansing, Michigan

Ballast weight from *Shenandoah* airship, E.J. Baker, Utica, Arizona

Odd or unique as some of the early gifts to Henry and the gifts from Fair Lane might be, the museum has even in recent years accepted gifts that rival their individuality, as the following pages will bear out.

"Smoking" Equipment

Acc. 51.35.1. Neg. B.111104.

It is hard to imagine what Henry and Clara Ford might have been doing with these items. They did, however, come from Fair Lane, loosely packed in a cardboard box, and all appear to have seen some use. A note on the box gave the date of November 18, 1939, but no other clue. The bottle contains pulverized marijuana ready to be made into cigarettes. Five finished marijuana cigarettes appear in the center of the photograph. The other items consist of scales for weighing opium pellets, a hinged wooden case to hold the scales, an opium lamp for heating the pellets before putting them in the pipe, and the opium pipe itself.

Clara Ford's Siamese Cigars

Acc. 51.32.125. Neg. B.110630.

When these two small brown cigars arrived at the Henry Ford Museum from Fair Lane, they were accompanied by some documentation. A note that appeared to be in Clara Ford's handwriting read: "Three puffs taken by Mrs. Henry Ford, lighted by the mother of the Queen of Siam, a dear little lady who had ten children and looked about 40 years old." An undated newspaper clipping provided the information that "the parents of the Queen of Siam, who are touring the United States, visited the Ford Airport Monday." Clara evidently did not enjoy the smoke; only one of the cigars has been lighted.

Calvin Coolidge's Sap Bucket

During the summer of 1924, Henry and Clara Ford entertained the Edisons and the Firestones at the Wayside Inn in Massachusetts. The men took a short trip to visit Calvin Coolidge, then completing his first year as president, at his homestead in Plymouth, Vermont. On that occasion, Coolidge presented Henry with a four-gallon wooden bucket used in tapping sap from maple trees; it had been made by one of Coolidge's ancestors about 1780. The photograph shows, from left to right, Harvey Firestone; Calvin Coolidge; Henry with his latest acquisition; Thomas Edison; Coolidge's son John; Coolidge's wife, Grace; and Major John C. Coolidge. This was not the only photograph taken. Journalists and newspaper photographers were flocking around, and as a result of all the publicity, a good many people came to assume that Henry prized old sap buckets. Almost inevitably, large numbers of old, leaky wooden buckets were soon pouring into Dearborn.

Neg. 0.7331.

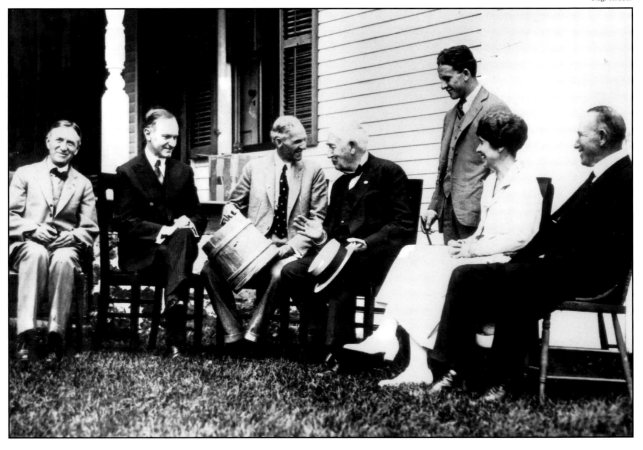

Edison's Last Breath

This corked test tube was found at Fair Lane in a glass case that also contained Thomas Edison's hat and shoes. A note on the tube solemnly declares: "The last breath of Thomas Edison." Needless to say, the contents of the tube are somewhat suspect, but no one dares uncork the tube to analyze the gas. Presumably, other such test tubes may exist somewhere; the story is told that during Edison's last illness, several were placed in his hospital room and were sealed immediately after his death.

Acc. 51.13.51.3. Neg. B.104142.

John Burroughs's Hands

Acc. 51.35.2. Neg. B.110628.

John Burroughs was a close friend of Henry Ford as were also Thomas Edison and Harvey Firestone. Their summer vacation trips together are well documented. Burroughs, a naturalist, is said to have taught Henry "the world beyond the factory." Burroughs was on the dock in New York to see Henry off on his well-intentioned European trip to stop World War I in 1914; and he joined the Fords on their yacht to visit Cuba in 1915.

Henry Ford not only had a statue of John Burroughs on the grounds of Fair Lane; he also kept this plaster cast of Burroughs's hands somewhere in the fifty-six rooms of the mansion. When Burroughs died at his home along the Hudson River in New York state in 1921, this object—life-sized, unpainted, and cast in white plaster of Paris by Mary Burt—was among the objects found on his desk. Burroughs's secretary, Clara Harris, sent it to Henry Ford, together with some of Burroughs's other belongings.

Victorian Gravestone

When Mary Abbott of Jackson, Michigan, offered this gravestone to the Henry Ford Museum in 1980, she wrote, "If you should want it, I would be very grateful as my family would prefer that I cease and desist from leaning it against a wall in our patio. It seems to make them nervous." The museum, lacking any examples of this art form, decided to accept the offer. The gravestone bears the following inscription:

<div align="center">

FAREWELL
NETTIE
Dau' of
Geo. A. & Phebe A. Parkhurst
DIED
Oct. 29, 1876
Aged
20 Yrs 1 Mo.
& 5 Days

———

A loved one has gone from our circle,
On earth we will meet her no more.
She has gone to her home in heaven,
And all her afflictions are o'er.

</div>

Acc. 80.76.1. Neg. B.84400.

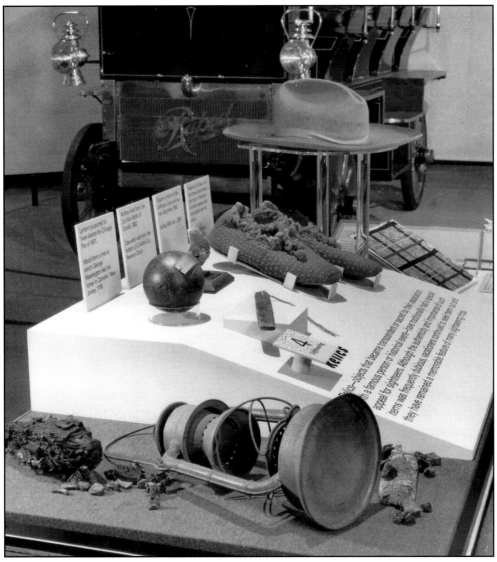

Buffalo Bill Cody's Hat

Shown with a number of other "relics" is a ten-gallon hat that supposedly once belonged to Buffalo Bill Cody, American scout, Indian fighter, and showman. Irving R. Bacon, who was Henry Ford's artist from 1930 to 1947, donated the hat to the Henry Ford Museum in 1935. As a youth, Bacon spent summers at Fort Yates, North Dakota, and on one occasion when Buffalo Bill brought his wild west show to town, Bacon sold him a portrait he had painted of him. Cody later commissioned Bacon to do paintings of western scenes, which are now in a museum in Cody, Wyoming. So there is reason to believe the hat, with some unexplained holes in its brim, may actually have belonged to Buffalo Bill.

The provenience of the other "relics" in the photograph is more questionable. The kerosene lantern is purported to be the one that Mrs. O'Leary's cow kicked over in 1871, starting the fire that devastated Chicago. Varina Howell Davis, First Lady of the Confederacy during the Civil War, is supposed to have knit the slippers in 1885. And the artillery shell is allegedly from the battle of Corinth, Mississippi, in 1862, while the little piece of wood is reputed to be from a tree to which George Washington tied his horse in 1776.

Oriole's Nest

Many people were aware of Henry's interest in birds, especially after his support of the Weekes-McClean Bill, which Congress passed in 1913 to protect migratory birds. Among them was E.W. Cottrill of Arizona, who sent this four-foot-long, glass-fronted oak cabinet containing an oriole's nest to Henry, with the following notation:

Nest of an oriole attached to the under side of a palm leaf from a tree at Castle Hot Springs, Arizona, on the tenth day of March, 1915, after it had been used once for brooding purposes. The entire nest is made of the threaded fibre of the palm leaf to which it is attached. The stripping and threading of the threads is also the work of the little nest builders. Note the ingenious manner in which the nest is fastened to the rib of the leaf by real stitches of needle like work.

It was one of the objects that came to the Henry Ford Museum from Fair Lane.

Cribbage Board

This object, sixteen inches long and carved out of bone, looks more like a small totem pole than a cribbage board, but that is evidently what it was intended as. In addition to small peg holes, the top has carved images of polar bears, walruses, and sea lions. The bottom is incised with a red walrus. The cribbage board came as a gift to the Henry Ford Museum soon after it opened in 1929. The donor is unknown, but the object is thought to have come from Alaska.

Glass-Jug Diorama

People seem to have been fond of sending Henry Ford glass bottles containing miniature ships, buildings, fans, flowers, cars, photographs, and a variety of other objects. Although hundreds of such items were sent to him, Henry probably saw very few of them. This one, however, he saw and evidently took a fancy to; at any rate, he took it home to Fair Lane. The diorama shows a large and glamorous woman, a smaller Henry Ford, another even smaller man (perhaps meant to be Edsel Ford), two 1935 Ford V-8 automobiles, and an assortment of flowers and cotton chickens. The donor is unknown.

Acc. 00.1510.4. Neg. B.110637.1.

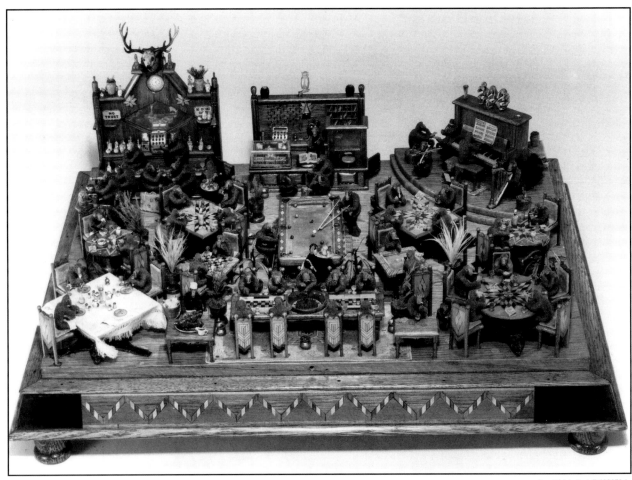

Gambling Diorama

Patrick J. Culinane made this diorama in 1914–1915 while serving a prison sentence in a jail in Charlestown, Massachusetts. Fitted with an ornate glass case, it depicts the activities that Culinane believed led to his downfall and that of his fellow prisoners. About seventy small monkeylike figures are scattered about, some drinking at the bar and others gambling as they play roulette, cards, craps, and pool. Each one-inch figure and piece of furniture is skillfully carved from a peach pit.

When the manager of a local Ford factory visited the prison, Culinane asked that his diorama be sent as a gift to Henry Ford, whom he greatly admired. Henry was so impressed with Culinane's craftsmanship that he arranged for his release from prison and for his employment at the Ford factory. Seven years later, Culinane was married, had three children, and was the proprietor of a roofing business in South Boston.

Doll Made of Redwood Bark

Acc. 72.177.10. Neg. B.101338.

In 1972 Almena Gray Wilde of Detroit donated her collection of over four hundred dolls from all over the world to the Henry Ford Museum. The one shown here, ten inches high, dates from the early 1900s and is made of the bark of a giant California redwood. The donation also included three furnished dollhouses made about 1860, 1900, and 1920; several models of ships; and a number of women's dresses and evening wraps dating from the early 1900s.

The donor was the granddaughter of John S. Gray, a banker who was one of the original stockholders in the Ford Motor Company. Gray put up $10,500 in cash in 1903—more than any other stockholder—and was elected the company's first president, a position he held until his death in 1906. By that time, he had not only recouped his original investment but also earned an additional $50,000 from it. He was nonetheless skeptical about the future of the company, gravely declaring that "this business cannot last." By 1915 the dividends paid to his estate totaled $10,000,000.

Argentine Soil Samples

Just why Henry and Clara Ford would have kept a box of soil samples from Argentina at Fair Lane might seem puzzling, but the inscription on the lid of the box provides the clue:

Buenos Aires, July 1945
Earth gathered from the Federal Capital, fourteen provinces, nine territories and W. Villaframe, to be scattered as a humble offering and a Christian homage rendered by the Ford Organization in Argentina, over the grave wherein lie the remains of that who was its worthy and beloved president, Mr. Edsel Bryant Ford.

Edsel Ford died on May 26, 1943, a blow from which Henry never recovered.

Acc. 00.1510.12. Neg. B.110620.

Acc. 00.1510.20. Neg. B.110635.

Walking Cane

Henry Ford received hundreds of canes as gifts over the years. This one, found at Fair Lane in 1950, has a multitude of inscriptions written in ink over most of its surface. One of the inscriptions indicates that William A. Willard of Hartford, Connecticut, carved the cane and that he took the wood for it from a tree on the grounds of Mark Twain's home in Hartford. Another inscription reads in part: "Presented to America's foremost merchant and manufacturer and honest citizen—Mr. Henry Ford, Dearborn, Michigan, as a token of high esteem and respect."

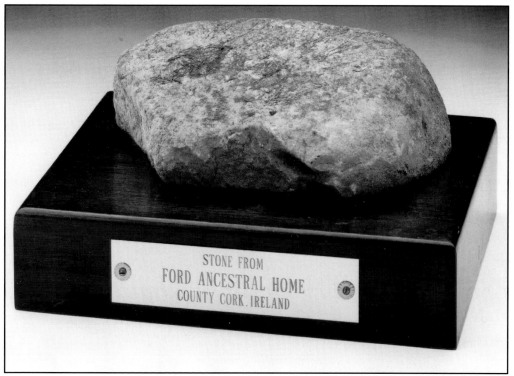

A Stone from the Irish Homestead

There are records indicating that Henry Ford's ancestors came from Somerset and Devon in England to Cork County, Ireland, during the time of Queen Elizabeth I. These ancestors were yeomen farmers associated with the upper-class family of Starwell who had been granted thousands of acres of land in Southwest Ireland, just a few miles inland from the coastal town of Clonakilty. A lease dated 1790 reveals Henry's great grandfather William Forde and two brothers, subject to a lease calling for rent of £6 per year. In 1819, another lease from Starwell was for 28 acres, requiring payment of £29 per annum. This arrangement was a lifetime lease between Jonas Starwell and Henry's great grandmother Rebecca, together with John Forde, Henry's grandfather. The home on this property, for their sizeable family, was only a one-room dry stone cottage.They barely eked out a living on their small plot of rented land.

An official at the Ford Motor Company in Cork, Ireland, sent this stone—set in a mahogany base carefully carved out to hold it and still retaining some of the lichen of the land from which it came—to Henry Ford in the 1930s. It is one of the stones that formed the cottage in County Cork where Henry's father, William, was born in 1826. After William and the other members of his family abandoned the homestead to sail for America in 1847, the cottage deteriorated, and by the 1930s, stones such as this must have been about the only thing left. Though Henry professed not to have had very warm feelings about his father, he nonetheless kept this relic of his father's birthplace. It was included with archival materials from Fair Lane that the Ford Motor Company donated to the Henry Ford Museum in 1964.

Today, at the site of the little stone cottage, one can find few stones of any size. The larger ones have been removed for local building projects; and the smaller ones have been picked up by souvenir hunters.

Washington-Elm Gavel

In the 1920s, when Henry Ford's agents were ransacking New England for antiques to furnish the restored Wayside Inn and sending the surplus to Dearborn, the Ford plant in Cambridge, Massachusetts, became the shipment depot. Apparently, the citizens of Cambridge did not take it amiss that Henry was relieving New England of much of the material evidence of its history, for in 1925 the City of Cambridge presented this gavel to him. It is made from a piece of the elm tree under which George Washington allegedly stood when he took command of the Continental Army in Cambridge in 1775. It came to the Henry Ford Museum from Fair Lane as a gift from Clara Ford's heirs.

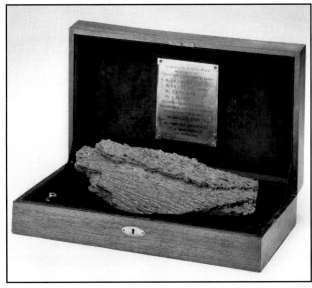

Petrified African Wood

This piece of brownish-grey rock in its rather elaborate case, complete with lock and key, arrived at the Henry Ford Museum from Fair Lane, with a note that read, "Made by God, found in the petrified forest in the Western Desert of North Africa." The brass plate on the inside of the lid bears the following inscription:

Souvenir of the Petrified Forest, Western Desert. Crossed with Ford Tudor No. A5464 by Mrs. P.M. Demetrio, Mr. P.M. Demetrio, Mr. A.R. Fromow, Mr. Phares. Alexander-Cairo, 295 kilometers. Consumption 12 litres per 100 kilometers. Speed 80 kilometers on soft sand. Presented to Henry Ford by Comptoir Automobile, P. de Martino & Company, 17 March 1928.

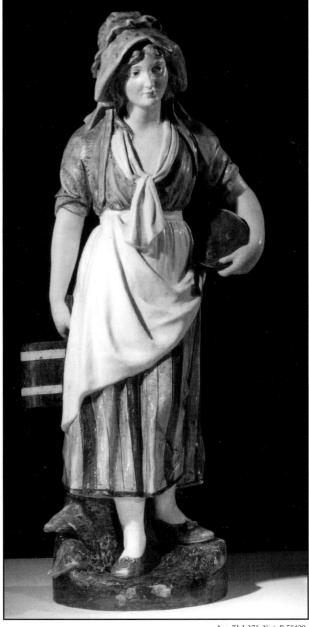

Acc. 71.1.171. Neg. B.58432.

Ceramic Milkmaid

Over four feet tall, this colorful Staffordshire milkmaid is part of a collection of more than fourteen hundred items that illustrate the history of the dairy industry. David R. Gwinn, former president of the Pennbrook Dairy Company of Philadelphia, donated the collection to the Henry Ford Museum in 1971.

Acc. 92.230.1. Neg. B.111108.

Ford Tomato Juice Bottle

This bottle is a relic of the Great Depression of the 1930s. Henry Ford at that time not only had thousands of acres in southeastern Michigan planted with soybeans; he also had hundreds of acres devoted to growing other vegetables, which he supplied to various welfare agencies free of charge. Tomatoes were among these other vegetables, and they were grown on eighty acres in Dearborn on the present site of the Ford Motor Company World Headquarters. An abandoned two-room schoolhouse on the site had been converted to a canning factory, and there, during a three-week period in September 1938, thirty boys worked along with six men bottling 52,505 cases of Ford Tomato Juice.

The bottle shown in the photograph may, for all we know, be the lone survivor of that Herculean effort. When Peter Brandt of Chappaqua, New York, donated the bottle to the Henry Ford Museum in 1992, he noted that he had moved it, along with the rest of his belongings, from house to house five times, feeling that it was too important historically to be recycled. The label on the bottle reads: "Ford Tomato Juice/Rich in Vitamins A, B, C/Made from Selected Tomatoes/Grown on the Ford Farms, Dearborn, Michigan/Also good in Tomato Cocktail, Cream of Tomato Soup, Meat Dressing, etc."

Acc. 92.205.1. Neg. B.111107.

Bottle of Curtis Rubbing Oil

Austin W. Curtis, Jr., the developer of Curtis Rubbing Oil, worked for eight years at the Tuskegee Institute as an assistant to George Washington Carver, the well-known botanist. Carver and Henry Ford were friends with a common bond, for while Carver was promoting the peanut, for which he discovered over three hundred uses, Ford was promoting the soybean, another adaptable legume, for which he found industrial uses ranging from paint to plastic. Carver frequently accompanied Ford to the one-room schoolhouses of the Edison Institute, where he instructed the children on the virtues of the peanut.

After Austin W. Curtis, Jr., left the Tuskegee Institute, he founded the A.W. Curtis Laboratories in Detroit, where he carried on Carver's mission of exploring what nature has to offer. Of the twenty-five health and beauty aids he developed during the 1940s—largely from peanut by-products—the best known is Curtis Rubbing Oil, a peanut-based medication for relieving the "minor aches and pains of arthritis and rheumatism." Ford R. Bryan of Dearborn, Michigan, donated the sample shown here to the Henry Ford Museum in 1992.

Acc. 00.1510.16. Neg. B.110617.

Miniature Wheelbarrow

A.J. Mayer of East McKeesport, Pennsylvania, crafted this ornament, two feet long overall, as a gift for Henry Ford in 1938. Well-proportioned, it is made of carefully joined, precision-cast pieces of aluminum. Its wheel turns freely, and its side boards loosen without separating from the base. Henry evidently appreciated the workmanship that went into it, for he took it home to Fair Lane, and there it remained until 1951.

Acc. 17.1.1. Neg. B.111109.

Acc. 00.1510.13. Neg. B.110618.

Miniature Gun-Plow

Henry Ford was so opposed to World War I that in late 1915 he organized a peace expedition to Europe in the hope of bringing the "terrible slaughter of Europe's manhood" to an end. Although the peace mission failed, it made the headlines in newspapers all over the country. The general public, including one Albert Krehlik of Cleveland, Ohio, was thus well aware of Ford's pacifist views. Remembering the adage about beating swords into plowshares, Krehlik proceeded to beat a gun into the shape of a plow—with the result pictured here—and in 1917 sent his handiwork to Henry Ford. The gun-plow has a brass plate identifying the donor and bearing the inscription: "Change the weapons for the plow."

WPA Shovel

During the 1930s, Henry Ford was frequently at odds with President Franklin Delano Roosevelt, and he made no secret of his aversion to the government programs that Roosevelt sponsored, including the Works Progress Administration. Inaugurated under the Federal Relief Appropriation Act of 1935, the WPA was intended to get people off the relief rolls and employ them in public works and cultural projects. Henry, however, considered the WPA a boondoggle, and whoever made this object for him must have been aware of that. The full-sized spade has a folding seat supported by two steel legs. On the seat is stamped "W.P.A. Shovel." It is surprisingly comfortable to sit on, and Henry managed to find room for it at Fair Lane.

Fordindia Casket

The Ford dealers of India, where the Ford Motor Company was known as "Fordindia," gave this fifteen-inch-long silver casket to Henry Ford on his seventy-fifth birthday. Adorned with ancient Hindu temples, it is set on a wooden base bearing symbols of Ford V-8 engines. A scroll inside the casket was signed by over sixty Indian dealers. Wallace Campbell, president of the Ford Motor Company in Canada, made the presentation on behalf of Fordindia to Henry Ford on July 30, 1938. Henry was evidently pleased with this manifestation of the cultural impact of his cars. At any rate, he took it home to Fair Lane, and it was still there in 1950.

Acc. 00.1510.2. Neg. B.110629.

Acc. 42.142.1. Neg. B.29289.

Mahatma Gandhi's Spinning Wheel

Henry Ford and Mahatma Gandhi, Hindu nation-alist leader, considered each other "sensible, peace-loving" men. Gandhi used the spinning wheel as the symbol of the economic independence he advocated for India, and he employed it in his campaign to boycott foreign goods. Henry sent Gandhi a note of greetings and good wishes in December 1941. In response, Gandhi picked out one of his portable spinning wheels and induced T.A. Raman, London editor of the United Press of India, to hand-carry it to Henry in Dearborn. The photo-graph shows Gandhi's granddaughter, Sumitra Gandhi, looking at the spinning wheel during a visit to the Henry Ford Museum in July 1961.

Motorized Roller Skates

Henry Ford, who loved to ice skate, might have relished this novel mode of tranportation. Introduced by the Motorized Roller Skate Company of Detroit about 1956, the unit consisted of an air-cooled, one-horsepower engine carried in a backpack weighing nineteen pounds; a flexible shaft transmitted power from the engine to a differential on the rear of one of the skates. The equipment included a one-quart gasoline tank and hand controls for the clutch, accelerator, and cutoff switch. The engine ran for about thirty miles on one gallon of gasoline, and the skater's top speed was about seventeen miles per hour. When the skater dropped the hand controls, the engine automatically stopped, but the skater could continue under his or her own power. To start the engine, the skater reached into the backpack and yanked a pull cord. The unit sold for $250.

The Motorized Roller Skate Company had high hopes for its innovative product and envisaged many uses for it, from transportation in rural areas to delivery services in cities. But despite receiving a good deal of publicity, the motorized skates were not a commercial success. Antonio Pirrello of Taylor, Michigan, donated the unit shown here to the Henry Ford Museum in 1985.

Acc. 85.116.1. Neg. B.102624.

Motorized Pogo Stick

Like the motorized roller skates, the motorized pogo stick was a short-lived phenomenon, but it is proof that failures are sometimes more interesting than successes. Produced by the Chance Manufacturing Company of Wichita, Kansas, about 1970, the "Hop Rod," as it was called, had a built-in one-cylinder engine with a spark plug at the top and a four-ounce gasoline tank with an attached carburetor at the bottom. Weighing 15 pounds, the Hop Rod could carry a load of up to 280 pounds. When the rider hopped onto the stick, a piston compressed the gases in the engine's combustion chamber, boosting stick and rider into the air. When they hit the ground again, the engine refired, boosting them

back up. With no weight on it, the Hop Rod stopped operating. It could run for about thirty minutes—the equivalent of six hundred "hops"—on four ounces of gasoline. It sold for $70. It came to the Henry Ford Museum along with the massive collection of automotive literature that the heirs of Henry Austin Clark, Jr., donated in 1992.

Radio Pill

Just over an inch long and less than a half-inch in diameter, this plastic capsule is small enough to be swallowed. The RCA Laboratories of Princeton, New Jersey, designed and manufactured it for medical applications about 1959. It contains a battery, transistor, condenser, coil with metal core, oscillator, and diaphragm. While traveling along the digestive tract, it is said to have emitted radio signals indicating body temperature, pressure, or acidity, depending on how it was adjusted. Vladimir K. Zworykin, vice-president of the Radio Corporation of America and an important figure in the development of electronic television, donated the radio pill to the Henry Ford Museum at some unrecorded date.

INDEX

Heinz's office desk, 386; horn arm-chair, 285; marshmallow sofa and chair, 286; office, 388; wicker stand, 286; Wright family desk, 284

Gadd, Charles W., 74
Gandhi, Mahatma, 423
garage, probable origin of, 113-14
Gasali, Luis, 321
gas station, 152
gauge blocks, 220
gavel, 418
General Electric Co., 23, 46, 173, 210, 213, 215, 222, 288, 289, 300, 358, 360, 363
General Motors Corp., 74, 125, 126, 134, 137, 185, 189, 334
generators: atomic, 215; bipolar, 209-10; hydroelectric, 213; large-scale, 211, 214; steam-driven electric, 212. *See also* Pearl Street Station
U.S.S. George Washington, 361
Gernsback, Hugo, 359
Gertenslager Co, 141
William L. Gilbert Clock Co., 307
E.P. Gilkinson & Sons, 146
glass, 255: fly trap, 256; jug diorama, 413; photosensitive, 344; sugar bowl, 255; tomato juice bottle, 419; water bottle, 257
Glass & Elliot, 351
glass ribbon machine, 224
Globe Iron Works, 57
Gold & Stock Telegraph Co., 350, 352, 373
Goodyear Tire & Rubber Co., 221
Goold, James, 76, 162
Gooney Bird. See aircraft, Douglas DC-3
Gorham Silver Co., 161
Gould, Jay, 353
Graham Brothers, 147
Grand Rapids Refrigerator Co., 270
gravestone, 410
Gray, Elisha, 346
Gray, John S., 415
Great Lakes Engineering Works, 184
Great Eastern, 351-2
Great Republic, 178-9
Greely, Adolphus Washington, 243
Greenfield Village, 17-20, 109, 247, 289
Grigsby-Grunow Co., 364
Grieves, Blanche Blackstone, 278
grinder, cylindrical, 219
guns. *See* firearms

hay baler. *See* baling press, hay
Hacker Boat Co., 183
Hacker John, 159, 183
Hall, George W., 55
Hall, John, 232
Hall, Thomas, 375

harrower, spike-toothed, 55
Haydens Mill, 63
Hansen, Walter J., 179
Harry Ferguson, 68
Haubner, T.D., 357
Haynes and Jeffries, 93
Heinz, H.J., 44-5, 386
Helmholtz, Hermann, 346
Henry Ford II (freighter), 184
Henry, Joseph, 345
Herreshoff Manufacturing Co., 180, 181
Hertz, John D., 126
Hertz, Heinrich, 347
Hertz Rent-a-Car, 126
Hess & Eisenhart, 132
Hickok Manufacturing Co., 223
Highland Park plant, 160, 214, 333, 387
Hitler, Adolf, 129, 156
Hitter, John and William, 331
Hoadley, David, 38
Holiday Inns, Inc., 154
Hollerith, Herman, 379
Holt Manufacturing Co., 70
Home Economizer, 271
Honda Motor Co., 104
Hoovens, Owens, Rentschler Co., 214
Hoover, Herbert, 20
horse ambulance, 82
horsepower, origin of term, 199
horses, Ford's dislike of, 52, 71; obsolescence of, 67
Hotchkiss, Benjamin B., 242
household items, 246-7
Howard, Dr. Alonson B., 41-42
Hughes, David, 350
hunting, 231, 235
Huygens, Christian, 207, 301
Hyatt, John Wesley, 258

icebox, 270
Ideal Manufacturing Corp., 151
Indianapolis Chain and Stamping Co., 391
Industrial Revolution, 87, 200, 203
Industrial Works, 170
Ingersoll Milling Machine Co., 222
Ingersoll-Rand Co., 173
Ingersoll Steel and Disc Co., 100
International Business Machines Corp., 379, 382
Interstate Commerce Commission, 171
ironstone china, 282
Ives, Joseph, 302

Japy Freres & Co., 307
Thomas B. Jeffrey Co., 137
Jehl, Francis, 19-20, 25-26, 166, 167
Jenkins, C. Francis, 348, 367
Jerome, Chauncy, 302
Jessup, George K., 211
Jew's harp, 159, 316

Jo-Blocks. *See* gauge blocks
Johansson, Carl E., 220
Johnson, Lyndon, 132
Jolly, J.B., 274
J.M. Jones & Co., 175
Josephine Ford (airplane), 190
jukeboxes, 324, 327

Karosseriefabrik Ludwig Weinberger, 129
Kearney & Wiggers Manufacturers, 386
Kellogg, W.K., 218
Kemp, Herman, 173
Kennedy, J.F., 132
Atwater Kent Manufacturing Co., 362
Kettering, Charles F. "Boss Kett," 189, 381
Kirby, Frank, 217
Klingensmith, Frank, 371
Knight, Benjamin, 314
Knowlton, E.J., 268
Korn, Arthur, 368
Krehlik, Albert, 421
Kruesi, John, 24
Kuralt, Charles, 158

LaFrance, Truckson, 138
Laird, E.M., 186
Lallement, Pierre, 72, 91
lamps, 287-9: betty, 290; Edison's incandescent, 297; giant electric (Mazda), 300; oil time, 296; oil wall, 293; rope-burning, 291. *See also* chandeliers; lanterns
lanterns, kerosene: police, 295; skating, 294
lathe, screw-cutting, 216
Lauhoff Brothers, 218
L. Lawrence Co., 225
Leland, Henry M., 185
Lenoir, Étienne, 207
John T. Lewis & Brothers Co., 205
Liberty airplane engine, 160, 185
Liberty Mutual Insurance Co., 131
Liebold, Ernest, 371-2, 397
light bulbs, 224. *See also* lamps; Thomas Alva Edison, incandescent electric lamp
Lima Locomotive Works, 174
Lim, Francis K.B., 385
limousines, presidential, 132
Lincoln, Abraham, 17, 244, 319
Lincoln Motor Co., 185
Lindbergh, Charles, 103, 128, 151, 189, 192; bust of, 259
Lind, Jenny, 319
Locomobile Company, 120
locomotives: Allegheny, 174; Baldwin, 167-8; Bogey, 163; De Witt Clinton, 162-3; diesel-electric, 173; electric, 166-7; Torch Lake, 163